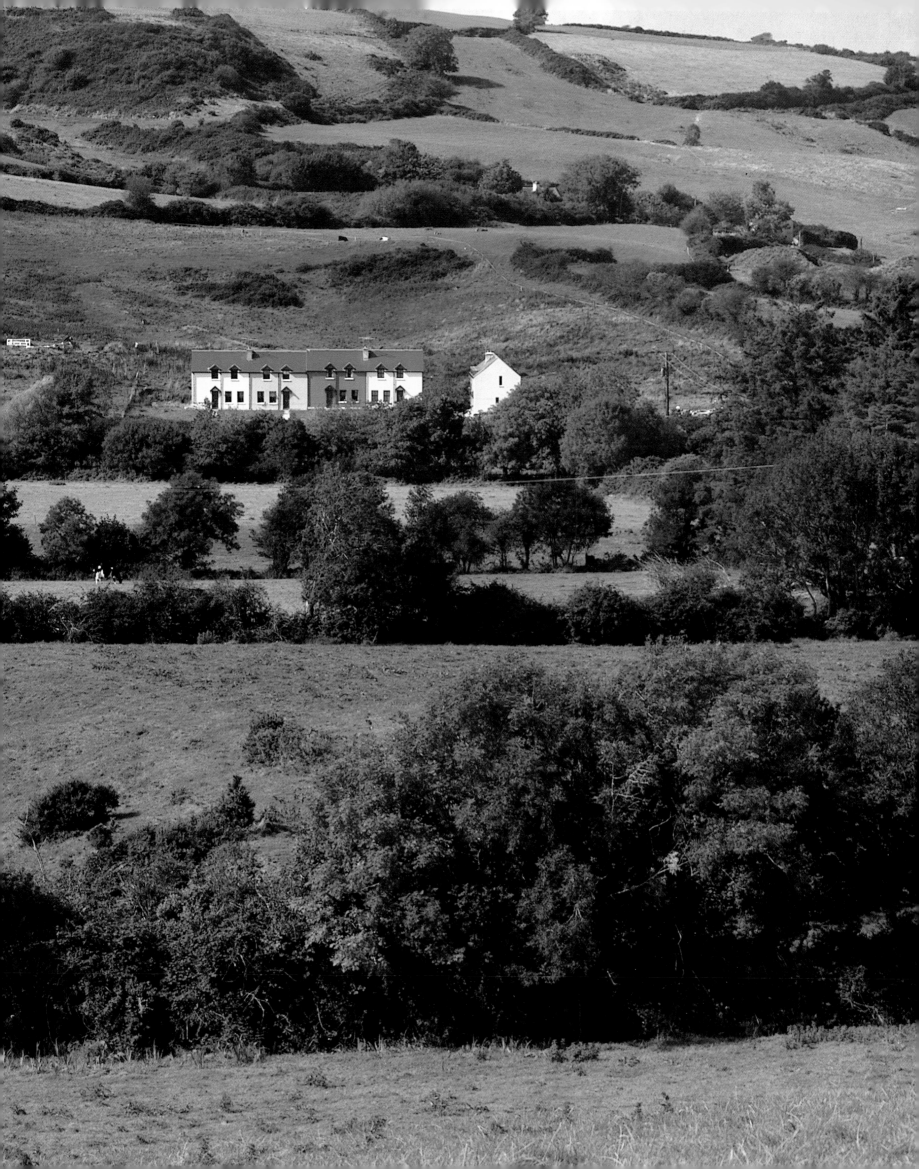

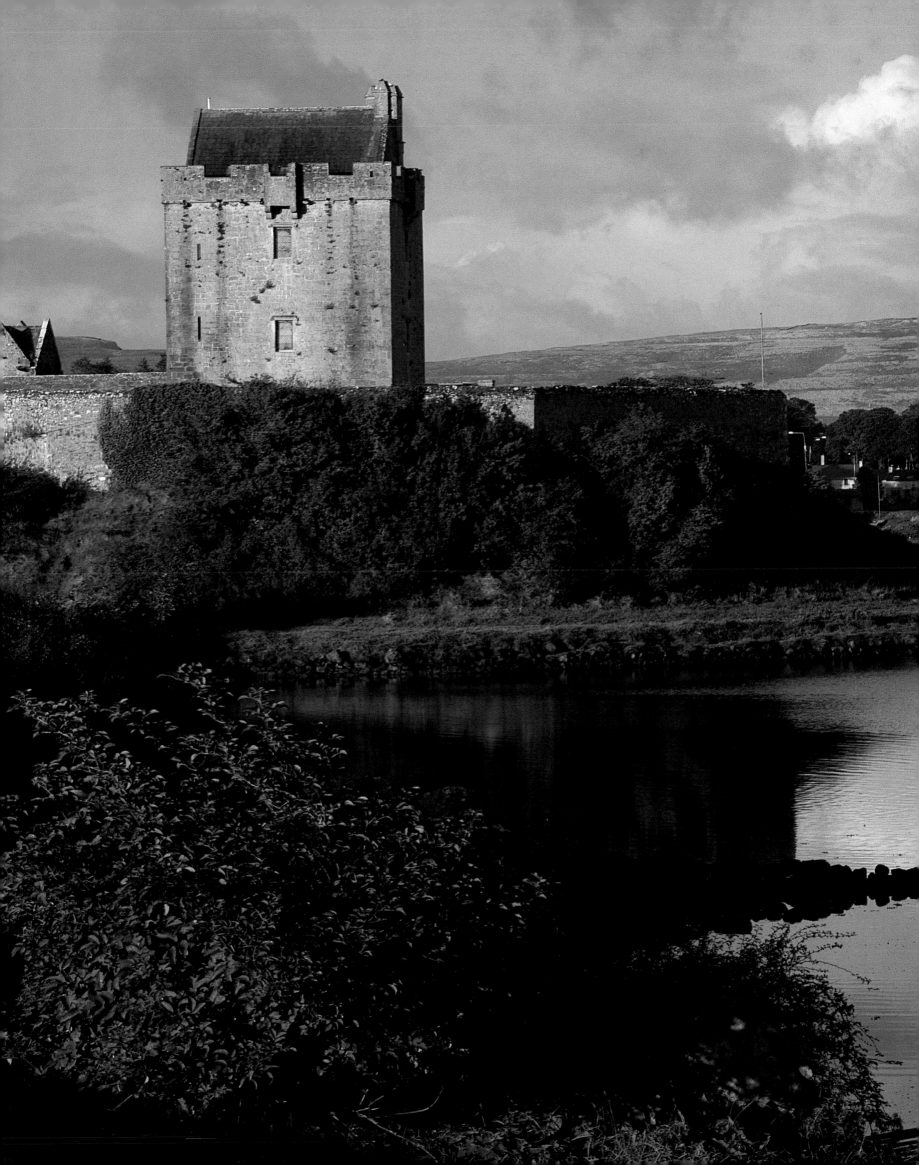

The Most Beautiful Villages of Ireland

CHRISTOPHER FITZ-SIMON

PHOTOGRAPHS BY HUGH PALMER

With 258 color illustrations

Thames & Hudson

Half-title page *Approach to a village: modern houses in vernacular style on the road to Rosscarbery in the Province of Munster.*

Title pages *The fourteenth-century Dunguaire Castle and the village of Kinvarra in the Province of Connacht; the castle was restored by Lady Ampthill during the 1960s, and is now splendidly maintained by Shannon Heritage. It is open to the public.*

Opposite *A detail from the Cross of Moone, in the Province of Leinster; the symbolic representation of the Miracle of the Loaves and Fishes contrasts startlingly with the naturalism of familiar Biblical scenes.*

© 2000 Thames & Hudson Ltd, London
Text © 2000 Christopher Fitz-Simon
Photographs © 2000 Hugh Palmer

First published in hardcover in the United States of America in 2000 by Thames & Hudson Inc., 500 Fifth Avenue, New York, New York 10110

Library of Congress Catalog Card Number 99-69558
ISBN 0-500-01998-3

Printed and bound in Singapore by C.S. Graphics

Author's Acknowledgments

The author wishes to thank the Librarian and Staff of the National Library, Dublin; the Linen Hall Library, Belfast; the North Western Library Board, Omagh; and the County and Branch Libraries situated in Adare, Bantry, Boyle, Cavan, Clones, Dean's Grange, Dalkey, Dun Laoghaire, Ennis, Enniskerry, Kilkenny, Letterkenny, Lismore, Mullingar, Sligo, Thurles and Wexford. Individuals who were particularly helpful were Norman Black, Cecily Breen, Evelyn Coady, Malcolm Dawson, Raymond Gibson, Jarlath Glynn, John Greene, Evelyn Johns, Michael Manning, Con O Conall, The Rev. Joseph O'Conor, Mrs O'Reilly, Mrs Salter-Townsend, Joy Vallely and Barbara Wallace. He would also like to thank the Chief Executive and Staff of the Northern Ireland Tourist Board; and the Manager and Staff of each of the following: Cork-Kerry Tourism, Ireland-West Tourism, South-East Tourism, Midlands-East Tourism, North-West Tourism and Shannon Development.

Photographer's Acknowledgments

Thank you to all those whose hospitality and helpfulness made my trips around Ireland such a joy, and especially to John Lahiffe of the Bord Failte office in London, at the mention of whose name, doors flew open as if by magic.
The pictures in this book are dedicated, with heartfelt thanks, to my true friend, Tom McKeown.

Contents

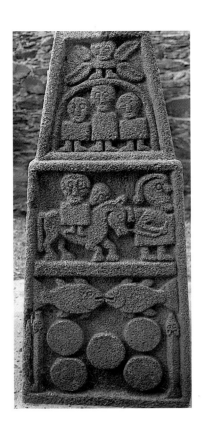

Introduction

THE ISLAND OF IRELAND has an area of 21,803 square miles and a population of 5,275,000. Its climate is temperate; a 'soft' day – of which there can be many – means one on which it is not persistently wet; yet Ireland's reputation for rainfall is somewhat unfair, for statistics show that there is an average of only sixty-five days in the year without significant sunshine; and a fine August day by a Fermanagh lake or beside the sea in Connemara is so enchanting it puts all dreams of the Mediterranean or California out of one's head. According to an American song, Ireland 'nestles in the Ocean': that ocean is the North Atlantic, and its Gulf Stream ensures much warmer winters than other European countries in the same latitude; usually there is snow for only a few weeks in upland regions, and no snow at all around the coast.

Politically speaking, the island is composed of Northern Ireland – which is part of the United Kingdom – and the Irish Republic. In common parlance these divisions are imprecisely referred to as, respectively, 'The North' and 'The South' – yet Donegal, the most northerly county of all, is part of the Republic. Such inconsistencies add to what is often described as the charm of Irish life. In terms of size and population, Ireland may be likened precisely to the State of Indiana: thereafter, however, all resemblance ends, for probably no land-mass in the world contains such a variety of topographical features concentrated in so confined a space.

Each one of the thirty-two counties has its own physical identity. There are no lakes in County Offaly, but in adjoining Westmeath there are more than twenty. In County Kildare, no hill rises above a thousand feet, but neighbouring Wicklow is entirely mountainous. Even within counties there can be extreme contrasts: the eastern half of Galway is flat, green and fertile, while the western is rugged, multicoloured and barren.

In social and demographic terms the divergences are curious and, at face value, puzzling. The people of the town of Sligo speak with an entirely different accent and intonation from their neighbours in Enniskillen, only forty miles away; one might as well be in different countries – and some would argue that one is. In east and west Cork, locally perceived differences in speech, customs, traditions and outlook are so abstruse as to be wholly appreciated only by those fortunate enough to have spent a lifetime in that attractive county; the distinctions

Threshold on the past (opposite); *the entrance to the remains of an early-Christian monastic enclosure at Glendalough in the Province of Leinster. This was the threshold of the future for the Anglo-Saxon king Alfred (849–899), known as 'the Great', who studied here.*

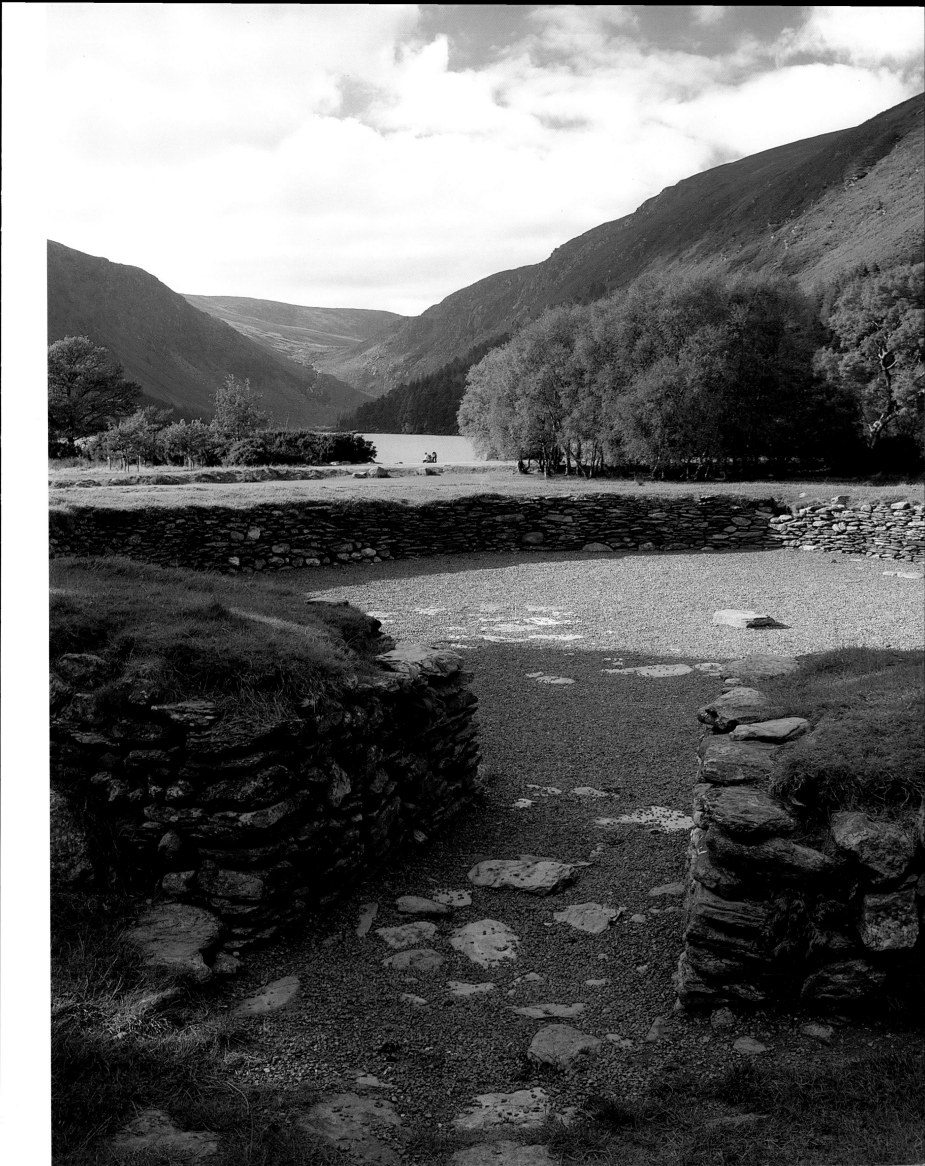

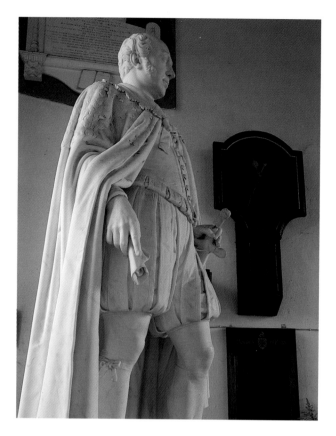

A sense of history: the 6th Earl of Carbery (1763–1842) evidently enjoyed dressing in the costume of his Elizabethan forebears. His statue, now in Ross Cathedral, formerly stood in the great hall of the family mansion at Castlefreke, in the Province of Munster.

are as enigmatic as the subtly changing landscape, observed as one travels on the road from Youghal in the east of the county to Castletownbere in the west.

The lively and interesting variations in the personality and character of the people have their origins in the migrations and settlements imposed by the politics of the past. During the numerous 'troubled times' which have punctuated Irish history, the causes of conflict have been generally seen as stemming from British incursion, colonization and government. Certainly this is the kernel to what still seems to be the persistent enigma of Northern Ireland. Since the Anglo-Irish Treaty of 1922, the Republic has slowly, and at last triumphantly, taken its place – as the insurgent Robert Emmet presciently remarked in 1803 – 'among the nations of the world'. The international media, with its propensity for the kind of simplification which reduces any circumstance to its least meaningful, has tended to equate the Loyalism (to the British Crown) of Northern Ireland with Protestantism, and Republicanism with Roman Catholicism. It was in response to this kind of unlearned generalization that a testy George Bernard Shaw declared a hundred years ago that he was 'a genuinely typical Irishman – of the Danish, Norman, Cromwellian and (of course) Scotch invasions'. He then remarked that though 'arrogantly Protestant by family tradition', he was 'an inveterate Republican and Home Ruler'. He continued: 'It is true that one of my grandfathers was an Orangeman; but then his sister was an Abbess; and his uncle, I am proud to say, was hanged as a rebel!'. Such intricacies of allegiance and attitude continue to permeate Irish life in all parts of the country.

In not including 'Celts' among his list of forbears, Shaw may have been showing uncharacteristic academic caution, for opinions differ as to who exactly the Celts may have been. Early Irish art, for example, is often sweepingly referred to as 'Celtic', but the extraordinary tombs and incised stone carvings of the Boyne Valley necropolis were created by a Neolithic people who were here prior to the Celtic migrations from central Europe. Our ideas of Celtic art stem largely from the nineteenth-century rediscovery of Ireland's past, and include such diverse manifestations as the stone sculptures of Newgrange and Knowth of about 3000 B.C., the gold Mooghaun Collar of about 700 B.C., the Tara

This ruminative Munster resident (right) probably has a more convincing theory about the origins of the multitude of 'standing stones' scattered over the Irish countryside than the visiting scientists who publish learned papers on the topic.

Brooch of about A.D. 700 and the illuminated *Book of Kells* of about the same time. Dating is as hazardous as the terminology.

The landscape of Ireland is richly endowed with artefacts indicative of several passing civilizations. Dolmens raised about two thousand years before Christ, court cairns, Ogham stones, and the great sculptural high crosses of the early Christian period are reminders of these ever-changing cultures. Over sixty round towers – of the kind which are almost as emblematic of Ireland as the harp and shamrock – also occur in Scotland, and were built to the same pattern from the 5th to the 12th centuries A.D. The numerous abbeys – now almost invariably ruinous due to Henry VIII's dissolution followed by Cromwell's destruction – bear witness to a close affinity with the European mainland. Contrast these with handsome Palladian and neoclassical country mansions and we see further European influences, appearing comparatively late, and mainly via England. The Gothic Revival in Ireland was almost entirely English-inspired. (For those wishing to see examples of five thousand years of building and decorative art all in one day, Meath is the county!)

While the received picture of Ireland, north and south, remains that of a land and a people chiefly involved in agricultural pursuits, and while exports of dairy and garden produce, meat and beverages are indeed on the increase, the fact is that manufactured goods – including computers and pharmaceuticals – are now by far the most important staples of the economy. Tourism is a growing industry: by 1998 the number of people visiting Ireland exceeded the local population of five million –

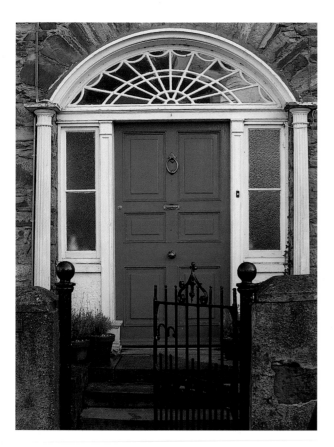

A splendid doorway and fanlight at Lismore in Munster (above); the 'Georgian' style survived long into the Victorian era in the Irish provinces. Another aspect of traditional Ireland – in this case, maritime – is picturesquely displayed in the crowded harbour of Dunmore East in Munster (opposite).

fortunately these visitors did not all arrive at the same time! During the summer months, however, major attractions such as the Trinity College Library in Dublin, the Boyne Valley necropolis or Muckross House and National Park in Killarney, can become uncomfortably crowded. The spring and autumn are therefore the pleasantest times for a leisurely tour, and rates in hotels and guest houses are substantially lower.

The villages in this book have been chosen in order to give a sense of variety rather than to represent every county. The term 'village', indeed, is not an Irish one. When Irish people speak of going to 'the town', they may have nothing more in view than a cross-roads with, perhaps, a few houses, a church and a pub. The Irish *baile* signifies a 'townland', which is something akin to the Scottish 'bailiwick' or English 'bailey' and may not necessarily contain any dwellings at all. In the Irish language, a *sráidbaile,* or 'street-townland', is the nearest one approaches to 'village', and a 'town' is described as a *baile-mór,* or 'great townland'. Thus, the people of many of the places featured in this book would be very surprised to learn that they live in a 'village'.

If one were to select villages purely on the basis of the charm and interest of streetscape and environs, one could produce several books of the same title. The aim here, however, has been to provide a sense of the variety of styles of Irish village – from scattered settlements, or *clocháin,* to the neat estate villages built by 'improving landlords'. There are villages which take their character from their situation and the consequent occupations of the people – fishing or milling or the distribution of a specific product such as linen; there are riverine villages, canalside villages, villages which are market-towns in miniature, villages which exist because of some great ecclesiastical foundation. The traditional Irish village of thatched white-washed cottages probably has pride of place, though few remain – yet villages built of a local stone with slated roofs, or villages where painted stucco assails the eye with astonishing brilliance are equally traditional, townland by townland, county by county, province by province.

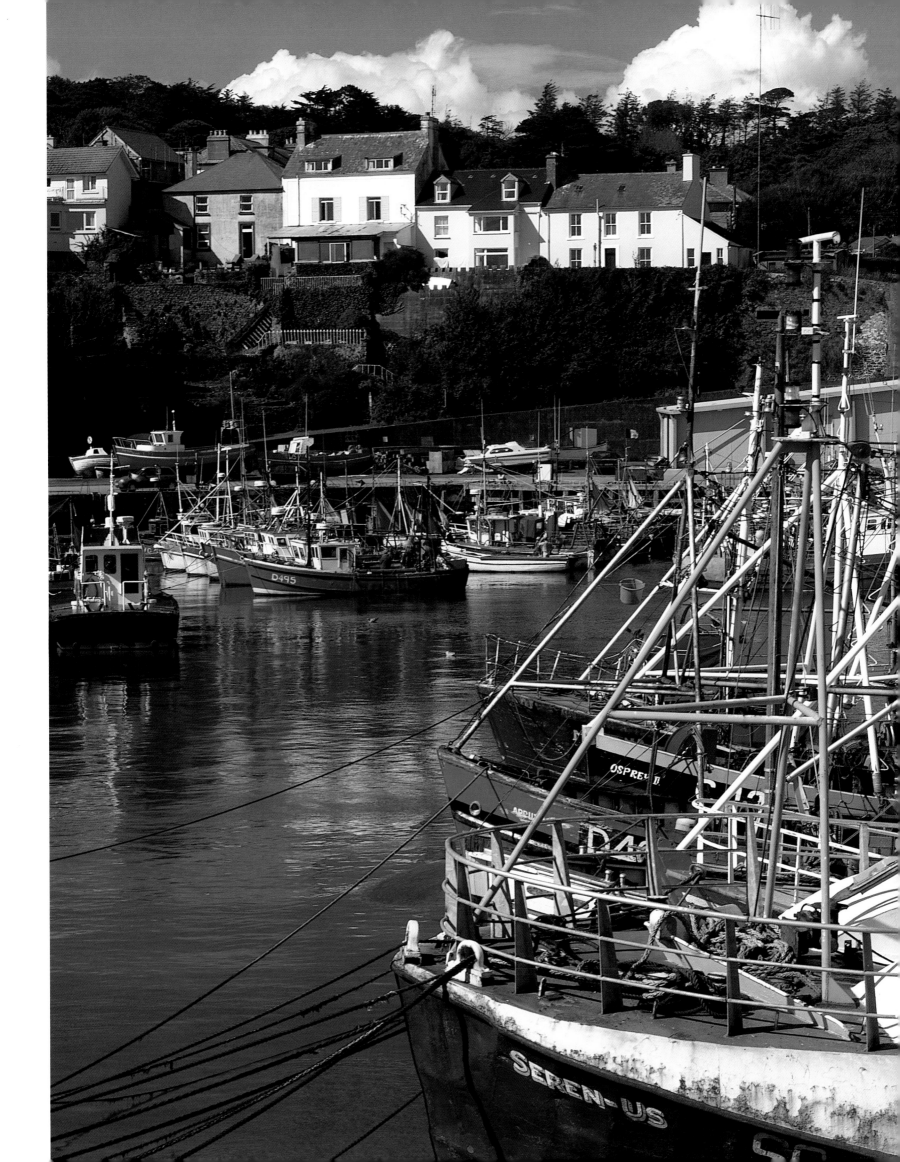

Ulster

THE MOST NORTHERLY province contains nine counties; alphabetically, these are Antrim, Armagh, Cavan, Donegal, Down, Fermanagh, Londonderry, Monaghan and Tyrone. Six of these counties comprise Northern Ireland, while Donegal, Cavan and Monaghan are part of the Republic. In no province are there so many contrasts of topography and demography, from the granite mountains of Donegal to the basalt uplands of Antrim, from the lakelands of Fermanagh and Cavan to the drumlins of Monaghan and Down. Scottish plantations in Elizabethan times, and English and Scottish plantations in Elizabethan and Jacobean, have led to conflict; but also, in a more positive way, to a rich variety of speech, industry and architecture. In practical terms, the visitor will find a much better developed road system in the counties of Northern Ireland, where a decision for systematic improvement was implemented as long ago as the 1950s; conversely, the three border counties of the Republic are noted for having the worst roads in the whole island, and are therefore the butt of numerous jokes: Cavan, for example, is universally known as 'The Pot-Hole County' – but the jokes diminish as the roads gradually improve. The term 'border' has proved an inhibiting factor to foreign visitors, conjuring up a picture of El Paso – but, since the advent of the European Union, frontier-posts have vanished, as have customs examinations. It is now possible to drive from one jurisdiction into the other without noticing the change – except, perhaps, in the standard of roads.

The Mourne Mountains (opposite) *occupy the south-east corner of the Province of Ulster. A popular destination for week-end walkers from Belfast – only 30 miles away – the outstanding natural beauty of the area is rigidly, though discreetly, protected.*

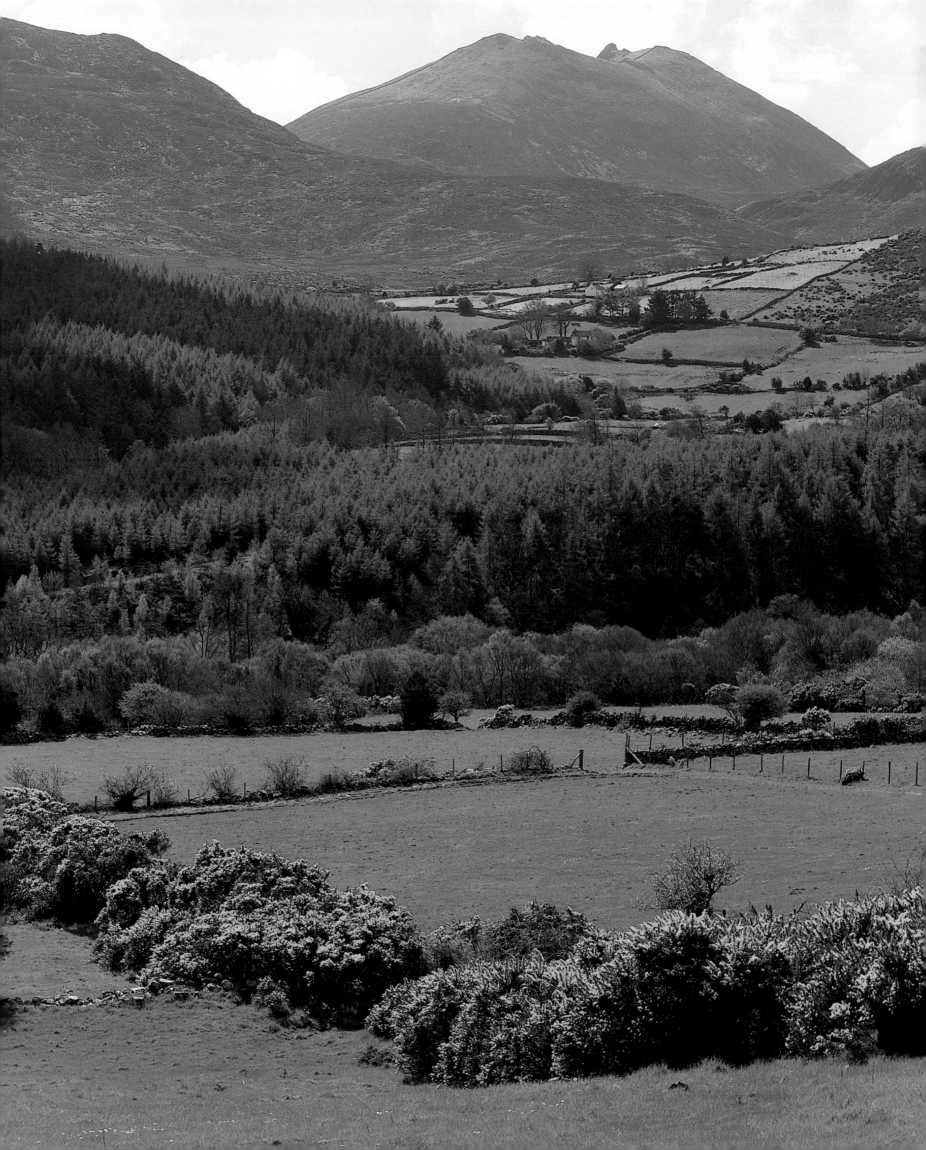

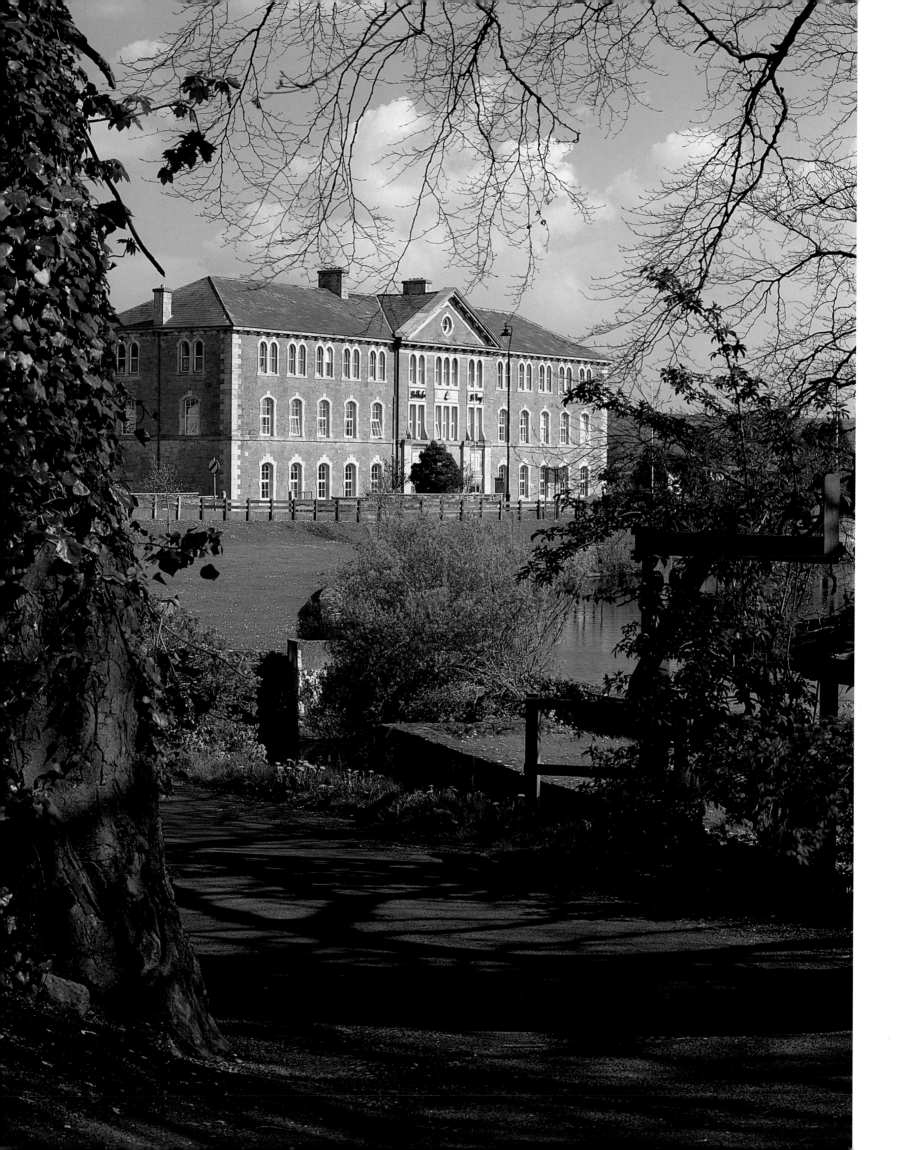

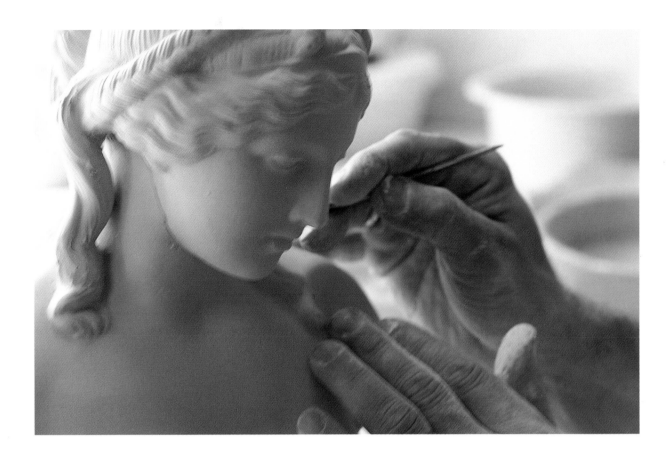

The foundation stone for what is now the headquarters (opposite) *of the celebrated Belleek Pottery was laid by Mrs Bloomfield, wife of the founder and proprietor, on 18 November 1858. The skilful hands of the fettler delicately complete the process of producing the fine Parian china* (right) *for which Belleek has a world-wide reputation.*

Belleek

(*Béal Leice* = Flagstone Ford)

FERMANAGH

'THE PARISH has not been the scene of any remarkable event, nor has it given birth to any remarkable person', wrote the anonymous officer in charge of the Ordnance Survey for Fermanagh in 1835. The writer was naturally unaware of the recent birth of the remarkable John Caldwell Bloomfield, son of a local landlord, who, twenty-three years after publication of the Survey, founded the Belleek Pottery in the extreme west of the county.

Bloomfield was an amateur geologist who discovered that due to the presence of kaolin – a fine white clay formed by the decomposition of felspar in granite – on his land, he had material for the manufacture of pottery. The other essential, power to turn the wheels which would produce slip (finely ground clay components) was abundantly available in the waters of the unquestionably mighty Erne. In spite of the work of craftsmen imported from Staffordshire, England, to train local labour in the manufacture of domestic ware, the firm did not prosper; only when it started to produce fine porcelain did it find an international market, and by the end of the century the highly decorated Belleek Parian china was to be found in

fashionable stores on Fifth Avenue and Bond Street. Queen Victoria was a customer.

The industry was a godsend to the local community, which hitherto had subsisted almost entirely on agriculture. Bloomfield was also instrumental in attracting a branch of the Great Northern Railway; this meant that coal could be imported more cheaply than by sea and river. Excursionists were also attracted, creating the nearby seaside resort of Bundoran. The railway was most successful during the two world wars, when other forms of transport were unobtainable; it closed in 1957. Now, tour coaches bring regular visitors.

The Pottery is still the most distinguished building. It contains a museum where Belleek ware of all periods is on display. The iconography of the Celtic Revival – harps, round towers, sunbursts, Irish wolfhounds and unending sprigs of shamrock – is very much in evidence. Other craft industries – weaving, knitting, crochet, as well as small independent potteries – have established themselves in and around the village, contributing to the local economy.

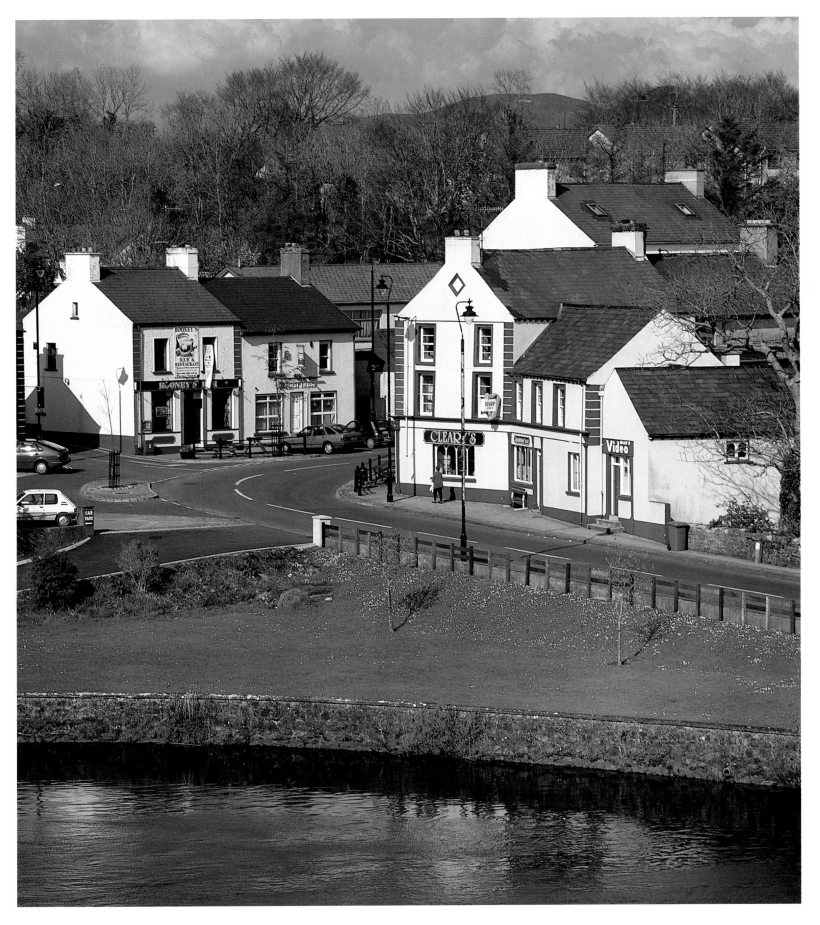

*T*he old houses of Belleek's main street and centre (opposite *and* above), *seen here from the fort on the south bank of the river Erne, have an exceptional architectural grace about them, especially when basking – complete with foliage – in the afternoon sunshine.*

Cushendall

(*Cos Abhann Dalla* = Foot of the Dark River)

ANTRIM

IT SEEMS EXTRAORDINARY that before the 1830s, when the Coast Road was constructed, the celebrated Nine Glens of Antrim were accessible only from the high plateau which forms the centre of the county. You could, of course, reach the villages at the foot of the glens by fishing-boat, but it seems that few intrepid explorers in search of the picturesque did this, preferring to trudge over headlands or to descend via the inland roads by pony-trap. The people of these villages were more familiar with the harbours of Scotland, twenty miles across the Moyle, than they were with their own hinterland towns of Ballymena and Ballymoney.

The Antrim Coast Road now links the villages at sea level. It was a military project, but was never required for bellicose purposes. It brought trippers from Belfast, and probably hastened the demise of the Irish language in the glens. Cushendall is situated at the confluence of the rivers which cascade from Glenaan and Glenballyemon; the combined waters are known as the Dall, which means 'dark' – and certainly it is dark and deep in comparison with the foaming torrents of its tributaries.

A certain Francis Turnley bought the village of Newtownglens from the Richardson family at the turn of the 19th century, restoring its old name. A noted traveller, Turnley is said to have modelled his Curfew Tower on a fort which he had observed somewhere in China – on the Great Wall, perhaps? Allowing for hyperbole, one might assume that the building was intended as a folly or eyecatcher, so it comes as something of a surprise to learn that it was built in order 'to contain riotous persons'. Turnley employed an army pensioner called Daniel McBride as a 'garrison of one man'. The egregious McBride was equipped with a musket, a bayonet, a brace of pistols and a thirteen-foot pike; it is unclear as to whether he had occasion to use them, but somehow one doubts it.

The slopes above Cushendall are rich in archaeological remains. On the south side of Glenaan there is a fine cromlech, and near it is the grave of Ossian – presumably the poet (also known as Oisín) famous for his contentious dialogue with St. Patrick, rather than the Ossian 'translated' by the Scottish versifier James MacPherson.

'Silent, O Moyle, be the roar of thy waters!' wrote the poet Tom Moore, recalling the fate of the Four Children of Lír, who were transformed into swans and destined to swim for a thousand years on the stretch of sea which separates Ulster from Scotland. There are legends and folk-tales a-plenty in the neighbourhood of Cushendall.

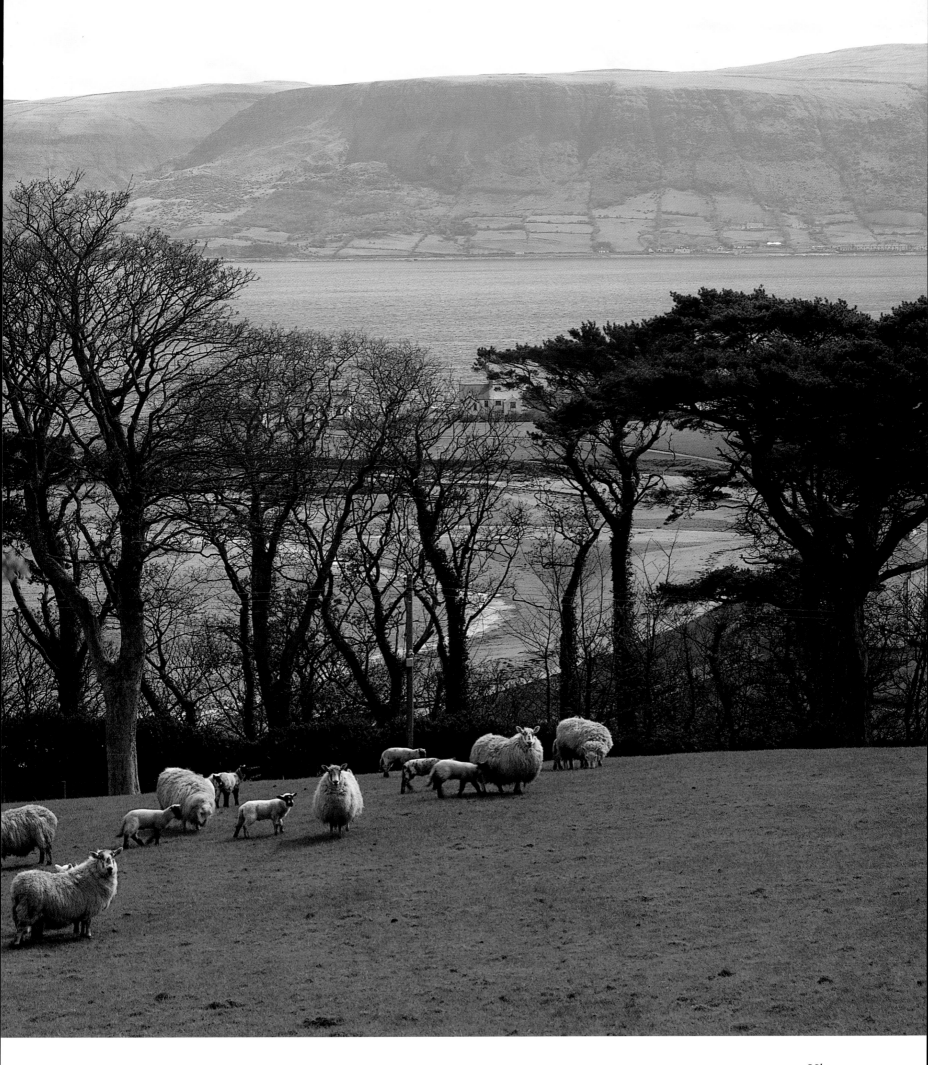

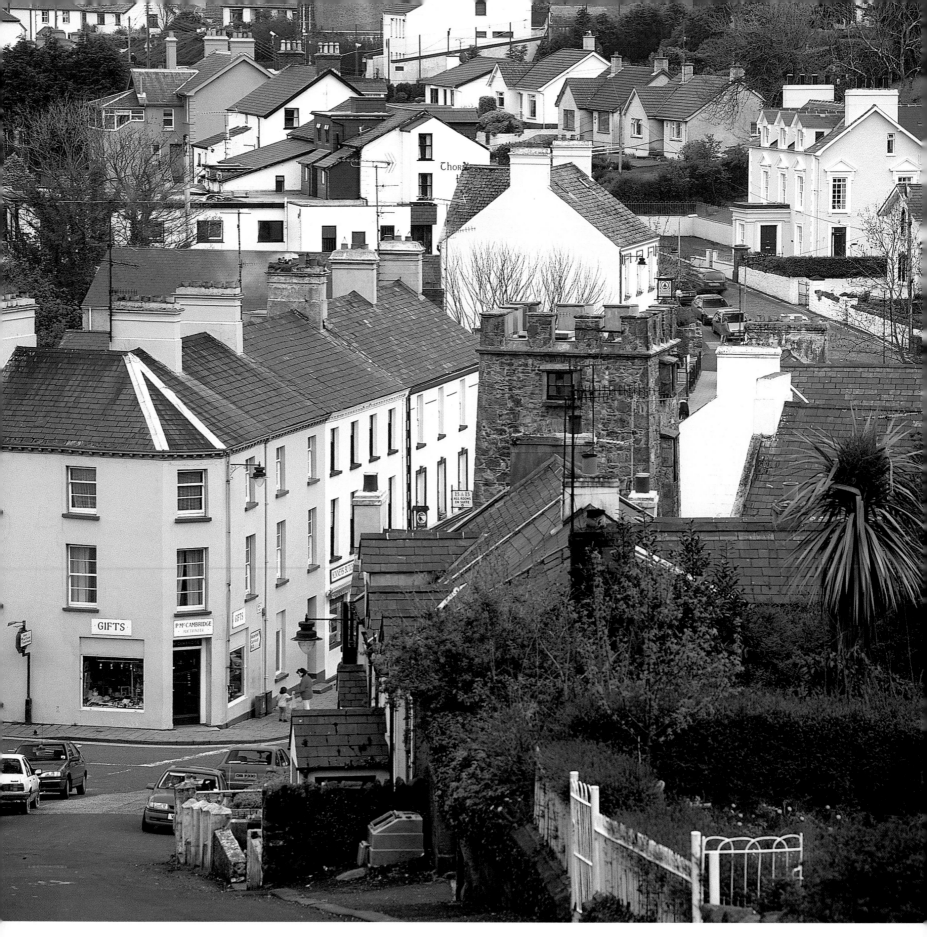

*T*wo *great highways, the Antrim Coast Road and the ancient inland road from Ballymena meet at this inauspicious intersection in the centre of Cushendall.*

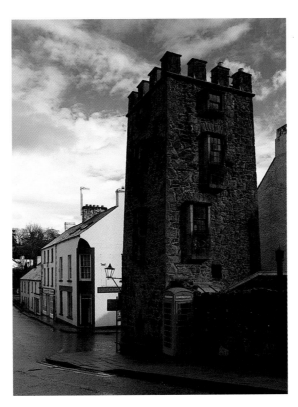

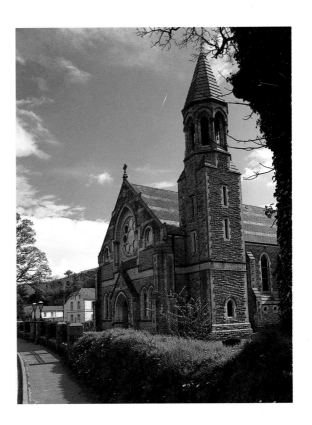

*A*rchitectural features of Cushendall include: Francis Turnley's *Curfew Tower* (above left); *the Roman Catholic church built by Father John McKenna in 1836 on land donated by Turnley* (above right); *and many charming semi-rural villas* (below).

Glaslough

(*Glas Loch* = Grey Lake)

MONAGHAN

*T*he road from the county-town of Monaghan leads into the main street of Glaslough (above). *In the same street stands this cottage with its original barge-boards* (above right); *fifty years ago such houses were being torn down – now those which are left have been sympathetically restored.*

COUNTY MONAGHAN was never rich in country mansions – in fact, it was never rich in anything – save at a few places where the possibilities for good grazing and tillage attracted planters, or land-grabbers as they were less politely called. What is curious is that the few very large country houses were built or extended in the reign of Victoria, an era generally regarded as one of economic stagnation in Ireland. The massive houses of Rossmore and Dartrey, all machicolations and crenellations, have vanished – some would say fortunately, for it would be hard to imagine two more hideous buildings. Annaghmakerrig (now the Tyrone Guthrie Centre, a workplace for writers and artists) and Glaslough Castle have survived. Glaslough, or Castle Leslie as it is now known, is by far the least bizarre, managing to live in visual peace with its surroundings rather than terrorizing them.

John Leslie, Bishop of Clogher, bought Glaslough Castle in 1665, and can not therefore be considered a planter in the conventional sense. The present house was built by Sir John Leslie in the 1870s with assistance from the distinguished Belfast architect W.H. Lynn. Lynn was also engaged to add a 'Norman' chancel to the church and, later, to design the memorial fountain to Sir John which remains the focal point of the village and was evidently the gift of 'his grateful tenantry'.

The Glaslough tenants had reason to be grateful. The 1845 famine reduced the village from a population of 400 to barely a hundred. The Leslies built a Fever Hospital, and gave employment to those who were able to work by creating a public water-supply. Far from being typical of the philistine landlord class, the Leslies were connoisseurs of the arts, amassing a notable collection of paintings and sculpture. In 1912 Seymour Leslie published an engaging memoir, *Glaslough in Oriel* – Oriel is the ancient kingdom which roughly corresponds with the present county of Monaghan. Four years later, Shane Leslie published *Songs of Oriel*; he also wrote a number of very popular ghost stories, and several biographies, including one of Cardinal Manning. His daughter Anita Leslie was the author of the exceptionally fine war memoir *Train to Nowhere* (1946), and his son Desmond Leslie, a composer as well as a writer, is the author of *Flying Saucers Have Landed* (1953).

In *Glaslough in Oriel*, Seymour Leslie speculates that 'it can be shown that an aeroplane could, with a favourable wind, cover the 340 miles separating Glaslough and London in four hours'. It is now possible to fly from Belfast to London in one hour, but given the time required for surface transportation from Glaslough, check-in, and the inevitable delays, he was just about right.

*V*aried aspects of Glaslough, human and
architectural: local historian Jack Heaney, seen
here beside the memorial fountain to Sir John Leslie
(below), was for 45 years an employee at Castle Leslie ;
(the bust of Sir John, stolen from its circular niche,
will shortly be replaced by a replica). St. Salvator's
Church (right); the Italian garden at Castle Leslie
(below).

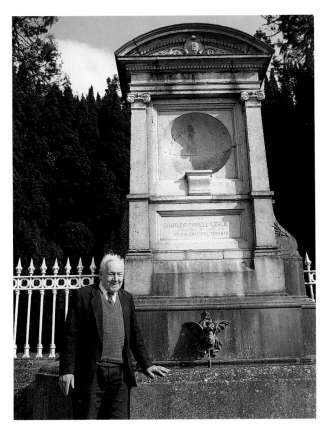

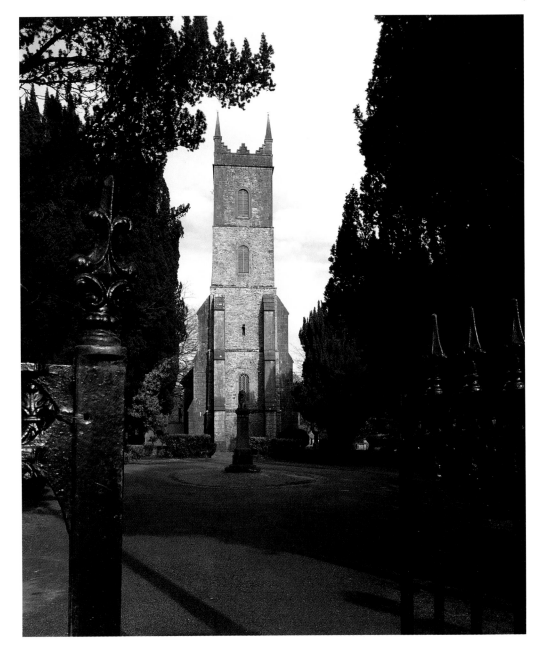

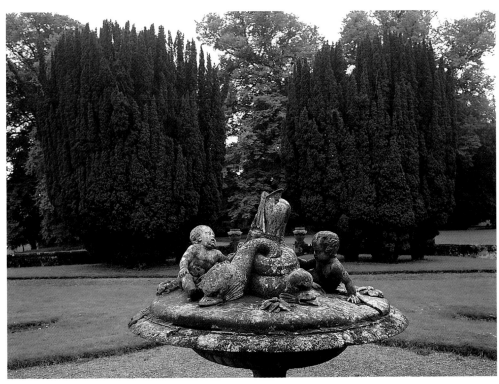

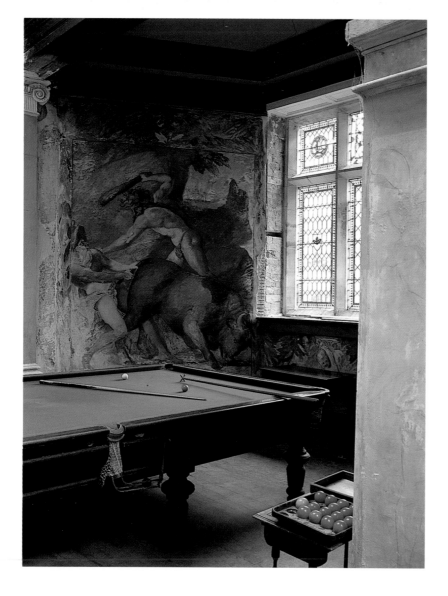

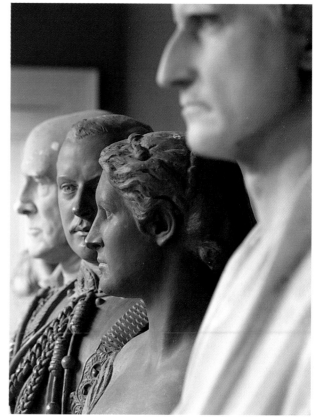

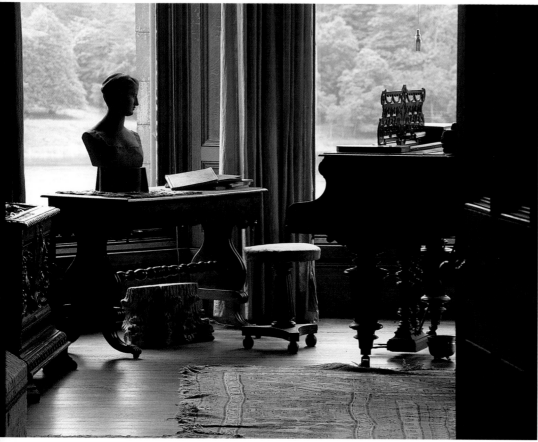

*T*he present Castle Leslie (opposite) *dates from the 1870s. Billiard players there* (above left) *may draw inspiration from* The Battle of the Centaurs *by Sir John Leslie (after Michelangelo). The bust of Theodosia Leslie* (left)*, who married Sir Joselyn Bagot of Levens Hall, Westmoreland, now surveys the drawing-room of the castle. The 1st Duke of Wellington, Sir Myles Ponsonby, Prudence Penelope Leslie, and that well-known personality, Anon, maintain a silent (though apparently animated) watch* (above)*.*

Flags in Loughgall's main street on 12 July (left) *commemorate William III's victory over James II at the Battle of the Boyne in 1690. The centre of the village is notable for its pleasing examples of domestic Georgiana* (opposite).

Loughgall

(*Loch gCal* = Cal's Lake)

ARMAGH

THE BRAMLEY SEEDLING, though probably less popular than it used to be, remains the symbol for Loughgall, Rich Hill, Kilmore and other villages of north Armagh. If the orchards are not now as central to the economy, the image of apple-growing remains strong in the Ulster consciousness. Twice a year hundreds of city-dwellers still make their way down the hawthorn-bordered by-roads – in the spring to look on the apple-blossom and to smell its fragrance, gazing and inhaling as if to recall and absorb the sensation of a more simple and innocent time; and in autumn, to buy Bramleys, Coxs, Pearmains, Laxtons and Beauty of Bath from the farmers, picking them off the trees, or searching for windfalls in the long grass.

The adjoining estates of the Drumilly and the Manor House – the latter once the home of the Cope family, of whom Field-Marshal Sir Gerald Templer was a distinguished descendant – are now a Department of Agriculture horticultural and plant-breeding station where the work carried out is relevant to the development of several locally important industries – mushrooms, ornamental nursery stock and specialist vegetable crops – as well as fruit. The Manor, with its handsome tree-lined avenue, neat little fields and picturesque lake, is maintained by that official body with the kind of affection and respect which perhaps should not

surprise, though in fact it does – and pleasantly so.

It is curious to find that Sir Charles Coote, writing almost two hundred years ago in the marvellous *Statistical Survey of the County Armagh*, found a remarkably similar ethos in this part of the county – 'The roads are excellent, the enclosures elegant, and the country in the highest state of fertilisation from hence to Loughgall village. A very active and attentive spirit of improvement is visible'. He did not admire the 'mansion of Drumilly', which he felt had a 'clumsy and antique appearance'; photographs do not seem to bear out his judgement, and unfortunately the mansion was demolished in the 1960s in an act of architectural vandalism unusual in Northern Ireland.

Loughgall is notable as the setting for the foundation of the Orange Order. In September 1795, a Protestant group known as the Orange Boys, occupying an advantageous position on a hilltop, defeated a large force of Defenders, a Roman Catholic organization, killing more than thirty of their number. Known as the Battle of the Diamond, its aftermath in James Sloan's inn in Loughgall resulted in the formal signing of a document setting out the precepts of an Order dedicated to perpetuating the 'glorious and immortal memory' of the Prince of Orange, otherwise William III, victor of the Battle of the Boyne.

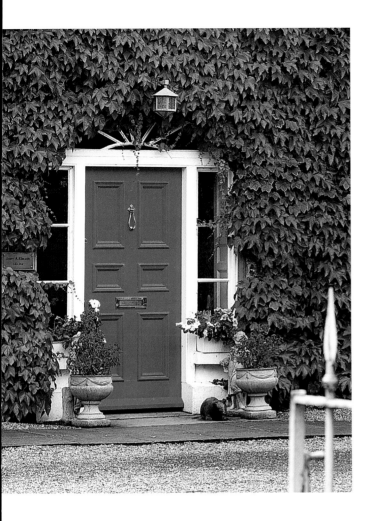

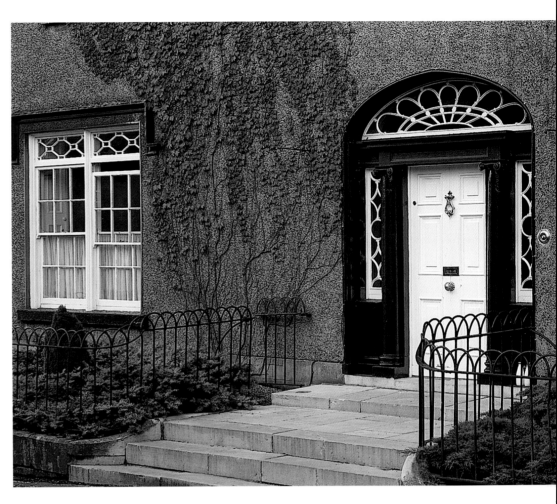

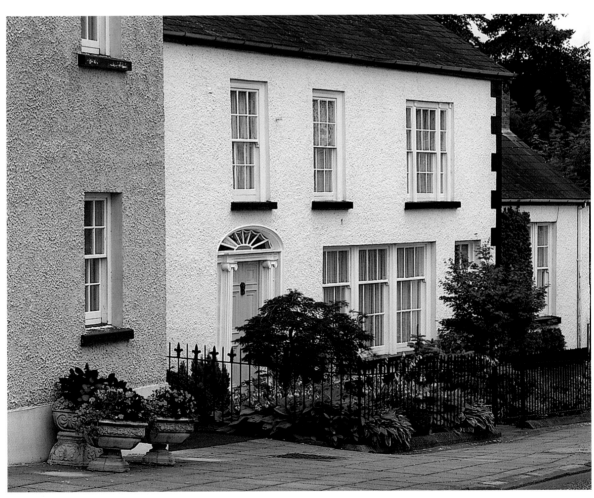

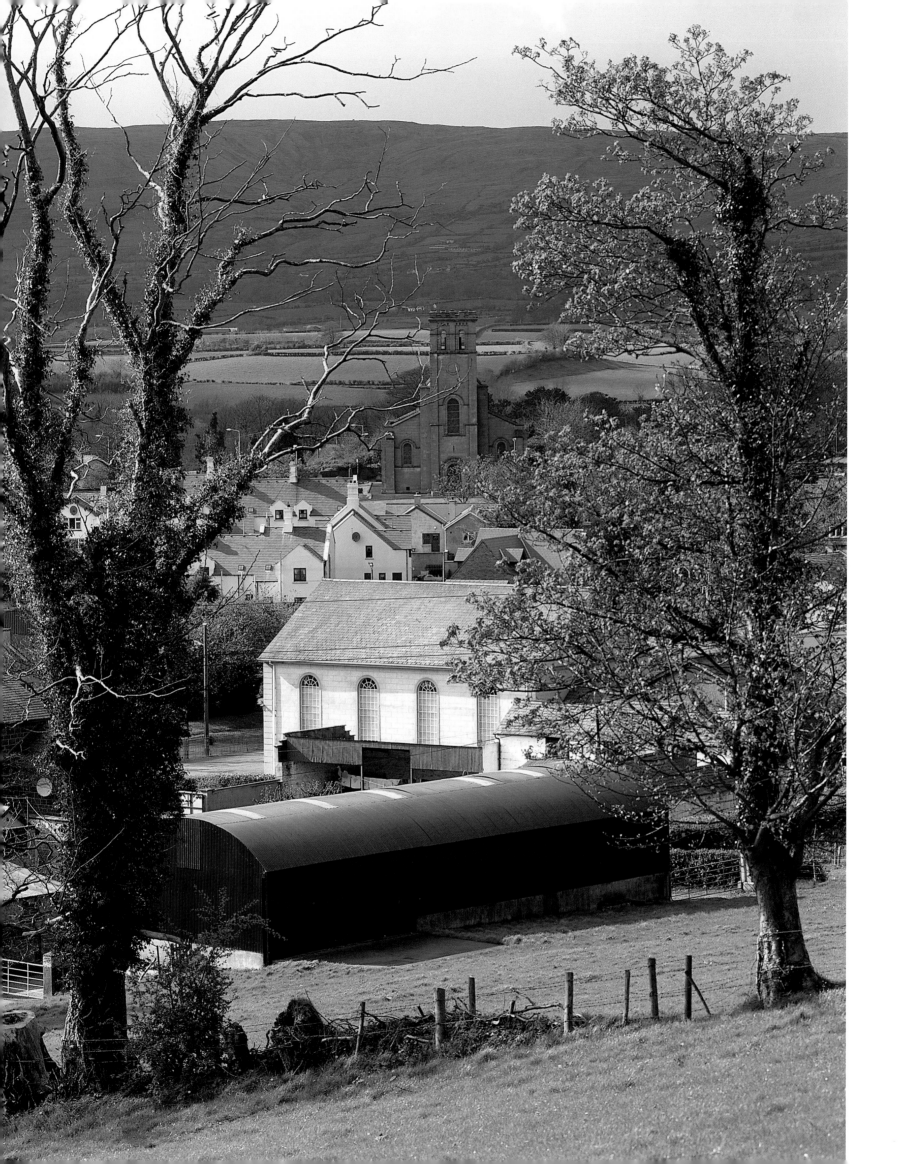

Moneymore

(Muine Mór = Great Shrubbery)

~~LONDON~~DERRY

THE ARCHAEOLOGIST AND HISTORIAN John O'Donovan, engaged in extensive fieldwork in County Londonderry in 1834, was at some pains to seek local information as to who had founded the numerous ruined churches, forts and stone enclosures with which the county was so plentifully endowed. 'Everything,' he wrote wryly, 'was erected by "the Danes" or "Finn McCool"' – the latter a reference to a pre-Christian heroic figure whose exploits are still recounted in Ulster folklore. Far less fanciful – indeed, completely factual – was the information that the village of Moneymore was founded by 'the Master and Wardens and Brethren and Sisters of the Guild of Fraternity of the Blessed Mary the Virgin of the Mystery of Drapers in the City of London'.

The more familiarly styled London Company of Drapers laid out the village in the third decade of the 17th century. The climate and soil were found to be particularly favourable to the cultivation of flax; appropriately enough, the Drapers took a special interest in developing the linen trade; so much so, that by the end of the 18th century Moneymore's linen fairs were not merely the largest in Ulster, but in the whole of Ireland.

The Moneymore which we see today is largely the result of an early nineteenth-century improvement scheme, also masterminded by the industrious Drapers. The Guild had the wisdom to engage a London architect, one Jesse Gibbons, as their 'Surveyor'. As well as being responsible for the overall plan, Gibbons designed the range of buildings known as the New Market House, the centrepiece of which is a high arch which leads to what was then the coach-yard. Modern shop signage has attempted everything possible to destroy the serene grandeur of this frontage, though with only partial success – for Gibbons' concept triumphs. The Old Schools are now the beautifully maintained Orange Hall. It is recorded that the Drapers subscribed £4,000 towards the erection of the Presbyterian Church, which is of a similarly discreet classical design. They paid for the entire building of the Church of Ireland parish church and, with becoming generosity, donated £250 for a Roman Catholic chapel.

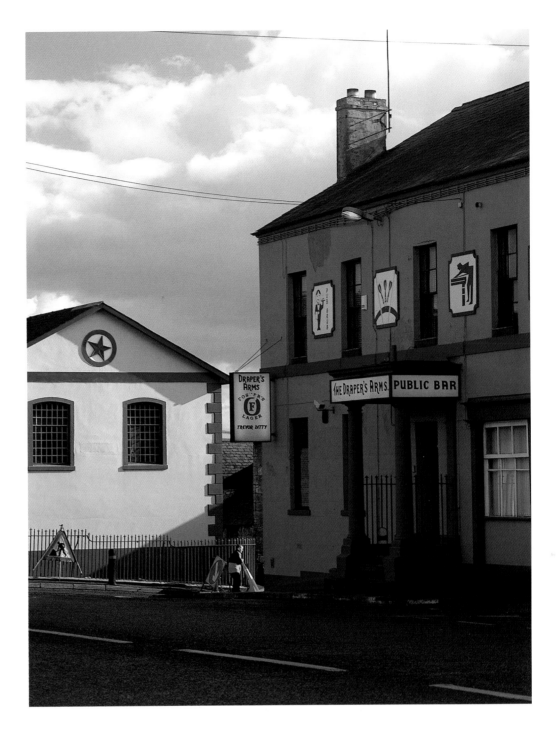

The greatest architectural delight of Moneymore is Spring Hill, built in the late 17th century by the Conyngham family, who came from Ayrshire. The marriage articles of Anne Upton of Castle Upton in the neighbouring county of Antrim required William Conyngham to build 'a convenient house of lime and stone, 2 storeys high', which William evidently did. This eight-bay 'modest mansion' dates from that time, but it is the curvilinear gables of the farm buildings which frame the forecourt, and the two matching wings of the house with their semi-octagonal fronts of 1785, which give Spring Hill its unique charm. The property was willed to the National Trust of Northern Ireland by the late Captain William Lenox-Conyngham, and is open to the public.

*M*oneymore: winter turns to spring on the edge of the Sperrin Mountains (opposite). True blue pub and Orange Hall (above): The Draper's Arms has been in existence since the 1830s; the Hall was formerly the school of 1820.

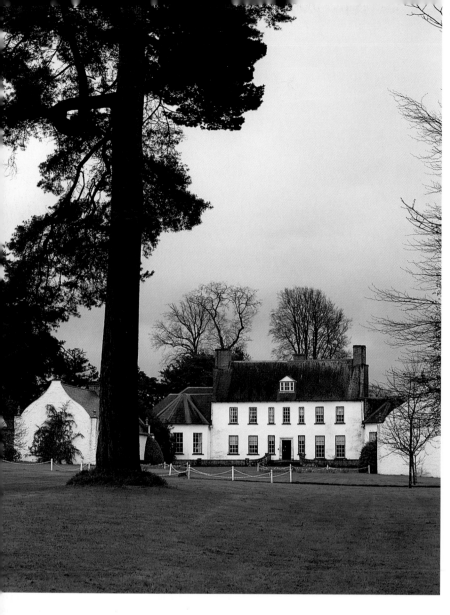

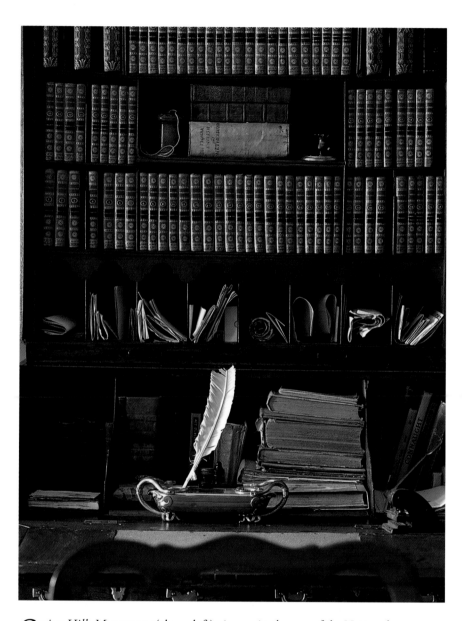

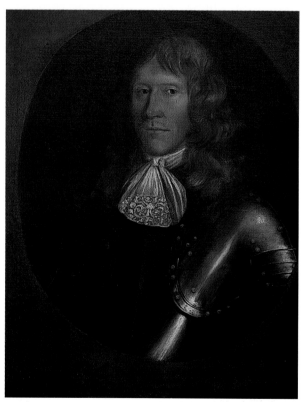

*S*pring Hill, Moneymore (above left), *is now in the care of the National Trust for Northern Ireland. Sir Albert Conyngham of Spring Hill* (left) *was a distinguished commander in the Inniskilling Dragoons. Among the books preserved in Spring Hill's unique library are Raleigh's* History of the World *(1614), Hobbes'* Leviathan *(1651) and an early* Gerard's Herbal. *The objects of family memorabilia* (opposite) *at Spring Hill include silver buttons from the Ballinderry Regiment of Infantry, Sir William Conyngham's insignia of knighthood, a Connaught Ranger's crest, and a watch by Daniel Quare.*

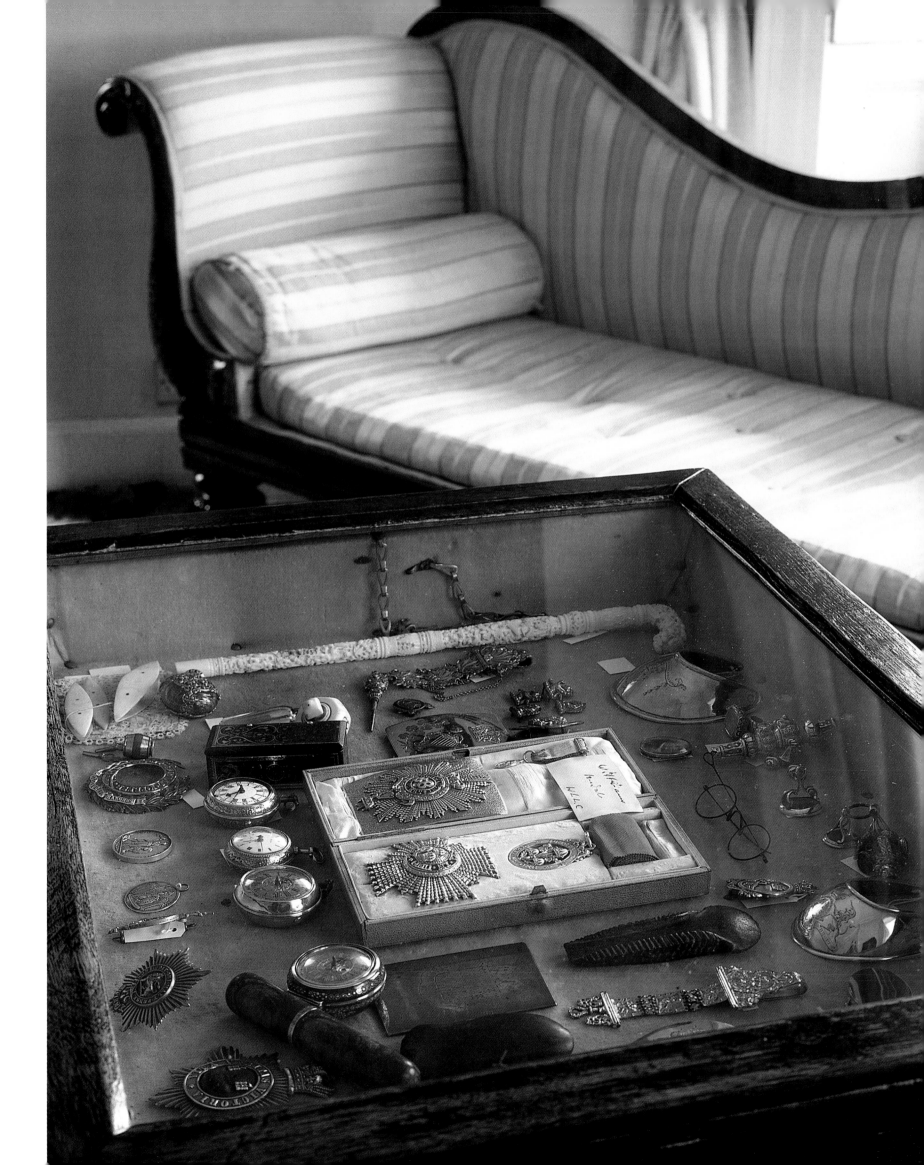

*I*f Plumbridge appears remote, it is none the less the centre of its own world; if described as 'off the beaten track', what wonderfully scenic tracks are those which meet here, from Derry to Gortin and from Newtownstewart to Draperstown.

Plumbridge

(*Droighead Lios and Caoraidheachta* = Bridge of the Fort of the Plunderings)

TYRONE

IT IS NO WONDER that any fort in this isolated and mountainous area of County Tyrone should have been subject to plunderings, from whatever faction or from whatever direction – and indeed in whatever period, for the sources of the tales of those acts of plunder have long vanished in the whirlpool of history. The modern name of the village is altogether more prosaic, and is said to have been adopted because the man who was employed to build the bridge over the Glenelly river did not possess a spirit-level or plumb-line, so he spat in the water and 'used his spittle as a means of getting the vertical line of the bridge straight' – a feat which is difficult to imagine. Another theory is that the stone from which the bridge is built is plum-coloured.

The fine Church of the Sacred Heart of 1892, which rises over the southern bank of the river, is also built of red sandstone, quarried in the parish – as the stone for the bridge probably was as well. Seen in silhouette from outside, the figures on the four windows at the east end must surely represent the four evangelists – but on entering the church and observing them as they should be seen with the light behind them, they turn out to be Christ, the Blessed Virgin Mary, St. Colm Chille (Columba) and one other, thought to be a saint of St. Patrick's entourage, probably his cook. (Why he has been given precedence over his master, the national saint, remains a mystery.) The magnificent beeches on the perimeter of the churchyard were planted at the time of the church's consecration. A monkey-puzzle tree frames a grotto dedicated to Our Lady.

All five roads which lead from the bridge of Plumbridge pass through the magnificent country of the Sperrin Mountains. Descriptions and attitudes differ. The author of *A Statistical Survey of County Tyrone* (1802) remarks that 'It is rare to find more industrious people than those of this county generally are. The want of industry proceeds more from not having the means of being industrious than from the inclination of the people towards idleness.' The Ordnance Surveyor some thirty years later did not seem to see much hope of prosperity in the Sperrins, a land wracked by emigration that was 'wild and uncultivated, especially in the east'; but the contemporary historian William O'Kane describes Tyrone as 'the essence of rural Ulster, a quiet Arcadia well away from large conurbations, with a sense of openness among its valleys, hills and farms' – which indeed it is.

There are a number of interesting antiquities within a mile or two of Plumbridge. The chambered grave on the mountainside to the east of the Dunnamanagh road repays the climb for the view alone. The site of another, about the same distance from the village on the Draperstown road, commands an unexpected view across the Glenelly valley into the rocky recesses of Barnes Gap. This is country for walking, and contemplation.

Rathmelton

(*Rath Mealltáin* = Knoll Fort)

DONEGAL

'FORGOTTEN' is the word which springs to mind in regard to this unusual old port, situated where the river Lenon meets the tide of Lough Swilly – but perhaps it is an unfair term, for the Rathmelton Heritage and Development Association has done much in recent years to preserve the historic buildings and streetscape, thus managing to retain the quaint atmosphere without recourse to gentrification. If the village was indeed neglected over the past hundred and fifty years or so, this has in many respects been advantageous. The closing of the quay to cross-channel and trans-Atlantic steamships which required a deeper berth than sailing vessels, and the failure to wrest the railway from parvenu Letterkenny, meant that there was little or no industrial development during the second half of the 19th century, and therefore no money to tear down and replace the remnants of the past. As it happens, there was considerable tearing down of the past in the more prosperous 17th and 18th centuries; stones from prehistoric sites were used in the rush to build the quay, and it is probable that the castle, originally built by the O'Donnells and taken over by the Stewarts during the Ulster Plantation, suffered the same fate. The handsome warehouses survive mainly from the 18th century. Linen, beer, hides, agricultural produce, salt fish – all these were exported, mostly to other port towns in Ireland – the sea routes being quicker and cheaper – but large consignments went abroad.

Emigration to the United States and Canada took place through Rathmelton from a surprisingly early date, especially by dissenters seeking religious freedom. The Reverend Francis Mackemie went to Virginia in 1683, where he was instrumental in organizing a cohesive structure for the small Presbyterian communities there. He is generally regarded as the father of American Presbyterianism, and commemorative postage stamps were issued in the United States and the Republic of Ireland to celebrate his tercentenary. There is now a commodious Presbyterian church in Rathmelton, built in 1904, but the Old Meeting House has been preserved by the Heritage and Development Association and now houses the Public Library and the Donegal Genealogical Centre, where a database of parish records from the whole county may be consulted at leisure.

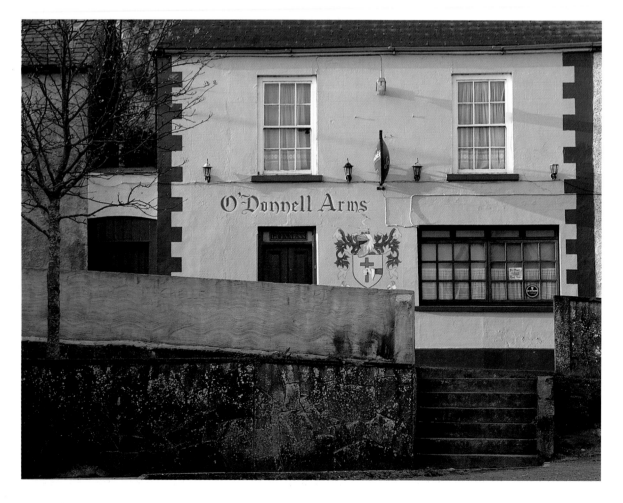

O'Donnell (left) *is the most illustrious name in Donegal: it has survived plantation, deportation, emigration. Among the most distinguished members of the clan were – and are – Colm Chille or St. Columba, (521–591), Red Hugh O'Donnell (1571–1602) scourge of Elizabeth I's colonists, Cardinal Patrick O'Donnell (1856–1927) and Daniel O'Donnell, one of Ireland's most popular singers. The warehouses on Rathmelton's quay* (opposite) *were constructed in the 18th century.*

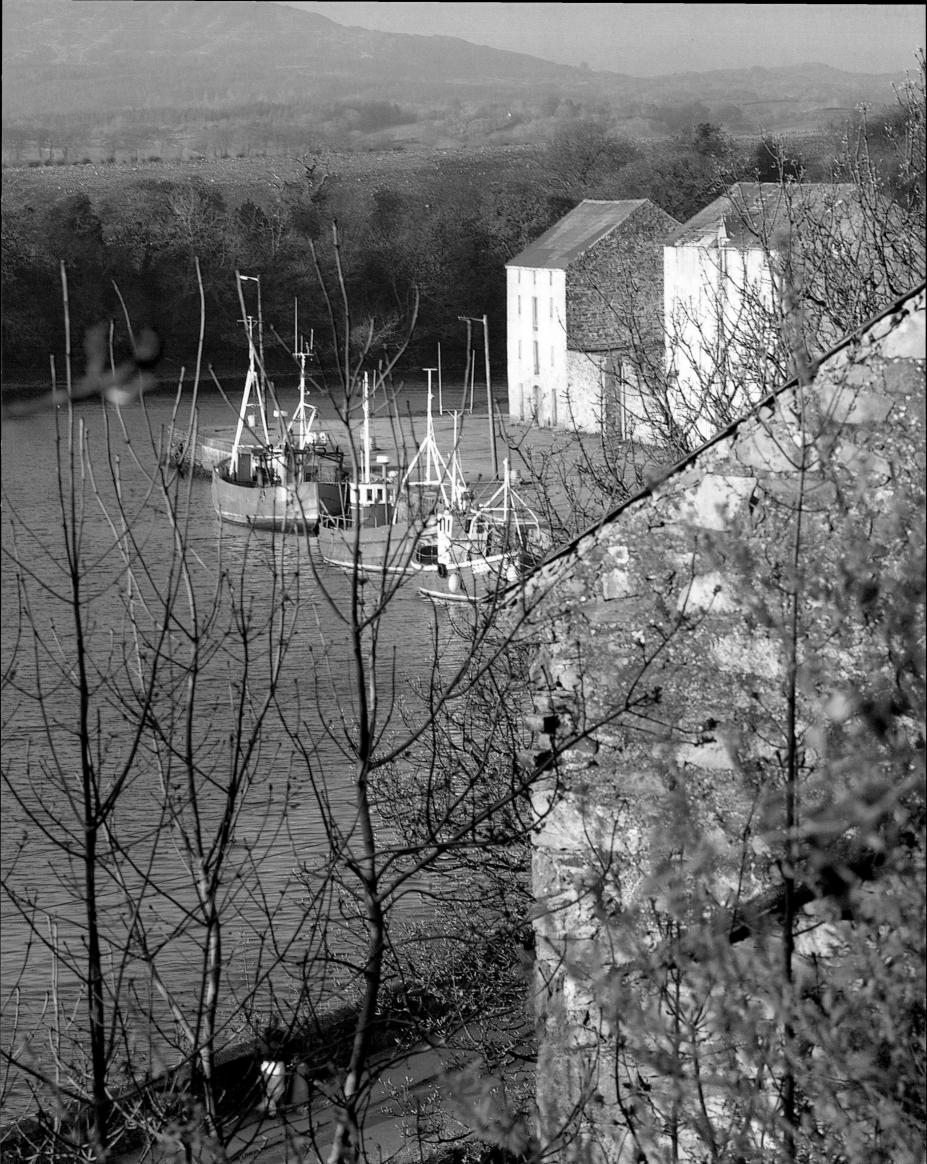

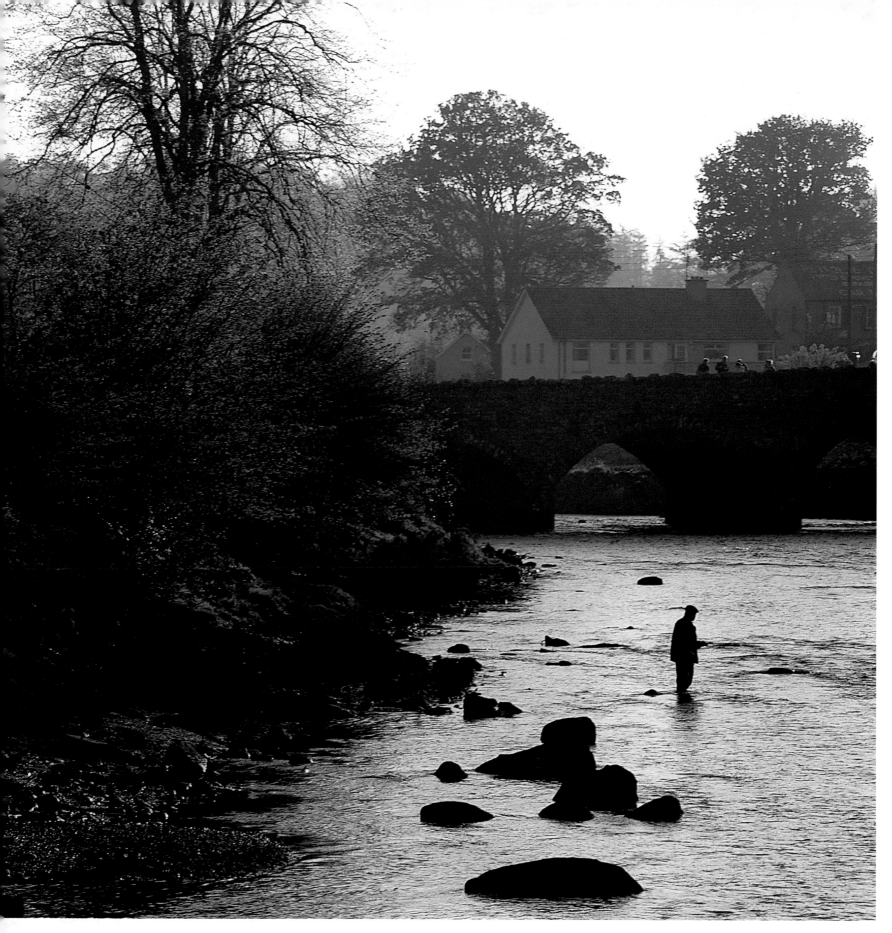

The river Lenon (above) flows through Rathmelton, inspiration of the BBC's popular radio serial 'Ballylenon', although the envy and malice of the characters were entirely fictitious. Some of the village houses, like those of Bank Terrace (opposite), were built as part of an employment scheme aimed at addressing poverty at a time when this was much needed. Today's prosperity astonishes returned emigrants.

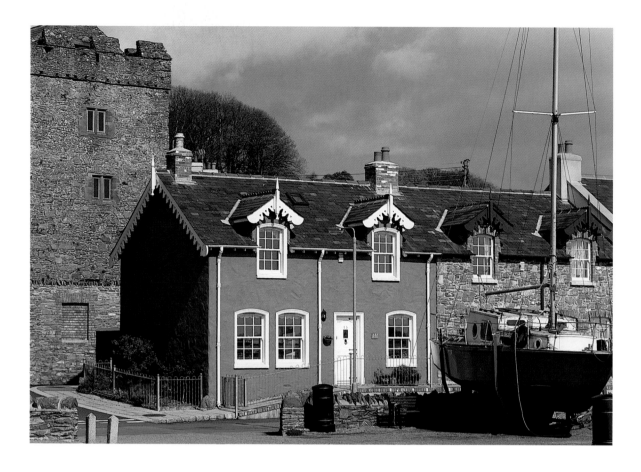

A seafaring idyll on the serene shore of Strangford; the car-ferry voyages confidently across the treacherous Narrows from Portaferry to Strangford (opposite). *The Mourne Mountains preside over the distant landscape.*

Strangford

(*Strang Fjord* = Strong Ford)

&

Portaferry

(*Port an Phéire* = Ferry Port)

DOWN

PORTAFERRY AND STRANGFORD confront one another across The Narrows, a marine sound of half-a-mile's breadth which, twice a day, experiences a ten-knot tidal flow, said to be the strongest in any European waters.

There is no written evidence that discloses a hostility, or serious mistrust, between the people of these two communities – Portaferry at the southern tip of the Ards Peninsula, Strangford on the 'mainland' of County Down – for the populations of both are of mixed origin and beliefs; planters and Gaels co-exist, and the ubiquitous Roman Catholic, Church of Ireland and Presbyterian churches in both centres are well attended. Yet their prevailing atmospheres are completely different. Portaferry, being the larger, is perhaps more aggressively businesslike – one hesitates to use the term 'commercial' in respect of a place where the dire effects of 'development' are hardly visible; Strangford, being the smaller, seems a much more genteel kind of place.

Strangford, indeed, is reminiscent of certain villages on the south coast of England. Neat little houses with dormers, crisply pointed stonework, pastel colour washes, and window boxes of pelagoniums and petunias, rise in terraces from a diminutive cove, culminating in church tower and castle – but here any comparison must stop, for

there is an almost unbelievable absence of tea-rooms, cake-shops and coffee-docks. This may indicate a less gregarious society – but it certainly reveals a disdain for the vulgar trammels of tourism. A hideous ferry terminal, the only scar on the village's pretty face, ought to deter visitors, though in fact it does not.

The car-ferry plies from Strangford harbour to Portaferry quay every fifteen minutes. Strangford has no hotel, but Portaferry boasts one – and should not be ashamed of boasting, for situation, accommodation and cuisine are wonderfully in keeping with the superb window-framed prospect of water, pleasure craft, aquatic birds, the Strangford shore and the Mourne Mountains beyond.

Both communities, which have obscure Norse origins, were very small until Sir James Montgomery developed Portaferry in 1620. By the end of the 18th century Portaferry had outstripped Strangford in size and importance. As the eminent architectural historian Sir Charles Brett has remarked, it now 'stretches sinuously along the shoreline': one can but add 'to the softly soothing sounds of the sea-swell'. Inland, and uphill, there is a pleasantly sloping square with a Georgian market-house. Visitors are beguiled by the Exploris Aquarium, where scholarly study of the Irish Sea is presented in a lively series of 'hands-on' exhibits.

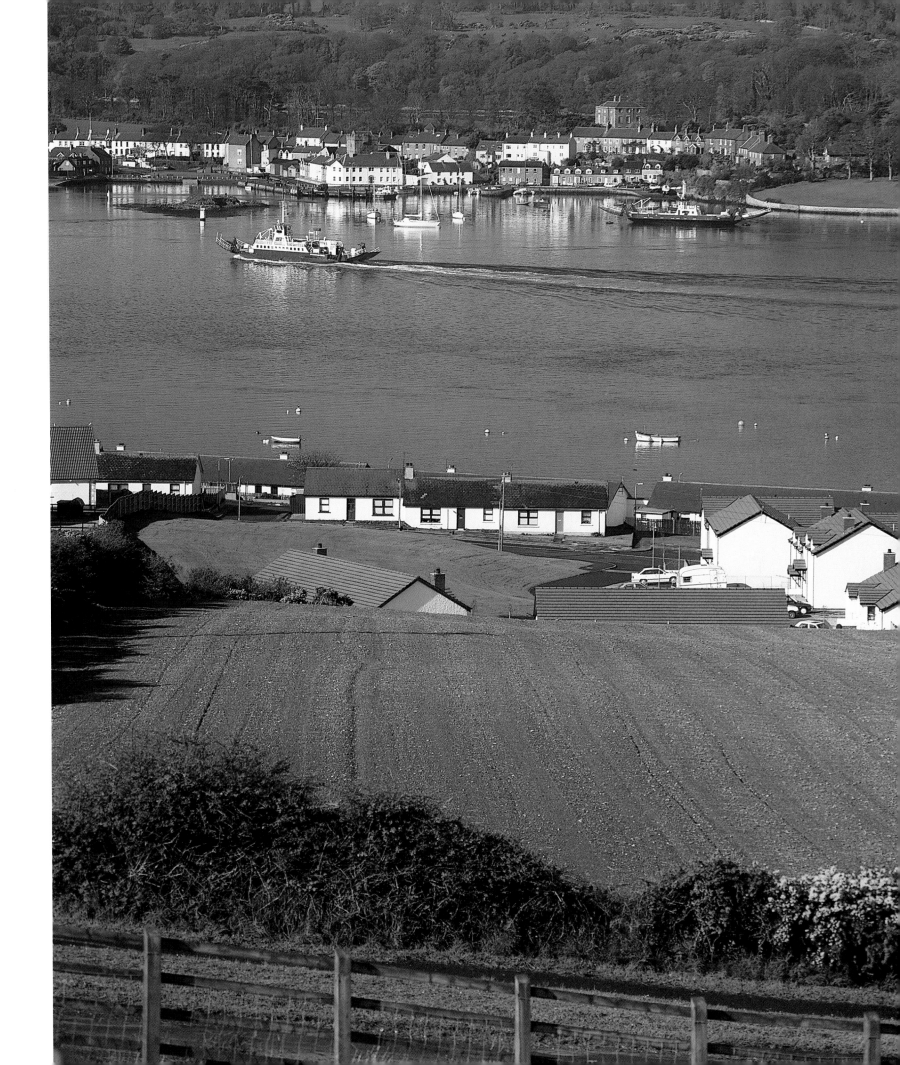

*P*ortaferry's Presbyterian congregation dates back to 1642, one of the oldest in Ireland. The church of 1841 in the Doric manner (above) is unusual in that both gallery and parterre are accessible from street level. The glazed section is a later addition. Matters more secular: there are thoughts of a drink in the High Street (above right), while other topics are discussed in The Square (right). Springtime blossom provides the foreground to a row of town-houses in Strangford (opposite).

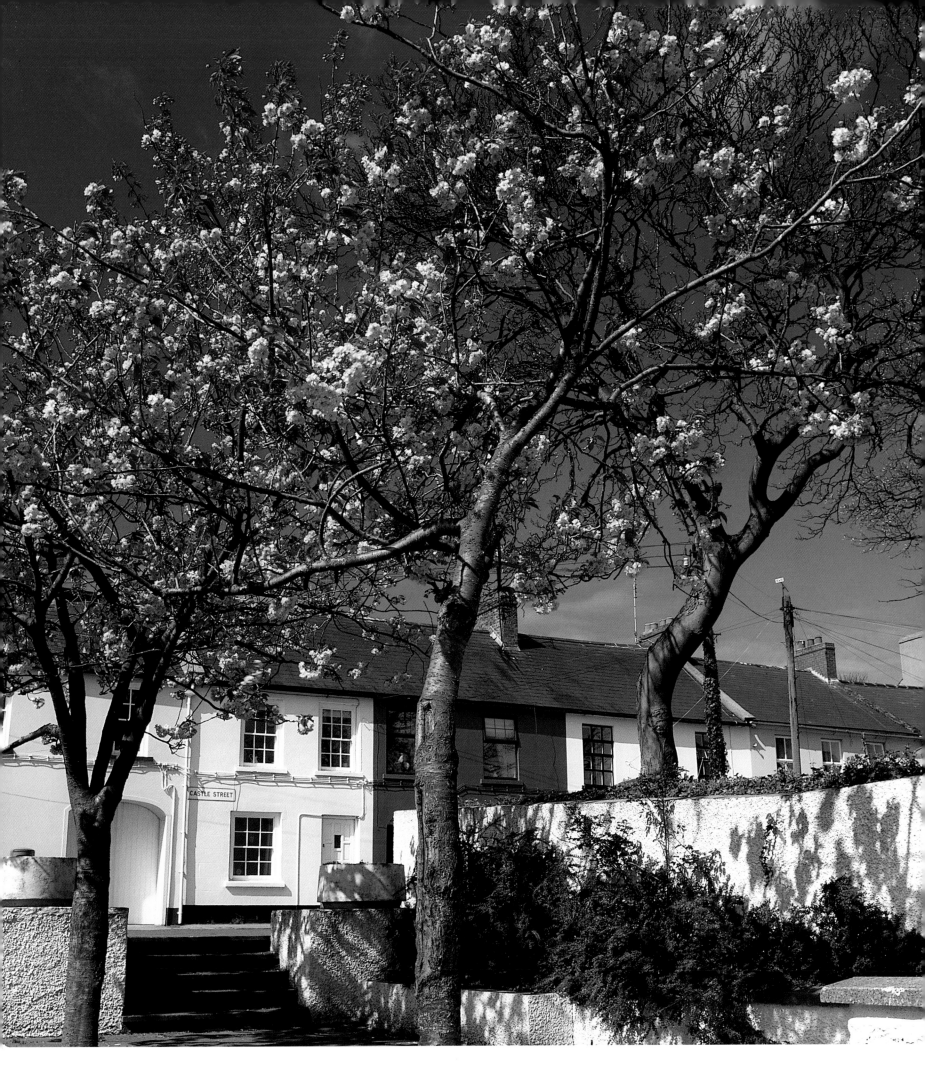

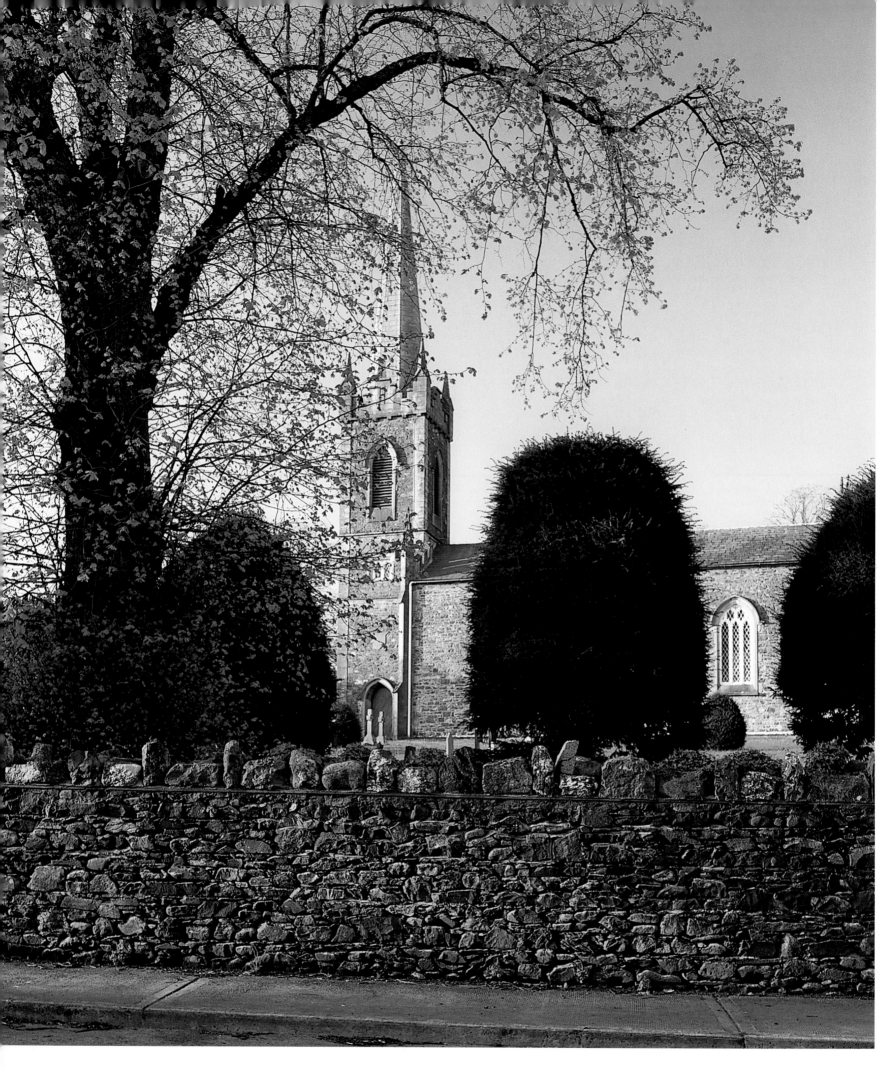

Virginia

(*Achaidh Lír* = Lir's Field)

CAVAN

VIRGINIA'S smiling public face, which puts all but the most determinedly gloomy traveller into holiday humour, nonetheless conceals a lifetime of trials and disappointments.

The proposed town was named – like the American state – in honour of the Virgin Queen, for it was Elizabeth I's royal wish that industrious English and Scottish folk should establish a marketing centre in the very south of Ulster, where as yet there were no towns of any significance. In 1686 she accordingly granted the lands of the Monastery of Aghaleere, which her father had earlier dissolved, to a certain Gerald Fleming. Progress was slow. By 1618 there were only eight houses – and wooden ones at that. Was it sloth on the part of the planters, or were they so ill-equipped with the necessities for agriculture and building that they simply could not proceed in any determinate way, or were Mr Fleming and his successors inefficient undertakers? Whatever the reason, the little band of Virginian planters had the mortification of seeing Cavan and Belturbet incorporated; and their annoyance was compounded in the knowledge that these two new towns, only half a day's ride away, were founded on existing settlements of the 'native Irish'!

A Dublin physician, Dr. Isaac Butler, travelling to St. Patrick's Purgatory at Lough Derg in 1745, remarked that the neighbourhood of Virginia was 'rude and desolate' – meaning uncultivated – and the village 'a poor dispicable place not affording a tolerable inn'. Butler did admire the three-arched stone bridge just above the confluence of river and lake; it stands to this day and proves that by the 18th century the planters possessed sophisticated architectural and engineering skills. Had he been vouchsafed the gift of clairvoyance, the Doctor would have predicted several superior inns to which the epithet 'tolerable' would be an insult – such as those which now face each other across the animated main street.

Fishermen from urban Europe, backpackers from Australia, weekend motorists from Dublin, mingle here with the farmers and shopkeepers, some of them descendants of those Elizabethans who took so long to become established. The present village owes its picturesque appearance largely to the family of the Marquis of Headfort, who built a lodge (now a hotel) on the wooded shore of Lough Ramor, and some neat terraces of cottages. The Headforts also inspired the yew-adorned Protestant church in the cleft of the Y where the road from Dublin divides – to the right for the upstart Cavan and Belturbet, and to the left for the less threatening Ballyjamesduff.

The Church of Ireland relocated the parish church of Lurgan, County Cavan, by a distance of three miles, to a more populous and commanding position in the village of Virginia, in the early 19th century (opposite). Tree branches in cast-iron support porch roofs of a terrace of cottages (above) in the village – the Industrial Revolution meeting the Romantic Movement.

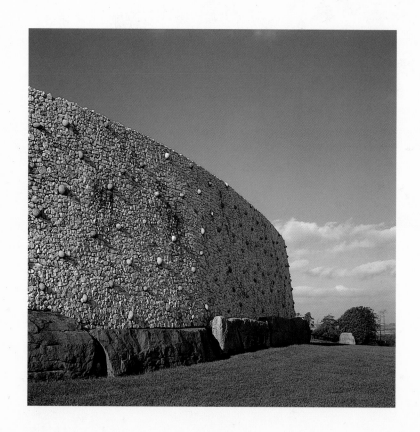

Ancient Ireland

Inhabited from *c.*7000 B.C., Ireland is rich in the surviving evidence of successive waves of settlement and culture. Newgrange, County Meath *(left)*, is striking evidence of an elaborate civilization dating from 3000-2500 B.C.. Stone circles, like this one at Drombeg, County Cork *(below)*, seem to have been used during the Bronze Age to determine the length of days of the year. Dolmens, such as this one at Poulnabrone, County Clare *(opposite)*, are to be seen in almost every county.

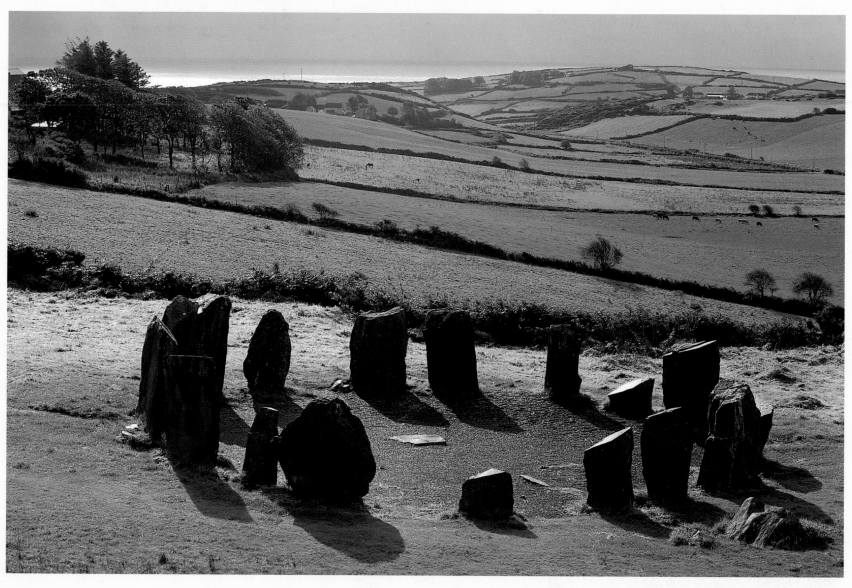

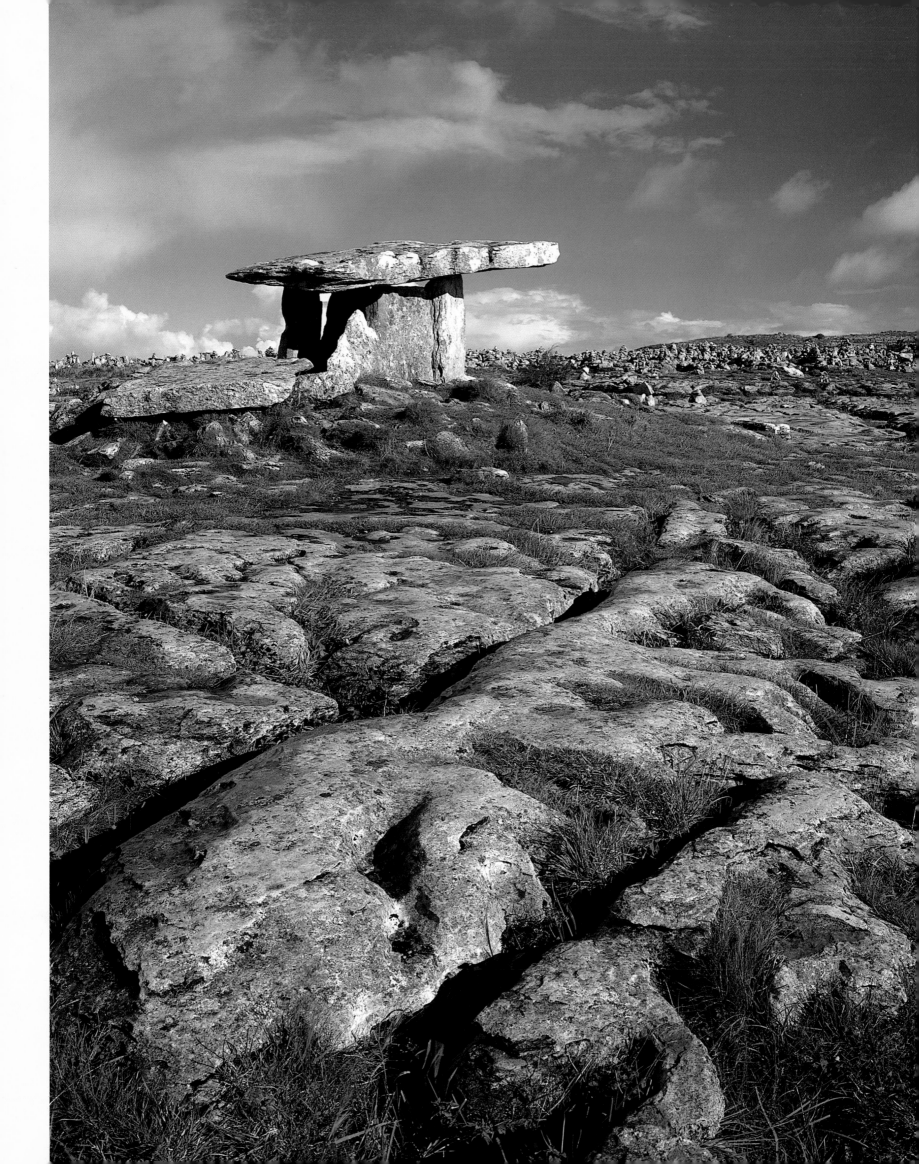

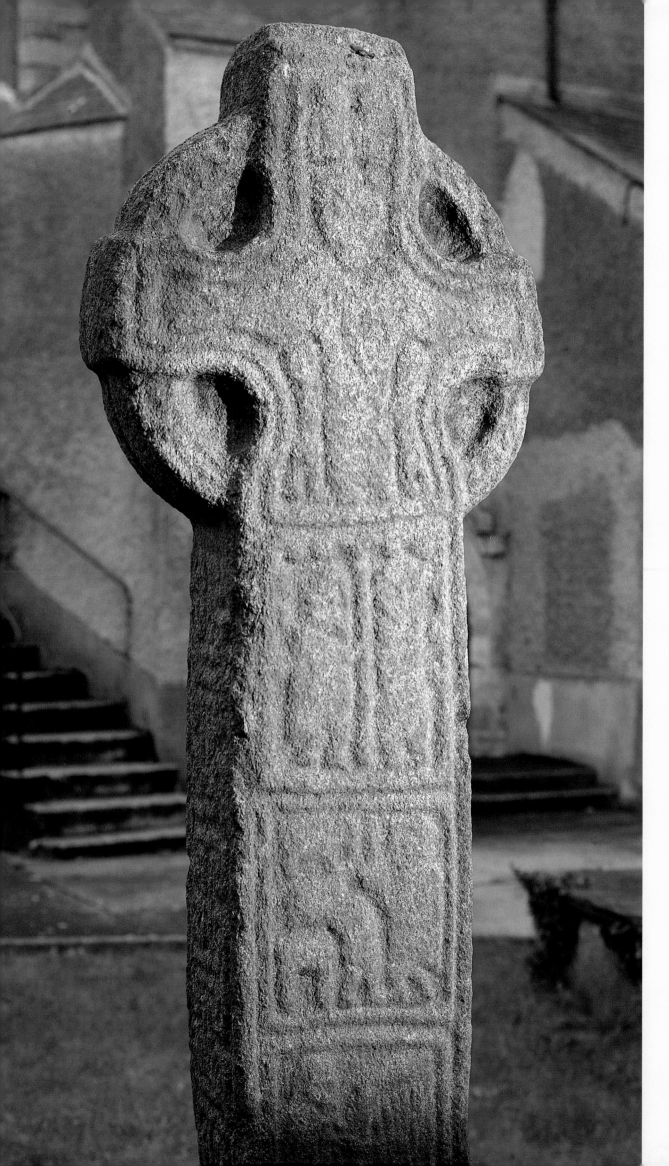

*T*his granite High Cross (left), one of two, was brought from an outlying parish, probably at a time of civil and religious strife, and re-erected within the enclosure of Duiske Abbey, County Kilkenny. The dolmen at Browneshill (opposite), near the town of Carlow, is estimated to weigh over a hundred tons and, if so, is unsurpassed in Europe.

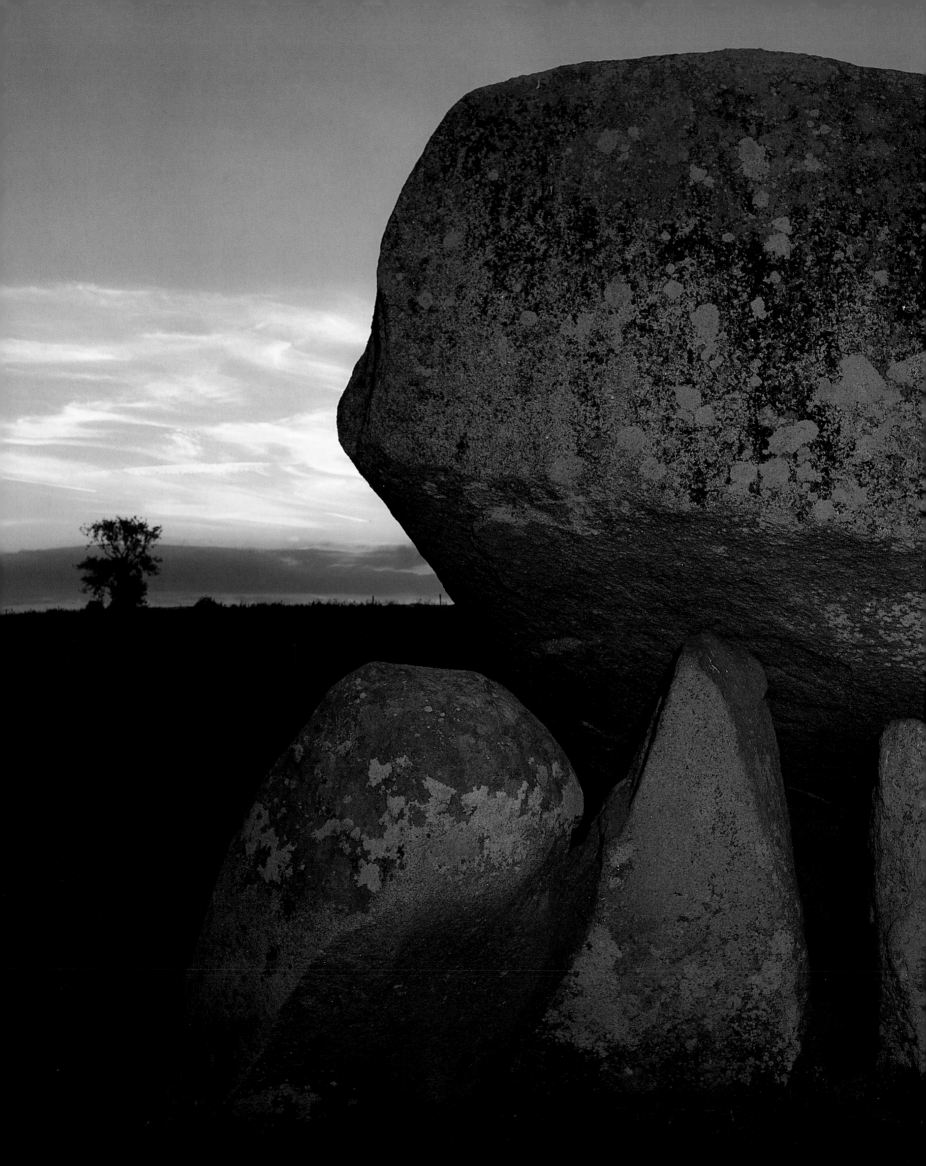

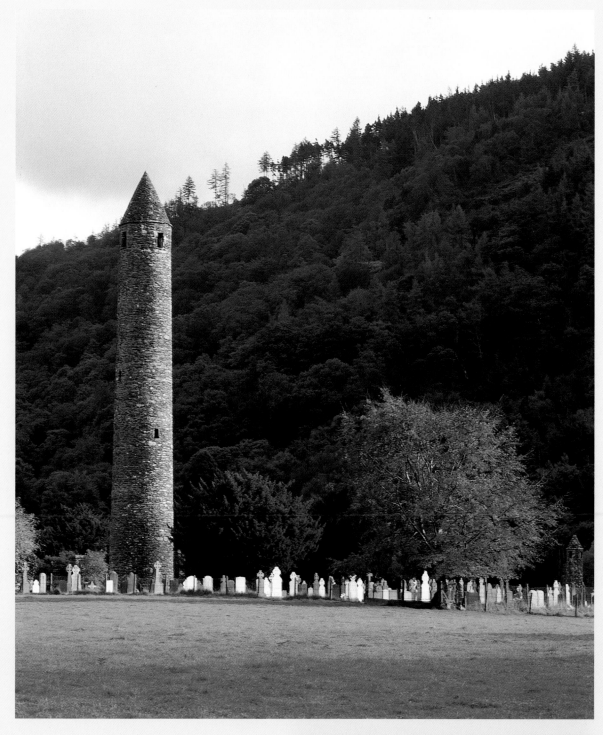

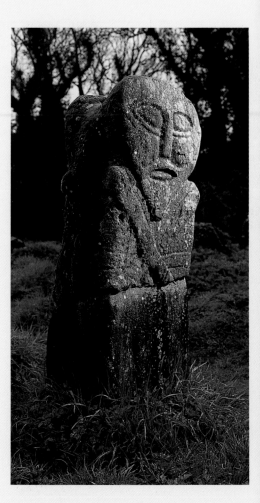

The date and origin of the two-faced figure (below) on Boa Island in Lough Erne has so far eluded scholars and antiquarians. Much easier to date is this fourteenth-century sculpture (opposite) at St. Mary's Church, Gowran, County Kilkenny. The effigy is believed to be that of either Joan, wife of Edmund, Earl of Carrick, or her daughter-in-law Eleanor, wife of the lst Earl of Ormond.

This well-preserved Round Tower (above) forms an impressive centrepiece to the remains of the sixth-century religious foundation of St. Kevin at Glendalough, County Wicklow. The decoration of a twelfth-century tomb in Cormac's Chapel (right) on the Rock of Cashel, County Tipperary, is heavily influenced by Viking art.

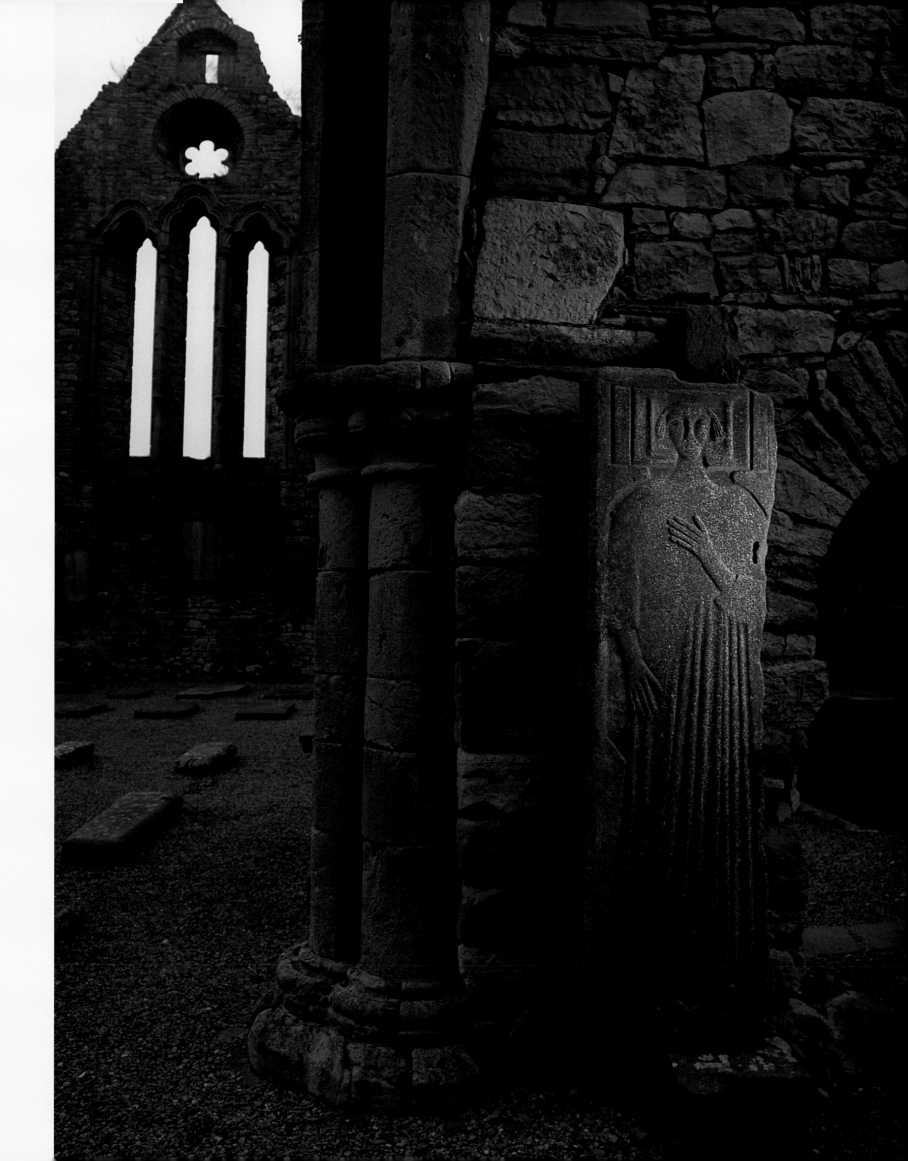

Leinster

THE SHAPE OF LEINSTER – the most easterly Province – has changed frequently and confusingly, eating at various times into Connacht and Munster, and consuming, rejecting and re-assimilating the ancient province of Meath. Its general character and its present image stem from the fact that it contains the region known as The Pale – a fifteenth-century enclave centred on Dublin and including much of Counties Kildare, Meath and Louth, inside which dwelt the most recent influx of colonists, anxious to retain their English connections and constantly at variance with their local rulers, who were almost entirely descended from the Norman invaders of two hundred years before. The other counties of Leinster – reading the map in clockwise direction – are Wicklow, Carlow, Wexford, Kilkenny, Laois, Offaly, Westmeath and Longford. Laois and Offaly stand somewhat apart, for they were planted in the mid 16th century and were then named King's and Queen's County respectively, after Philip II of Spain and Mary Tudor. Apart from the Wicklow and the Slieve Bloom Mountains, Leinster is predominantly flat and arable, with broad slow-flowing rivers and spacious castle-dominated towns. The Normans have left their mark very strongly here as builders and urban administrators – in spite of earlier and later developments, the feeling in cities and towns such as Kilkenny, Carlow, Enniscorthy, Kildare, Trim and Drogheda is unassailably Norman. The Irish language first expired in Leinster, though two Irish-speaking districts have been artificially and successfully implanted in the rich lands of County Meath.

The Bay of Dublin (opposite), *chief city of Leinster and capital of the Irish Republic; Bulloch Harbour at Dalkey to the south of the present city was a more important port than Dublin in early times because of its constant deep water at all tides.*

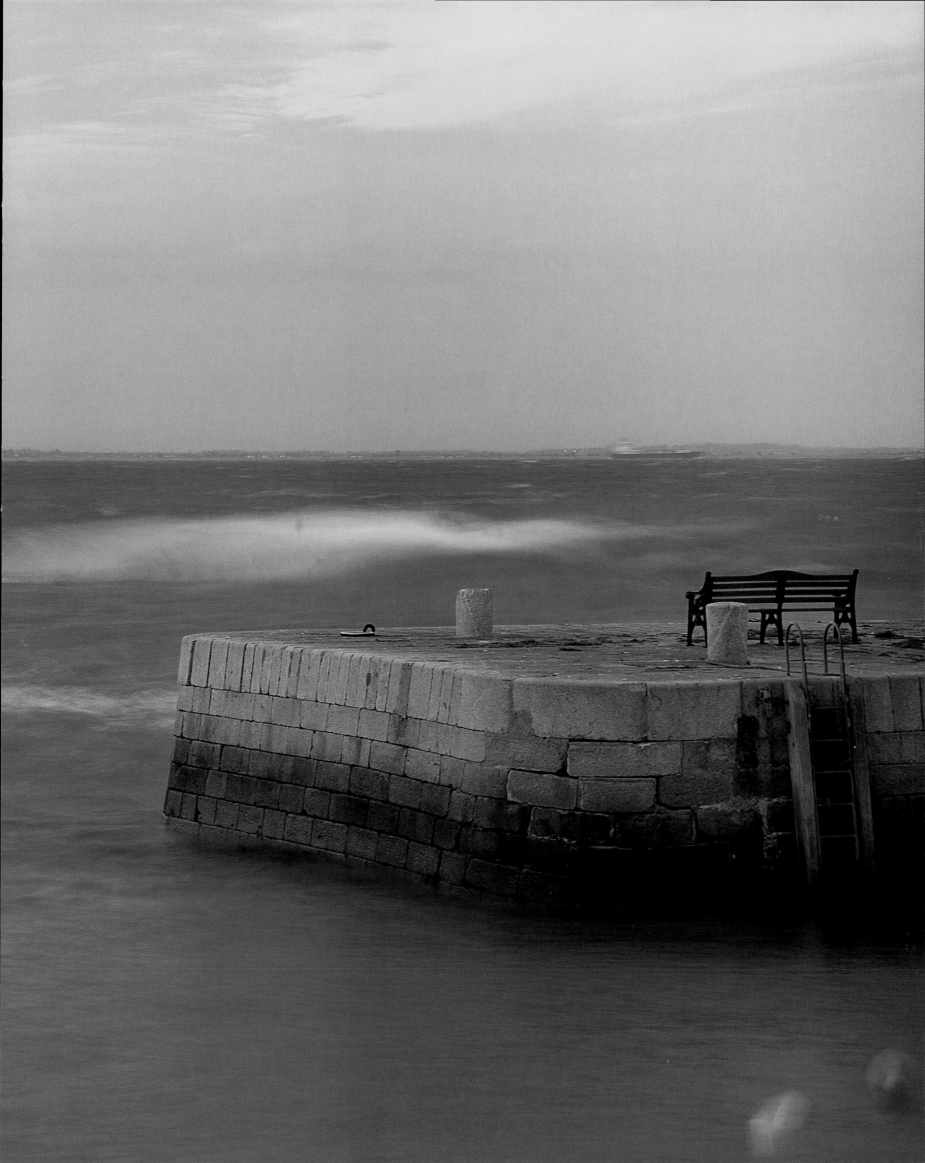

Ardagh

(*Ard Achaidh* = High Field)

LONGFORD

LEGENDS ABOUND about Ardagh – pagan, early Christian, architectural and plain fanciful.

The magical tale of Etain and Midhir, first collected in the *Book of Leinster* (*c.*1150) has the princess Etain transformed into a dragonfly, reborn as a mortal, and finally united with the god Midhir (in some versions Aengus) in the guise of two swans. Padraic Fallon's play *The Wooing of Etain* (1955) and Eavan Boland's poem *The Winning of Etain* (1967) deal with strands of the story. A recent sculpture by Eamonn O'Doherty at the Ardagh Heritage Centre reminds us of the intricately metamorphosed lovers.

An accusation of nepotism surrounds the consecration of the first Bishop of Ardagh by St. Patrick, for St. Mel was thought to be Patrick's nephew; yet their relationship has a touch of the legendary about it, for some scholars seem to think that they lived at different periods! The remains of St. Mel's oratory may be seen in the grounds of the modest Protestant church of 1810, just across the road from the nineteenth-century Church of St. Brigid, a Gothic edifice of cathedral-like splendour by William Hague that surprises by its sheer size in a village which otherwise impresses by smallness.

Another legend – created by himself – has the young Oliver Goldsmith returning on foot by night from school in Elphin to his parsonage home at Lissoy (a somewhat roundabout route), knocking on the door of Ardagh House in the belief that it was an inn, and being hospitably entertained by the Fetherston family. Goldsmith used this incident, further embellished, as the central motif for his perennially entertaining comedy *She Stoops to Conquer*, or, *The Mistakes of a Night*, first performed in 1773. A maquette of Foley's famous statue of Goldsmith is preserved in Ardagh House.

The attractive cottages which cluster round the village green have given rise to another legend, that of their 'Swiss' provenance. Certainly, they would

look rather odd in the Alps. Steeply pitched roofs, decorative bargeboards, tall stacks and latticed windows suggest a more English rusticity. They were in fact designed by the English architect J.R.Carroll, who was commisssioned by Sir Thomas Fetherston in 1862 to improve the housing of tenantry in picturesque fashion. It is these cottages which contribute most to Ardagh's special charm.

Ardagh's seventy or so inhabitants share the work which has resulted in their village winning the county award in the Tidy Towns Competition thirty times, and three times as the tidiest town or village in Ireland. These people maintain their surroundings discreetly, welcoming visitors but never encouraging crowds. They have created a modern legend out of a number of legends.

The Gothic clock-tower at the centre of Ardagh, County Longford, commemorates Sir George Fetherston who was largely responsible for the attractive design and layout of the village (opposite). *This rhapsodical sculpture* (above) *by Eamonn O'Doherty celebrates Etáin and Midhir at the Ardagh Heritage Centre.*

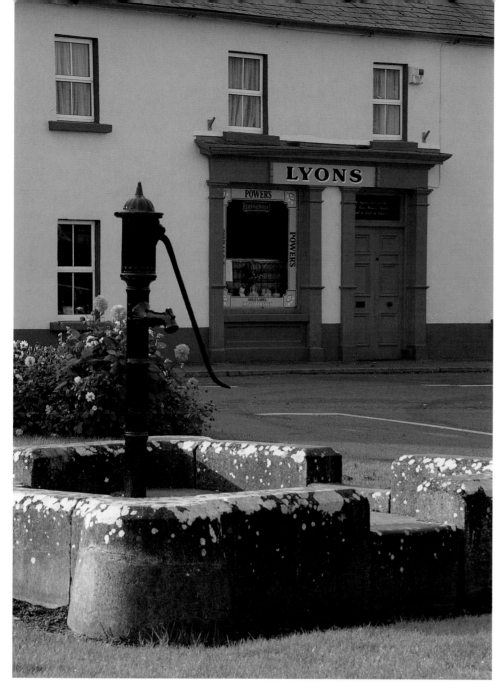

*T*he neat tranquillity of Ardagh village , which has won the County,
Regional and National Tidy Towns Competition so many times it
is impossible to keep count, informs its attractive small shop fronts and
well-maintained estate houses.

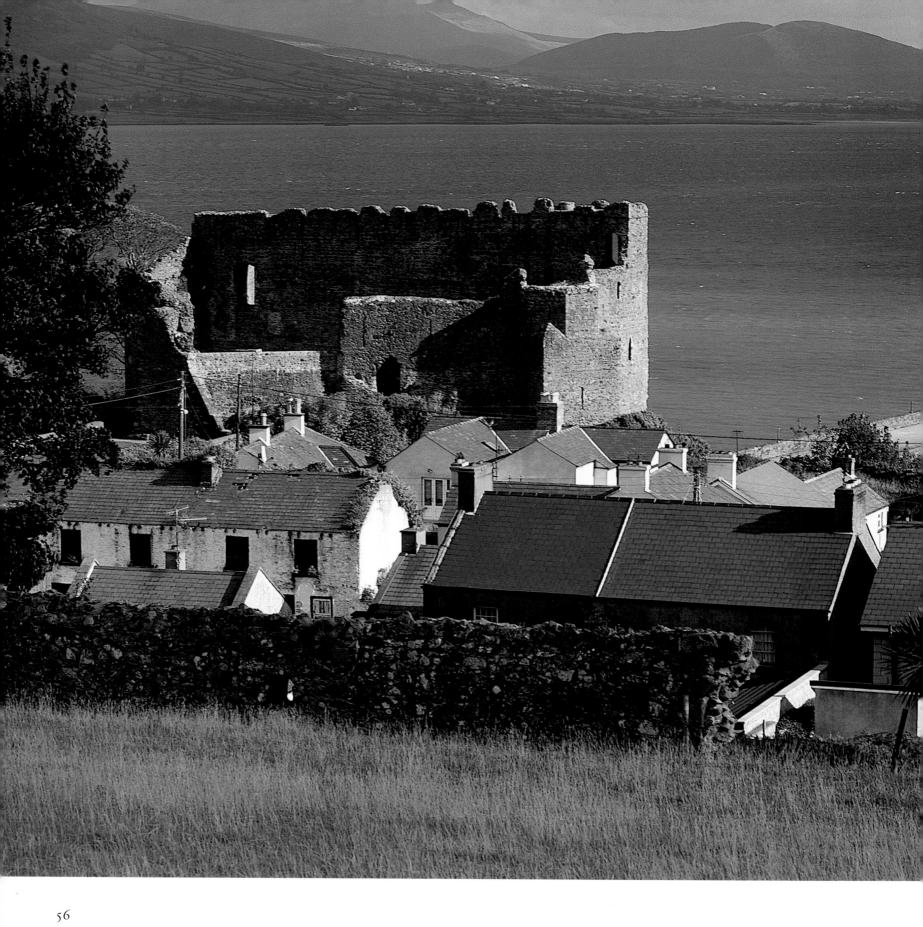

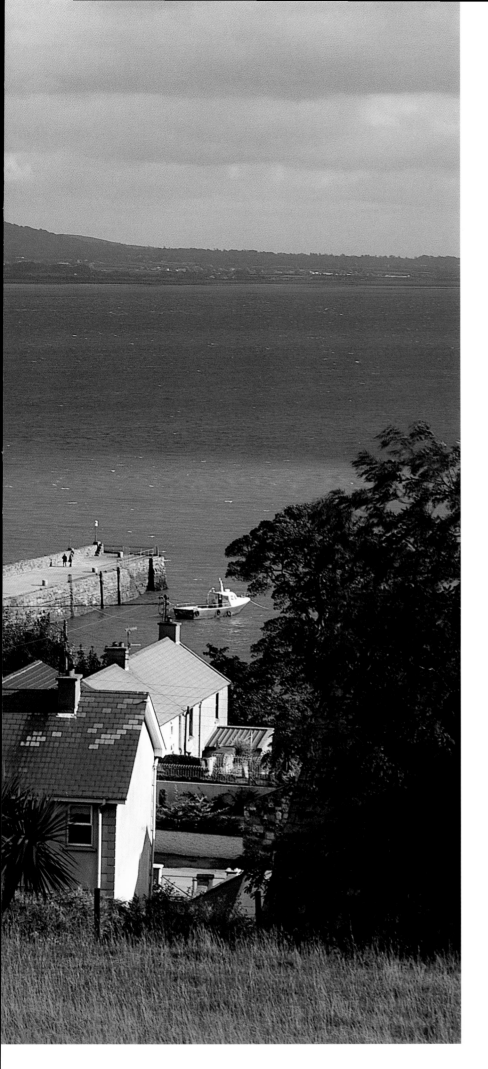

Carlingford

(*Carlinn Fjord* = Carlinn's Fjord)

LOUTH

NOBODY QUITE KNOWS who Carlinn may have been – some Viking adventurer, perhaps. By the time the Norman de Laceys laid out their town in the 13th century, the name for the deep inlet which pierces and divides the Cooley and Mourne Mountains had obviously entered common parlance, and it was only natural that the town should take its official title from its natural surroundings.

Carlingford miraculously retains its medieval street pattern. Today's residents still pass daily through the arch of one of the old town gates; there are two fine tower-houses, the remains of important monastic buildings and an enclosing wall – not to speak of the castle, named in honour of King John – now a ruin, but a supremely impressive one. The 'miracle' of Carlingford's preservation stems, ironically enough, from factors governing its own decline: the death toll of the Cromwellian and Williamite wars, the development of an inland road from Dublin to Carrickfergus (Belfast did not figure in this equation until well into the 18th century) and the inexplicable migration of the herring shoals upon which the economy was largely based. Had Carlingford developed like its neighbours Dundalk and Newry, the old streets would have disappeared under factories and housing schemes.

The opening of the coastal railway in 1876 provided a minor respite from what might have been terminal decay. Excursionists came for the sea-bathing, though not in very great numbers; but the construction of a deep-water harbour only four miles away at Greenore on the same line, the establishment of steam-packet services from Greenore to Lancashire and North Wales and the building of a very smart quayside hotel there, again drew away much-needed business. A real increase in tourist numbers in the last quarter of the 20th century, allied to a growing interest in architectural conservation and the enhancement of townscape, has reinvigorated Carlingford for the first time in about two hundred years.

All the streets, except the main road along the seafront which follows the track of the now vanished railway, were laid out in medieval times. Most of the town houses are eighteenth- and nineteenth-century refurbishments of much older dwellings. 'The Mint' is almost undoubtedly the building where coins were minted for a short period from 1467. 'Taafe's Castle' is the fortified residence of the powerful family of that name. 'The Tholsel' served as one of three gates. The Church of the Holy Trinity, with its solid tower that suggests militaristic rather than religious intentions in the minds of those who built it, was deconsecrated in 1991 and sympathetically converted as a public centre for historical and environmental studies by the enterprising Carlingford Lough Heritage Trust.

The Cooley Peninsula affords this dramatic yet somehow calming view across Carlingford Lough towards the Mountains of Mourne.

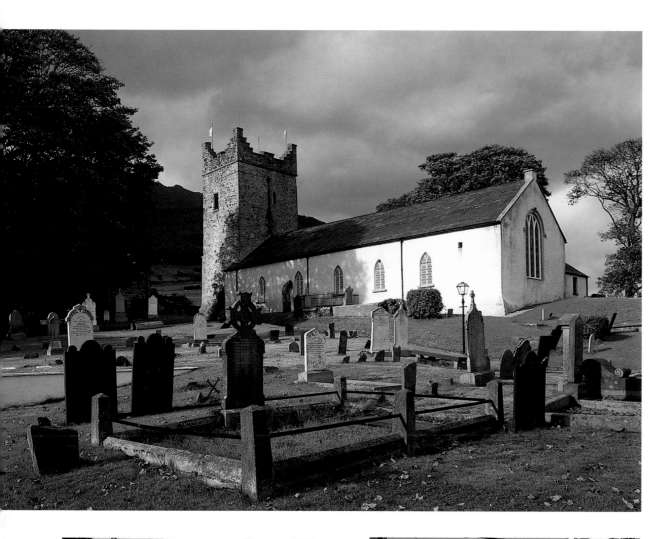

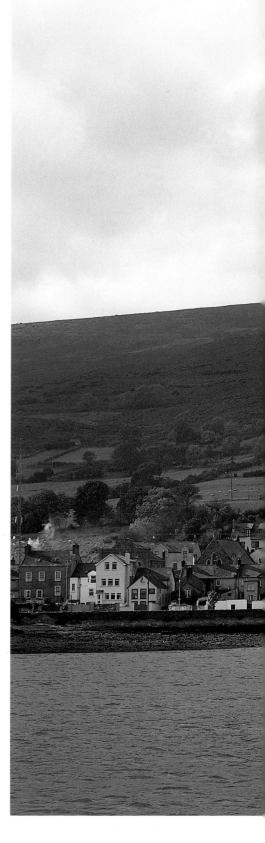

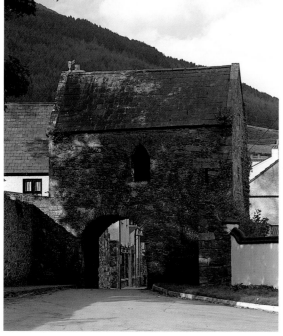

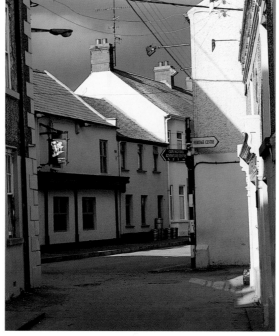

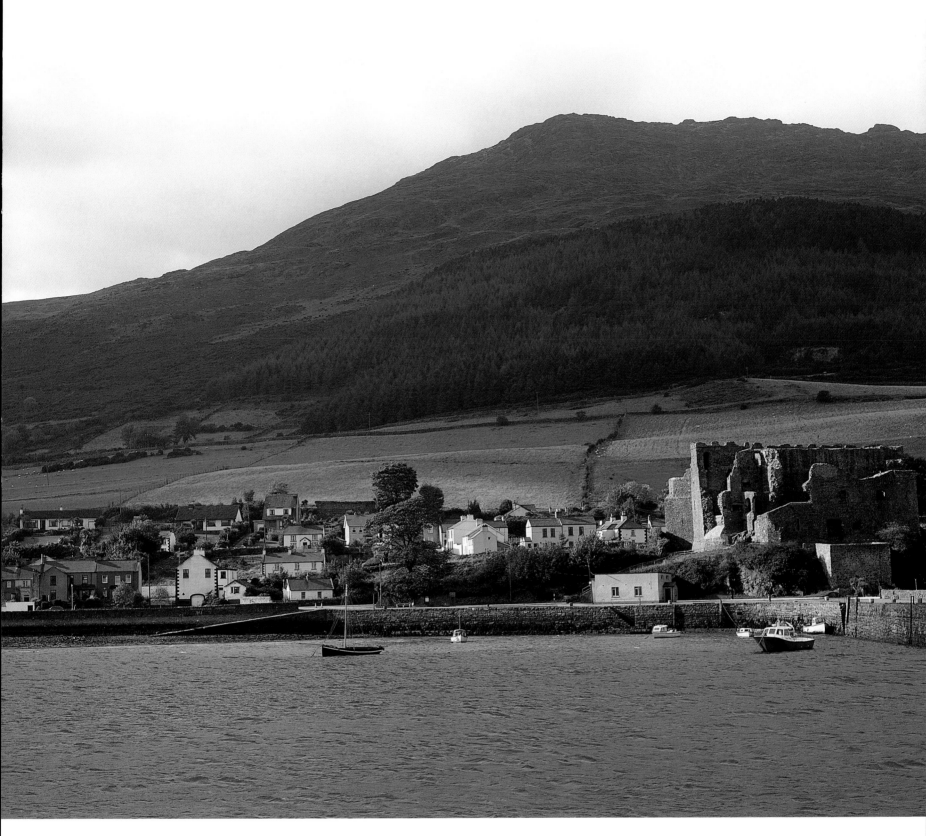

The sights of Carlingford (clockwise from top left): *Holy Trinity Church, now the Carlingford Heritage Centre; the village from the harbour bar, King John's Castle and the Cooley Mountains beyond; Tholsel Street; and the Tholsel Gate, where 'tholes' or tolls were levied on merchandise.*

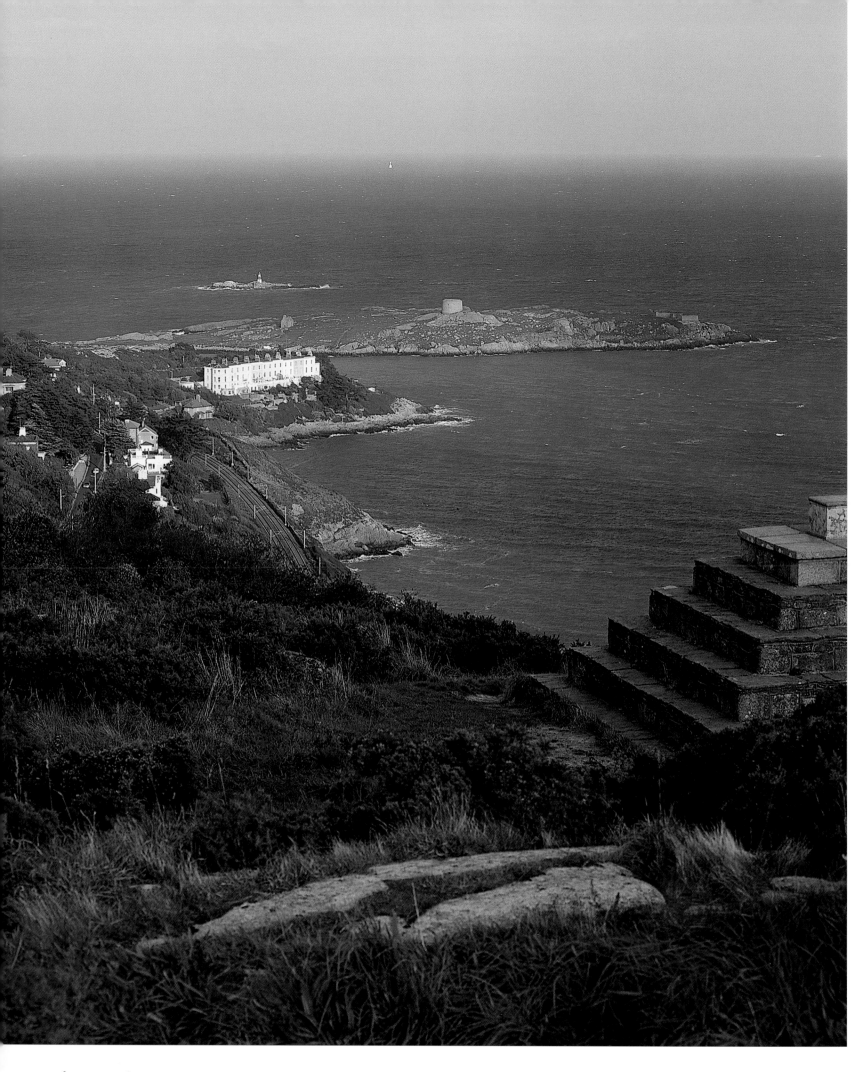

Dalkey Island and Sorrento Terrace, with Dublin Bay beyond (opposite), *present a splendid vista from Killiney Hill. The Queen's, the oldest pub in Dalkey* (right), *is as much frequented by the indigenous population as by the internationally esteemed writers, artists and musicians who have come to live in the village.*

Dalkey

(*Deilg Inis* = Thorny Island)

DUBLIN

SEVERAL once remote rural villages have been absorbed over the last two centuries by the growth of the cities of Dublin, Belfast and Cork. Most have lost their individuality in the slurry of suburbs, and indeed have given their names to those suburbs. One which has retained its particular identity, in spite of the aggregation of alien housing which surrounds yet does not belong to it, is the village of Dalkey in County Dublin. Quite how it has survived – or why it is regarded by its inhabitants as a place apart – is not entirely possible to define. These matters should remain as mysteries.

One tediously practical reason may be that Dalkey is not situated on a through route, but at the seaward end of what was, in medieval times, a track connecting its harbour to what would become the centre of Dublin, seven miles away. Dalkey was better situated for trade than Dublin, because of its deep-water quay – the estuary of the river Liffey was susceptible to silting. The seven castles of Dalkey – of which three survive – must have been a highly visible and menacing manifestation of the importance of guarding its marine and landward approaches.

Excavations on the now uninhabited Dalkey Island, a few hundred yards off the coast, have shown that the site has been inhabited since 4000 B.C (Dublin is a parvenu by comparison.) The two early Christian churches, one on the island and the other just off the present main street, are dedicated to St. Begnet. It is perhaps this main street – known as Castle Street because it is flanked by Archbold's Castle and Cheever's Castle – which gives Dalkey its villagey atmosphere. There is every possible kind of shop – no need to visit the conurbational malls,

and certainly no need for a trip into town except in search of something quite outlandish and probably unnecessary. The Post Office and the Library are also in this street; greetings are exchanged, as are views: the gossip essential to the well-being of any village is maintained.

Granite is everywhere – on quaysides, pavements, kerbs, boundary walls, churches, castles. Dalkey Quarry, which has eaten into the hill immediately above the village, leaving a remarkably jagged profile, supplied the granite for the harbour or 'marine refuge' of Kingstown (now Dún Laoghaire) in the years 1815 to 1825. This vast enterprise resulted in Dún Laoghaire becoming a very large commercial centre – all the more reason for Dalkey to remain enclosed, serene and very self-possessed.

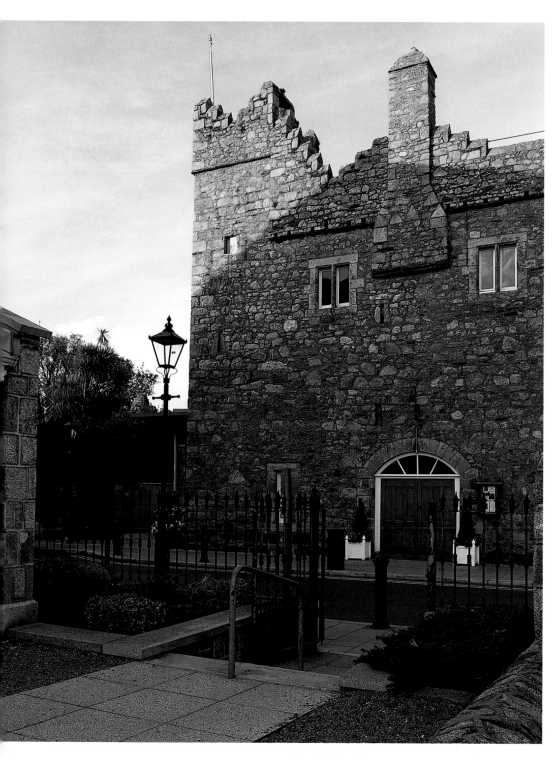

*M*uch of Dalkey's charm lies in the contrast of the grand and not so grand: *Goat Castle* (above) – so-called because it bears the goat coat-of-arms of the Cheevers family – is now the Dalkey Town Hall and contains a first-class museum of local history; the fifteenth-century Archbold's Castle (opposite) in Dalkey village, with the Church of the Assumption of 1841; and two typical Dalkey frontispieces (right).

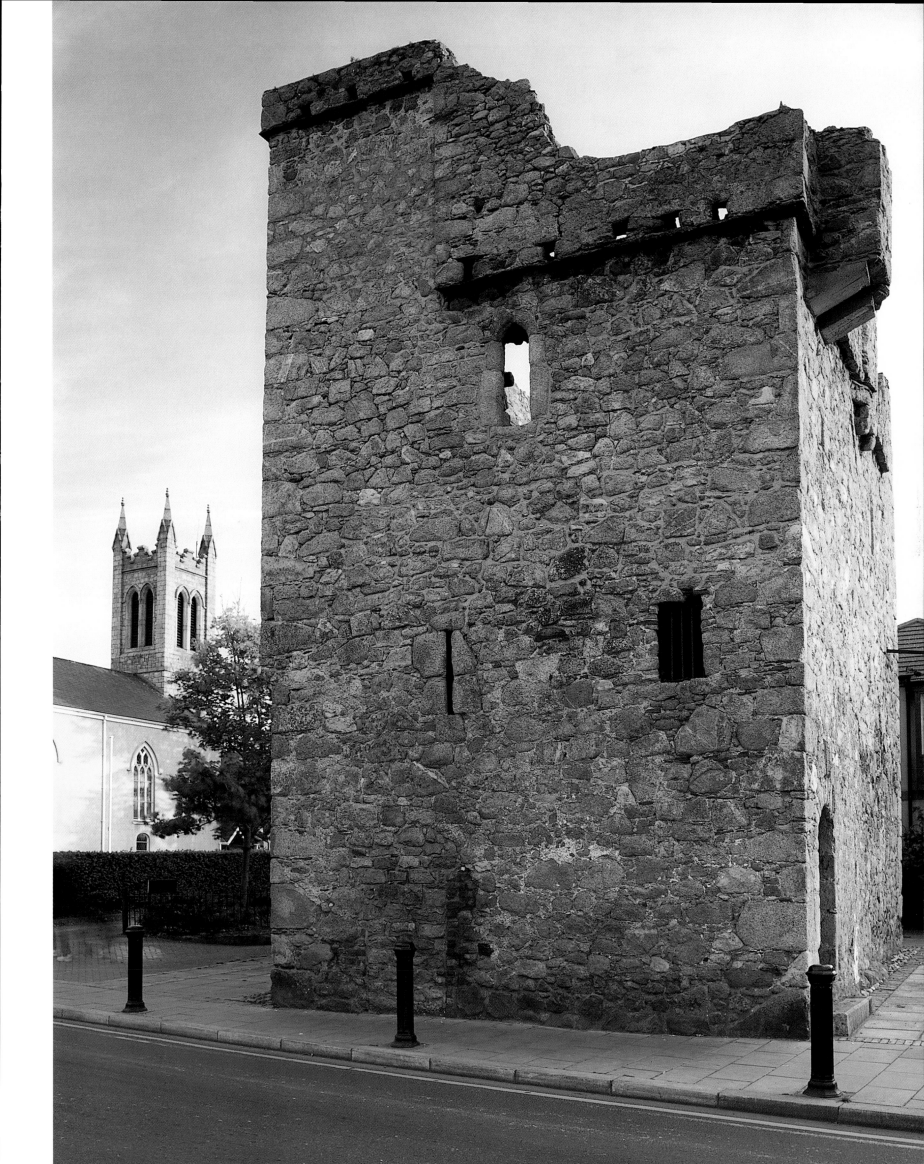

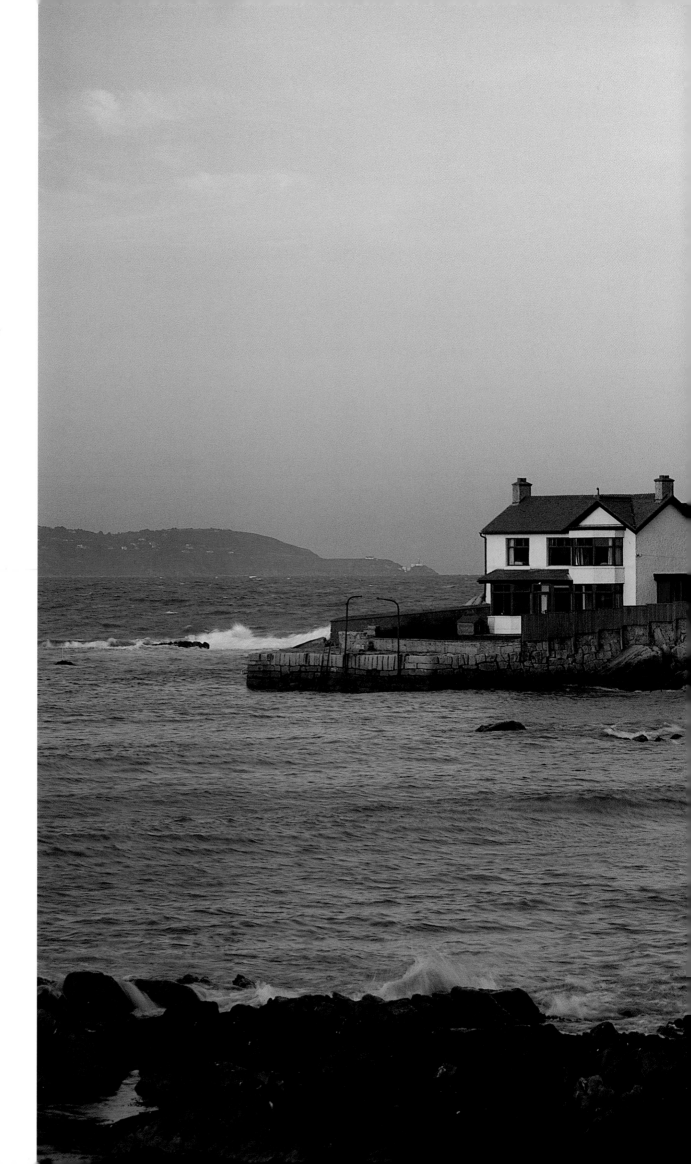

Sandycove Harbour is within a ten-minute walk of the centre of Dalkey. The white house to the right of the photograph was designed by the architect Michael Scott in the 1930s and is regarded as the earliest domestic example of the Modern Movement in Ireland.

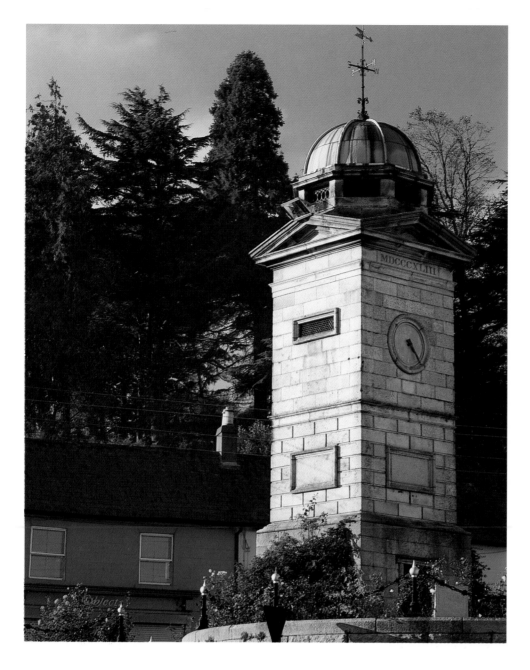

The Powerscourt memorial clock and fountain (left) provide a focal point for the centre of Enniskerry, further graced with pleasant nineteenth-century estate cottages (below).

'terrifying' – the former term presumably referring to the Powerscourt parkland and the latter two to the more mountainous terrain. Certainly 'picturesque' is rather too tame, though painters such as George Barret (1732–84) and William Sadler (1782–1839) made much use of that adjective. A painting by Barret in the Mellon Collection in Washington, D.C. shows this landscape precisely, with Powerscourt House in the pastoral middle distance and the Sugarloaf Mountain awesomely dominating the entire prospect.

Barret also painted the celebrated waterfall which descends in one continuous torrent for over three hundred feet down a wooded cliff face. George IV was entertained in Enniskerry by the

Enniskerry

(*Ath na Scáirbhe* = Rocky Ford)

WICKLOW

A COUPLE OF GENERATIONS AGO the older people still referred to 'Annaskerry', which sounds much closer to the original Irish name for the village. Some official of the Ordnance Survey of the 1830s inscribed 'Enniskerry' on his beautiful new map, and in the course of time Nature imitated Art. Whatever the name, the place is exceptionally attractive, caught in the cusp between the luxuriantly cultivated lands of the Powerscourt demesne and the wild glens of the Dargle and Glencullen rivers which lead up into the Wicklow Mountains.

Two hundred years ago this *mélange* of scenery was variously described as 'sublime', 'awful' and

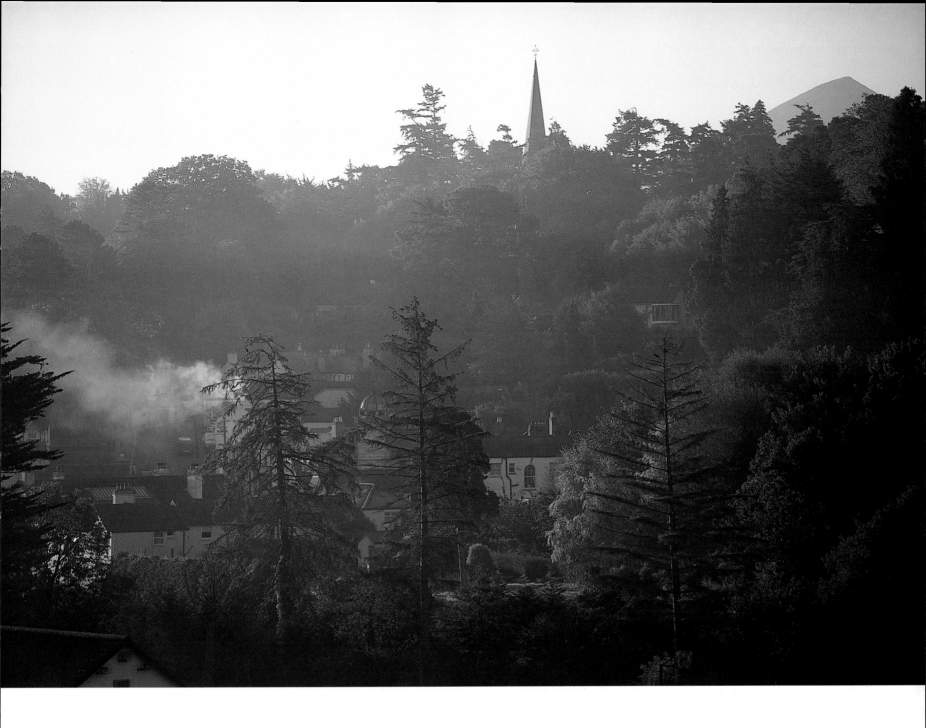

fifth Viscount Powerscourt in 1821. There are two conflicting accounts of his visit – or non-visit – to the waterfall: the first that a drought resulted in a feeble stream, and men with barrels of water were concealed beyond the summit to increase the flow; the second that a special bridge was built to accommodate the royal party, but it was washed away when a sluice gate was suddenly opened. History would have been undoubtedly altered had the monarch been standing on the bridge at that moment.

Powerscourt House, which replaced an earlier castle, was accidentally destroyed by fire in 1974 – mercifully its façade was saved and, as restoration proceeds, continues to form the centrepiece of its superb landscape. It was built by Richard Cassels or Castle in 1731, and the gardens and terraces were laid out just over a hundred years later to the design of Daniel Robertson, who was inspired by the Villa Butera in Sicily.

There are two Gothic churches with elegant steeples situated on high ground at opposite ends of the village. St. Patrick's Church of 1857 was a gift of the Marchioness of Londonderry, whose first husband had been the fifth Viscount Powerscourt. The Roman Catholic church of the same period is by Patrick Byrne, most of whose work elsewhere is in a neoclassical style.

Set in a pleasantly wooded landscape (above), *Enniskerry looks the very picture of sylvan peace in the autumnal haze which mingles with smoke from garden bonfires. The formal gardens and house of Powerscourt* (overleaf) *lend a special distinction to Enniskerry: one of two figures of Pegasus poised for flight over the round pond; the garden front of Powerscourt. The bronze vases and tritons came from the Duke of Litta's* palazzo *in Milan.*

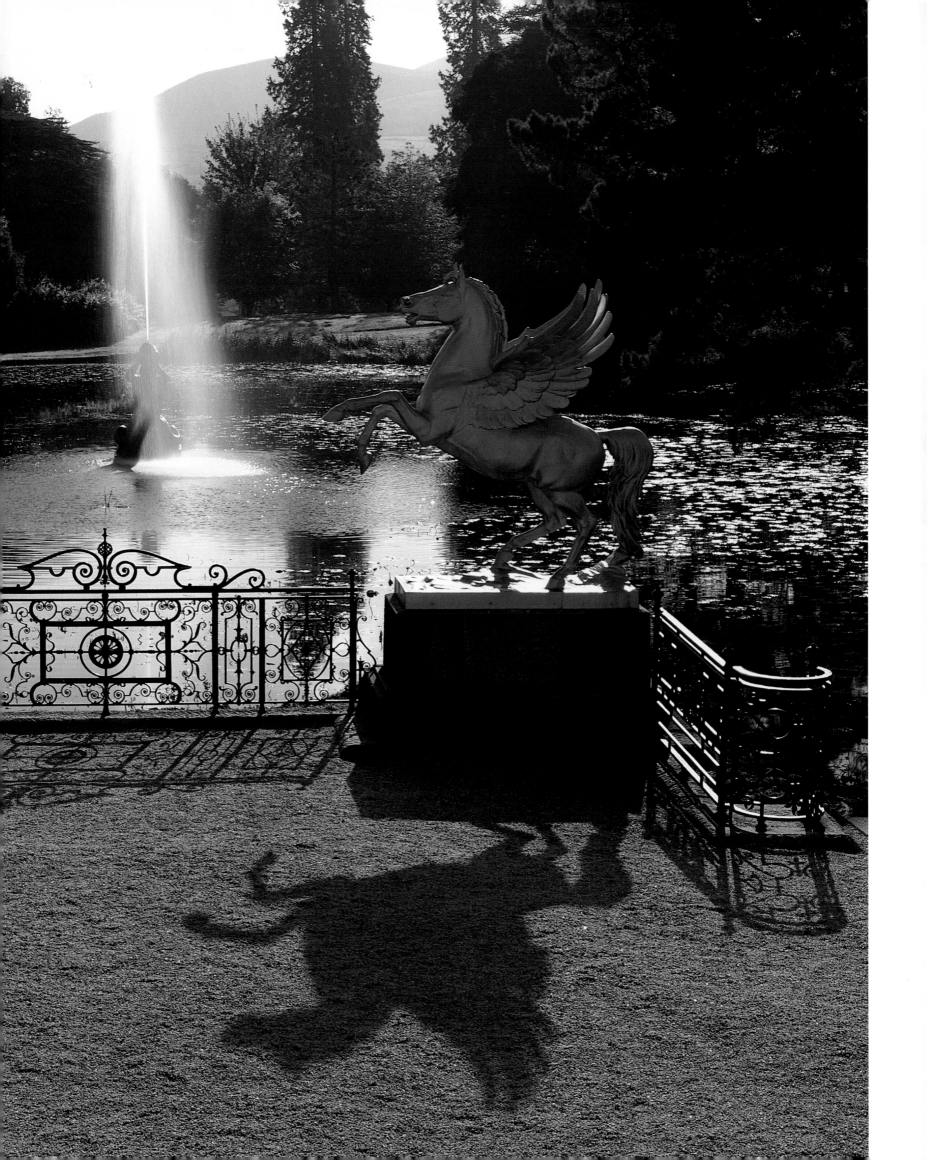

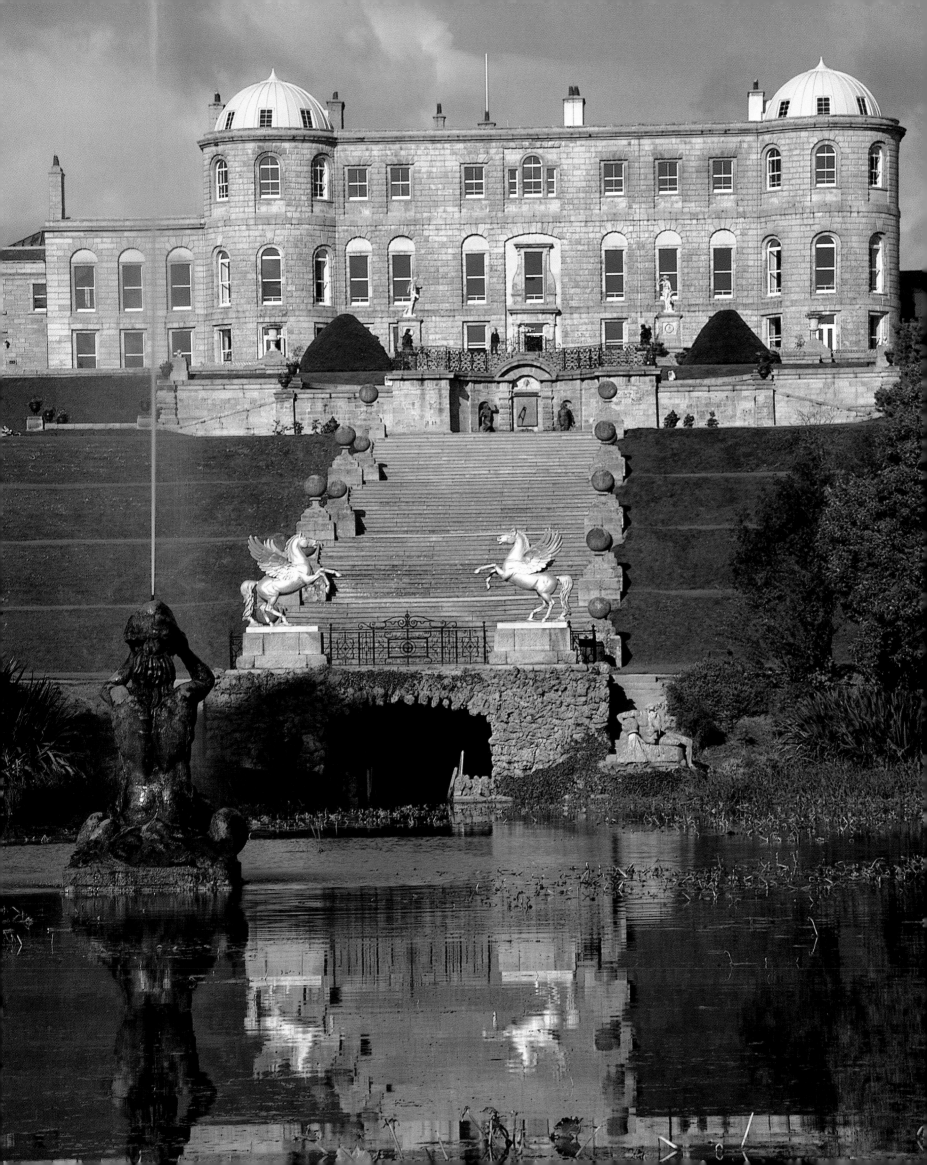

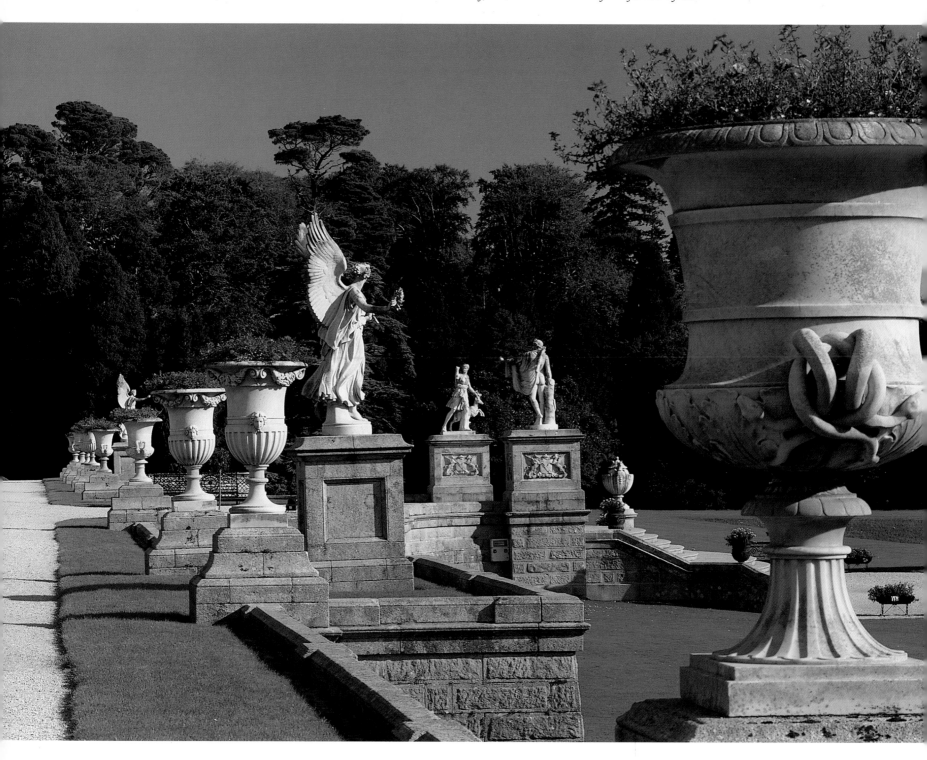

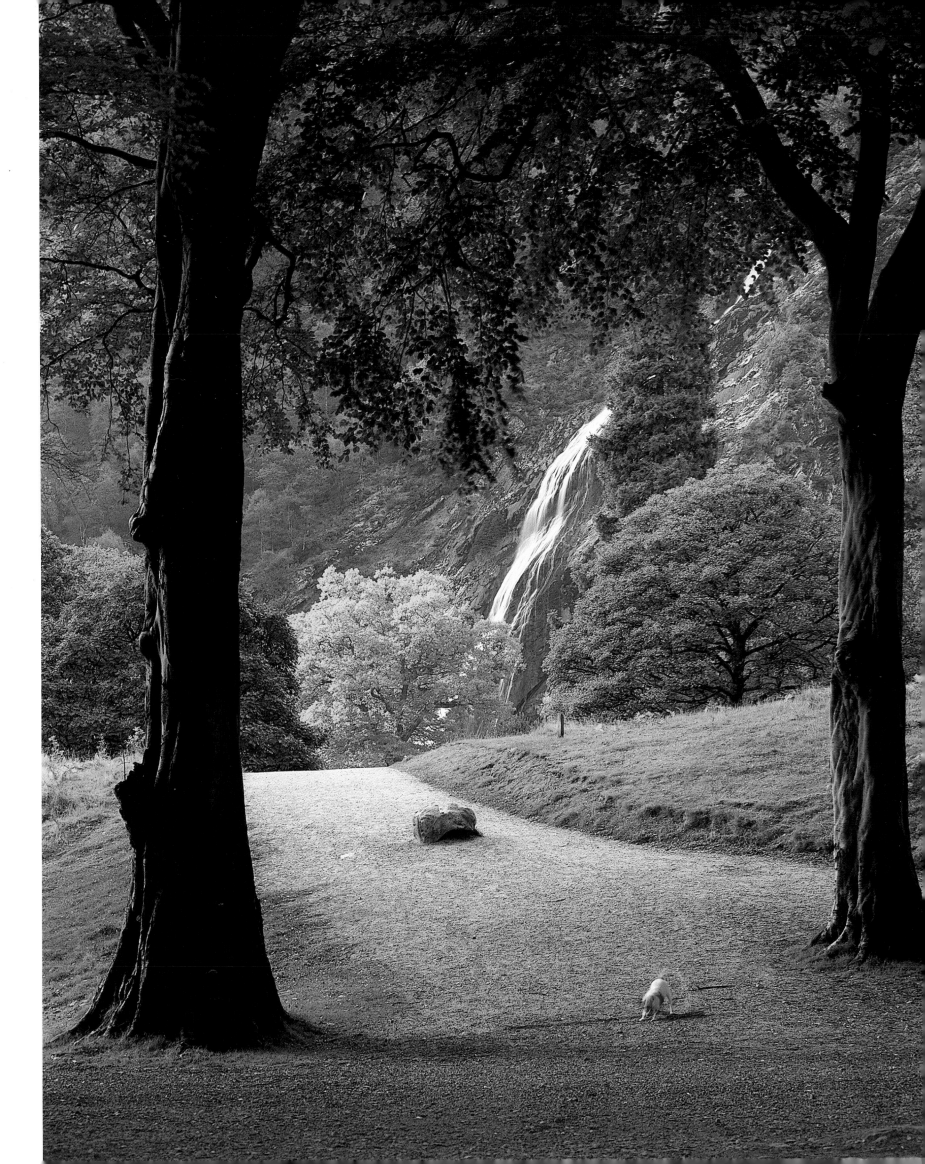

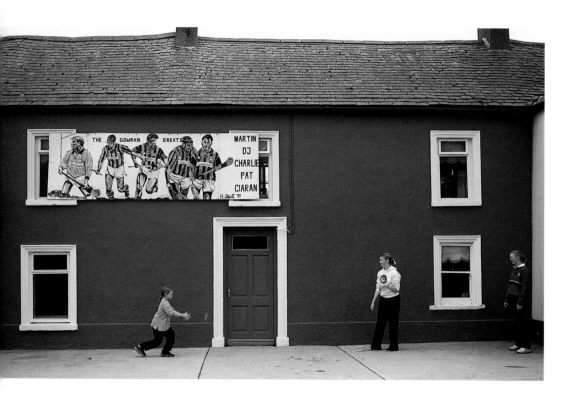

Gowran's history. Theobald Fitzwalter, Chief Butler of Ireland, incorporated Gowran as a Norman town in 1180, dispossessing the O'Dunphy sept. In 1316 Edward Bruce and his Scots soldiers plundered the town. The victorious William III rode by in triumph after the Battle of the Boyne in 1690, on his way to meet the Duke of Ormonde at Kilkenny Castle. In 1890, a year before his disgrace and death, Charles Stewart Parnell addressed a monster meeting in the cause of Home Rule.

Gowran is now much less important politically than it was in medieval times. Most people know it for its famous racecourse – its old Irish name, 'Steed's Way', is astonishingly prescient. Arkle and Dawn Run are among the horses which have thrilled the crowds that regularly include presidents and princes and other notables.

Gowran

(Bealach Gabhráin = Steed's Way)

KILKENNY

SITUATED on the main road from Dublin to Waterford, Gowran provides a tranquil stopping-place for the jaded motorist. Recent preservation work by the Office of Public Works at St. Mary's Collegiate Church, largely inspired by the enterprising Gowran Development Association, has led to a renewal of interest in the history of both church and village, as the publication of their excellent historical study makes evident. The rebuilding of the stone boundary walls and entrances – part of a highly successful youth training programme – has suddenly opened up this hitherto rather inaccessible building and its surrounding graveyard to public view.

Since its foundation at an unknown date in early Christian times, St. Mary's has undergone more than the usual number of alterations, additions, razings and demolitions which seem to be the norm for Irish ecclesiastical buildings. Evidently the nave finally collapsed at some time in the 17th century, leaving only the chancel with a roof, and this portion has remained in use as a place of worship for the Church of Ireland. Two successive rectors at the turn of the 19th and 20th centuries did their utmost to preserve the monuments – among which are the extraordinary fourteenth-century effigies of a man and a woman, in low relief, clearly carved by the same hand, and with a kind of minimalist discretion.

A newly planted space between the church and the village street has been named the High Garden. Headstones have been placed here, with inscriptions giving information on salient events in

Kilkenny's hurlers are celebrated on this banner (above left). Other charming sights of this village include estate cottages, commissioned in 1908 by Lady Ann Ley of Gowran Castle (above), and the old road from Dublin to Waterford (opposite), under St. Mary's Church.

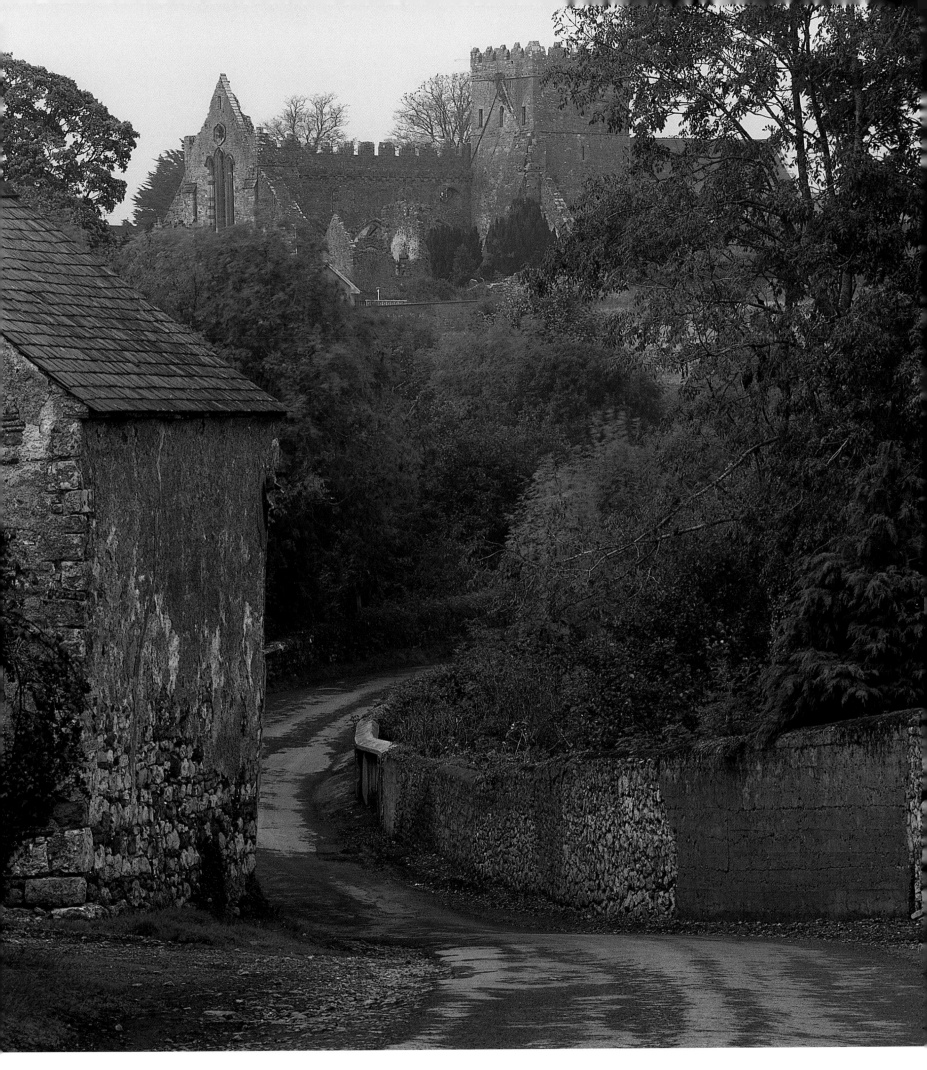

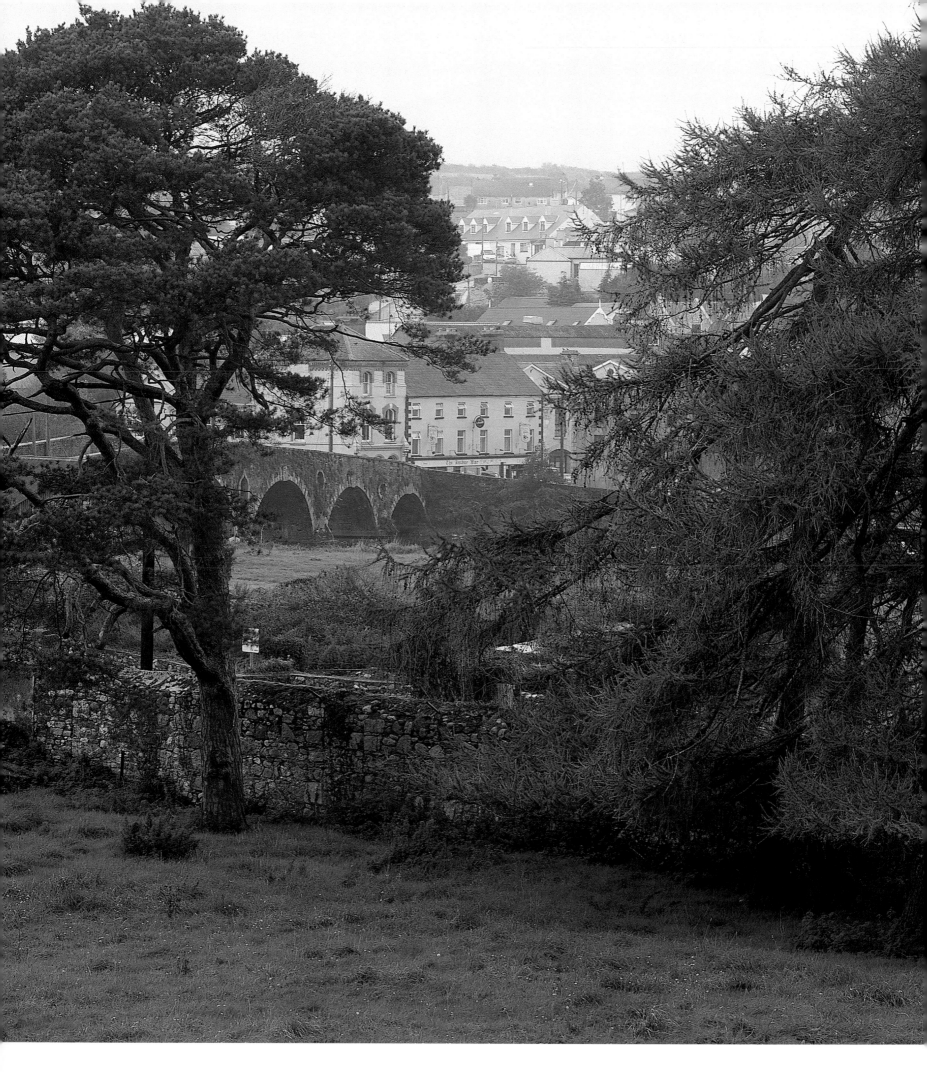

Graiguenamanagh

(*Gráig na Manach* = The Monks' Grange)

KILKENNY

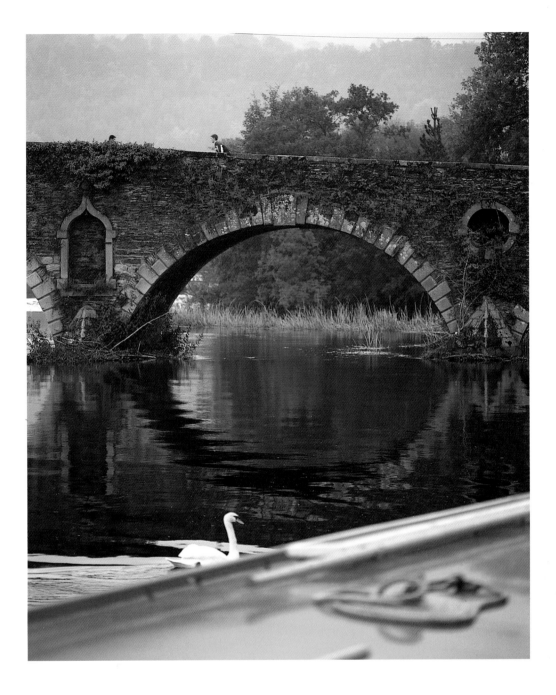

GRAIGUENAMANAGH is remarkably pleasantly situated on the broad-flowing river Barrow, where a handsome bridge connects the counties of Carlow and Kilkenny. The Barrow is as much a favourite with walkers as it is with boating parties, particularly as there is a public tow-path which becomes more and more picturesque as the river plunges south, entering the steeply wooded valley between Brandon Hill and the Blackstairs Mountains in its rush towards New Ross and the sea.

The Duiske (*Dubh Uisce* = Dark Water) enters the Barrow at Graiguenamanagh, giving its name to the abbey which is the centrepiece of the village. In its heyday Duiske Abbey was the largest Cistercian foundation in the country. What is surprising – in a land where most of the noblest examples of pre-Renaissance architecture are in ruins – is that Duiske is sound of wall and roof: this is due to recent rebuilding as a result of a concerted effort by the people of the locality and the imaginative co-operation of the Office of Public Works.

Duiske Abbey was founded in 1204 by William the Marshal, probably the most enterprising of the Norman leaders. At the dissolution of the monasteries it was granted to James Butler, known as 'the King's man'. The Butlers managed to retain the property at the rebellion of 1641, but their luck did not last and, as followers of King James, their estates were forfeited after the Williamite wars and purchased from the Crown by the Agar family from Gowran. The Agars remained in possession until well into the 20th century, and were responsible for building many of the pretty street houses.

Much was expected of the Barrow Navigation, a scheme associated with the Grand Canal Company. In 1760 the first locks were built, and by 1770 boats of up to forty tons could reach Graiguenamanagh. One of the expected benefits of the canal traffic was the establishment of a hotel to accommodate businessmen and passing tourists. At the end of the 18th century the rate for 'a bed, for one person, in a room containing only one bed' was three shillings and three pence; this included 'porterage between the hotel and boats, and six pence to the Chamber-Maid, which is paid to her by the Hotel-Keeper'. If a person wished to stay for more than a fortnight the rate was doubled, because the purpose of the hotel was to encourage water traffic and not residence in the town. It is hardly necessary to add that the hotel only survived for a few years.

Water-borne trade never developed to the extent expected, and for over a hundred years the river frontage had a dissolute look. It is ironic that a flourishing hotel now exists in a superbly reinstated quayside warehouse – a handsome four-storey stone building which had remained derelict for a considerable time. Pleasure-boats moor throughout the summer. At last Graiguenamanagh is enjoying the material advantages of its supreme situation.

The County Carlow bank of the river Barrow yields a fine view of Graiguenamanagh on the Kilkenny side (opposite). *The ornamental niches on the downstream side of Graiguenamanagh's bridge* (above) *are said to have been designed to impress canal-borne travellers arriving from Waterford.*

Village details (clockwise from top right): *a window embrasure in Duiske Abbey; F.J.Murray's remarkable shop-front which takes its inspiration from the window design of the Abbey; nineteenth-century widows' houses; and the Main Street.*

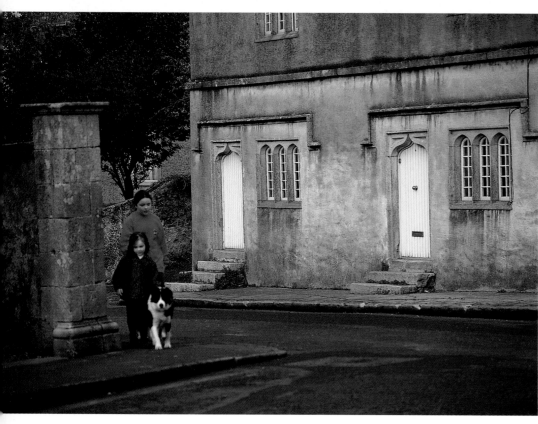

Time for a pint and a chat in Mick Doyle's of Graiguenamanagh (opposite).

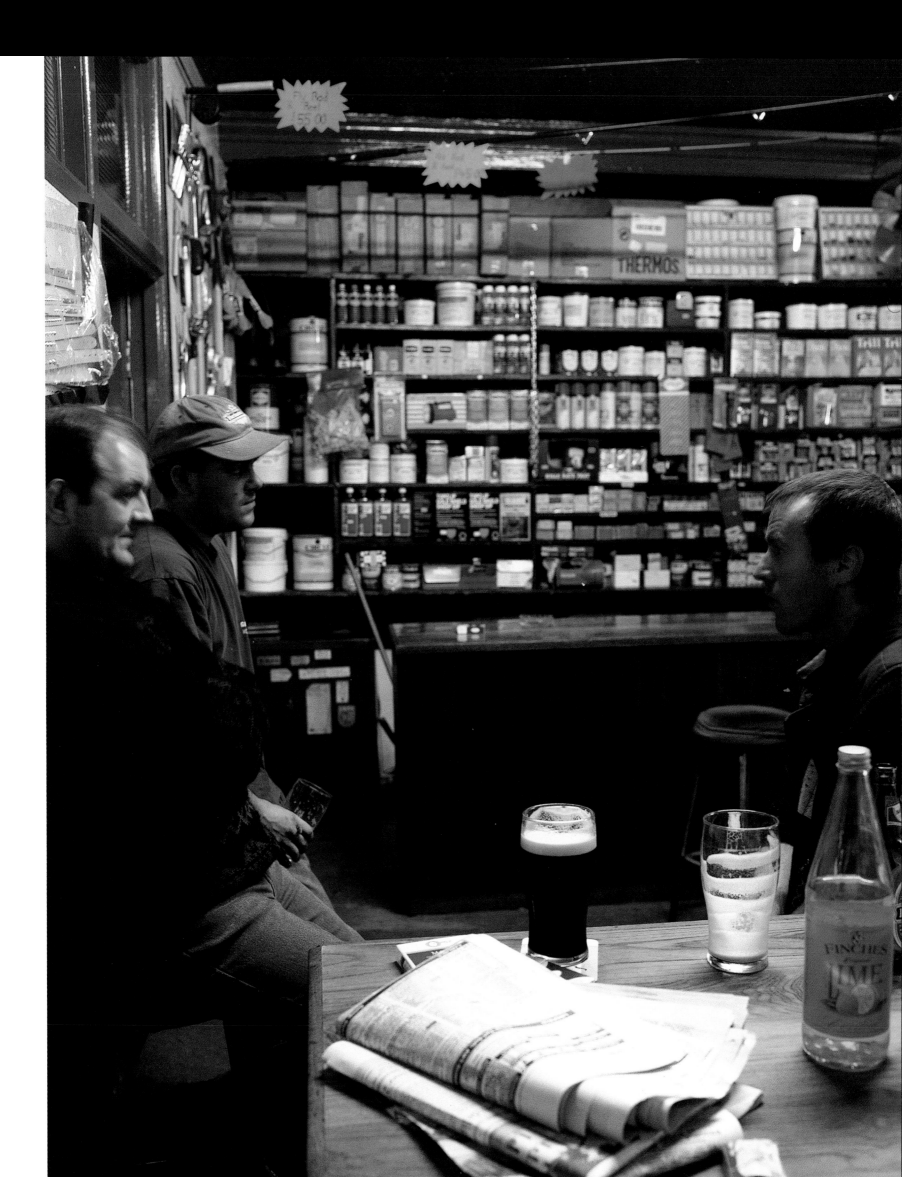

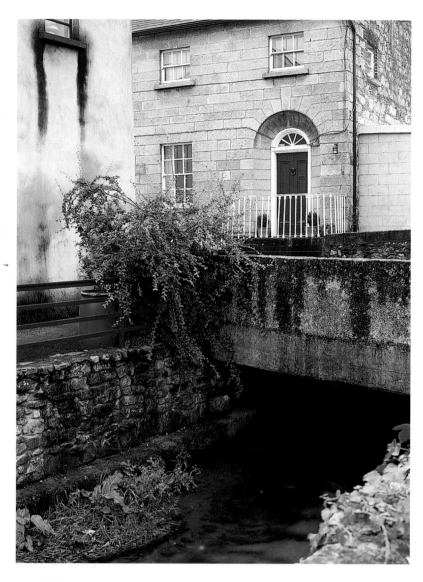

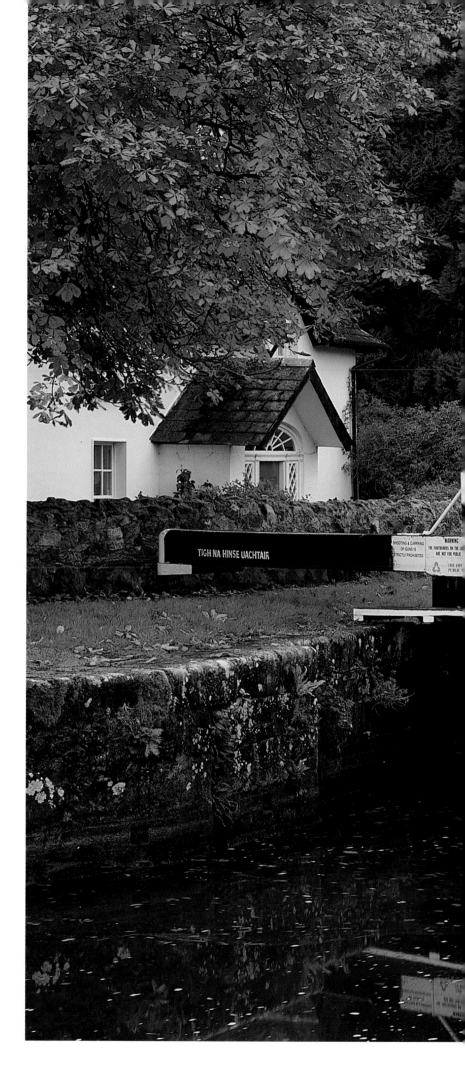

*T*his neat stone house (above) *graces the centre of Graiguenamanagh.
The splendidly maintained lock complements its beautifully
restored lockside house* (opposite). *This bank of the Barrow Navigation
is more correctly known as Tinnehinch.*

TIGH NA HINSE UACHTAIR

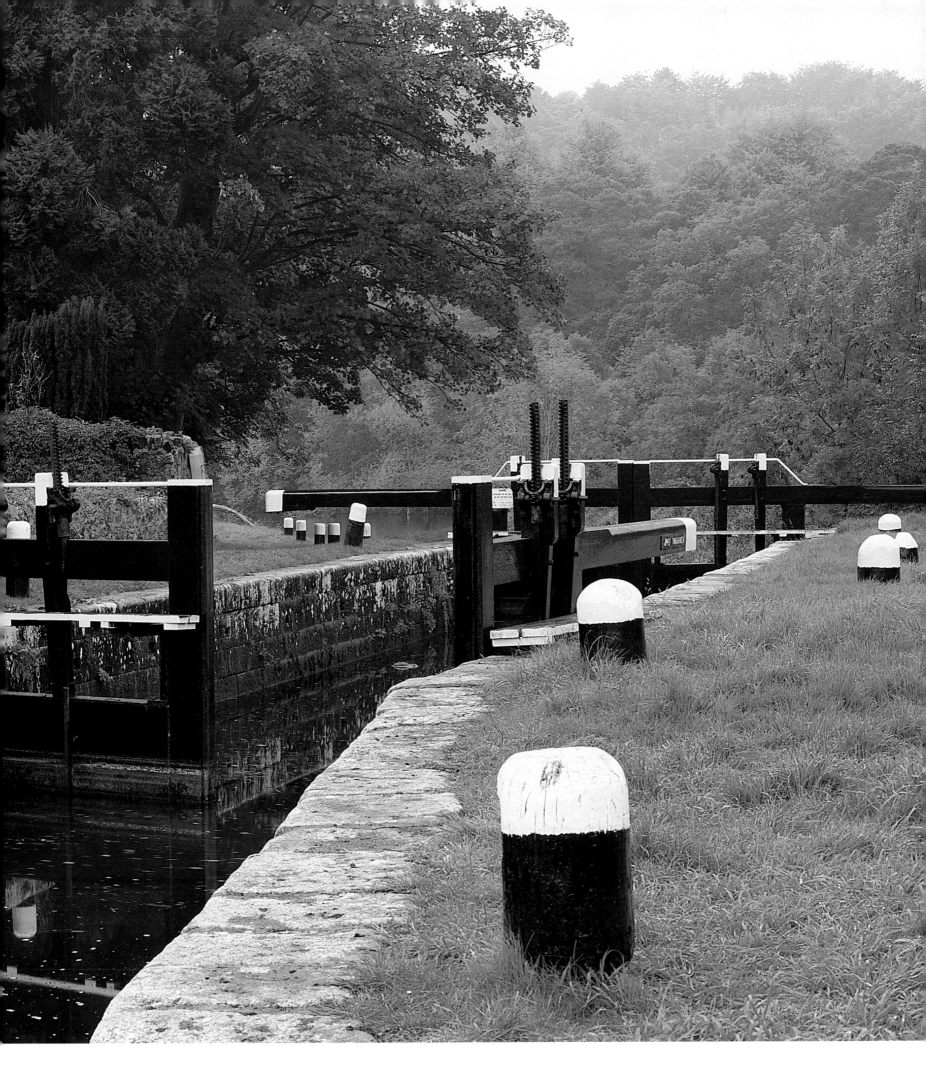

Kilmore Quay

(*Cé na Cille Móire* = Great
Church Quay)

WEXFORD

TWO EASY-GOING ROADS, one coming from roughly the direction of New Ross and the other slightly less ambiguously from Wexford town, converge at a sandy spit of land known as Crossfarnogue or Forlorn Point. On either side of the point are great curved strands bounded by yellow dunes, known in the neighbourhood as 'burrows'. The burrows restrain the waters of brackish reedy lakes, the haunt of multitudes of wildfowl. This is the extreme south-east corner of Ireland – a mild coast, by the look of it, one might think. Not so, however – for there have been hundreds of wrecks. Should a vessel get too far into the bay bounded by Crossfarnogue Point, the Ballyteige Burrow and Baginbun Head, an early nineteenth-century historian has written ominously, 'it is impossible to beat out, and there is no place of refuge'.

The village of Kilmore Quay grew up in a natural way around the harbour which was created by far-sighted local people on Crossfarnogue Point after the famine of the 1840s, when it was proposed that a fishing industry might be one answer to the question of a moribund economy. These people were right, and the Kilmore Quay fishing fleet

rapidly became – and still is – one of the most important in Irish waters. The two main roads and their connecting streets or lanes now give a kind of definition to the village, but at the time when most of the houses were built there was no such formality, and Kilmore Quay was more of a *clachán*, or gathering of dwellings, than the conventional *sráidbaile*, or street-village. The original houses, all neatly thatched and whitewashed in the tradition of several hundred years, vary to an extraordinary degree: one-storeyed, two-storeyed, one-and-a-half storeyed, hip-roofed, dormer-windowed, gable-windowed, with porches, without porches. The largest two-storeyed houses are known as 'thatched mansions'.

Kilmore Quay is situated in the Barony of Bargy. Bargy, and its neighbouring Barony of Forth, were noted up to about a century ago for the survival of a dialect known as Yola, brought to this corner of County Wexford by post-Norman settlers and based on Middle English, with a tempering of Irish words and phrases. Certain sayings in the current English of the locality are identified as Yola. A tradition which still survives in Kilmore Quay is the placing of wooden crosses at pre-ordained points on the route of a funeral cortège, usually by the chief mourners. This is known to have been inspired by pilgrims returning from Santiago de Compostela, who observed the rite where Charlemagne's soldiers had died at the Battle of Roncesvalles in A.D. 778. When the new cemetery was opened at Kilmore Quay in 1953, the old custom was preserved.

The Parish Church at Kilmore Quay (above) *is a dominant presence near the harbour which shelters the village's fishing fleet* (opposite).

There are many magnificent examples of the thatcher's craft in Kilmore Quay (below and opposite). The teeming bird life of the Wexford coast is reflected in the names of the village's fishing boats (bottom).

During the 1930s, Eddie Goff, a local man who understood the nature of winds, tides and soil erosion, built this and similar walls (above) throughout Kilmore Quay. They are unique to this neighbourhood.

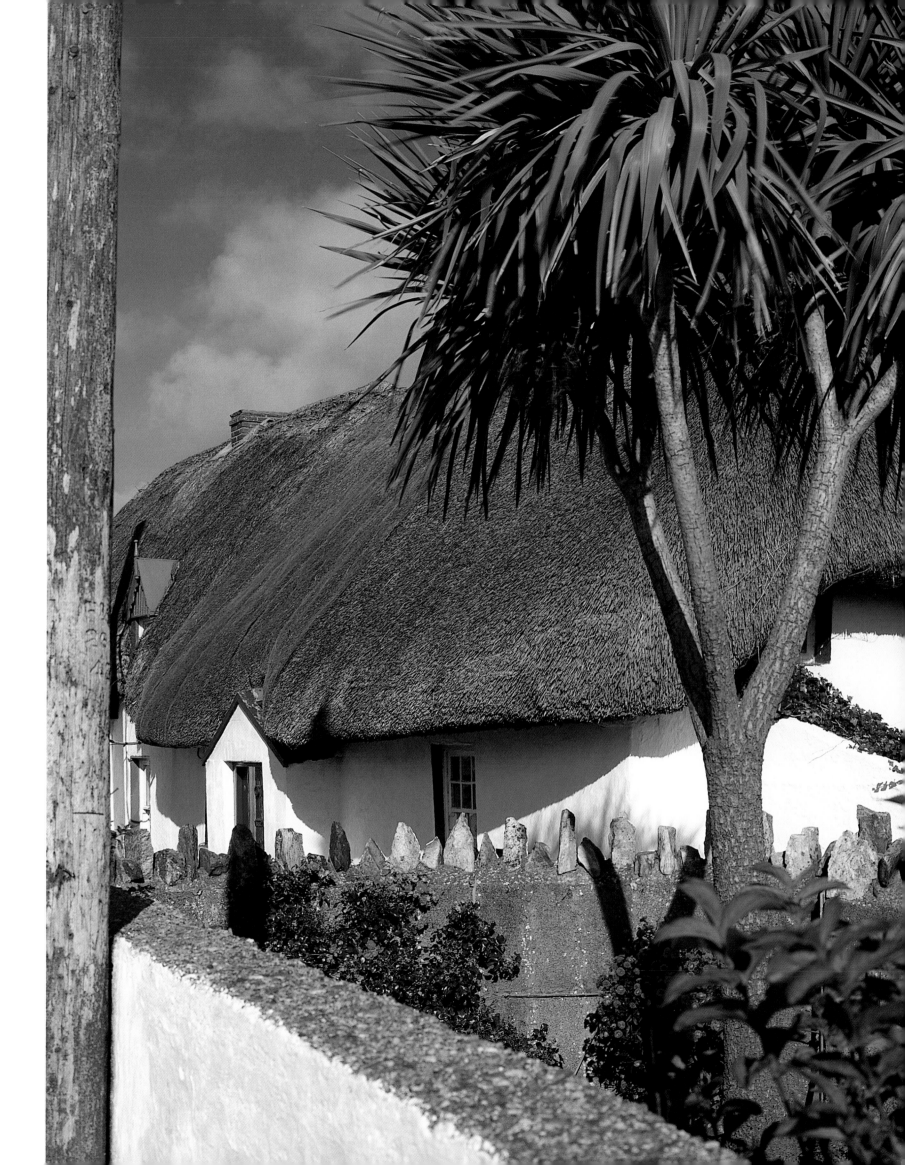

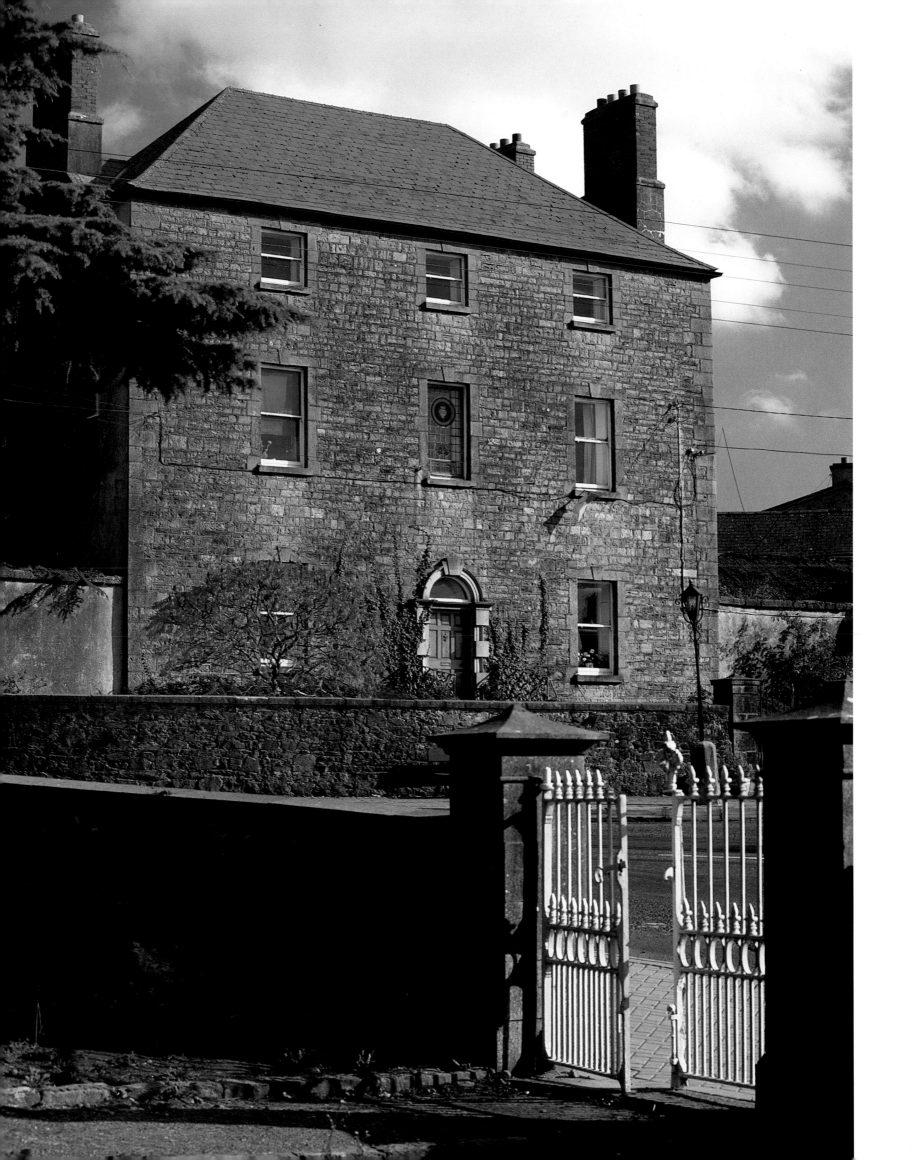

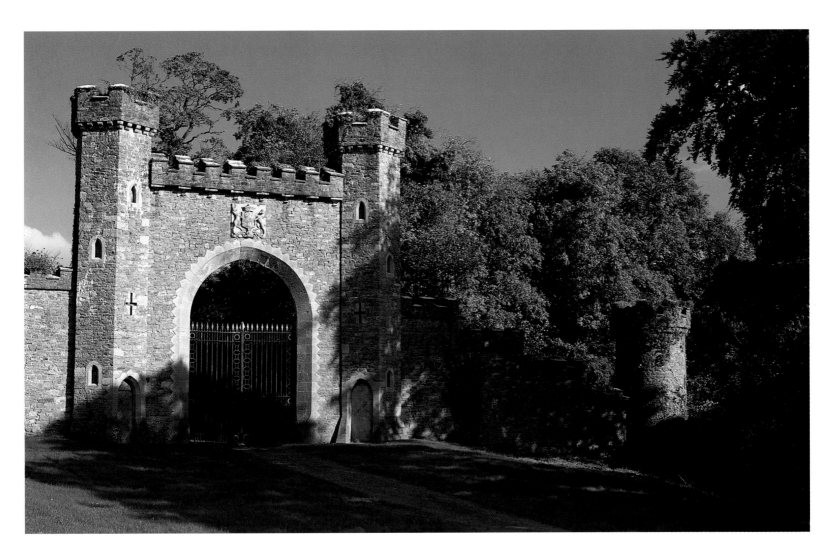

Slane

(*Baile Sláine* = Slane's Town)

MEATH

*T*his handsome eighteenth-
century house (opposite) *is
one of four, all similar, which –
though much altered – still regard
one another diagonally at the
cross-roads in Slane. A much more
formidable edifice in the village is
the Gothic gatehouse to Slane
Castle* (above). *The arms are those
of Earl Conyngham – later the 1st
Marquis – and his wife Elizabeth
Denison.*

IT HAS BEEN SAID that County Meath 'has
everything': the best land, prosperous towns,
pleasant scenery, the greatest number of antiquities,
and fine examples of architecture of all periods.
Within a fifteen-minute drive of the village of Slane
one may visit the spectacular Boyne necropolis of
c. 5000 B.C., the remains of the twelfth-century
Cistercian abbey of Melifont, the site of the Battle
of the Boyne (1690), and Townley Hall, a splendid
neoclassical country house of 1794 by the Irish
architect Francis Johnston.

One does not have to walk outside the confines
of the village, however, to see as many interesting
sites representative of almost as wide a spread of
history. A souterrain dating from pre-Christian
times can be found by the Ardee road. A few
hundred yards away, on the summit of Slane Hill,
St. Patrick lit the paschal fire on Easter Monday
A.D. 433, an event which had extraordinary political
as well as religious repercussions. It seems that King
Laeghaire had forbidden any rite which would rival
his festival at Tara on the same date; he observed
the smoke over Slane, sent a band of men to take
the perpetrators into custody, questioned Patrick,

and was subsequently converted to the new faith.

No buildings from St. Patrick's time survive on
the hill – the Friary and Church are considerably
later. The view of the Boyne valley from the top of
the tower is quite inspiring – for its own sake as
much as for the historical associations which it
brings to mind. The settlement at Slane was sacked
several times by Norsemen – based in Dublin,
apparently; and by Anglo-Normans in 1172 and
1175. It continued in decay until restored by Sir
Charles Fleming, Lord of Slane, in 1512. The
Flemings lost their lands to the Conynghams in the
Revolution of 1641, and the Conynghams remain at
Slane Castle to this day.

The Conynghams laid out the present village in
the second half of the 18th century. Motorists
travelling from Dublin to Derry cannot fail to be
impressed by the neat piece of town-planning at the
main cross-roads – which is really an octagon. The
four great matching houses of 1767 have endured a
number of vicissitudes – what is wonderful is that
they are all still there. The house on the north-west
corner was for some time an inn; that on the north-
east corner is now the presbytery.

All that remains of Fennor Castle is the ruin of a later manor house (right), *familiar to motorists travelling on the old Grand Jury road from Derry to Dublin through Slane. Terrace houses of local limestone* (below) *typify the many simple and well proportioned buildings in this village. Its Roman Catholic church* (below right) *is one of few erected between the Reformation and the Catholic Emancipation Act of 1829; because the law forbade a belfry on a Roman Catholic place of worship, this one was erected a few feet away from the building! The approach to the village from the south yields a splendid view of the bridge over the Boyne, a terrace of houses once occupied by employees of the nearby grain mill, and the tower of the abbey church on the site where St. Patrick lit his historic Paschal fire in A.D.433.*

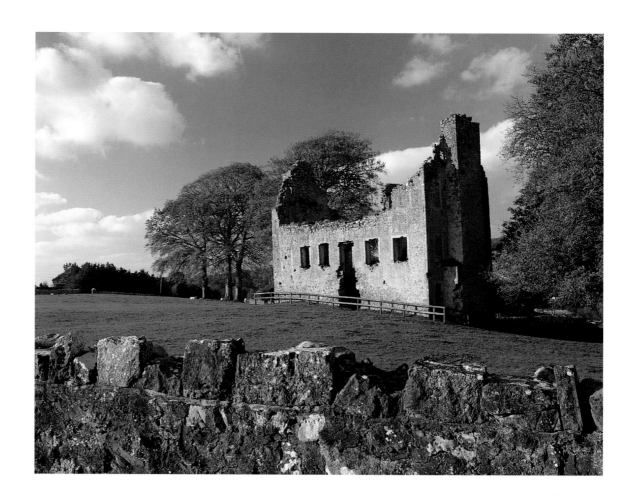

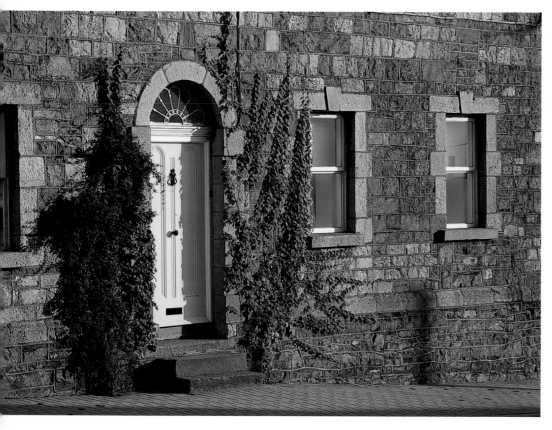

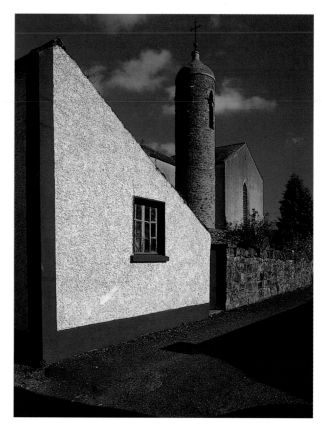

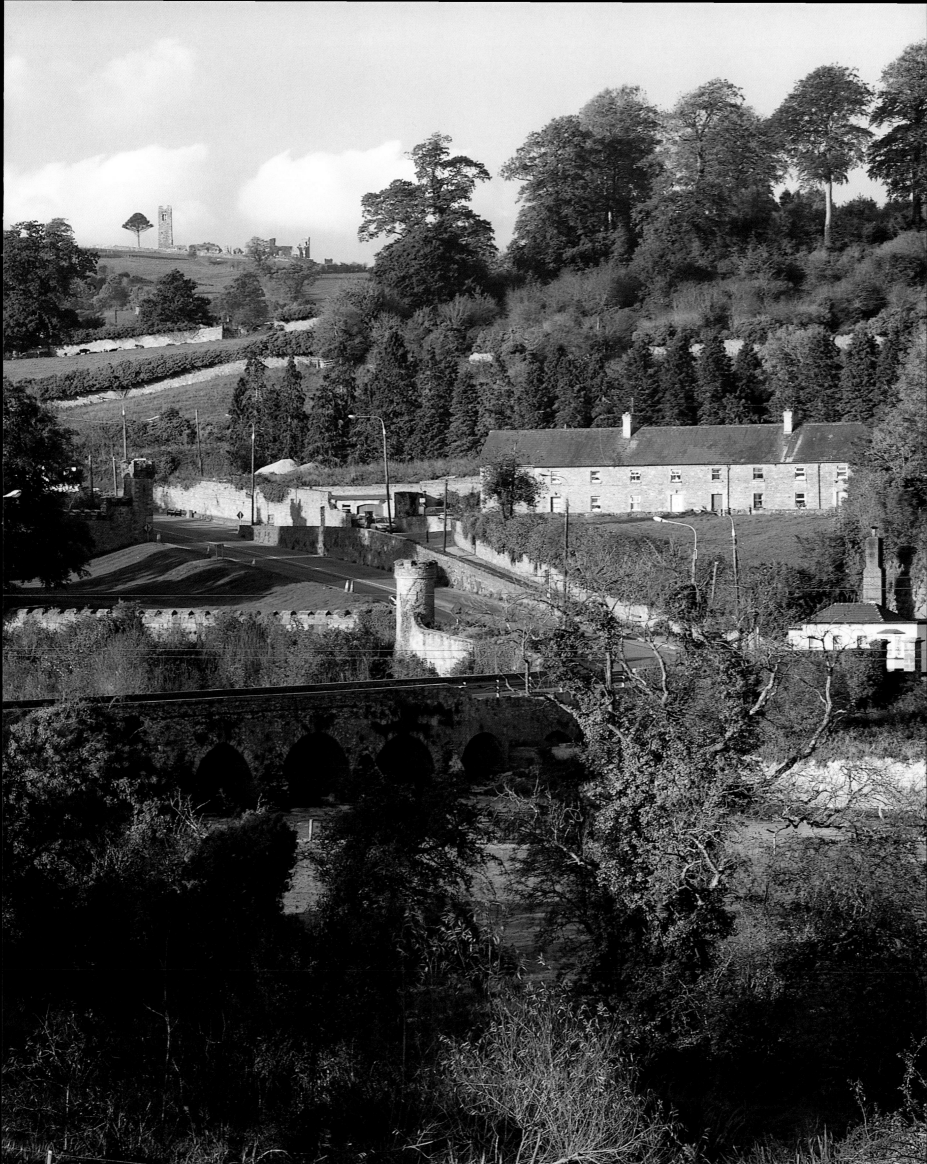

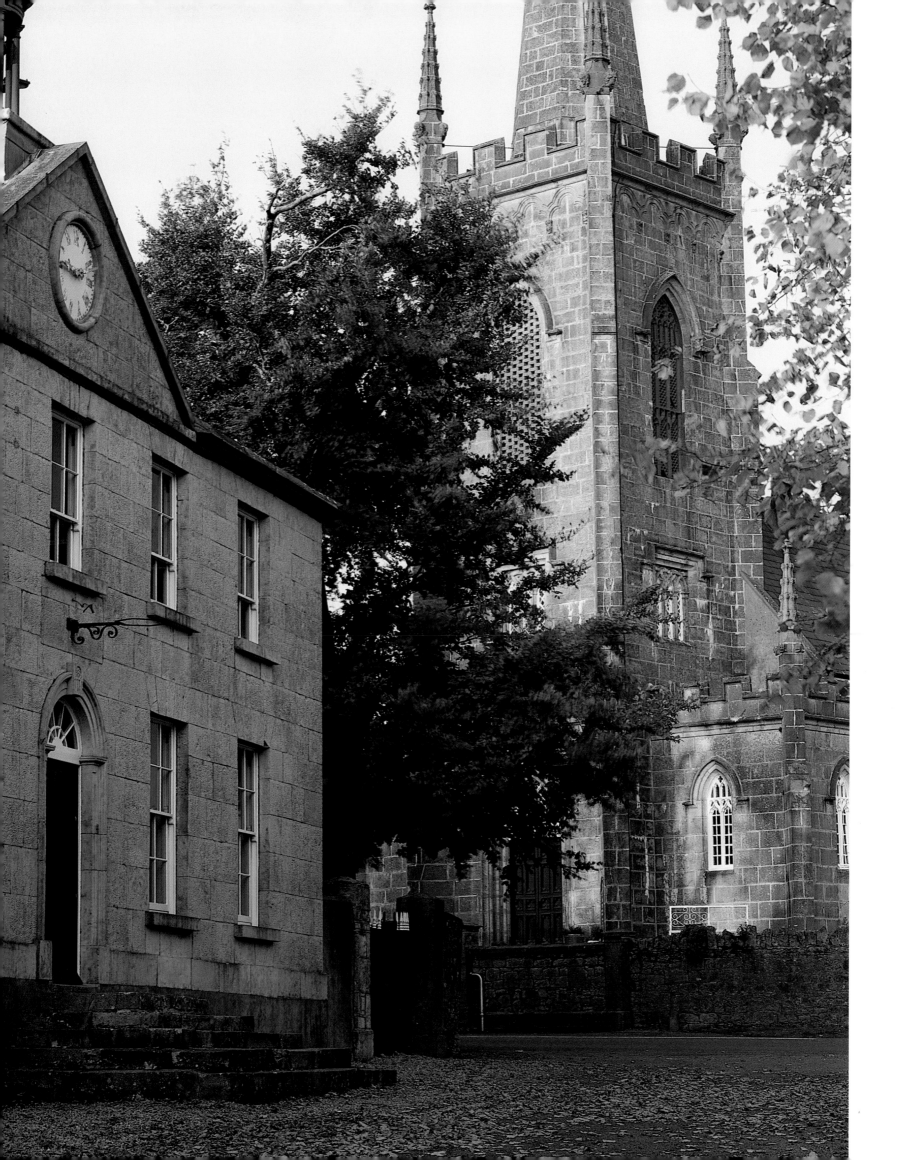

Tyrrellspass

(*Baile an Tirialaigh* =
Tyrrell's Town)
WESTMEATH

THE TYRRELLS originally came from Triel in northern France. Like the other Anglo-Norman families who settled in Ireland after 1169, the Tyrrells became, in the famous phrase, 'more Irish than the Irish', and so it was only a matter of course that they should have lost their lands at the time of the Cromwellian interregnum. The castle, or tower-house, at the western end of the village was only one of many Tyrrell properties in County Westmeath, and it was saved due to a complicated negotiation with one of Cromwell's colonels. It later passed to the Rochforts, Earls of Belvedere.

The 'pass' is hardly discernible today, but in ancient times the narrow strip of land rising above the turf bog was of immense strategic importance. The *Slí Mor*, one of the five great roads radiating from Tara (the seat of the High Kings) passed along the glacially deposited gravel bluffs known locally as 'eskers', affording a relatively dry-shod passage across the low-lying central plain. The Tyrrell castle commanded a section of this route, which the modern road from Dublin to Galway follows fairly closely, rudely levelling some of the most impressive esker formations. Fortunately official policy has more recently resulted in the conservation of this extraordinary and quite unique feature of the midland landscape.

The Rochfort family generally had a poor reputation as landlords, but Jane, Countess of Belvedere (1775–1836), was of a quite different disposition and it was she who laid out the crescent-shaped green and saw to the provision of a new church, a court-house, a school, an orphanage and a Methodist chapel. In doing so she also introduced an extraordinary sophistication to what is otherwise a traditional village streetscape. Some of these early nineteenth-century public buildings have recently become private homes.

The mutiny of the Connaught Rangers at Jullundur and Solan in 1920 is commemorated on the headstone of James Daly in Tyrrellspass graveyard. While home on leave, soldiers learned of atrocities committed in Ireland by the Auxiliaries (the 'Black- and-Tans'), and on returning to India expressed their horror and concern by refusing to go on parade. Sixty-nine men were tried by court-martial and fourteen sentenced to death. All sentences were commuted save one, that of Daly, who was shot at Dagshai Prison. His body was returned to Tyrrellspass in 1970.

These two handsome buildings in contrasting architectural styles – St. Sinnach's Church and the former Court House – (opposite) *contrive to blend together tastefully in the scheme devised by Jane, Countess of Belvedere, for the Green. Tyrrellspass has a number of such quiet corners, seen to advantage here in autumnal light* (right).

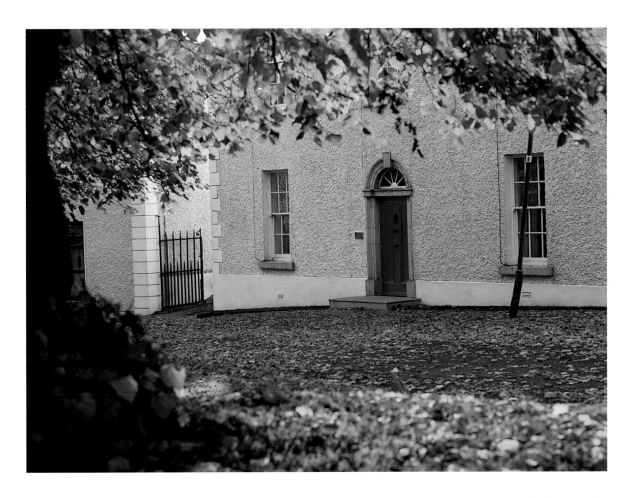

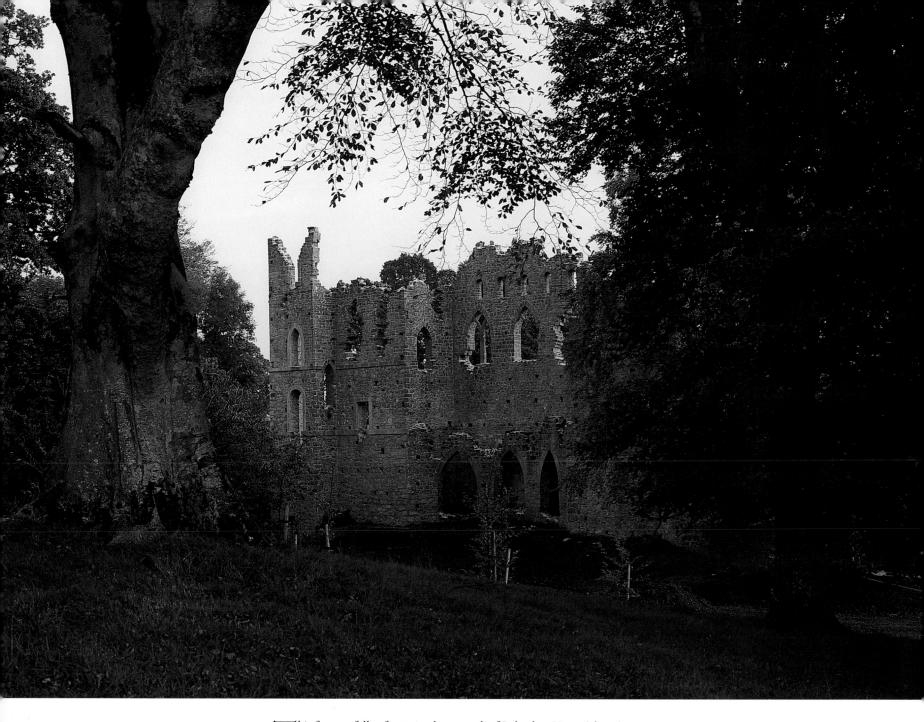

This famous folly of 1760 in the grounds of Belvedere House (above), known as the Jealous Wall, is said to have been built to obscure the house of Lord Belvedere's brother, believed to have been Lady Belvedere's lover. Another renowned spot in the village is the Holy Well near St. Stephen's Church (opposite), maintained in as natural a state as possible, avoiding the worst excesses of commercialism.

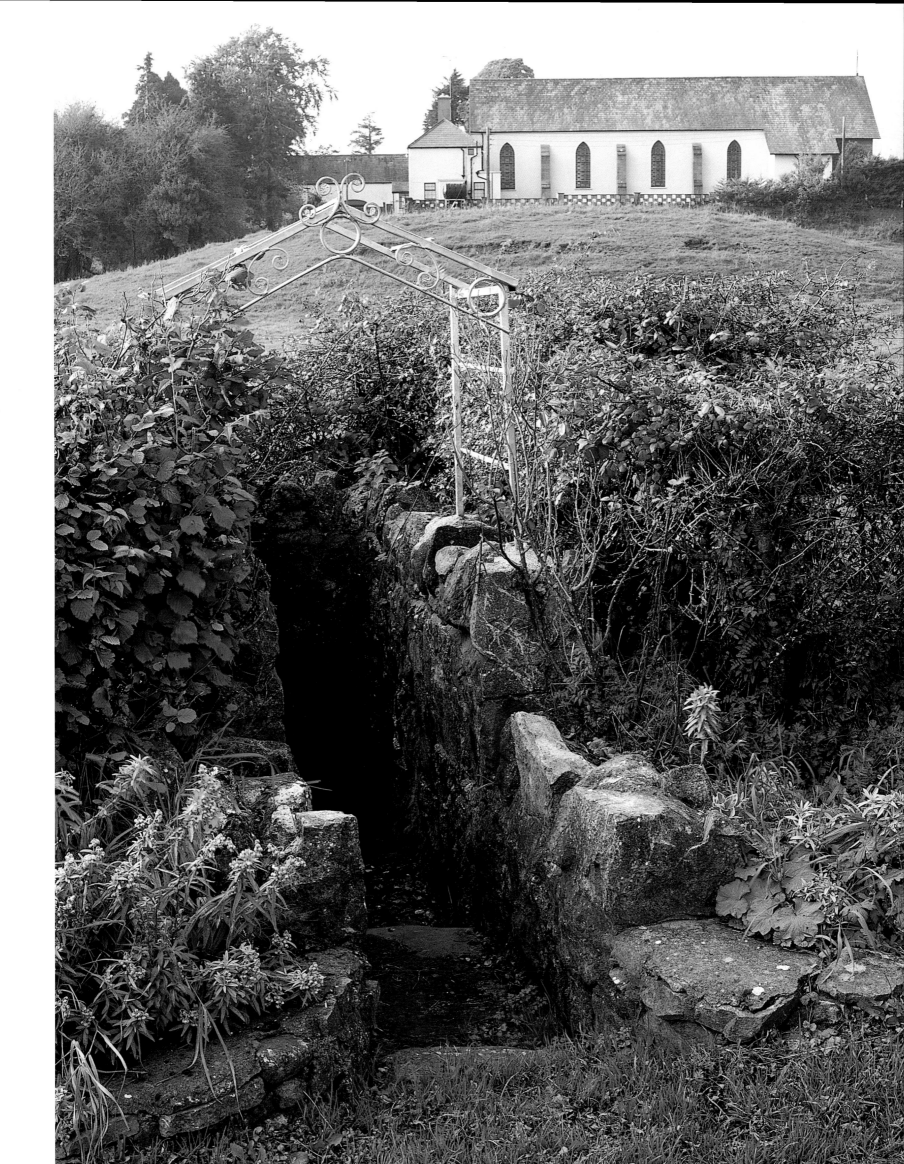

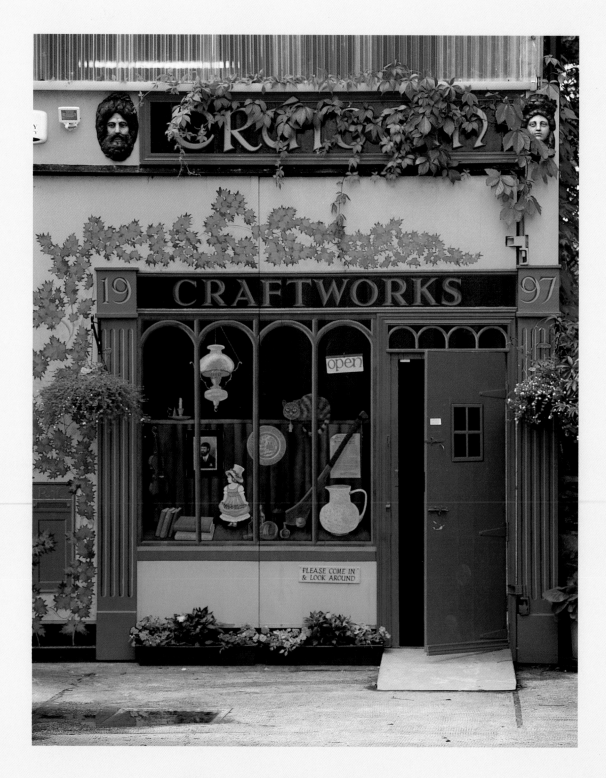

Bar and Shop Fronts

Many a main street of village and small-town Ireland is brought strikingly to life by a series of intriguing frontages – those of the local bars and shops. These may be works of remarkable ingenuity, such as that of the Crúiscin ('jug') Craftworks *(above)* in Roundstone, County Galway. It presents a *trompe-l'œil* façade, to the delight of the customers, where even the resident cat is a creation of the artist's brush. Others excite by the warmth of their invitation, like this glowing pub window *(opposite)*.

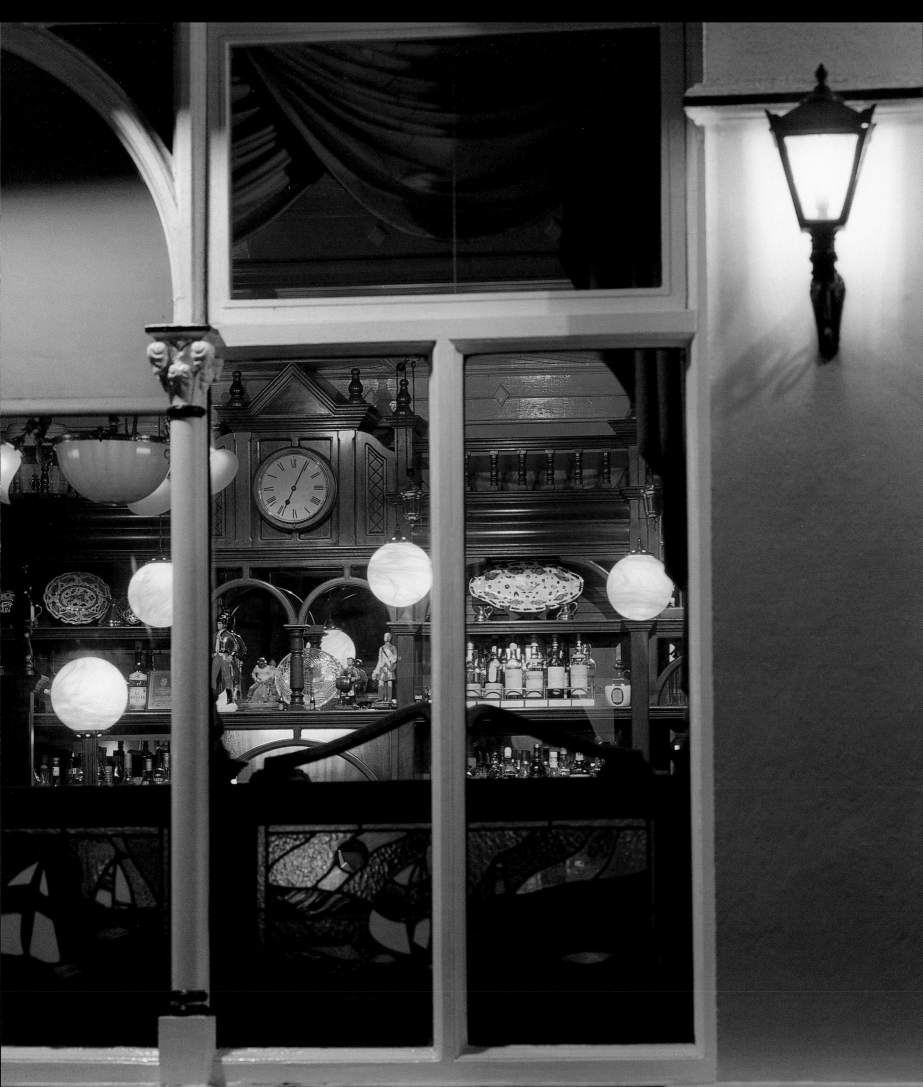

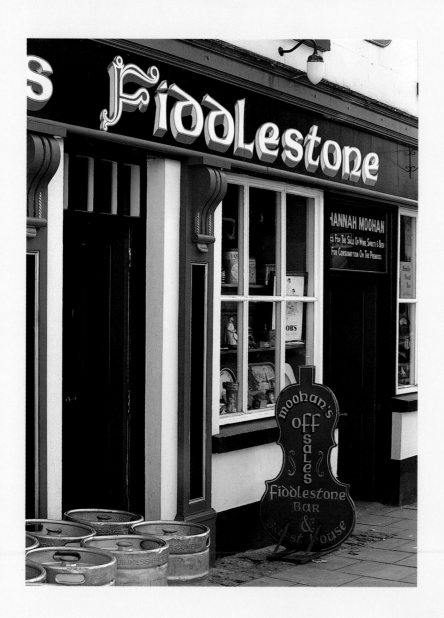

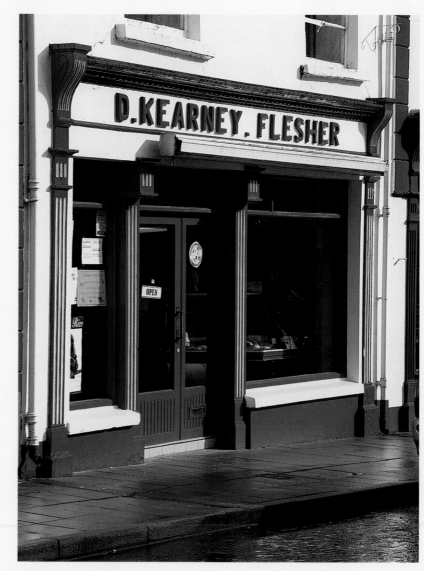

*T*he Fiddlestone (above) in
Belleek, County Fermanagh,
takes its name from a nearby fiddle-
shaped monument to a musician who,
having taken stronger waters,
tumbled into those of the river Erne
while attempting to cross by boat.
Butchers are universally known as
'fleshers' in Ulster, hence the sign over
this shop in Cushendall (above right).
Bars and groceries traditionally face
each other within the same
establishment – Doyle's of
Graiguenamanagh, County Kilkenny.
The frontage aspect changes with the
time of day (opposite, clockwise
from above left): early morning
before opening-time at Nolan's Bar,
Rosscarbery, County Cork; evening
after closing-time outside Brady's
Outfitters in Virginia, County
Cavan; and open-house at Lena's in
Adare, County Limerick.

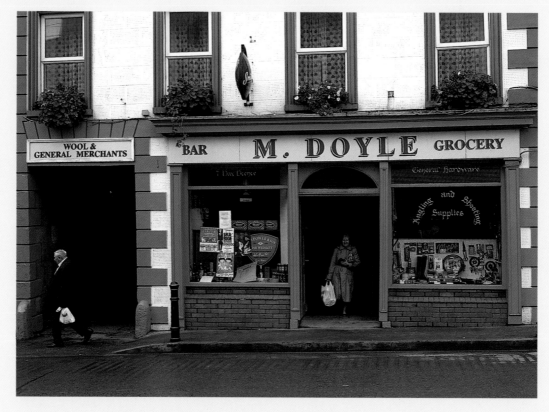

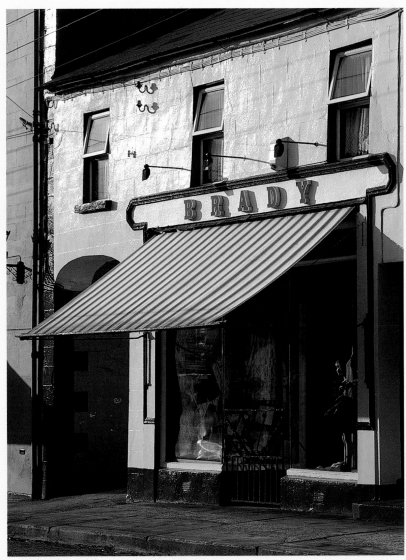

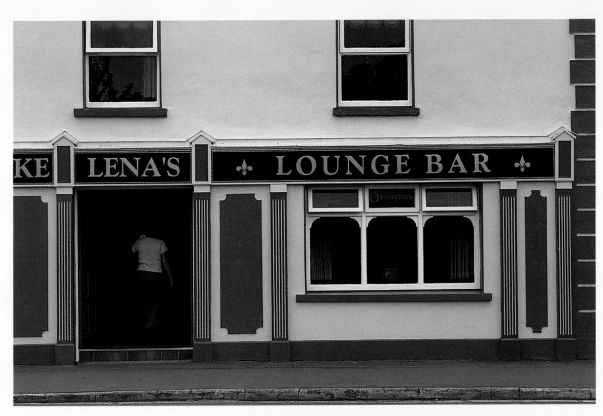

A dare, County Limerick, presents a study in scarlet and a rhapsody in blue (right and below). Customers might be wasting their time looking for sweets (or indeed anything) behind Scanlan's deceptive façade in Lismore, County Waterford (opposite above); by contrast, business is brisk at Joyce's of Graiguenamanagh, County Kilkenny (opposite below).

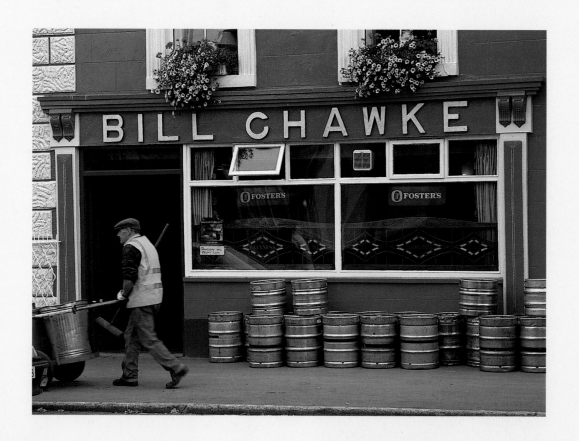

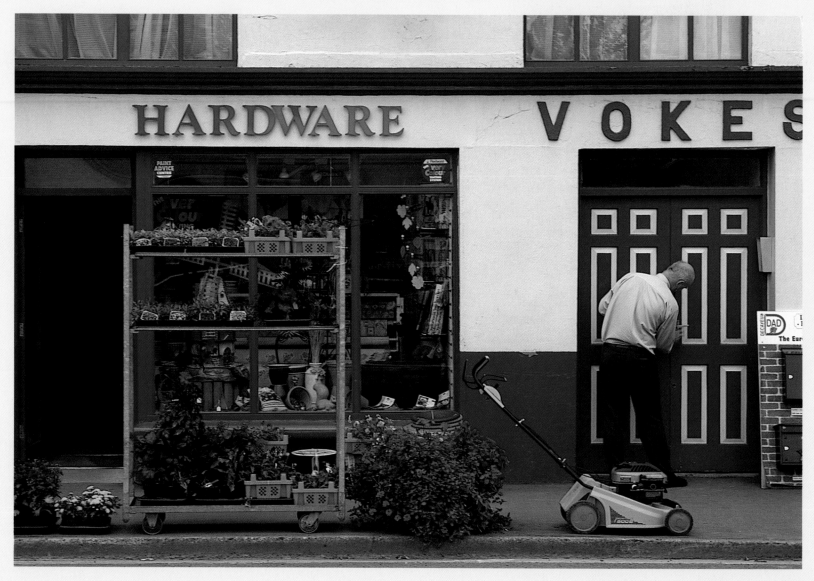

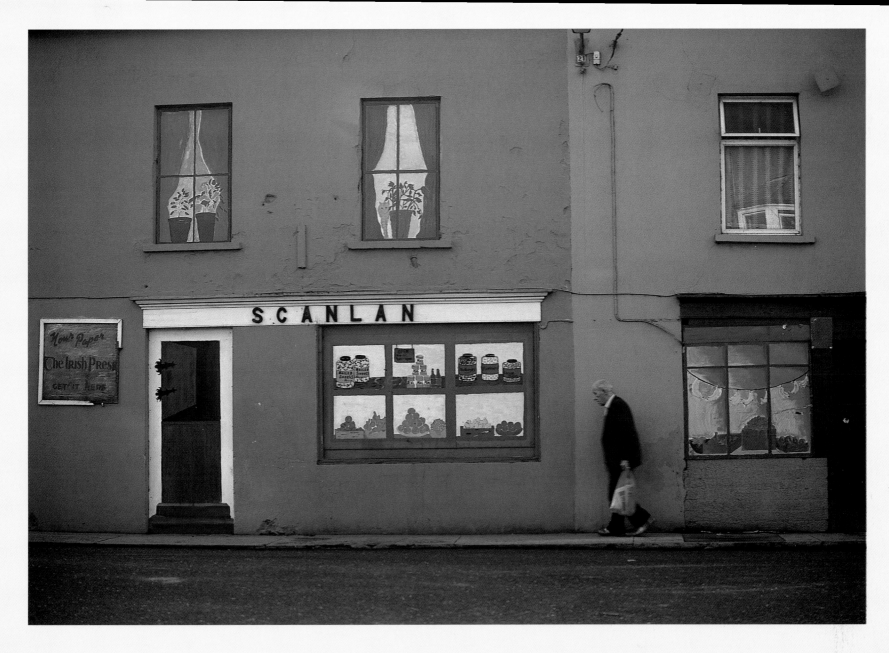

Connacht

WHILE PROVINCIAL BOUNDARIES have altered, and some were not properly formalized until comparatively recent times, Connacht has always enjoyed a particular identity. The mythological Queen Medb of Connacht ruled a people who were greatly feared for their 'deeds of valour' (pillage and rapine) by those of other regions. This identity has been maintained, probably because of Connacht's remoteness from the chief centres of administration of the last eight hundred years, and also because of its geographical situation to the west of the river Shannon, jutting formidably into the Atlantic Ocean. When the Cromwellian regime was intent upon dispossessing landowners elsewhere, these unfortunate people were told, in a now famous phrase, to go 'to hell or Connacht' – because the land was believed to be agriculturally unproductive, and because there was a sanguine feeling that anyone living there, being out of sight, would also be conveniently out of mind. There are only five counties – Sligo, Leitrim, Roscommon, Mayo and Galway – but the last two are among the largest in the country. Commercial development has been slower than in most parts of Ireland, but has been given impetus by the establishment of regional airports at Sligo and Galway, and an international airport at the unlikely location of Knock, County Mayo. The city of Galway, with its burgeoning business parks, its progressive educational institutions and its vibrant lifestyle, has doubled in size over a quarter-century, and is said to be the fastest growing urban centre in the European Union.

Rockfleet Castle on the shore of Clew Bay (opposite) is a historical and architectural landmark in the Province of Connacht. It was the home of Gráinne ní Mháille, or Grace O'Malley, variously described as Queen of Connacht, The Pirate Queen, or – by Sir Philip Sydney – 'a most famous feminine sea Captain'. She impressed Elizabeth I by addressing her as queen to queen.

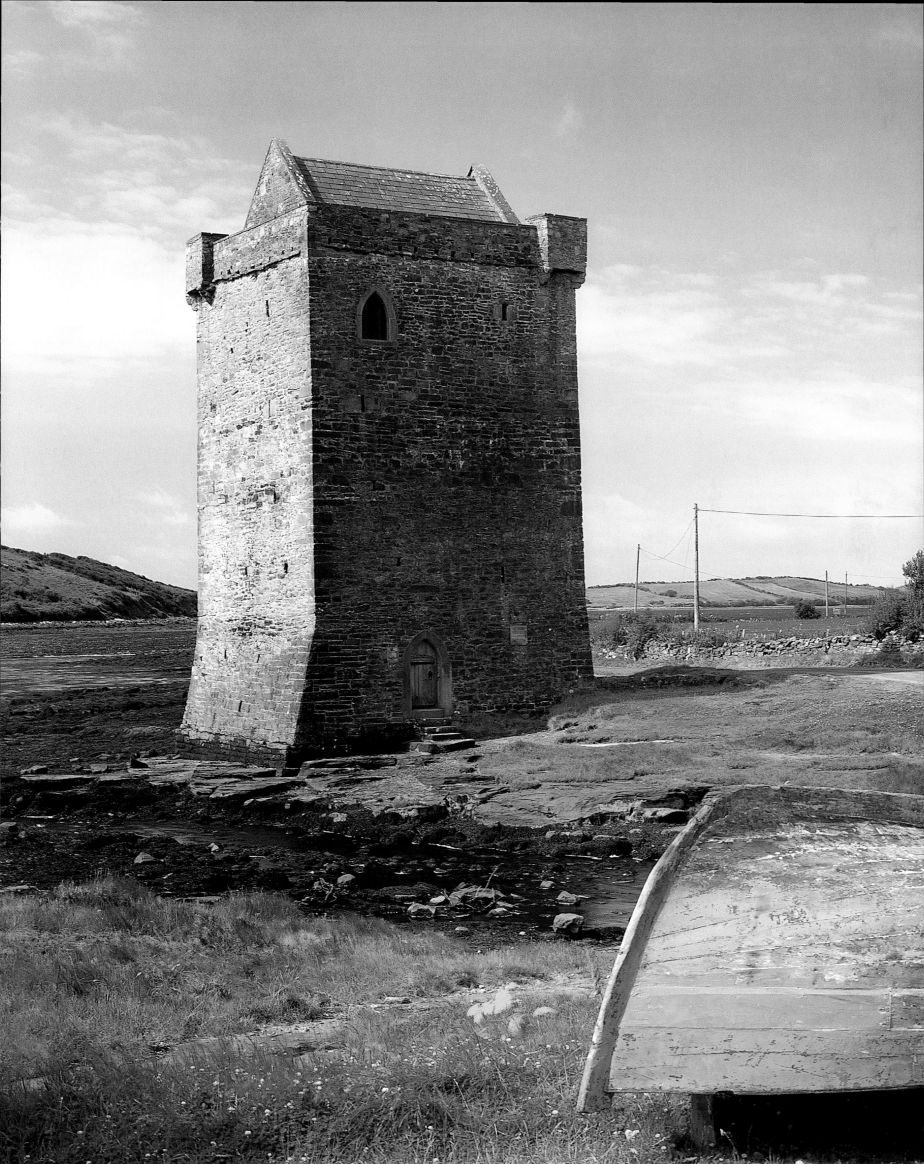

The landscape near Ballinafad, looking towards the Bricklieve Mountains, in County Roscommon, provides a wonderful introduction to Connacht.

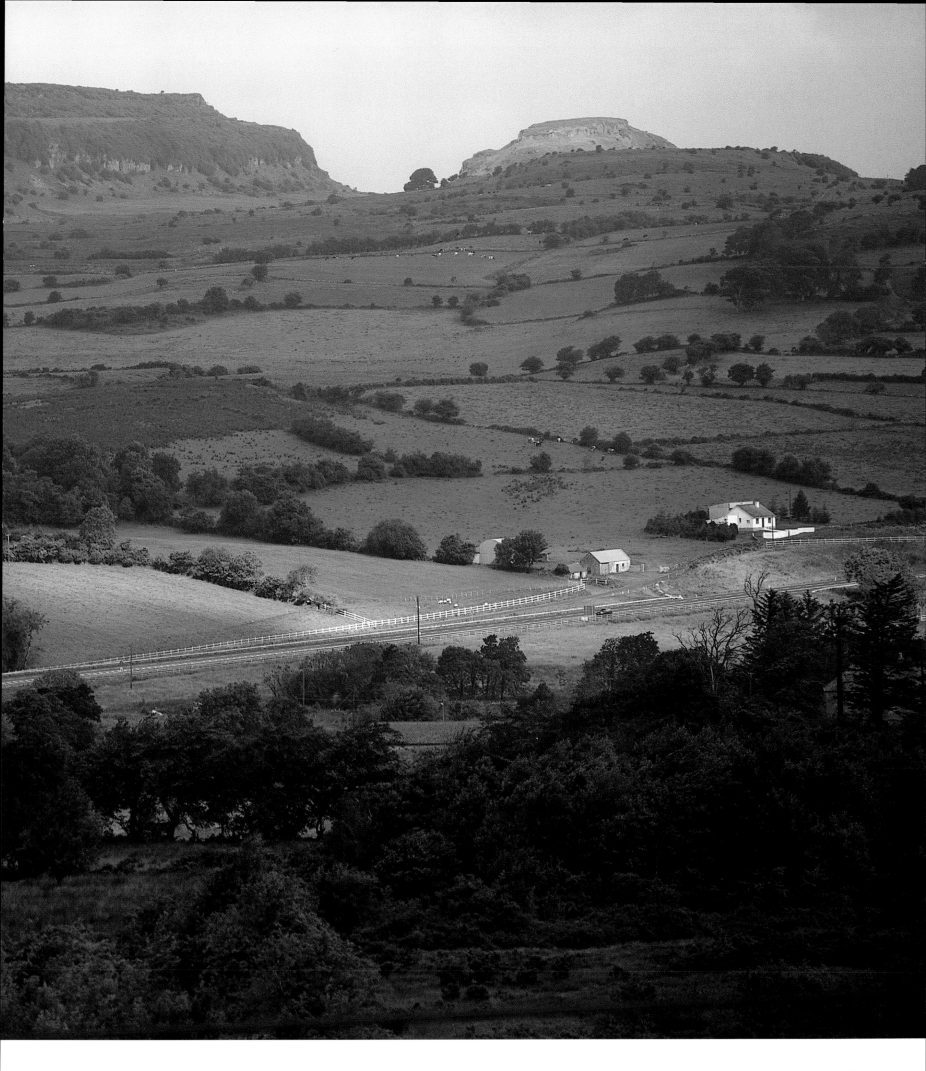

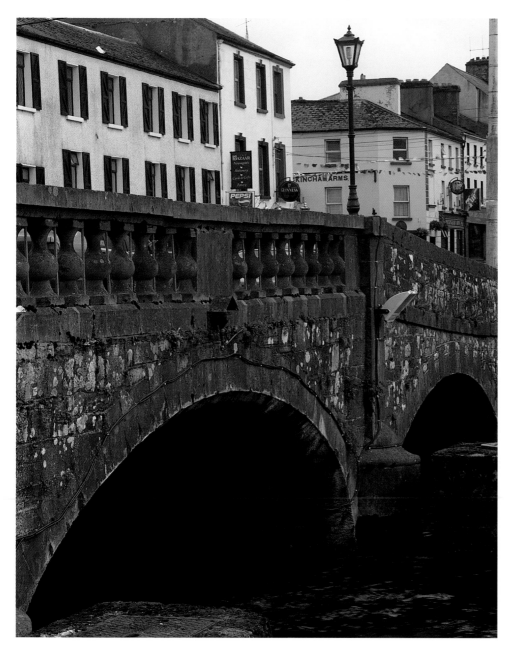

The handsome balustraded bridge over the Boyle river (above) *is one of the centrepieces of this village, which more resembles a small city, because of its wealth of fine architecture, like the King House* (opposite). *Its comparatively small population, however, fortunately qualifies it for inclusion here.*

Boyle

(*Mainistir na Búille* = Boyle
River Monastery)
ROSCOMMON

WHEN, in the early 19th century, Captain Caleb Robertson of Tangier House, County Roscommon, started clearing away 'the accumulated earth' which concealed the bases of the four massive columns supporting the tower of Boyle Abbey, he found the latter to be 'beautifully ornamented with various sculptural designs'. He was naively expressing the amazement of those who heretofore had looked on ruins as something either squalid or picturesque, hardly to be given more than a passing thought either way. His action in exposing the columns to view prefigures the work of interested amateur antiquarians of a later date.

Now the remains of Boyle Abbey are maintained as a National Monument; in fact, the gate-house has been handsomely reinstated, and contains a large-scale model of the surrounding buildings. Boyle was incorporated as a borough a century after the dissolution of the monasteries; with its religious foundation gone, it still remained a place of importance. There was a thriving market for dairy produce. Herds of cattle grazed on the Plains of Boyle. Wool was produced from flocks on the Curlew Mountains, where the ground rises up beyond the Boyle river.

The Curlews are remembered for a viciously fought battle in which Sir Conyers Clifford, Governor of Connacht and a general in Elizabeth I's army, lost 1,400 men against Red Hugh O'Donnell, who knew the terrain and survived with only two hundred casualties. Clifford's ritually beheaded body was found in a furze bush, and

sanctimoniously delivered to the monks of Trinity Island in Lough Key for burial. The *Annals of Boyle*, compiled on Saints' Island in the same lake, are now preserved in the British Museum. They treat of the history of the world from earliest times to the rather more specific date of 1270. The *Annals of Lough Key* continue roughly where they leave off; both are of sixteenth-century origin.

A pleasant by-road leads alongside the river Boyle from the Abbey to Lough Key. Lough Key Forest Park contains the site of Rockingham, designed by John Nash for the King family as the most stately of stately homes. It was accidentally burned down in 1957, but the breathtaking view from its terrace over the island-crowded lake has not altered – rather, it has been enhanced by

continuous planting. The Kings, or Stafford-King-Harmans as they were to become, vacated their house in the centre of Boyle for this secluded spot in 1788, leaving the original King House to the Connaught Rangers as a barracks. It was temporarily used by the Irish Army, and later fell into decay. In 1989 Roscommon County Council took the imaginative step of rehabilitating it completely, employing local craftsmen using traditional techniques. Now there are three storeys of exhibitions and displays covering the history of the province, the story of the King family, the military connections of Boyle, and a special section in which the process of restoration is graphically explained. The Roscommon County Library occupies the vaulted ground-floor rooms.

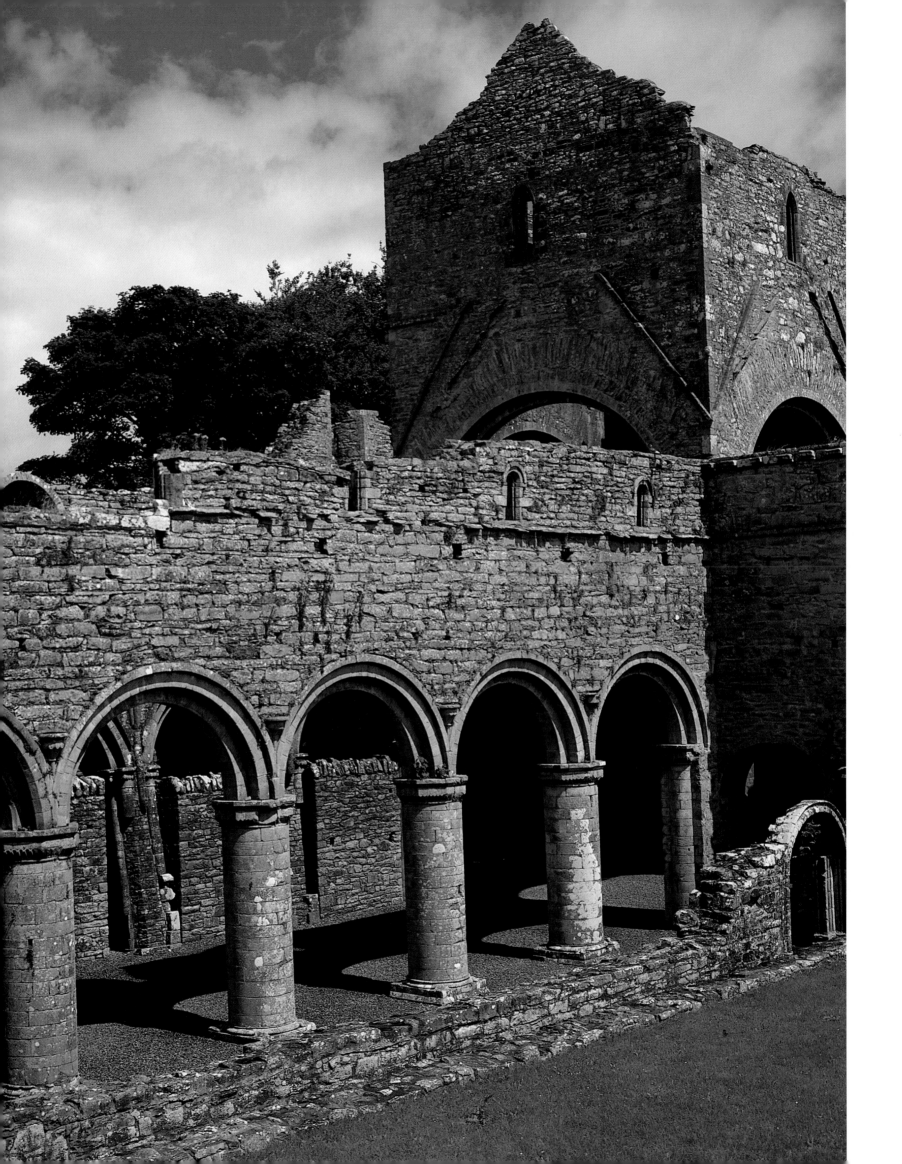

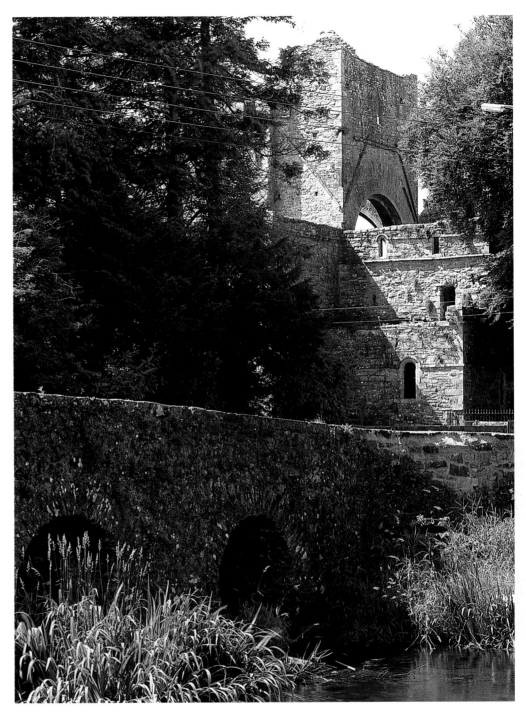

*B*oyle Abbey was founded by the Cistercian order in *1161. The abbey church, of which much of the tower survives, was consecrated sixty years later; the whole complex exemplifies the transition from Romanesque to Gothic. The Romanesque arches (opposite) are especially spectacular, while the play of sunlight and shadow (left and above) seems to bring out the best in this attractive spot. The carving of the disembodied hand holding the crozier (above left) appears on what is believed to be the grave slab of one of Boyle's early Cistercian abbots.*

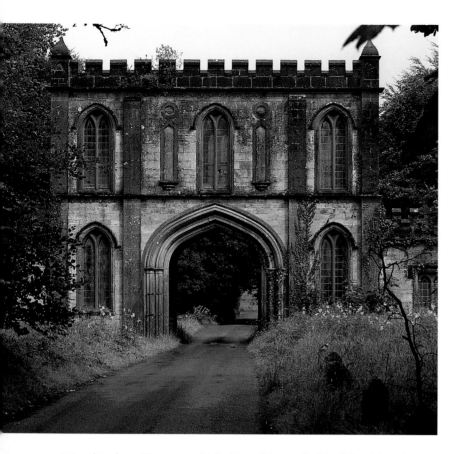

*R*ockingham House, to which this striking arched building (above) *acted as a gate lodge, has now vanished. The former Rockingham estate encompasses Castle Island in Lough Key* (right) *and is now a superbly maintained Forest Park. The island was originally fortified by the McDermotts.*

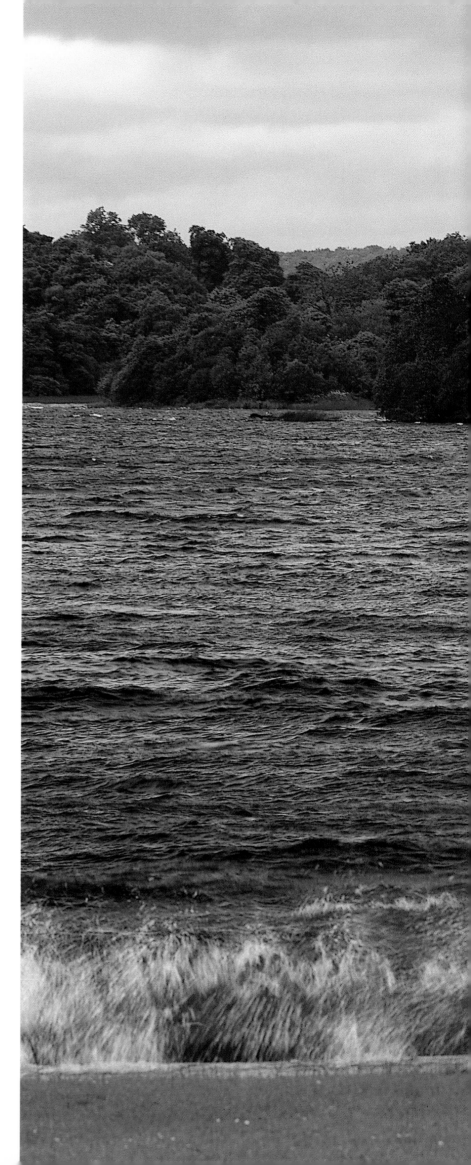

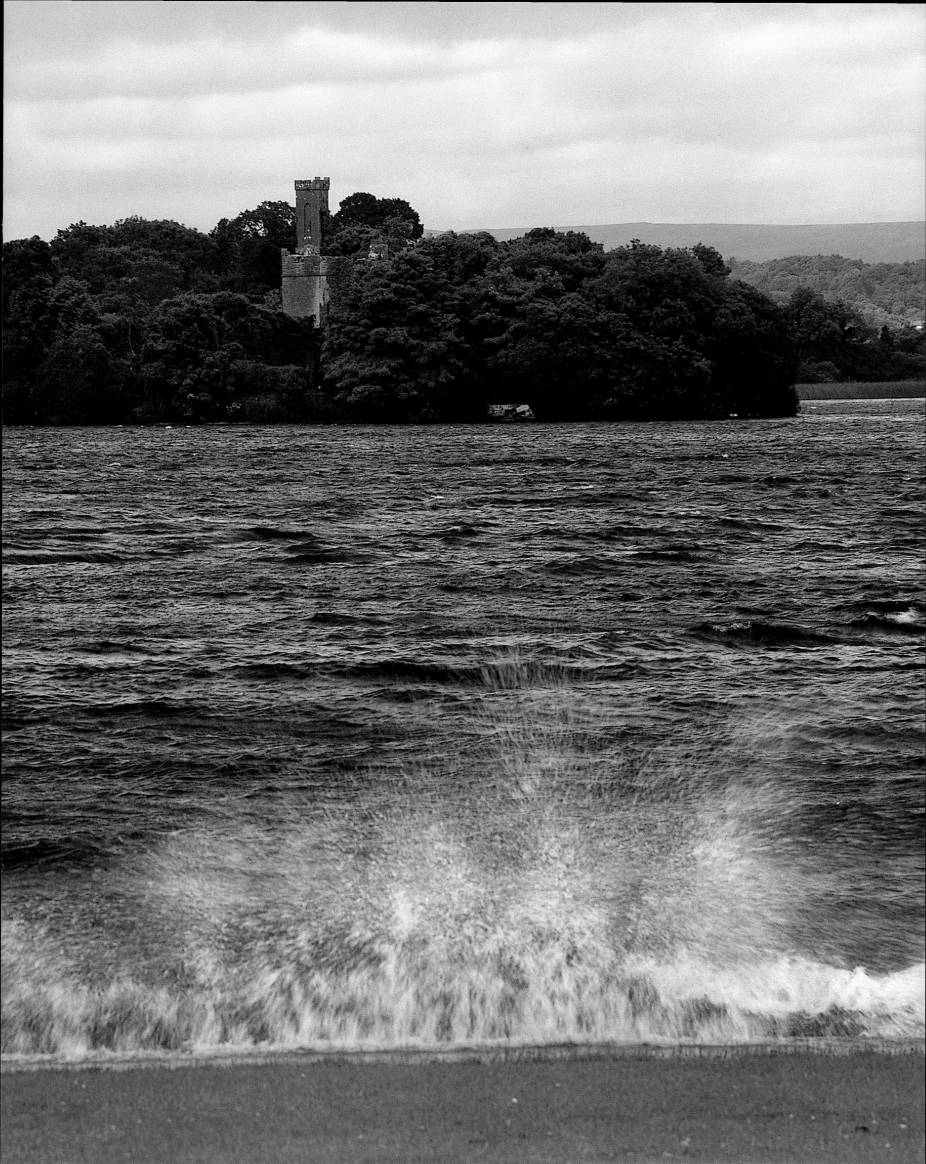

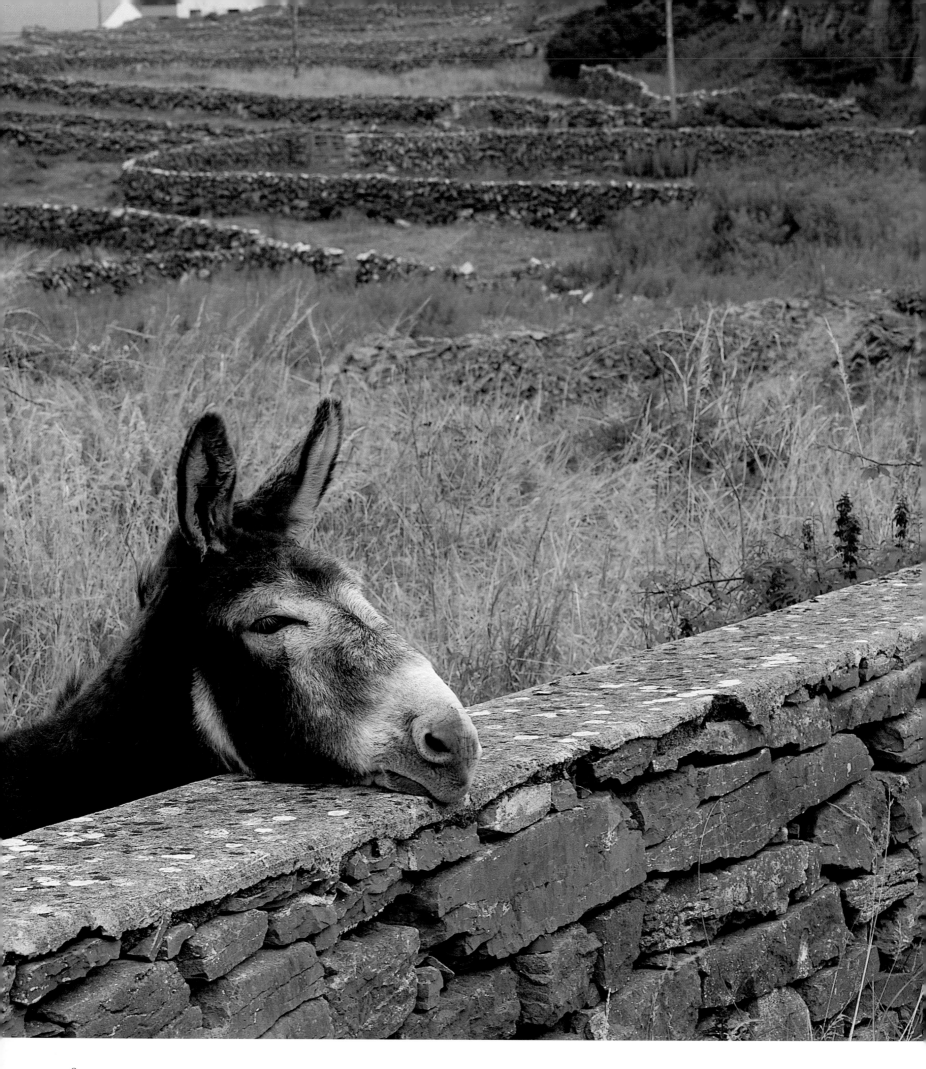

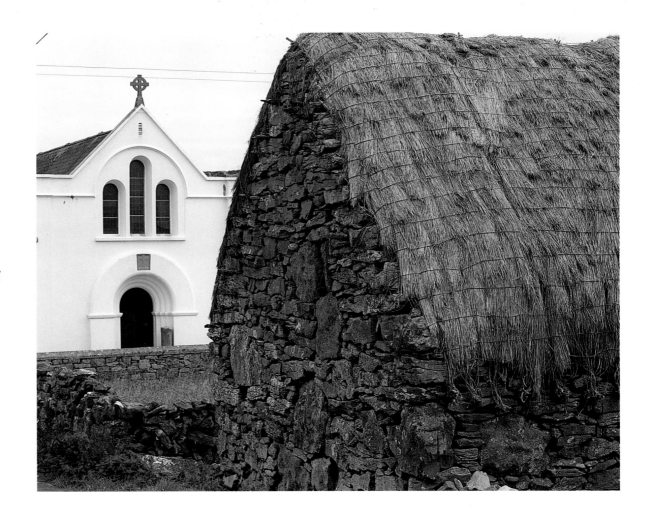

Childhood memories of the Aran Islands are sustained by scenes where each tiny enclosure is inhabited by a domestic animal (opposite). The church on Inishmaan was built in the early years of the 20th century in a plain Hiberno-Romanesque style (right). Ancient stone is everywhere as a building material – in drystone walls and the ruggedly textured structures of simple barns.

Inishmaan

(*Inis Meáin* = Middle Island)
GALWAY

THE THREE ARAN ISLANDS slant across Galway Bay as if hunching their shoulders against the wind and spray. Yet at other times, when the weather suddenly turns Mediterranean, they look as if they are floating on turquoise glass.

About three hundred people live on Inishmaan, which is three miles long and two across. Many outsiders have sought the consolation of the Irish language and an older way of life on Inishmaan. Douglas Hyde, author of *Love Songs of Connacht,* the most influential translation from the vernacular of the Literary Revival, came here many times; later, he became the first President of Ireland. William Wilde, Oscar Wilde's father, guided an expedition from the British Association, in the year before he published his astonishing three-volume *Catalogue of the Contents of the Museum of the Royal Irish Academy.* The islanders were, and are, used to the studious and paternalistic observations of foreigners. The received view of the Aran Islands as repositories of charmingly primitive customs and quaint speech was successfully ridiculed by Martin McDonagh in his iconoclastic comedy of 1996, *The Cripple of Inishmaan.*

The playwright John Millington Synge, author of *The Playboy of the Western World,* has left the most sensitive and complete picture of life on, and inspired by, Inishmaan. Of the house where he habitually lodged he wrote in his journals, 'The kitchen where I shall spend most of my time is full of beauty and distinction. The red dresses of the women, who cluster round the fire on their stools give a glow of almost Eastern richness, and the walls have been toned by the turf smoke to a soft brown that blends with the grey earth-colour of the floor'.

The Aran Islands are geologically a part of Clare, sharing with that county the limestone karst formation which gives both their distinctively precipitous grey hills, the absence of all but those trees which can find shelter on rocky declivities, and an abundance of wild flowers. There is limestone everywhere, and it is the natural building material, giving an unyielding solidity to the houses. The six villages on Inishmaan are really one long village, with different names that are spoken as you walk along the road that joins them together like stones on a string: *Baile an Mhothair,* 'the thicket townland', *Móinín na Rúaige,* 'little bog of the rout', *Baile an Lisín,* 'townland of the garth', *Baile an Dúna,* 'townland of the fort', *Baile na Seoigeach,* 'Joyce's townland', and finally *Cinn an Baile,* the 'head of the townland'.

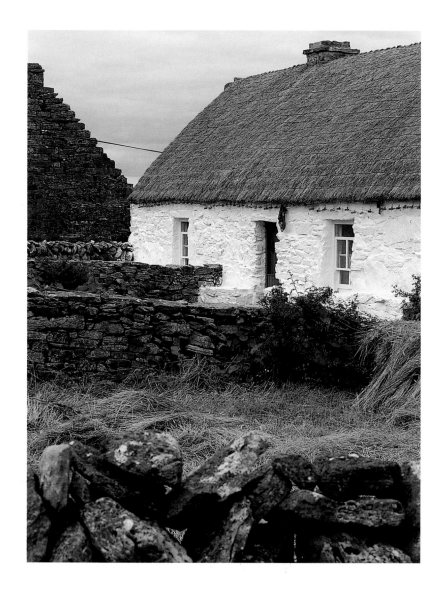

*I*n this cottage on Inishmaan (above) *the playwright J.M. Synge used to stay during successive summers at the turn of the 20th century. The island's church contains this fine stained-glass* (above right) *dedicated to Máire Maigdilin (Mary Magdalene). Happily, the bicycle* (right) *remains the most effective form of transport in this place of maritime tranquillity, still criss-crossed by simple drystone walls* (opposite).

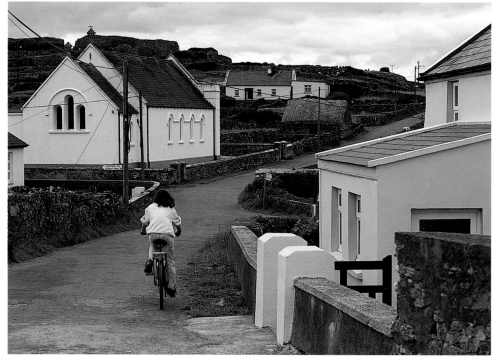

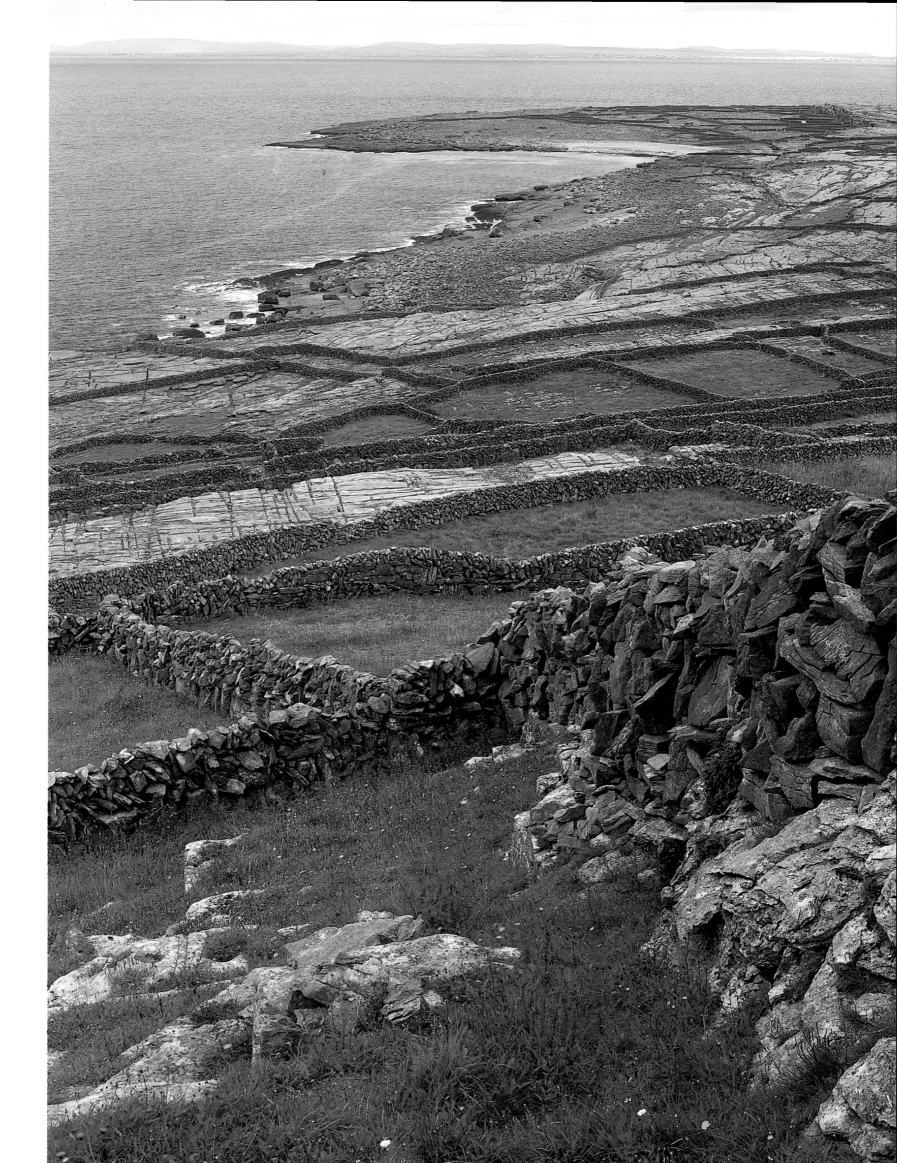

Newport

(*Baile an bhFhiacháin* = Town of the Ravens)

MAYO

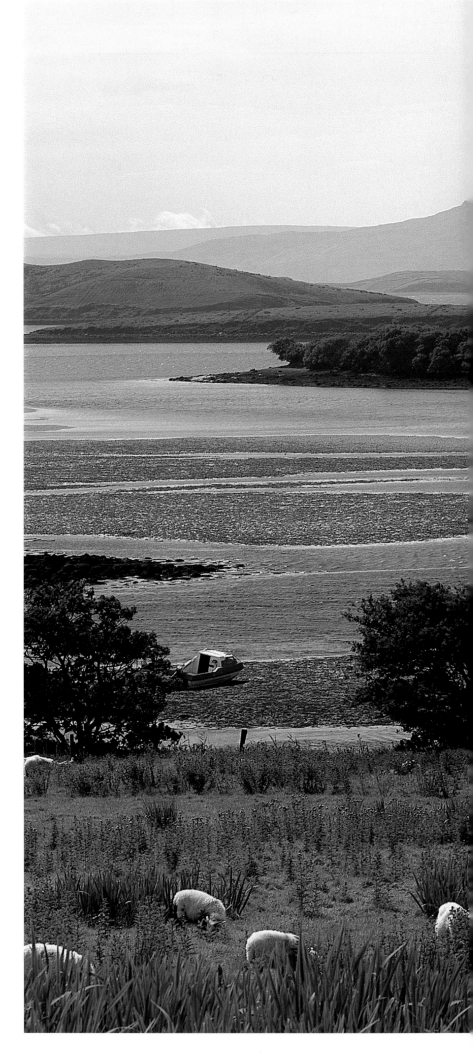

A village on the waters: Newport Bay (right) is an inlet of Clew Bay; the inspiring remains of Burrishoole Abbey (above), founded by the Dominican order in 1486, look on to the Burrishoole Channel.

THE ESTUARY of the Oak river, which drains Beltra Lough and therefore much of central Mayo, provided the principal port for the county until overtaken by Westport in the 19th century. In earlier times there was a settlement around the Dominican Abbey of Burrishoole, now a melancholy foreshore ruin haunted by the ghosts of those inmates who were murdered by Cromwellian troops in 1653. In the rather more enlightened 18th century the 'new port' was created about two miles away by a certain Captain Pratt. He introduced a linen manufactory under the management of

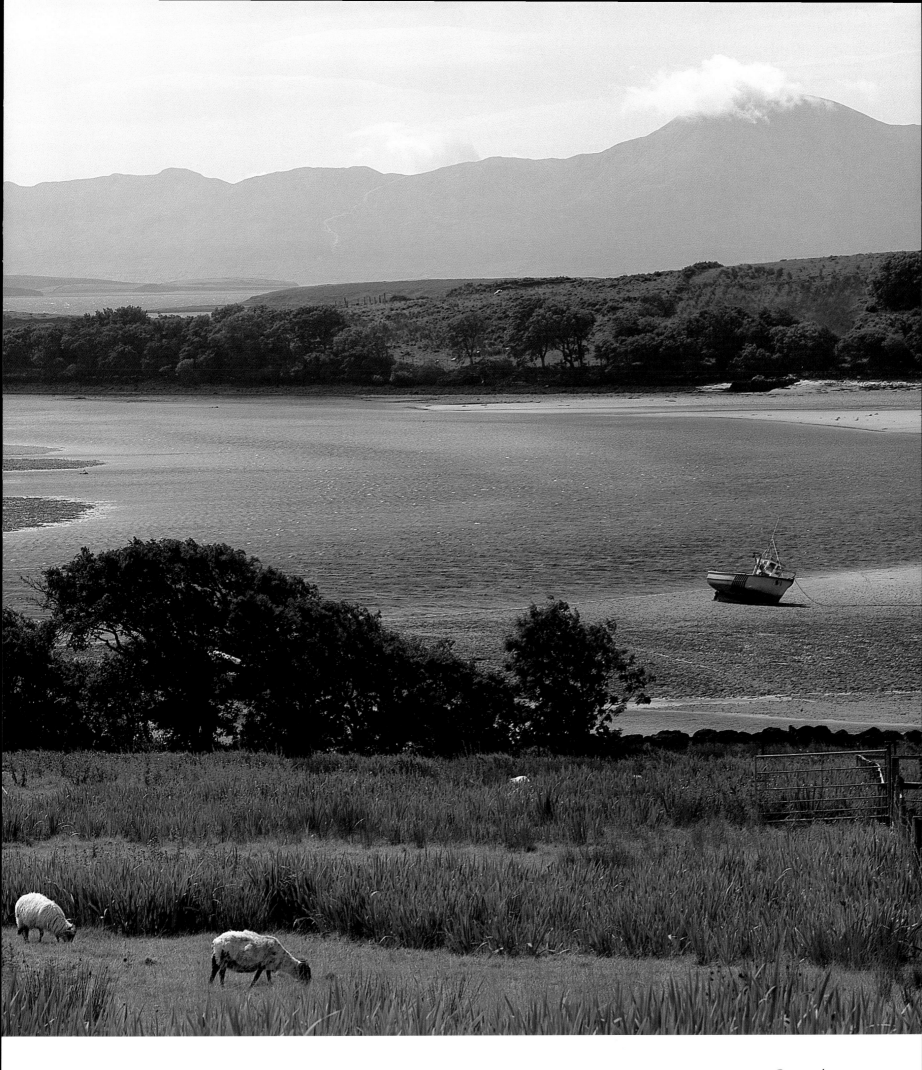

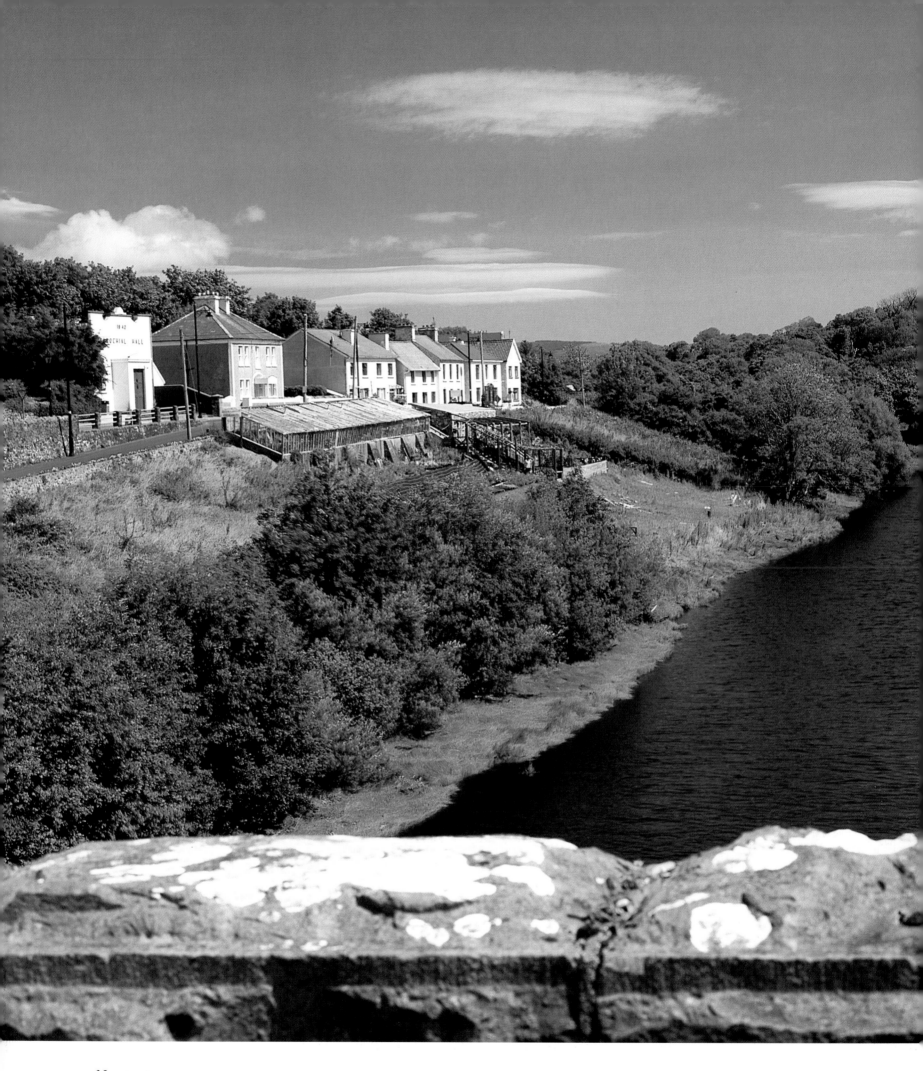

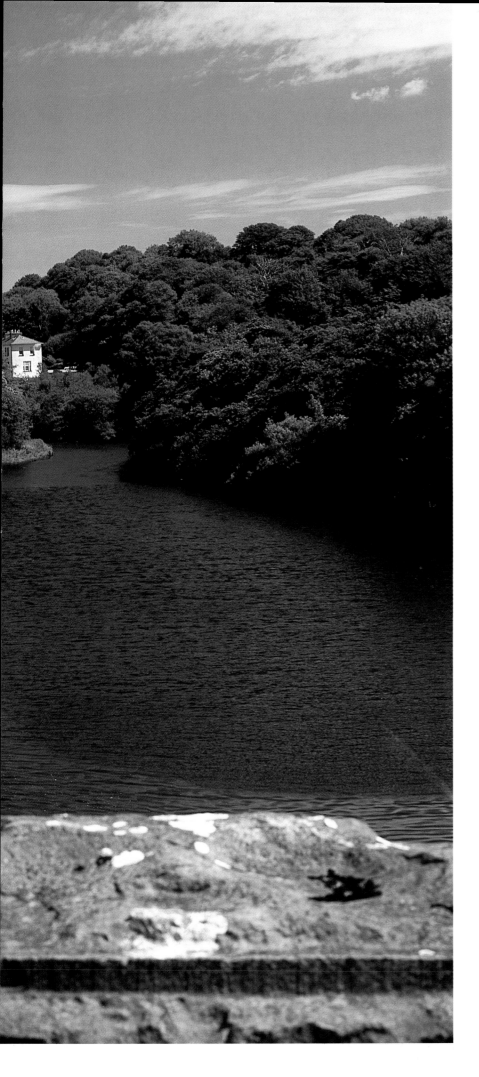

immigrant Quakers, but it only succeeded for a few years. However, his wharf and its sustaining village took root on the convenient and pretty site where ravens were wont to nest, giving their Irish name to the spot. This traditional name was disregarded, but fortunately the name which the Captain preferred soon fell into disuse: New Port Pratt.

The quays were formally laid out towards the end of the same century by James Moore, agent for the landowning Medlicott family. After Moore's death the Medlicotts sold their estate to the O'Donnells, one of the old Irish families which had turned Protestant. Newport reached its peak of mercantile prosperity under these O'Donnells, but it was during this period that the village saw one of its blackest days, when on 9 June 1799 Father Manus Sweeney was hanged from the market crane in front of the fair-day crowd, having been charged with assisting the French in the insurrection of the previous year. Sir Neil O'Donnell gave testimony aganst him, branding himself for all time as one of the chief villains in the multitude of stories which have grown up in the folklore surrounding the incident.

Newport's greatest benefactors in the early 20th century were Martin Carey, a local merchant, and the parish priest of the time, Canon Michael McDonald. Mr Carey's lasting memorial is St. Patrick's Church of 1912, designed by R.M.Butler in the Celtic Revival style, which derives from thirteenth-century Hiberno-Romanesque tempered by the simplifications of the Modern Movement. The frontispiece is inspired by the doorway of Clonfert Cathedral. Father McDonald gave his life-insurance gratuity towards the commissioning of the three-light east window, now regarded as the final masterwork of the Irish stained-glass artist Harry Clarke.

*O*ne of the finest views of the river at Newport is from its viaduct; there is continuous local debate about the name of the river – historians, maps, guidebooks and residents differ as to whether it should be the Brown Oak, the Black Oak, or simply the Newport!

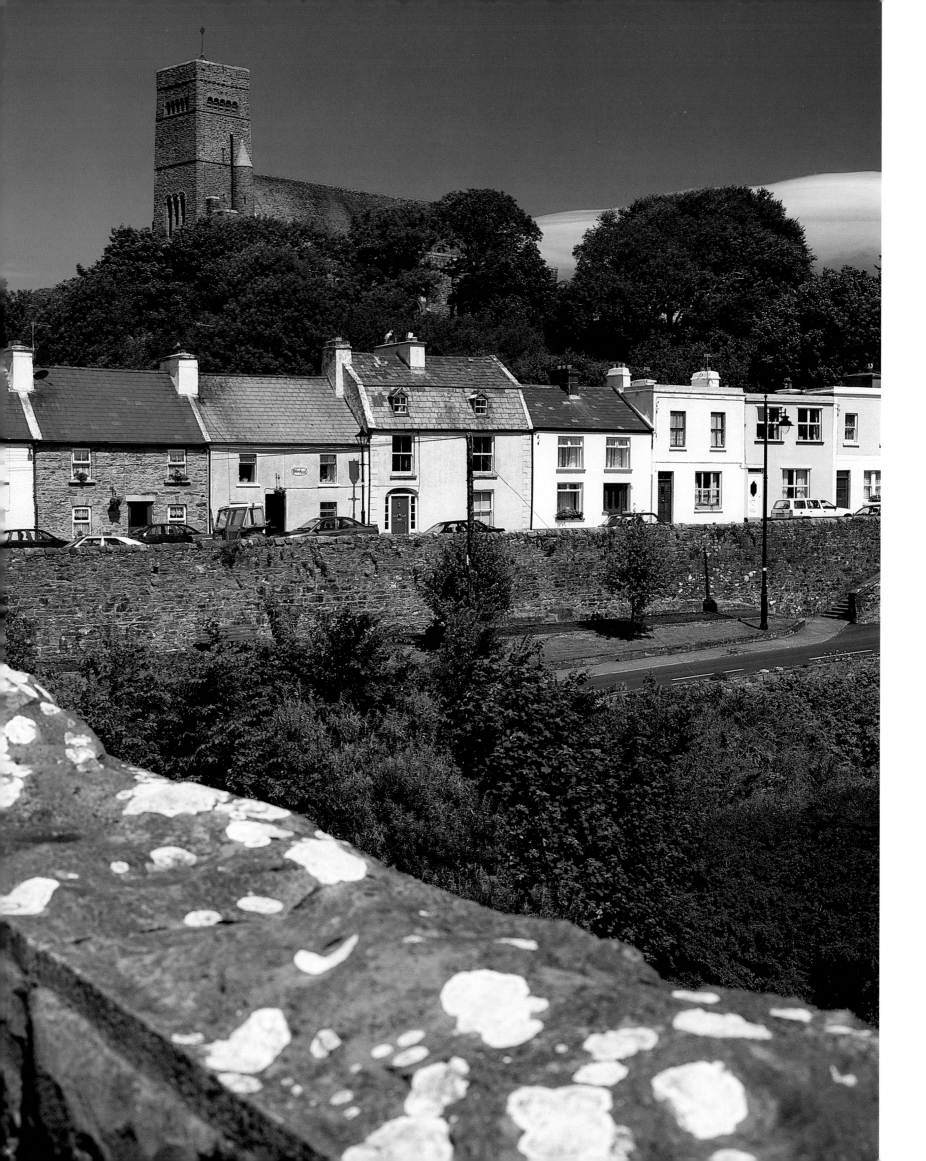

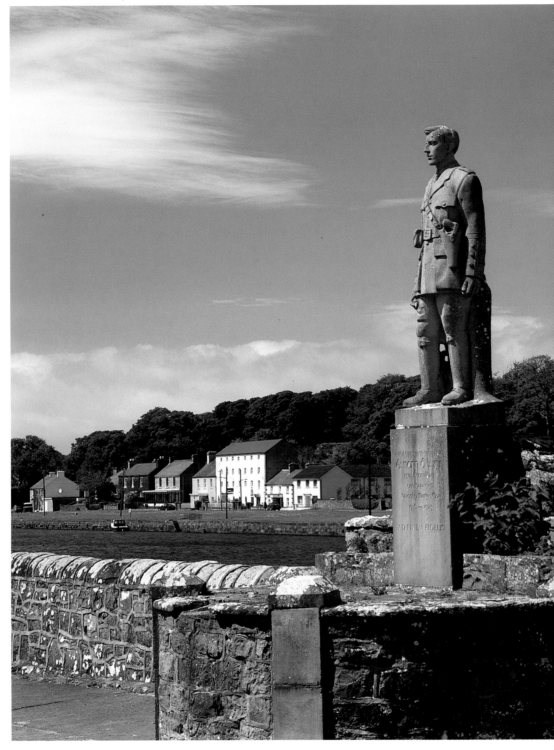

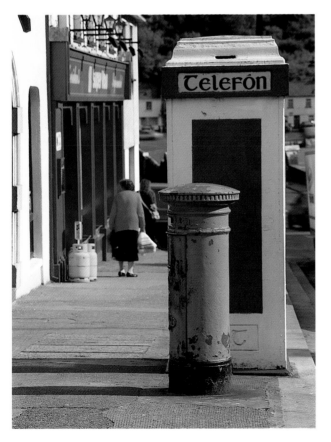

A fine day in Newport makes the attractive details of the village doubly beguiling. The statue (above) commemorates Commandant Ned Lyons, hero of the War of Independence.

An ancient anchor (above) recalls Newport's former maritime prominence. The disused railway viaduct (right), parallel to the road bridge, gives walkers their best introduction to Newport, dominated by St. Patrick's Church (above right). The three-light Last Judgement window by Harry Clarke (opposite) was commissioned in 1927; the intricacy of its composition and the glory of its colours are best appreciated in the morning when the sun is in the east.

Rosses Point

(*Ros Ceite* = Level Promontory)

SLIGO

ROSSES POINT is a household name throughout Ireland, and indeed much further afield. Those arriving for the first time are invariably surprised by the smallness of the village, for the population is under one thousand: how can its fame have travelled so far? The reasons are many, and quite diverse. The Sligo Yacht Club has been holding regattas since 1822, on Sligo Bay during the summer and on Lough Gill in autumn and spring. The County Sligo Golf Club has been attracting players from all over the world to its spectacularly situated course between strand and mountain since 1894.

Long before such pastimes had become fashionable, Sligo Bay was known to the captains of trading vessels who took pilots on board off Rosses Point in order to negotiate the perilous channel between Coney Island and Deadman's Point, and thence into the Garvogue river and up to Sligo Quay. A local historian has shown that at the close of the last century an average of five hundred ships a year plied between Sligo, North America, the Mediterranean and the Black Sea ports. This traffic has been greatly reduced, but the Rosses Point pilots continue their time-honoured tradition when need be.

Among the great shipowners of Sligo was William Pollexfen, grandfather of the poet William Butler Yeats and the painter Jack Yeats. The Yeats children spent many holidays with their grandparents, Jack staying for much longer periods. The boys also visited their Middleton kinsfolk, who were millers and landowners and lived successively at Elsinore and Bawnmore Lodge in Rosses Point. Uncle George Pollexfen lived at Moyle Lodge, and William Pollexfen took Elsinore for a time. Great aunt Mary Yeats lived at Seaview.

Rosses Point figures in dozens of Jack Yeats' drawings of the life of quaysides and jetties, and its spirit is evoked in several superb paintings, among them the mesmeric *Memory Harbour*. Allusions to Rosses Point, Cumeen Strand, Lisadell and Drumcliffe abound in W.B. Yeats' poems, along with the names of his two magic mountains, Knocknarea and Ben Bulben. With the libraries and art galleries of the world holding such a multitude of literary and visual references, it is no wonder that the fame of Rosses Point extends well beyond its sandy shore.

*F*rom Strandhill to Rosses Point stretch the waters of Sligo Bay, looking
 towards the distinctive form of 'bare Ben Bulben's head', the
mountain under which W.B. Yeats is buried.

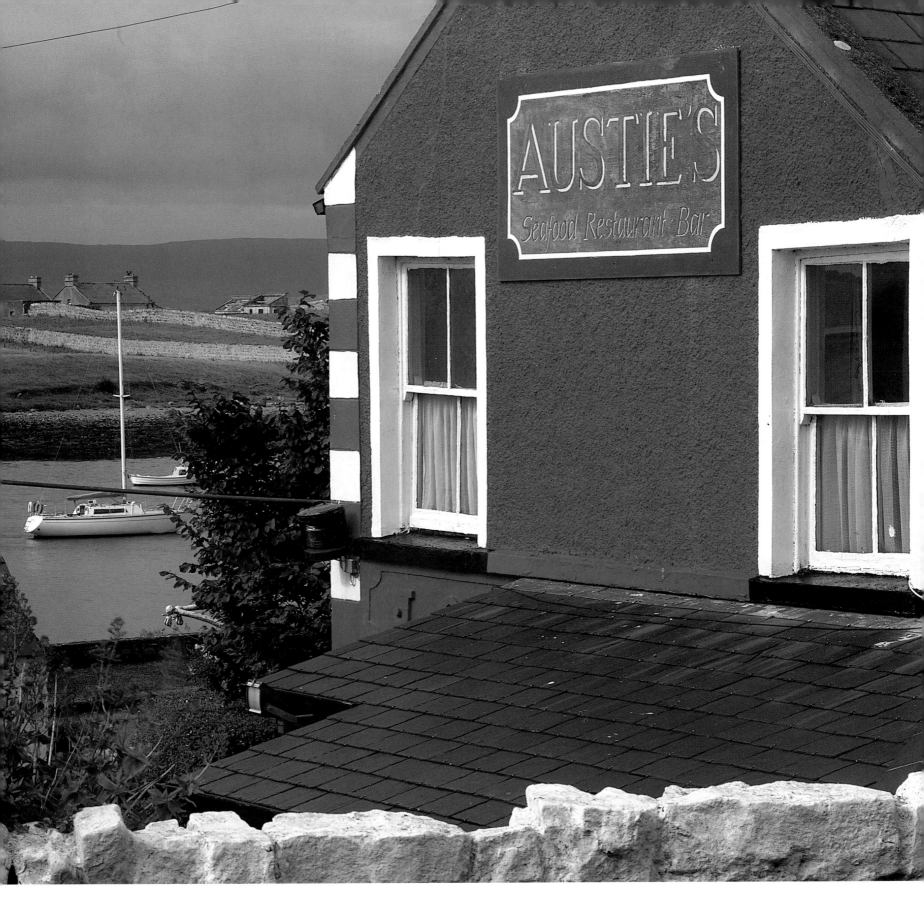

A morning's stroll through the streets and lanes of Rosses Point will reveal many fascinating nooks and crannies.

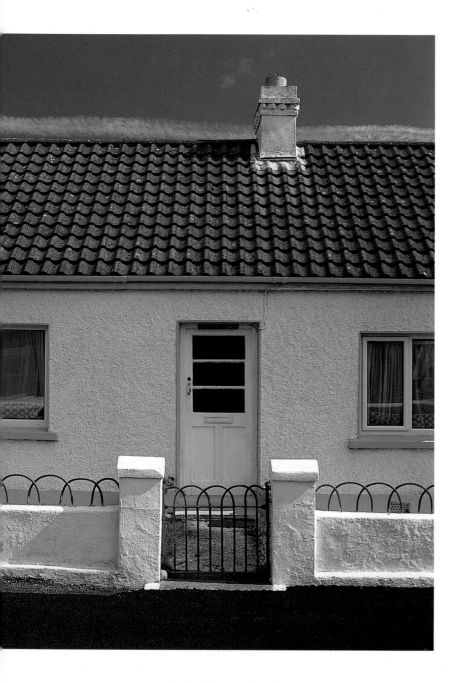

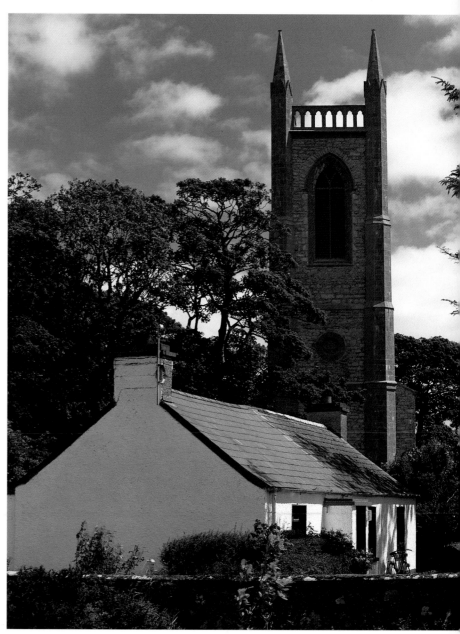

Traditional family holidays are apparently even more popular in Rosses Point than they were before the days of mass tourism (these pages). This may be due in part to the number of attractive cottages on offer, to the presence of historic sites such as Drumcliffe Church, and to the wide and windy spaces like Deadman's Point with its view of Sligo Bay and Lissadell Strand. Lissadell House (overleaf) is a special attraction, with artefacts and emblems relating to the lives and times of the courageous and talented Gore-Booth family – colonial administrators, explorers, and, in later times, Constance (1868-1927), painter and revolutionary leader, and Eva (1870-1926), poet and social reformer.

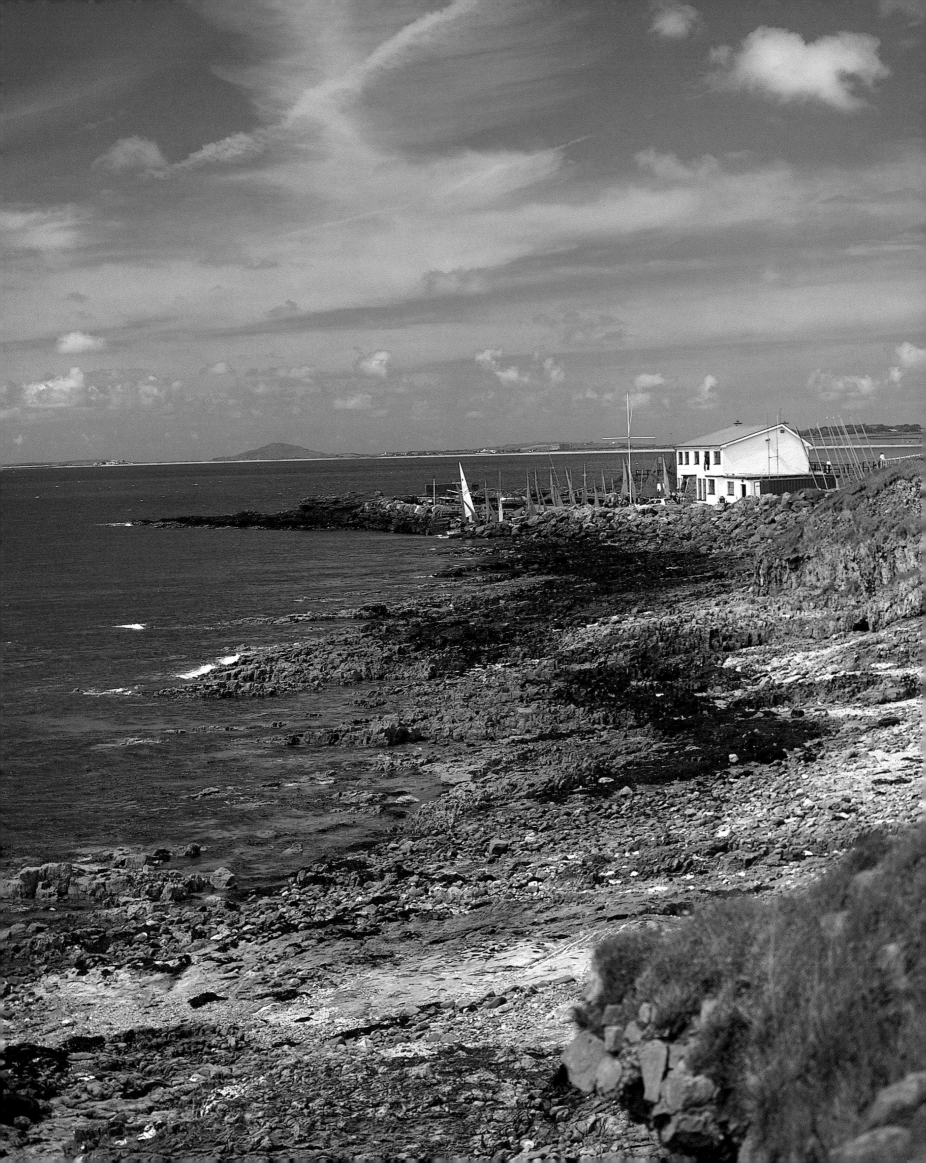

Galway hookers (left), *the traditional craft of the Connemara seas, were rapidly disappearing until a campaign begun by the poet Richard Murphy resulted in the conservation of several old vessels. Now there is an annual regatta at Roundstone. Around the harbour* (opposite) *some of the older village houses have given way to a 1990s residential development.*

Roundstone

(*Cloch na Rón* = Seals' Stone)

GALWAY

ROUNDSTONE, described in tourist brochures as the prime example of the traditional Irish maritime village, was in fact built by a Scots engineer in response to a government scheme to improve communications and relieve poverty in an area where no town or village had previously existed. The name Roundstone should give away the fact that the village is not indigenous, for although Alexander Nimmo and his helpers managed to translate *cloch* correctly as 'stone', their linguistic powers then failed, and they ascribed 'round' euphoniously to *rón*, which actually means 'seal', of which there are usually a number to be seen sliding in and out of the sea.

Nimmo came to Ireland from Perthshire in 1822 as Surveyor and Engineer of Western Districts. He was responsible for laying most of what are now the main roads of Connemara, and he also built almost all the piers and causeways. There had been a quay on the northern side of Betraghboy Bay, where the people from the small islands came ashore in currachs. Nimmo designed the fine harbour on this site, which now appears in so many postcard views. He bought small plots of land, and encouraged Scots fishermen to settle, build houses, and create a fishing industry. These people were lowlanders, speaking English. When the Irish government established its policy of providing preferential social schemes to *Gaeltachtaí* or Irish-speaking districts a hundred years later, Roundstone was not included.

A Roman Catholic church was built in 1832. The Franciscan order established a national school. Ten years later a Protestant church was erected on the edge of the village. Yet Roundstone can not really be said to have thrived until the mid 20th century when guest-houses grew into hotels and summer visitors, seeking glorious scenery, white beaches for bathing, mountain walks and interesting flora and fauna, started arriving in greater numbers.

William McCalla, the son of a Scots settler who became Roundstone's earliest innkeeper, interested himself in the plant life of the neighbourhood and took pleasure in conducting visiting botanists on walks to observe the rich variety of species. He died in one of the cholera epidemics which followed the famine, but not before he had identified the rare heather *Erica mackaiana*: this is his true monument, though botanists from all over the world also visit his tomb.

The novelist Kate O'Brien (1897–1974) lived for a time in the old house which she called 'The Fort' – in fact it was an auxiliary workhouse. *Without My Cloak, The Land of Spices, The Last of Summer* and *The Flower of May* are her best-known works. Along with most of the serious authors of prose fiction of her generation, she had the bitter experience of seeing her books banned in the nineteen-thirties and forties by the Censorship Board. They are now triumphantly back on the shelves of bookshops and libraries.

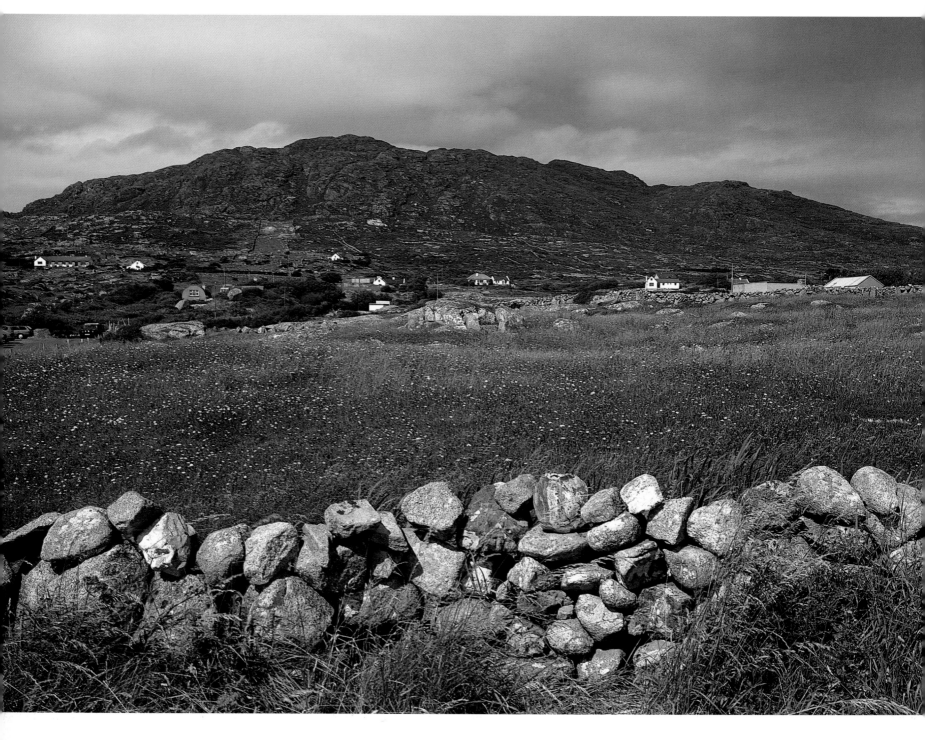

*B*eyond Roundstone rises Errisbeg Mountain (above), *and the landscape of Connemara yields yet more picturesque combinations of lake and mountain between Roundstone and Ballinahinch.*

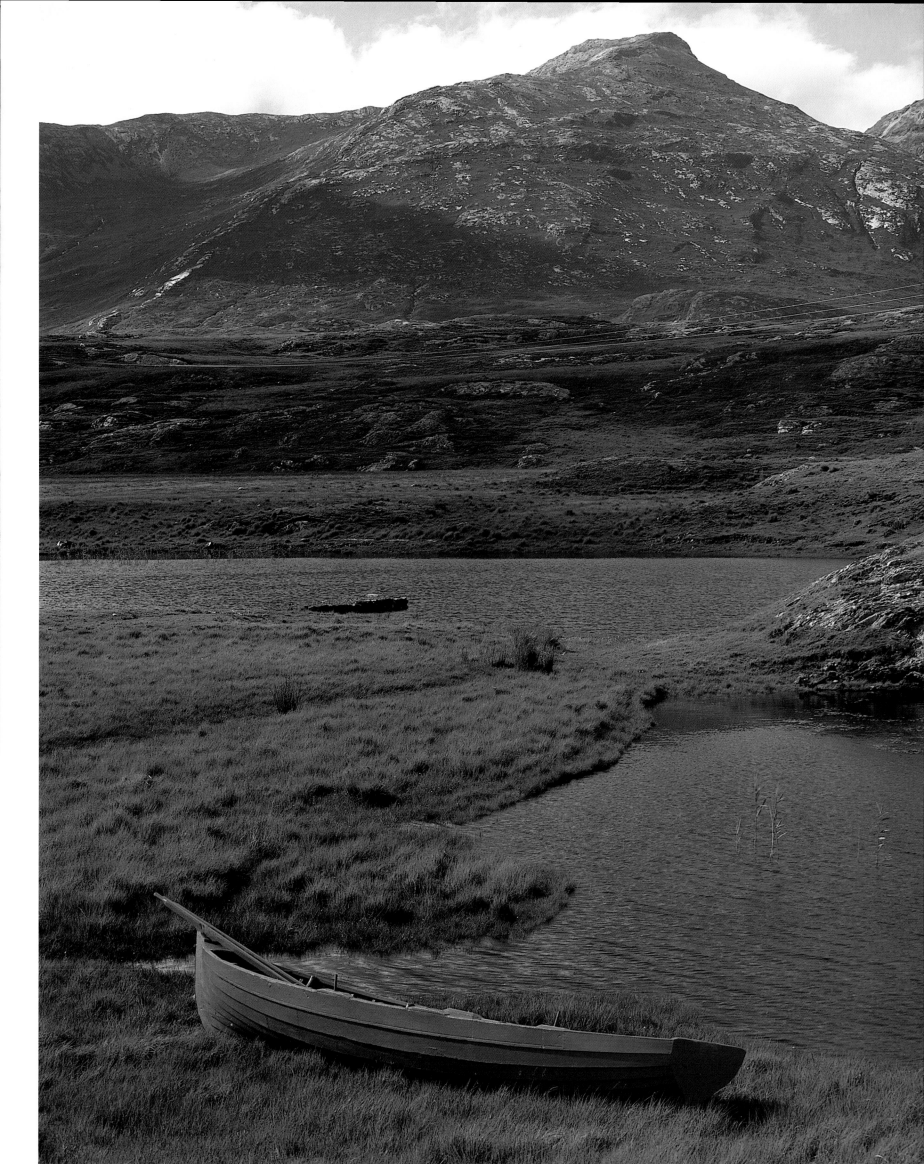

The Painted Villages

The use of bright colours on stucco façades and gables in the second half of the 20th century has been attributed to a variety of causes – reaction to the drabness of the post World War II years, to Tidy Towns Committees, and especially to the improvement in the national economy and therefore of the family budget. Colour was always used, of course - from the ochres and beiges of seaside terraces in Ulster to the faint tinge of blue taken from the potato-spraying mixture and added to the whitewash of western farmhouses. Exotically coloured buildings are now seen everywhere, but most especially in the south-west, where the fashion for one household to outdo its neighbour has led to the use of the generic term 'painted villages'. And places such as Castletownbere (*above* and *opposite*) now glow as never before.

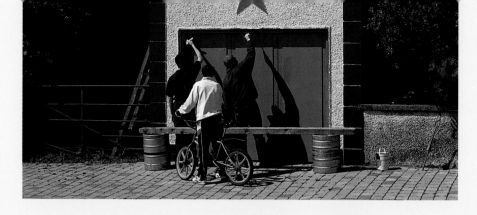

repainting of frontages has to do with local pride, the creation of a favourable impression for the visitor, and, ultimately, giving personal satisfaction, whether in *Rosses Point* (right), *Rosscarbery* (below right), *or Castletownbere* (below) – *where artistry extends to the pictorial representation of a nearby landmark. Bantry* (opposite), *on the other hand, seems to have a taste for the blues.*

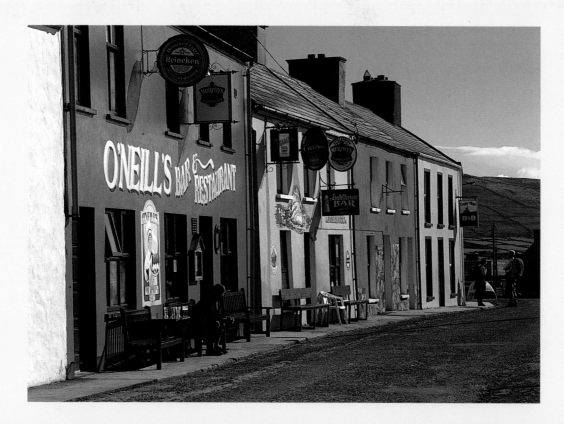

*A*llihies (left) *and Eyeries*
(below), *both in West Cork;
in some villages unoccupied or
abandoned houses are brightly
painted by the Tidy Towns
Committee in order to remove any
sense of dereliction. Buildings in
Eyeries, County Cork (opposite
above and* below left) *were
repainted in sombre tones in 1997
for the production of Deirdre
Purcell's film* Falling for a Dancer, *which is set in the 1930s. Following
shooting, the late twentieth-
century palette – as here – was
restored. But brightness never left
Bantry (opposite below right).*

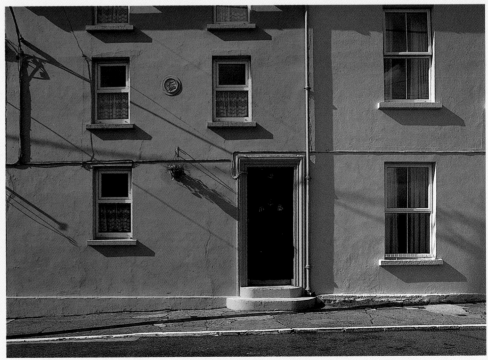

Munster

CLARE, Cork, Kerry, Limerick, Tipperary and Waterford are the six counties of Munster. The county system was introduced by the Elizabethans, founded on the concept of the English shires. Upon these administrative divisions are based the modern Irish electoral constituencies; the counties also form the basic units of the Gaelic Athletic Association's remarkable organizational network for the national games, Gaelic football and hurling. Nowhere more strongly than in Munster does one find such fierce loyalty to the concept of county – the prowess of the Kerry footballers or the Tipperary hurlers is followed, argued and cheered on every parish field and before every television set in the run-up to the County Finals. (These lead to the Provincial and ultimately to the All-Ireland Finals at Croke Park stadium in Dublin.) Another manifestation of the county system most apparent in the towns of Munster is the presence of the County Hospital; when the health service was taken in hand at the foundation of the State, every county was provided with a sparkling new general hospital – and here they still are, in Killarney, Ennis, Nenagh and so on – dazzling white concrete, flat-roofs and steel window-frames in the 'modern manner' of the 1920s, as conspicuously incongruous in design as one could possibly imagine. The three great cities of Munster are Cork, in its romantic setting of islands and waterways – a leisured, friendly place – Waterford, with its handsome neoclassical public buildings and celebrated glass industry, and Limerick, astride the river Shannon, where at last the decayed medieval and Georgian quarters are undergoing restoration.

A Munster landscape, following rain; needless to say, where the rainbow ends, a crock of gold awaits the person who is imaginative enough to seek a spade and dig deeply before the vision vanishes.

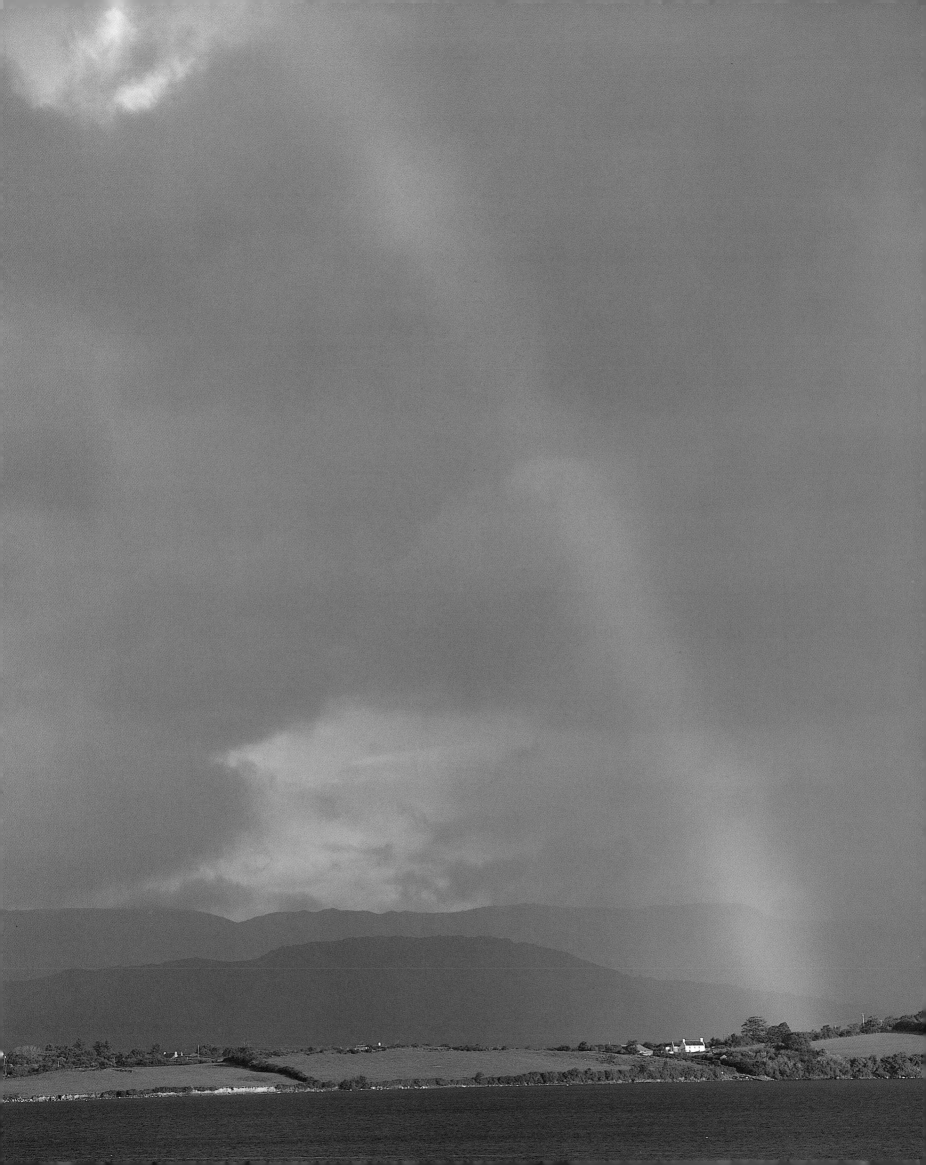

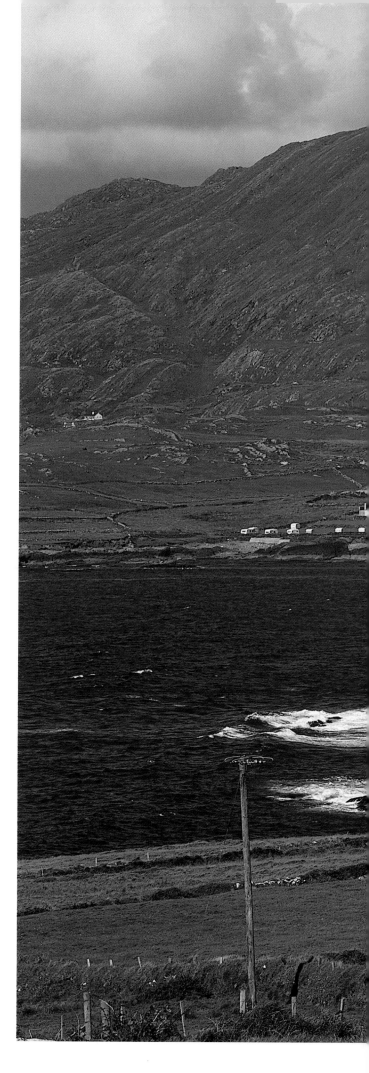

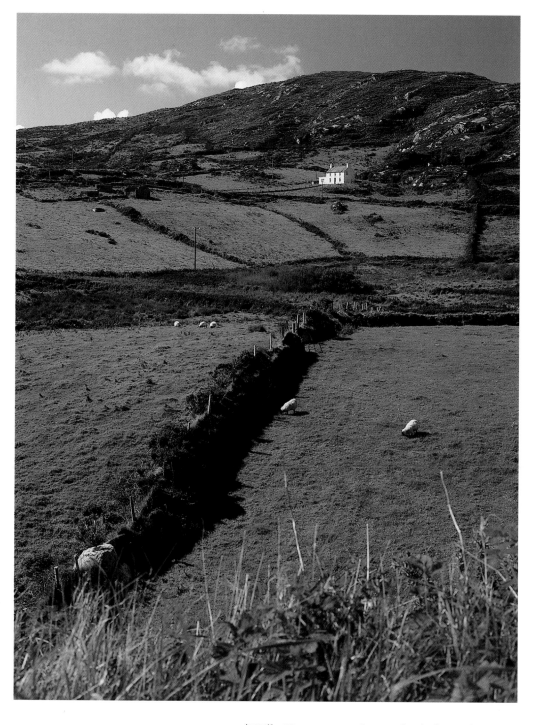

*T*he Kenmare river lies in a land of rugged
 beauty: the Beara Peninsula, County Cork,
west Munster.

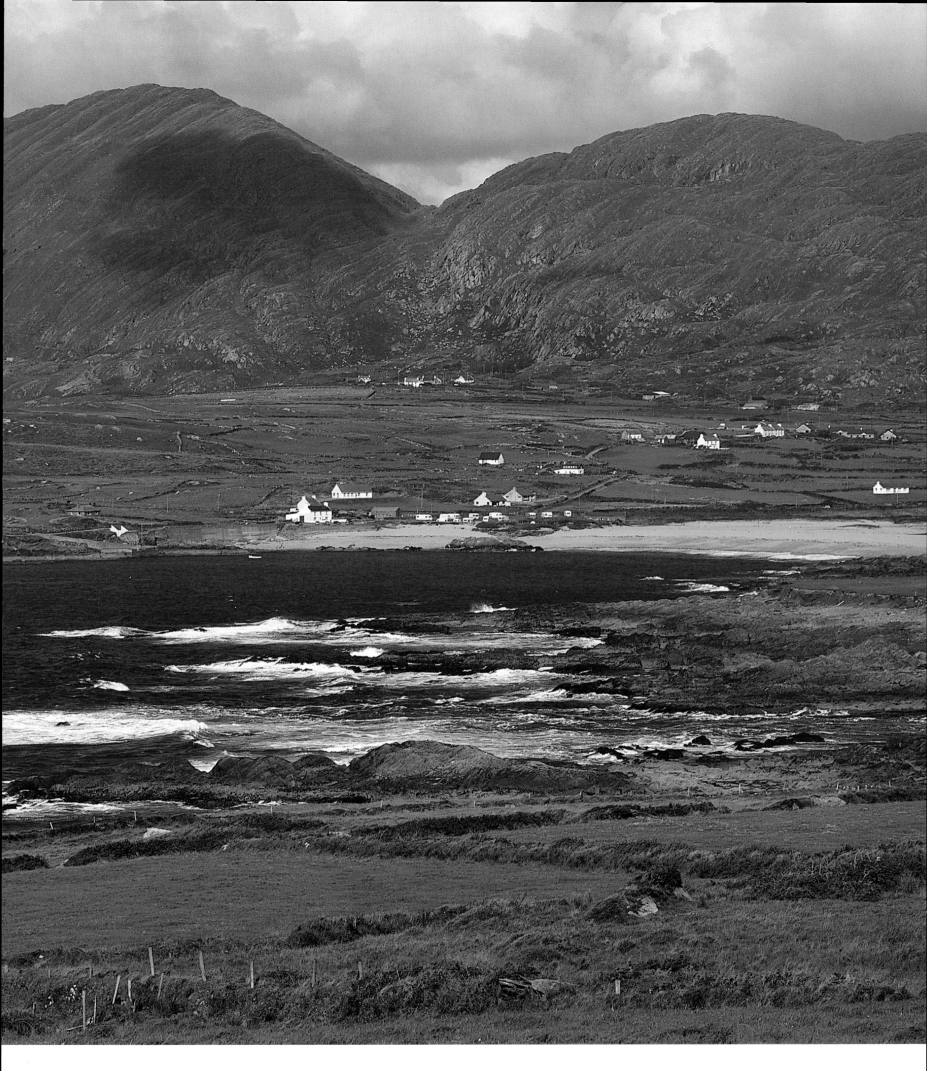

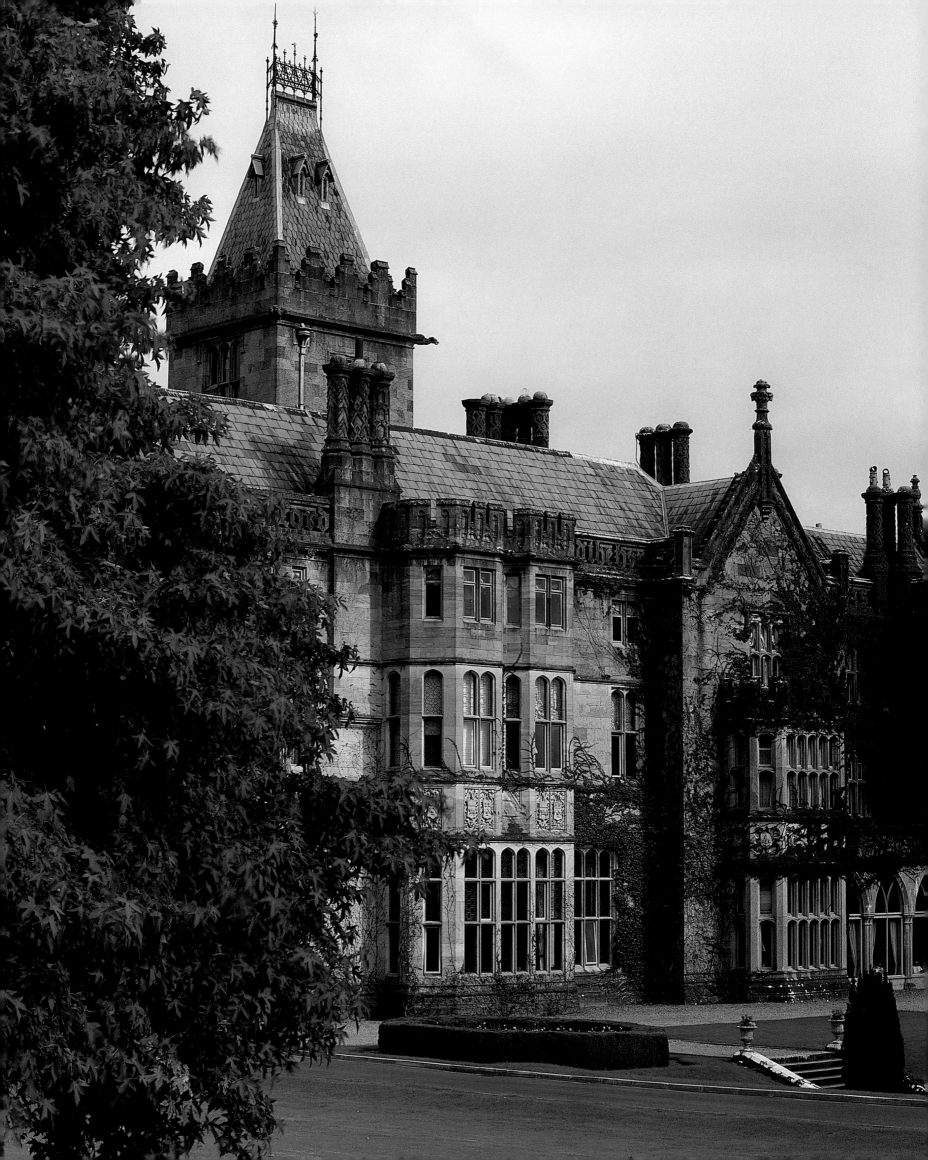

Adare

(*Ath Dara* = Oak Ford)

LIMERICK

THE PASTORAL RICHNESS of the County Limerick landscape is comparable to the richness of utterance in the Irish-language poetry which was composed in the neighbourhood of Adare during the 18th century. A school of poets, known as *Filí na Máighe*, the poets of the river Maigue, flourished here, Seán 'An Ghrinn' O Tuama being the leading spirit. *Grinn* means 'sharp' – there is a tradition that the Maigue poets were the originators of the 'limerick' type of verse squib, but this is unlikely, for the metre of the limericks popularized by Edward Lear is quite different.

Adare is also rich in buildings, both refined and vernacular. The so-called Desmond Castle – which was only occupied by the Desmonds for part of the 16th century and was really the seat of the Fitzgeralds – and the Franciscan Friary are now no more than magnificent ruins rising up from the banks of the Maigue. It was the second Earl of Dunraven who not only improved the village but was responsible in 1807 for the restoration of the fourteenth-century Augustinian Priory as a place of worship for the Church of Ireland. Three years later he saw to the rebuilding of the derelict thirteenth-century Trinitarian Priory, for use as a Roman Catholic parish church; this Priory dominates the centre of the village, a superb and unexpected monument to early architectural conservation and religious tolerance.

The second Earl also laid out the two groups of thatched cottages which give Adare its distinctive appearance, and which are the principal reason for the very large tourist trade that the village enjoys. The daily influx of visitors has been discreetly catered for with car-parking concealed behind hawthorn hedges, and a convenient Visitor Centre next to the County Library. In this library may be seen a copy of the now very rare *Memorials of Adare* by Caroline, Countess of Dunraven, which embodies the enthusiasm which she and her husband shared for local history and topography.

The former seat of the Dunraven family, the Tudor Revival Adare Manor, is now a hotel. Begun in 1832, it replaces a smaller Georgian house; it was completed in 1876 by P.C.Hardwick of Limerick and A.W.Pugin of London. The Pain brothers of Cork designed the magificent Long Gallery.

A special feature of Adare is the way in which subsequent generations have respected the early nineteenth-century townscape. Even recent local-authority housing estates are in keeping with what has gone before.

*A*dare Manor (opposite) *is the former home of the Dunraven family. Although celebrated architects contributed to its completion and decoration, the grand design was that of the 2nd Earl, and the work was carried out by James Connolly, a local stonemason. Less grand but nonetheless of great charm is one of many pretty slate-roofed cottages in the centre of Adare* (right).

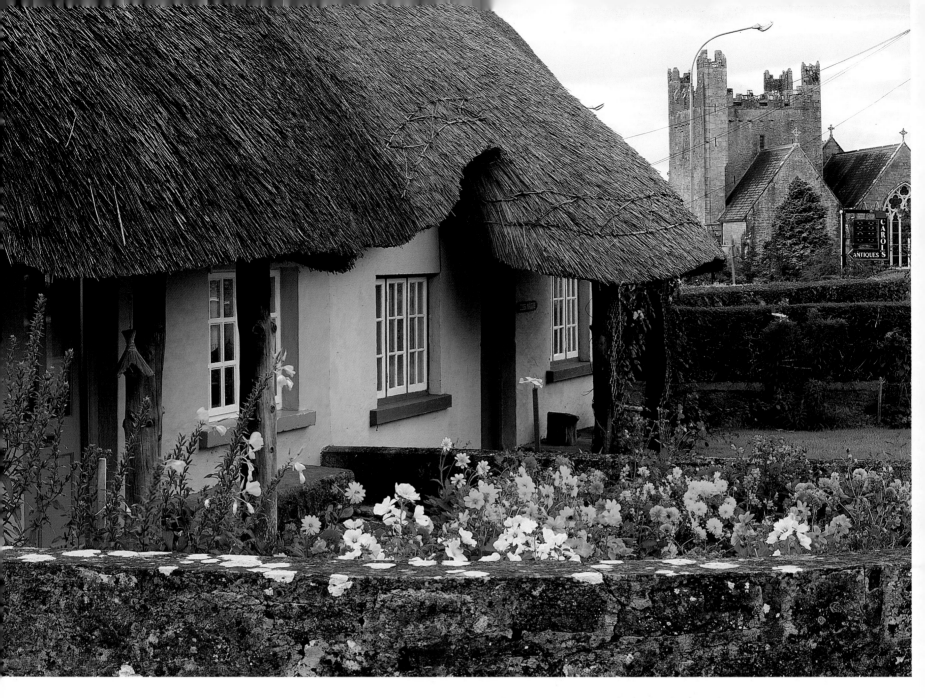

*I*t is the trim thatched cottages which give Adare its special resonance and romance. The Trinitarian Abbey (above) is now the Roman Catholic parish church. The 2nd Earl and Countess of Dunraven were responsible for improving the village, and thus the lives of their tenants, in the early 19th century. The domestic buildings which they introduced derive from a style found in the west of England.

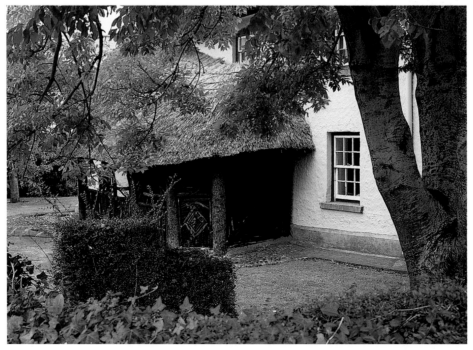

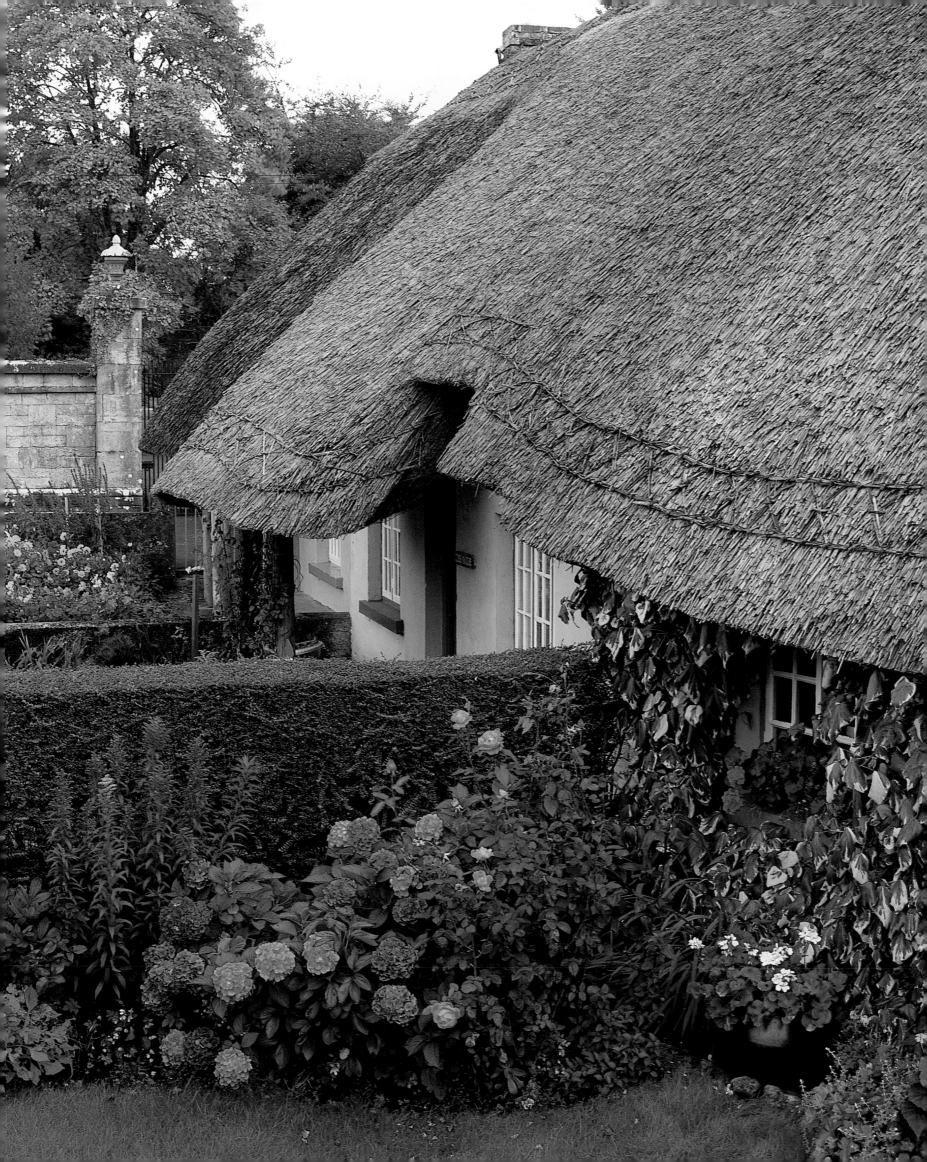

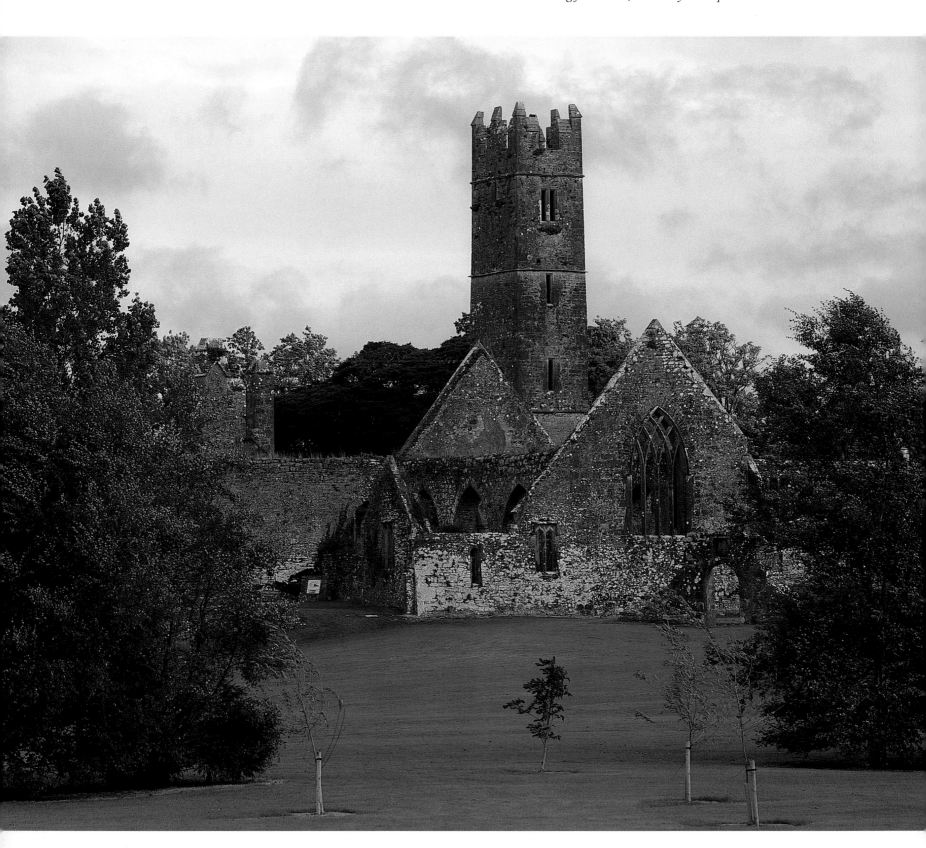

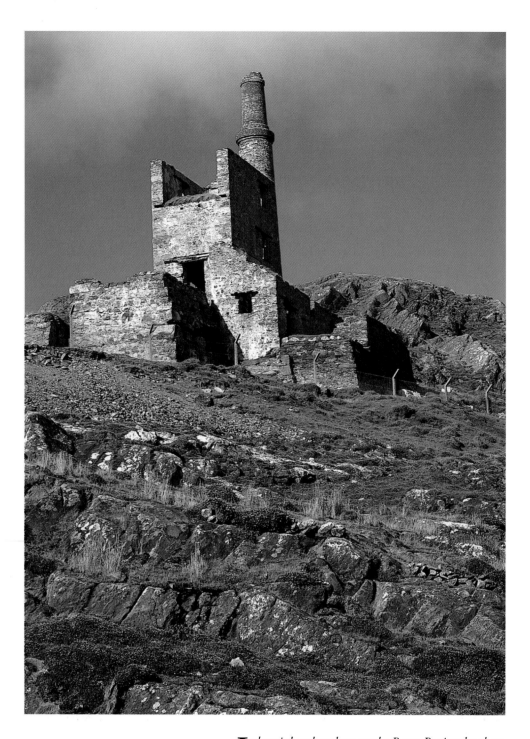

Industrial archaeology on the Beara Peninsula: these buildings (above) were part of the Allihies copper mines. The village (opposite), which now has fewer than twenty houses, once had mines sufficient to support a population of several thousand.

Allihies

(*Aillighthe* = Place of Cliffs)

CORK

COPPER was mined in the cliffs of West Cork in prehistoric times. The earliest miners are said to have lighted great fires in natural caves; water was thrown at the heated rock, causing the quartz to break away; the quartz was then pounded with sea stones and the copper grains washed clear. A Colonel Hall of Glandore found copper on his property at the turn of the 19th century, causing him to prospect for richer seams in other parts of the county. He came across traces at Allihies, but did not have the resources to proceed with his venture. However, members of the wealthy Puxley family, who lived nearby, exploited the find from 1812.

Allihies is quite unlike one's usual perception of an industrial village. For a start, the panorama of mountain, cliff and beach suggests something much less satanic. The physical evidence of toil and hardship has vanished, for economic workings petered out in this century, and what is left has been consigned to the polite category of industrial archaeology. The mines were the most extensive and productive in Ireland in the mid 19th century, when over a thousand people were employed and over 5,000 tons of ore were produced annually.

Miners from Cornwall were settled at an early stage, in order to train the local people. The remains of the 'Cornish village' can still be seen on the mountainside, along with the Protestant church which they built for their own worship. Labour unrest, famine and cholera led to a diminution of output, and the discovery of copper in Montana in the 1880s resulted in mass emigration. Many of the wealthiest families in Butte, Montana, are the descendants of Allihies miners. A few returned in 1914, believing there was still a great deal of unexploited ore, but in spite of investment from abroad and financial assistance from the government, these and other attempts to restart mining have been unsuccessful. Today, the population of Allihies is less than two hundred.

Allihies, and its near neighbours, Ardgroom and Eyeries, on the northern coast of the Beara peninsula, are perhaps the most notable of all the villages in Cork and Kerry for the use of an astonishing range of bizarre colours on the stucco façades of the houses. In summer this is quite dazzling, and during the winter months it gives a wonderful warmth and radiance to the streetscape.

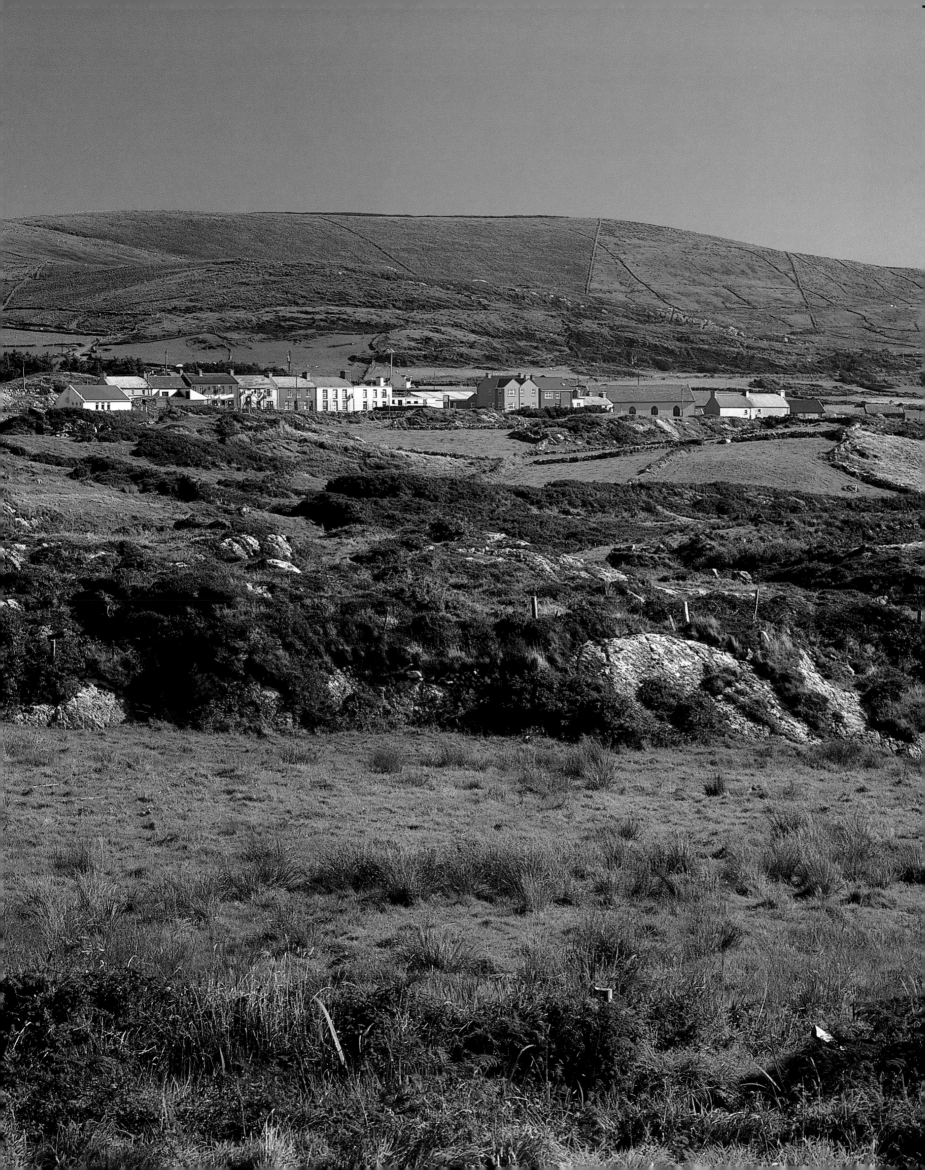

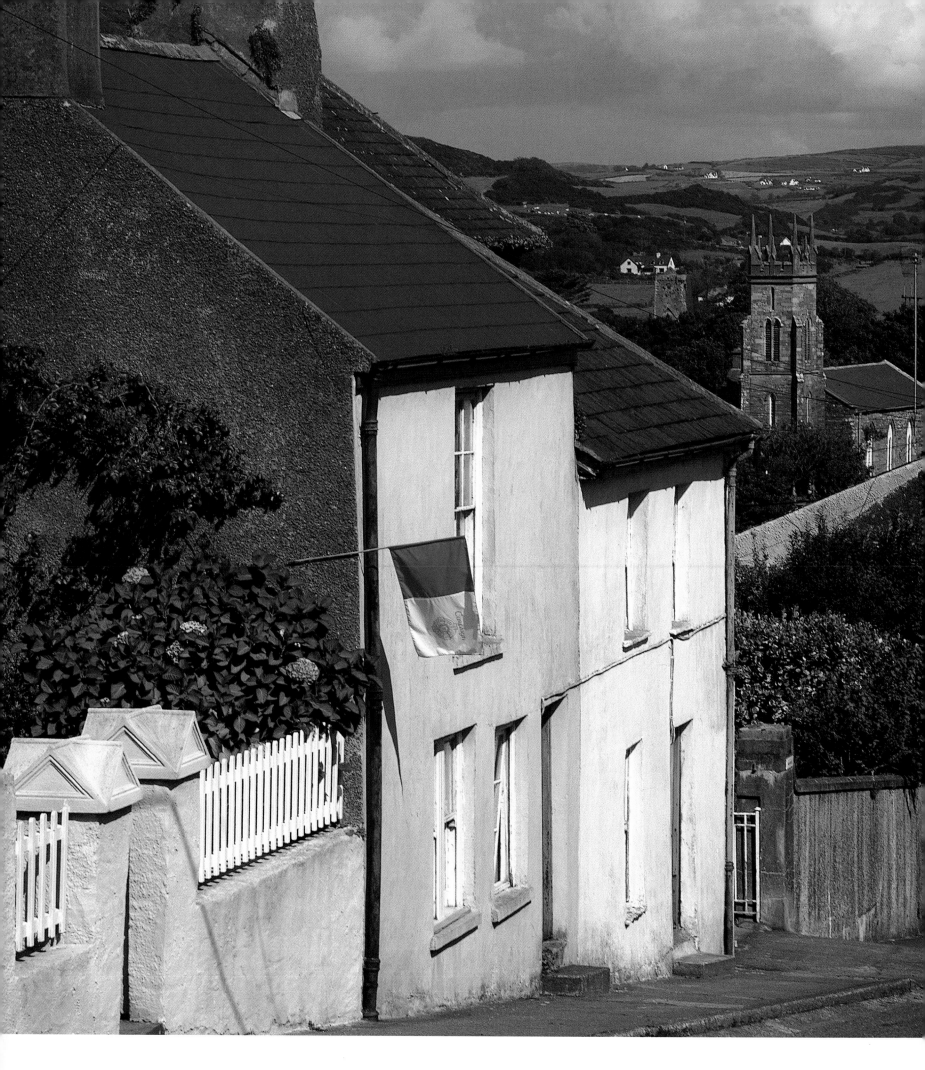

Castletownsend

(*Baile an Chaisleáin* = Castle Town)

CORK

THIS EXTRAORDINARY ENCLAVE of Anglo-Irish ascendancy has survived into a more democratic and egalitarian world not merely unscathed, but enhanced. Judging by old photographs, as well the observations of today's residents, the village is looking even more prosperous and *soigné* than it did in the heyday of the West Carbery Hunt, tennis parties on the lawns of the great houses, and jolly regattas on Castle Haven.

This is not to say that such activities do not continue – they do, but with a less restricted membership, a broader constituency. The four most distinguished – and talented – families are the eponymous Townsends, the Chavasses, the Coghills and the Somervilles. George Bernard Shaw married Charlotte Payne Townsend of The Castle, in 1898. He referred to her as 'my Irish millionairess', which does not seem to have accorded ill with his, or her, socialism. The Reverend Claude Chavasse published a number of much admired biblical studies in the early years of this century. Captain Nevill Coghill won the V.C. at the Battle of Isandalhwana in 1879, and Professor Nevill Coghill of Exeter College, Oxford, published his bouncing translation of Chaucer's *Canterbury Tales* in 1951.

Edith O.E. Somerville was the collaborator with her cousin Violet Martin ('Martin Ross') on the series of immensely popular stories which satirize this very society, the hilarious *Experiences of an Irish R.M.,* published between 1899 and 1915. These ladies also wrote several realistic novels which their relatives considered to be 'rather too French'. Miss Somerville's monument at St. Barrahane's Church features crossed quills and a hunting-horn – she was Master of Fox Hounds; the symbolism on other memorials is of a more military and naval mien. In spite of the trappings of colonialism, no house in Castletownsend was burnt during the troubled times of the early 1920s.

Castle Haven had an interesting history prior to its being seized from the O'Driscolls and granted to Colonel Richard Townsend, a member of Charles I's Long Parliament. One of the creeks was known from earliest times as *Leaba na Luinge* or 'Bed of the Ship', signifying a safe mooring-place. In 1601 a naval engagement took place between the English under Admiral Levison and the Spaniard Pedro de Zuibar, the English suffering defeat. Matters altered, however, for Zuibar was on his way to assist in what turned out to be the final disaster for Gaelic Ireland, the Battle of Kinsale.

The colours of the Cork football team fly from a house in Castletownsend's main street. It is difficult enough for modern motor vehicles to negotiate its steep incline: what it can have been like for the carriages and pony-traps of earlier residents is hard to imagine.

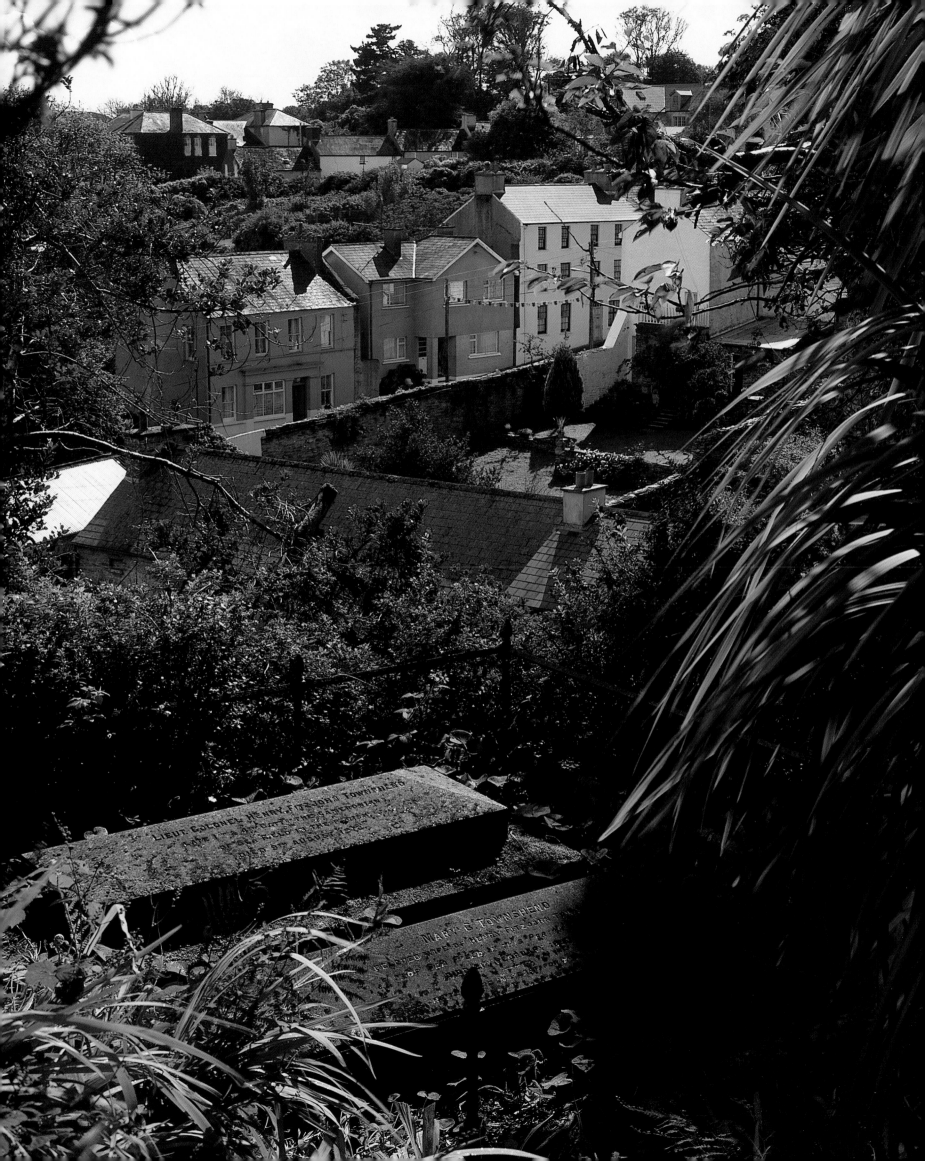

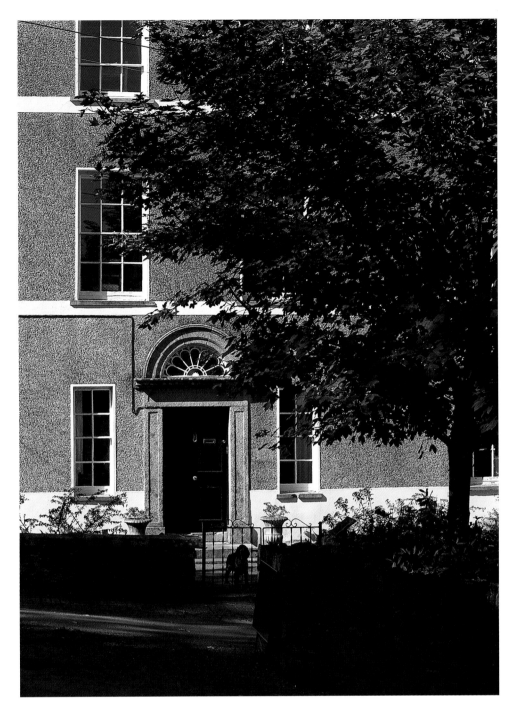

*H*idden gardens and last resting places in Castletownsend form a pattern of secrecy behind the houses of the village (opposite), many of which have intriguing associations. Sundial House (above left) *was formerly the village hall. It was built in 1906 by public subscription and the munificence of local landlords.* Shana Court (above), *now a private residence, dates back to 1725 when it was built as the Custom House. Contraband goods were stored in its capacious cellars. The Celtic revival mosaic* (left) *in St. Barrahane's Church was designed by Edith OE. Somerville in memory of her cousin Violet Martin, the 'Martin Ross' of their literary collaboration.* Castle Haven (overleaf left) *has been the scene of intrepid smuggling incidents, a fierce naval encounter, and genteel regattas.* St. Barrahane's Church (overleaf right) *was designed by James Pain of Cork in 1826; it contains remarkable memorials to the several distinguished families of the neighbourhood.*

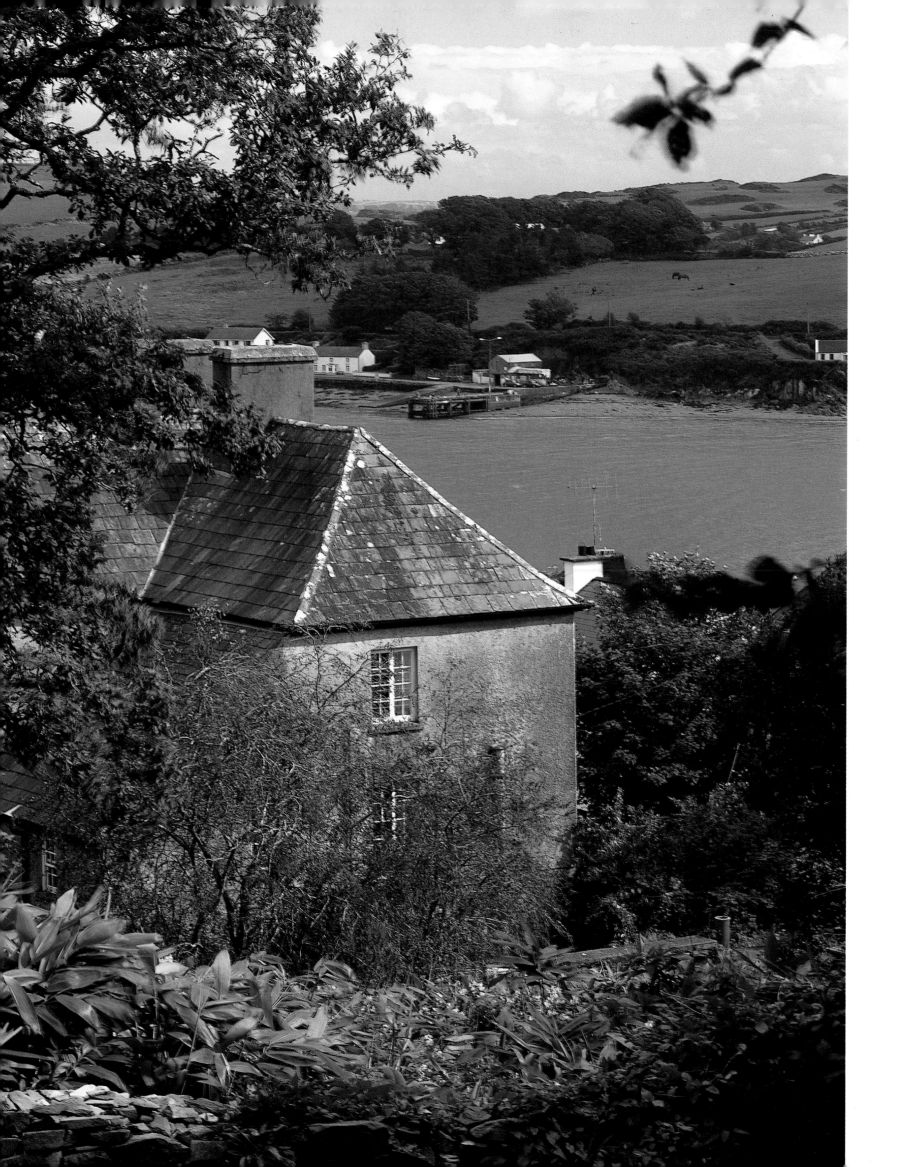

Dunmore East

(*Dún Mór* = Great Fort)

WATERFORD

THERE ARE MANY DUNMORES in Ireland, this one confusingly distinguished by the designation 'East' – although there are several which are much more easterly. There might be a logical reason for this, were the village situated on the eastern shore of the three-mile-wide estuary known as Waterford Harbour – but it is not: it commands the western entrance. Dunmore East is as curious as its name, for its serpentine street, following the topography of strand and cliff and ocean inlet, contrives to support as many different social classes of people as there are varieties of dwelling in which to house them.

Long-established members of the fishing community live fin-by-gill, so to speak, with briefcased commuters from Waterford city. Erstwhile holiday-makers, nostalgically returning to the scene of bucket-and-spade summers, have retired to reside next door to the more flighty foreign weekenders of today. What tensions arise from chance or planned encounters among this heterogeneous assemblage of persons, in Post Office, marine-goods store or Fishermens' Hall, can only be guessed at. What is certain is that to the outsider everything appears as serene and peaceful as the pier-protected cove on a calm May morning.

Prior to the government decision to create a terminal for the packet-boat from Milford Haven, Dunmore East did not exist – save for a collection of fishermen's huts on the foreshore and the remains of the fort which gives the place its name. The ubiquitous Alexander Nimmo [see 'Roundstone'] advised that this location, being free of sandbanks, would be the most suitable for the construction of a harbour. Building occupied the years 1815 to 1823, but the success of the venture was short-lived, for improved marine technology a decade later dictated that the larger ships now coming into service should berth at Waterford. A substantial fishing industry had grown up, however; and as early as 1837 the historian Samuel Lewis noted that there were cottages for letting to visitors.

The harbour was greatly expanded in the 1960s and now supports one of the largest fishing fleets in the European Union. 'Cottages for letting' are visible everywhere, the most recent doughtily striving to complement existing homes by means of an abundant utilization of thatch. There are numerous guest-houses, and three hotels – one of them, The Haven, was the home of the Malcolmsons, the Waterford mercantile family who engaged J.S.Mulvany, architect of the National Yacht Club in what was then Kingstown, to design it for them.

The umber-coloured sandstone cliffs topped by vivid green fields, the numerous concealed coves and little bays of brown sand, the flurry of foam-capped waves turning from onyx to opal to sapphire in the constantly changing light, are most memorably interpreted by the painter Norah McGuinness – a founder of the Irish Exhibition of Living Art and a visitor to Dunmore East – the centenary of whose birth occurred in the year 2000.

Traditional architecture survives and thrives in Dunmore East: one of the indigenous – as distinct from more recent – thatched cottages (above). In spite of several enlargements and improvements to the harbour of Dunmore East, the old lighthouse (opposite), built in the form of a Doric column, has been carefully preserved.

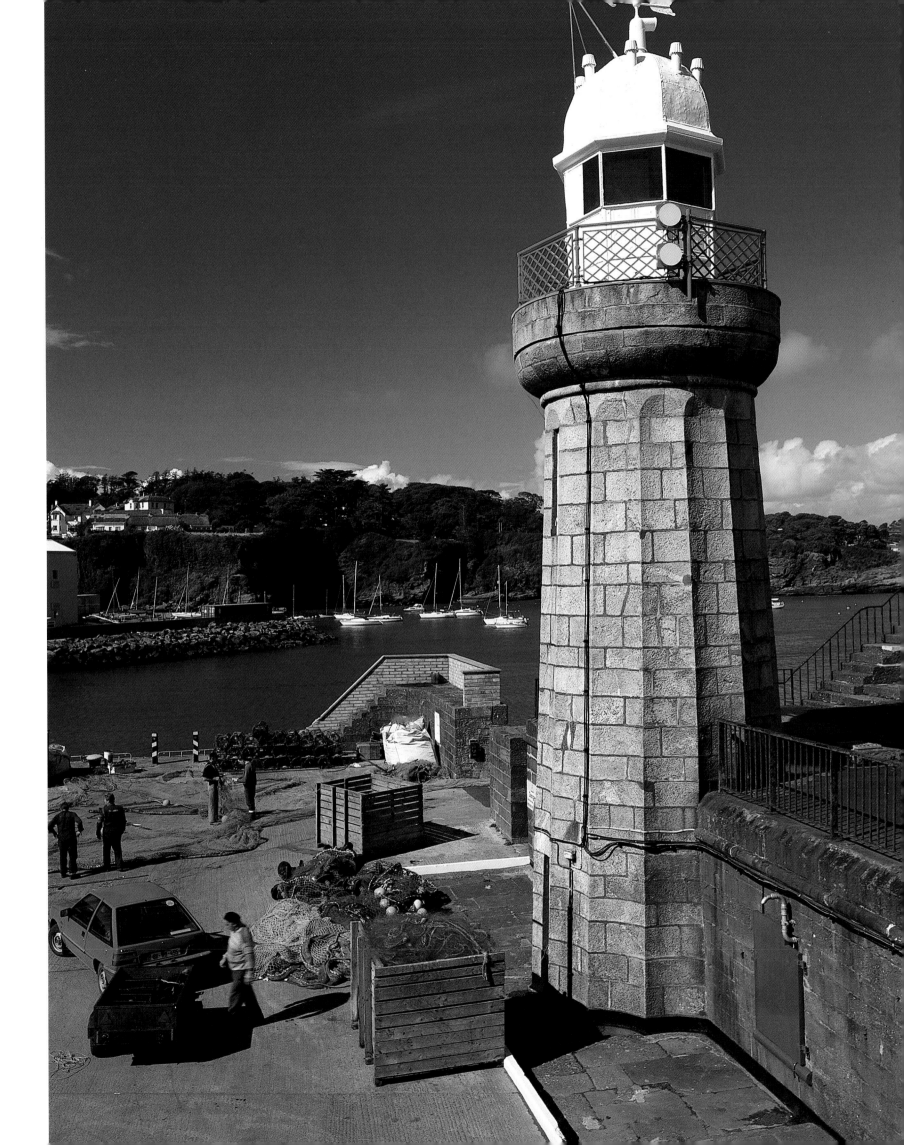

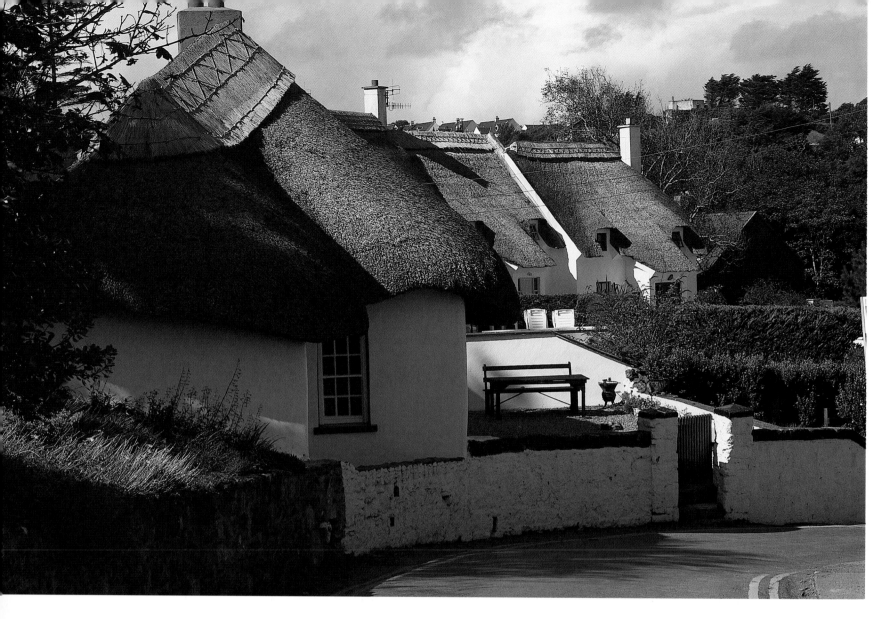

*C*uriously enough, these thatched
cottages (above) *are of*
comparatively recent date, while
this handsome slated terrace (right)
is part of the older streetscape of
the village.

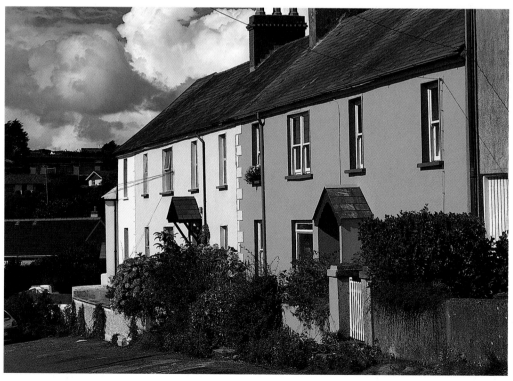

Porches, gables and dormers abound on the individual houses and terraces of Dunmore East, situated in the Norman Barony of Gaultier.

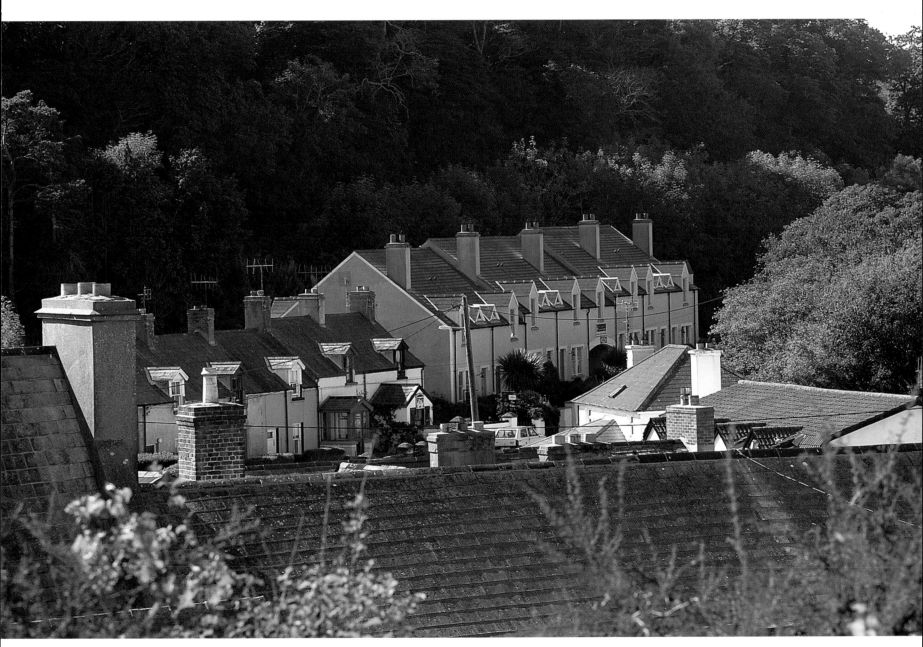

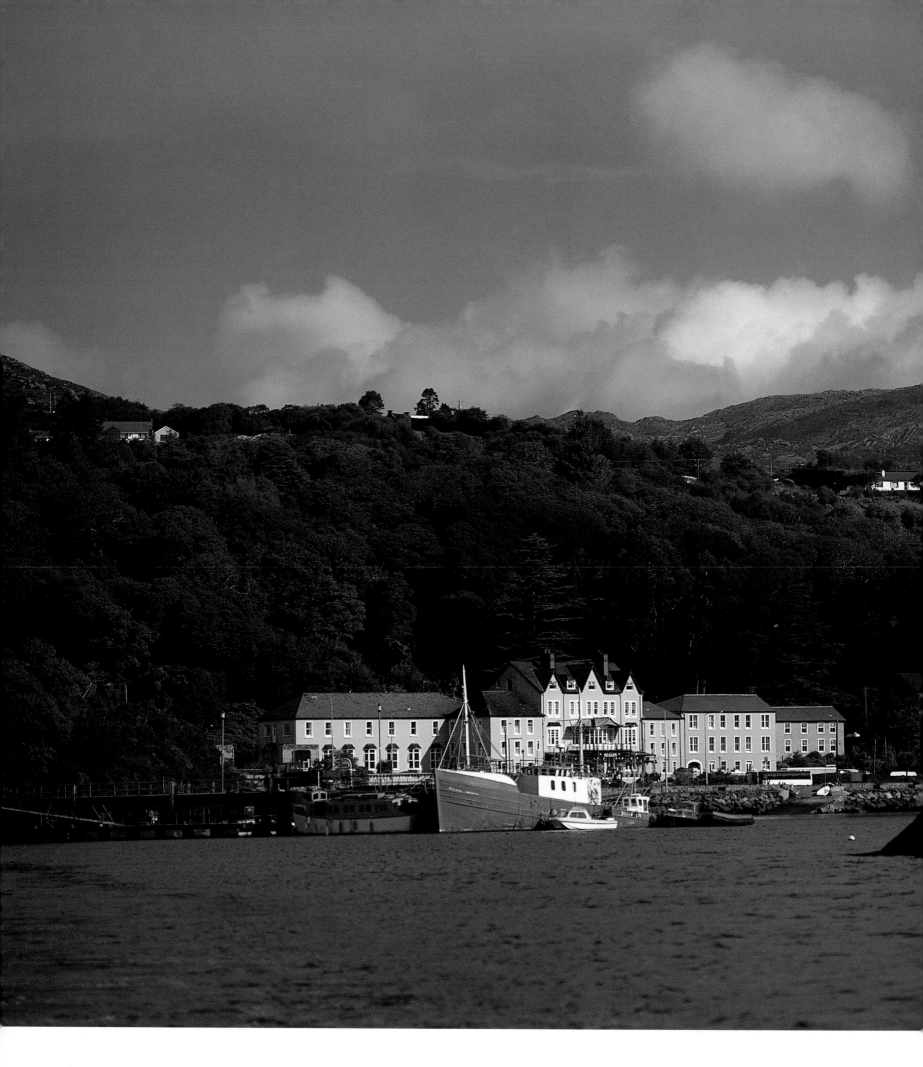

Glengariff

Gleann Garbh = Rugged Glen)

CORK

'What sends picturesque tourists to the Rhine and Saxon Switzerland?', enquired William Makepeace Thackeray in 1843. 'Within five miles round the pretty inn of Glengariff there is a country the magificence of which no pen can give an idea.'

Photographs can give an excellent idea, however, and surely substantiate the novelist's claim. Thackeray stayed at what is now the Eccles Hotel more than half a century before Annan Bryce bought and planted the island of Ilnacullin (*Oileán na gCuileann* = Holly Island) a quarter-mile off-shore in Bantry Bay. Had Thackeray been able to see the result of Bryce's work, and especially his Italian Garden, he would, if possible, have extolled the charms of Glengariff in even more ardent fashion.

Annan Bryce engaged Harold Peto to design the gardens. Comprehending the nature of the micro-climate, they introduced plants which no-one believed would flourish in the British Isles. A hundred men were employed in transporting soil by rowing-boat, and in building the pavilions, the clock-tower, the walled enclosures, the ponds and promenades – not to speak of the planting and nurturing of the hundreds of species which kept arriving from overseas. The outbreak of World War I put an end to the development work, and the proposed residential villa was never built. Roland Bryce left the island to the people of Ireland in 1953, and it has been superbly maintained by Dúchas, the Heritage Service, ever since.

George Bernard and Charlotte Shaw visited Ilnacullin in 1923. Like Thackeray, they stayed at the Eccles Hotel, and it is said that Shaw wrote *St. Joan* there. Perhaps he revised it, for it had already been accepted for production by the New York Theatre Guild. Daphne du Maurier was also a visitor: her novel *Hungry Hill* takes its title from the mountain of that name, which dominates the northern shore of the bay.

A local poet, Mary Sullivan Regan, celebrated the early days of flying in ballad form with her *Song of the Glengariff Aviator*, which is quoted in Richard J. Hamilton's fascinating book, *Beara and Bantry Bay*. In the poem, an emigrant Irish bride 'on a foreign shore' asks her dashing young aviator husband to 'Take me back to old Glengariff, dear...' He gallantly agrees, and the reader prepares for some desperate tragedy; but not at all –

> *...with love their pulses were throbbing,*
> *And with joy their hearts were filled*
> *When they landed safe without jar or break*
> *On the top of Hungry Hill!*

*T*he 'rugged glen' of Glengariff's ancient name is surprisingly verdant. *The Eccles Hotel at its seaward end has provided hospitality to many distinguished travellers for a century and a half.*

*T*he gardens of Ilnacullin, Glengariff: this
gateway (left) *leads from the nurseries of the
walled garden to the lawn in front of the Casita,
a tea-house of Bath stone. The clock-tower
(above)* stands at the north-west corner of the
walled garden. The temple (opposite) *is adorned
with marbles from Italy, Greece and Ireland.
Camelias, myrtles, azaleas, rhododendrons,
leptospermums, and exotics from as far afield as
South America, bring the wider world to this
recreation of Italy on an Irish island.*

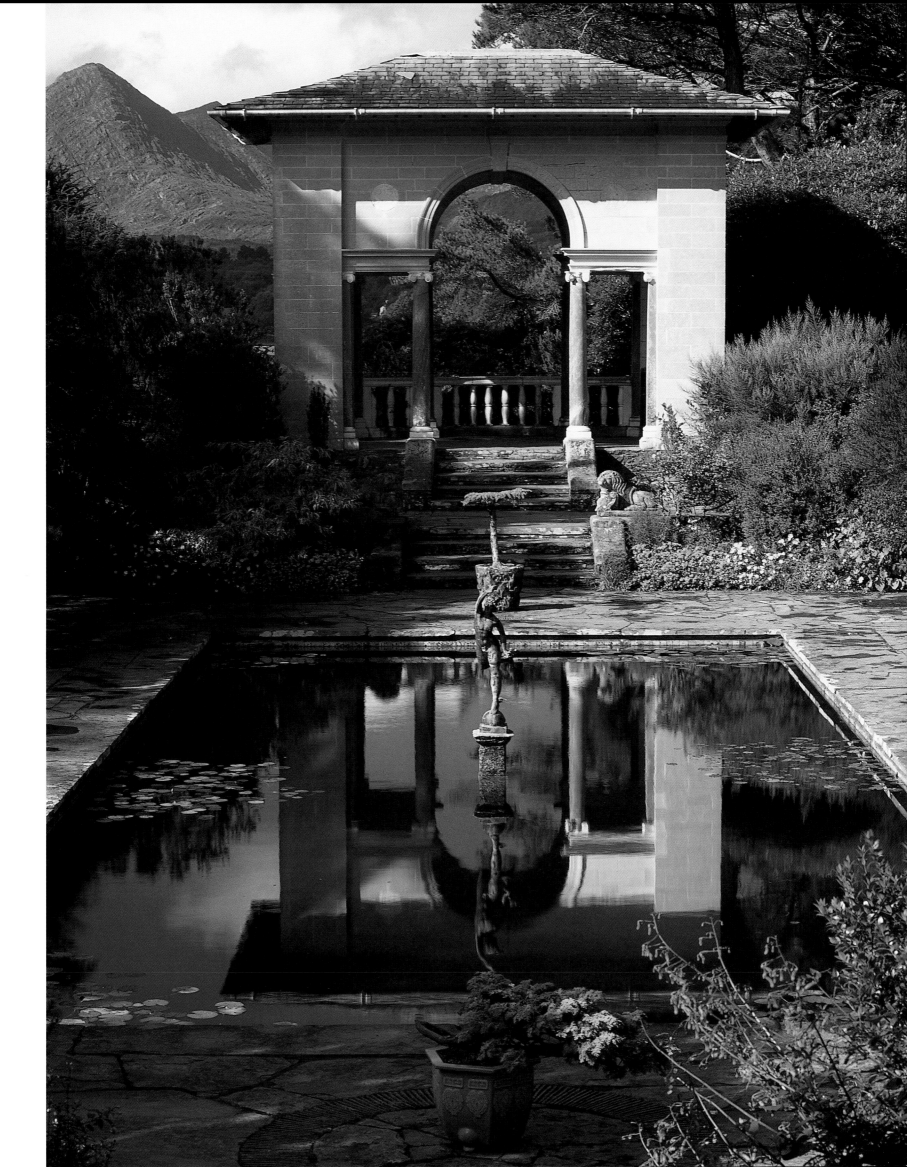

As if the Italianate exoticism of Glengariff were not enough, the road to Cork passes below the balustrade of Bantry House, only ten miles away, on a kind of corniche which makes one wonder if one is really on some Mediterranean coast.

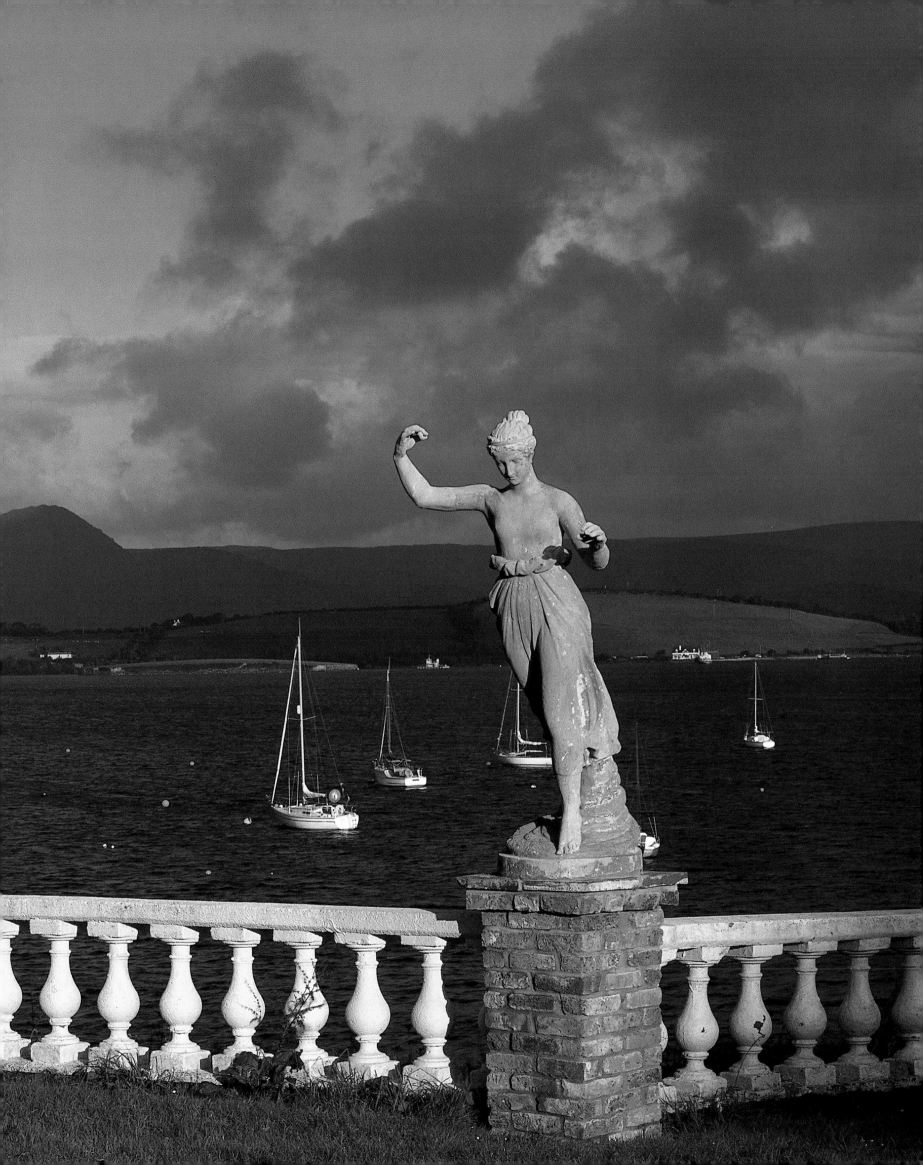

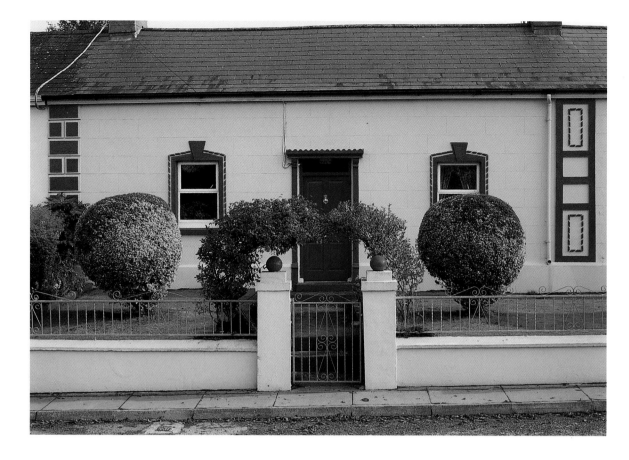

*U*nassuming yet ingenious neatness characterizes the presentation of this Holy Cross cottage (left). *The abbey* (opposite) *was founded by Dónal Mór O'Brien, King of Thomond, about 1180. It was dedicated to the Blessed Virgin Mary and to the Holy Cross. Most of the present building dates from the 15th century.*

Holy Cross

(*Mainistir na Croise Naofa* = Abbey of the Holy Cross)

TIPPERARY

WHEN the Italian entrepreneur Charles Bianconi (1786–1875), who lived at Longfield House overlooking the river Suir about six miles downstream, drove his first 'long cars' over Holy Cross Bridge, the Abbey of the same name was no more than a destitute ruin. Yet in spite of its sad state, the faithful still came to the place where a fragment of the True Cross had been venerated prior to the dissolution of the monasteries. Today the scene is quite different. The Abbey has undergone a remarkable process of rehabilitation, and the motor-coaches which have replaced Bianconi's horse-drawn vehicles bring hundreds of pilgrims who offer prayers before the authenticated relic received from Rome in 1977.

The move towards the Abbey's restoration began as long ago as 1869 when the Church of Ireland was disestablished and ownership of historical ecclesiastical buildings – almost all of them in ruins – was transferred to the Commissioners of Public Works; most were subsequently listed as National Monuments. A hundred years later the people of the parish began a campaign to have the Abbey church reinstated as a place of worship. A special Act of the Oireachtas (Government) had to be passed – but once this had been achieved an international fund-raising campaign started in earnest. Following archaeological excavations, and the removal of graves which had been sited within

the walls while the building was roofless, work began in 1971. The Abbey became the parish church in 1975, and the little post-Emancipation parish church nearby was retained as a community centre.

The village of Holy Cross is a great deal smaller than it was in late medieval times. During the 1970s an estate of thatched cottages of traditional design was built by a local co-operative society, with state assistance, as part of the 'social tourism' concept – designed to integrate visitors with villagers and holiday homes with the local landscape. However artificial the project may have seemed at the time, these cottages have now weathered, and they blend with the rural street and river bank.

The Bianconi long cars – sometimes referred to as 'side cars' because passengers sat along the sides of the waggons, facing outwards – covered 4,000 miles of road, revolutionizing communications in the south and west of Ireland. With the coming of the railways Bianconi altered his timetables so that his cars met trains at the new stations and transferred passengers to outlying towns and villages. Those for Holy Cross alighted from the train at Thurles, and took the long car bound for Cashel. George Bernard Shaw has the characters in *John Bull's Other Island* arrive by 'Bian' at the fictitious Ballycullen as late as 1904. The Italianate Bianconi memorial garden may be seen at Boherlahan six miles south of Holy Cross.

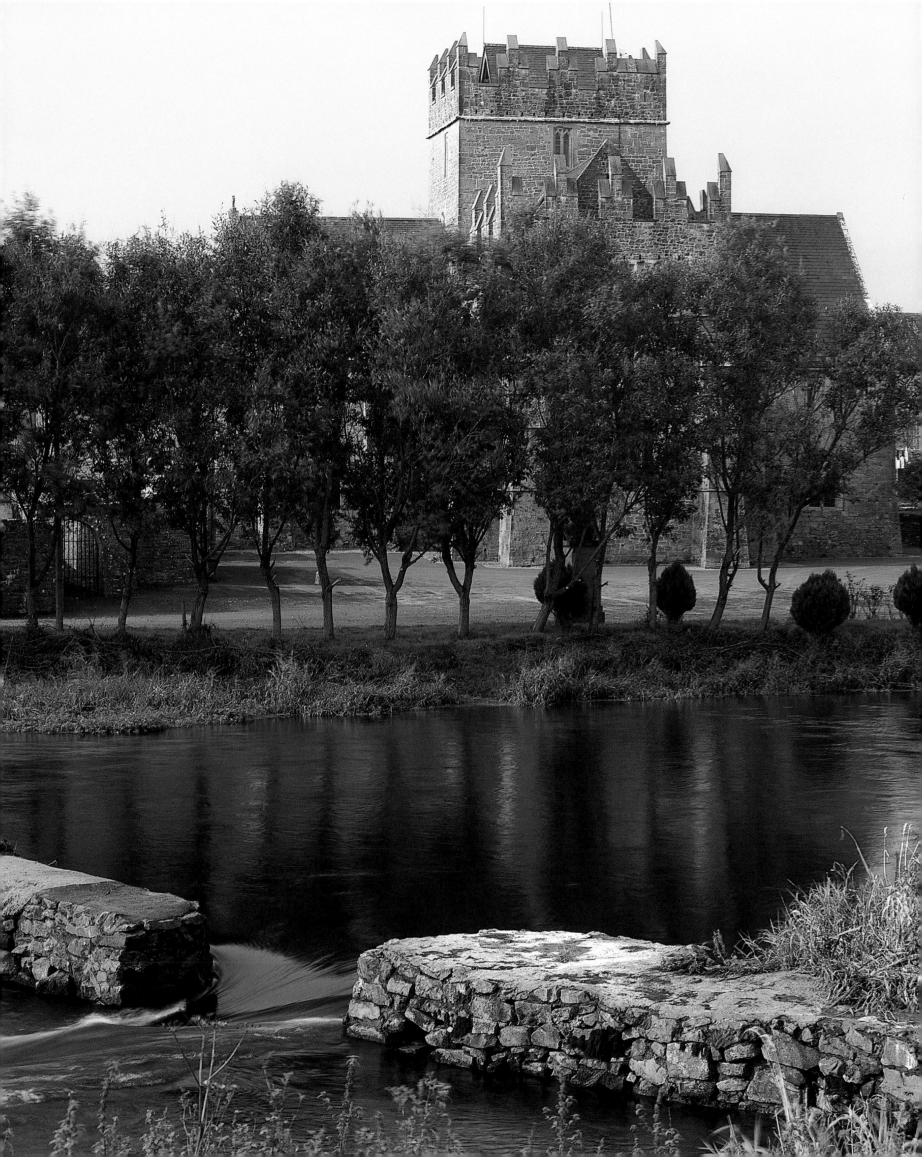

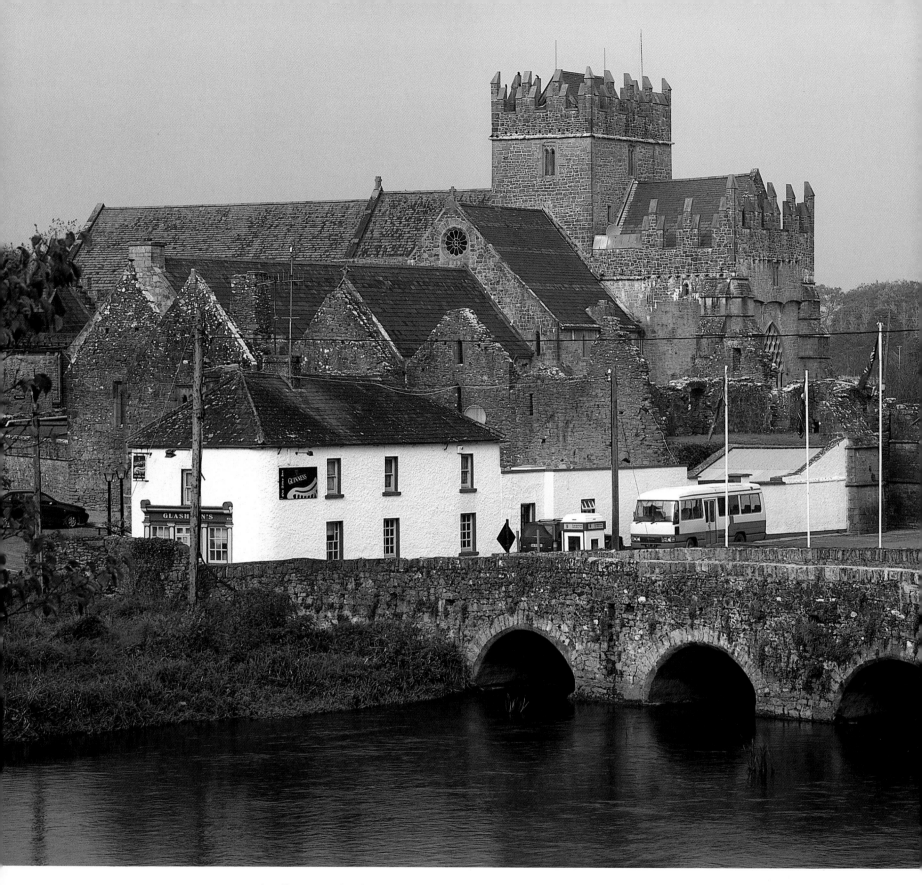

*T*he centre of Holy Cross is dominated by the mass of the abbey
buildings (above). Tradition and innovation mix easily in
the village: the name Hayes or O'Hay derives from the Irish OhAodha
and is ubiquitous in County Tipperary (opposite above); this cottage
(opposite below) was in fact built in the 1970s, part of a building
programme to cope with the influx of visitors.

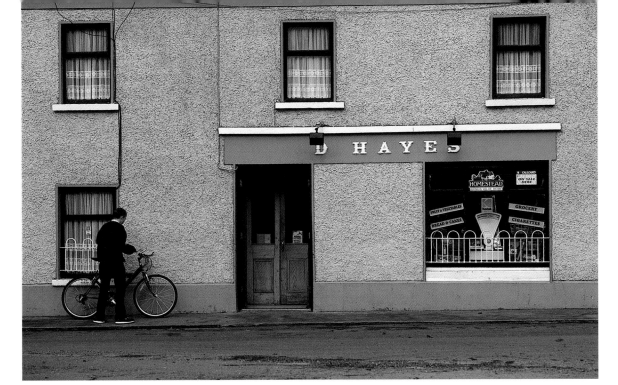

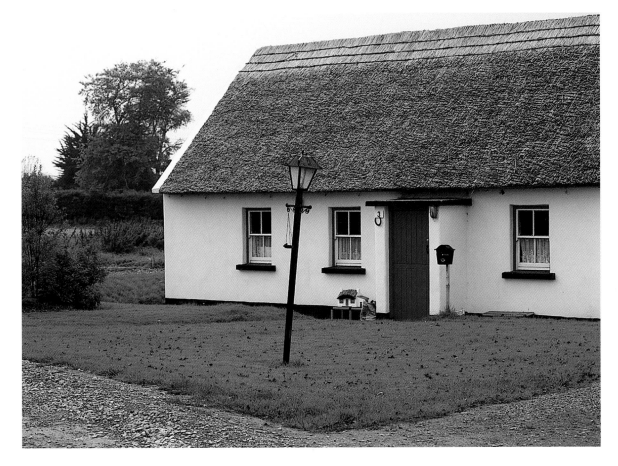

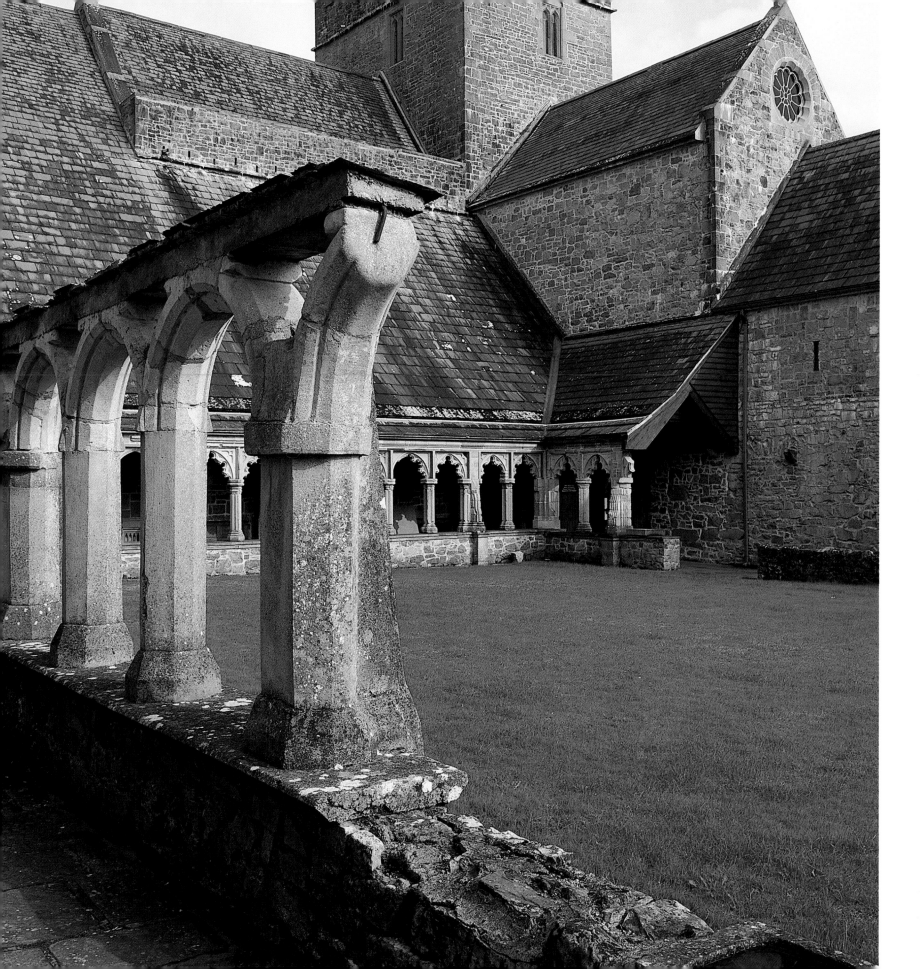

*T*he remains of the cloister
are now carefully
preserved (opposite). *The
sedilia* (right) *in the chancel
of Holy Cross Abbey; the seats
are intended for the priest
celebrating the mass, the
deacon, and the sub-deacon.
The largest of the shields
carries the English royal arms
as they appeared in 1405.*

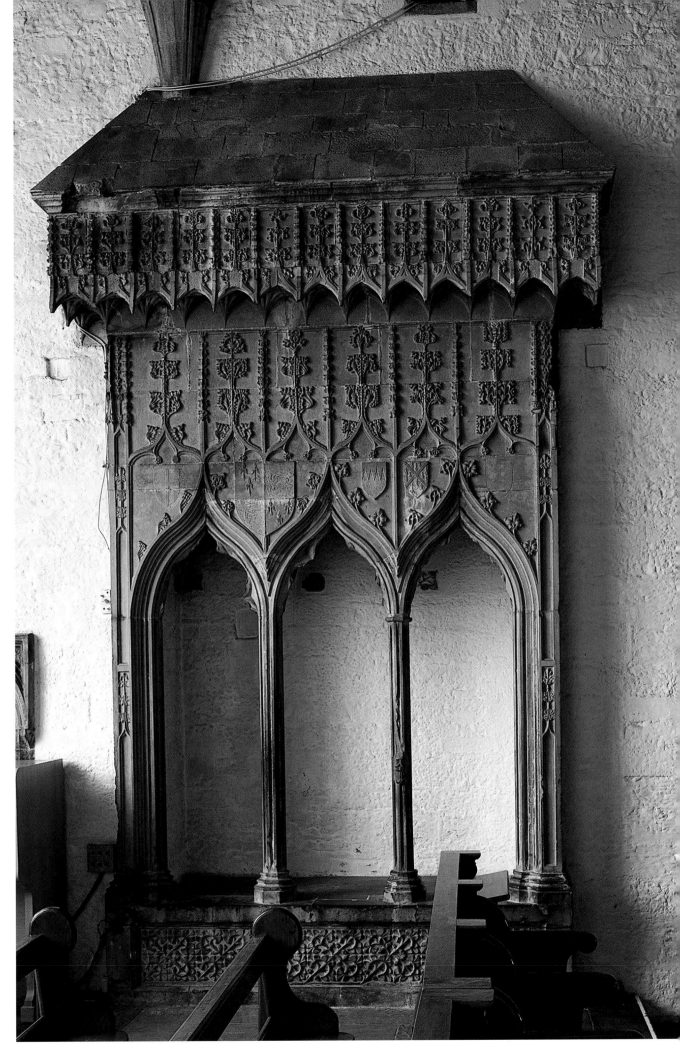

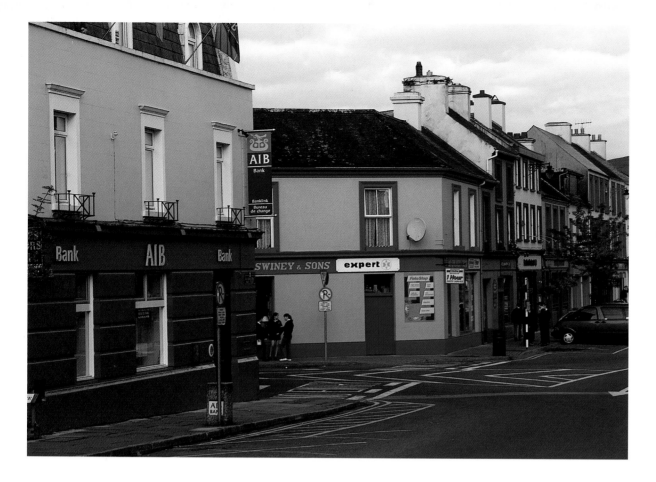

Kenmare

(*Neidín* = Little Nest)

KERRY

KENMARE is superbly situated at the lowest crossing of the Kenmare river, where mountain roads descend and converge among forests of abundant foliage. It was the rich soil of the valley which attracted English settlers following the wars of 1641–51 – after driving out the indigenous families they proceeded to improve the land, often using the original owners as cheap labour. It was the rich blend of mountain, wood and sea which attracted the first intrepid travellers who came in search of romantic scenery a hundred and fifty years later. Henry Fitzmaurice, 1st Marquis of Lansdowne, laid out the village at the end of the 18th century, taking care to build an inn: the Lansdowne Hotel remains to this day as a memorial to the ethos of the time, the grasping intruder turned benefactor.

Kenmare is still a tourist village, but without any of the visual or environmental disadvantages which the term implies. There is barely any employment in conventional industry, but there is a great deal in tourism, though this is seasonal. Of over forty restaurants, many of them of gourmet standard, only a bare half-dozen stay open to delight the visitor during the winter. The same is the case with the larger hotels, some of which are listed among the world's most distinguished. The famous Park Hotel is a case in point – it began as the Great Southern in 1897, an imaginative initiative of the now defunct Great Southern Railway Company; it provided, and still provides, marvellous views,

luxurious accommodation and superb food – but not during the winter. It has been said that what Kenmare needs each October is a sudden change to an Alpine climate, with accompanying snow and ski-slopes – who knows but that Science might not achieve such a consummation for Kenmare in the twenty-first century?

The neighbourhood is also rich in antiquities. One of the most interesting is off Pound Lane – a stone circle orientated towards the setting sun, probably built during the third millennium B.C. The nearby Cromwell's Bridge – so-called, for Cromwell never came to County Kerry – may have been built by seventeenth-century English settlers but is more likely of earlier date; another theory is that the name derives from the Irish word for a moustache, *croimeal*, because the bridge is shaped like one! The 'cursing stones' at Feaghna – they lie in hollowed-out basins on a large limestone table – may have been a pestle-and-mortar device for crushing corn, but folklore declares otherwise: if you wish to lay a curse on your enemy you turn the stones while uttering the most frightful imprecations. The poet Samuel Ferguson recalls how a group of disaffected druids railed – to little effect, it later appears – against King Cormac:

> *They loosed their curse against the king,*
> *They cursed him in his flesh and bones,*
> *And daily in their mystic ring*
> *They turned the maledictive stones...*

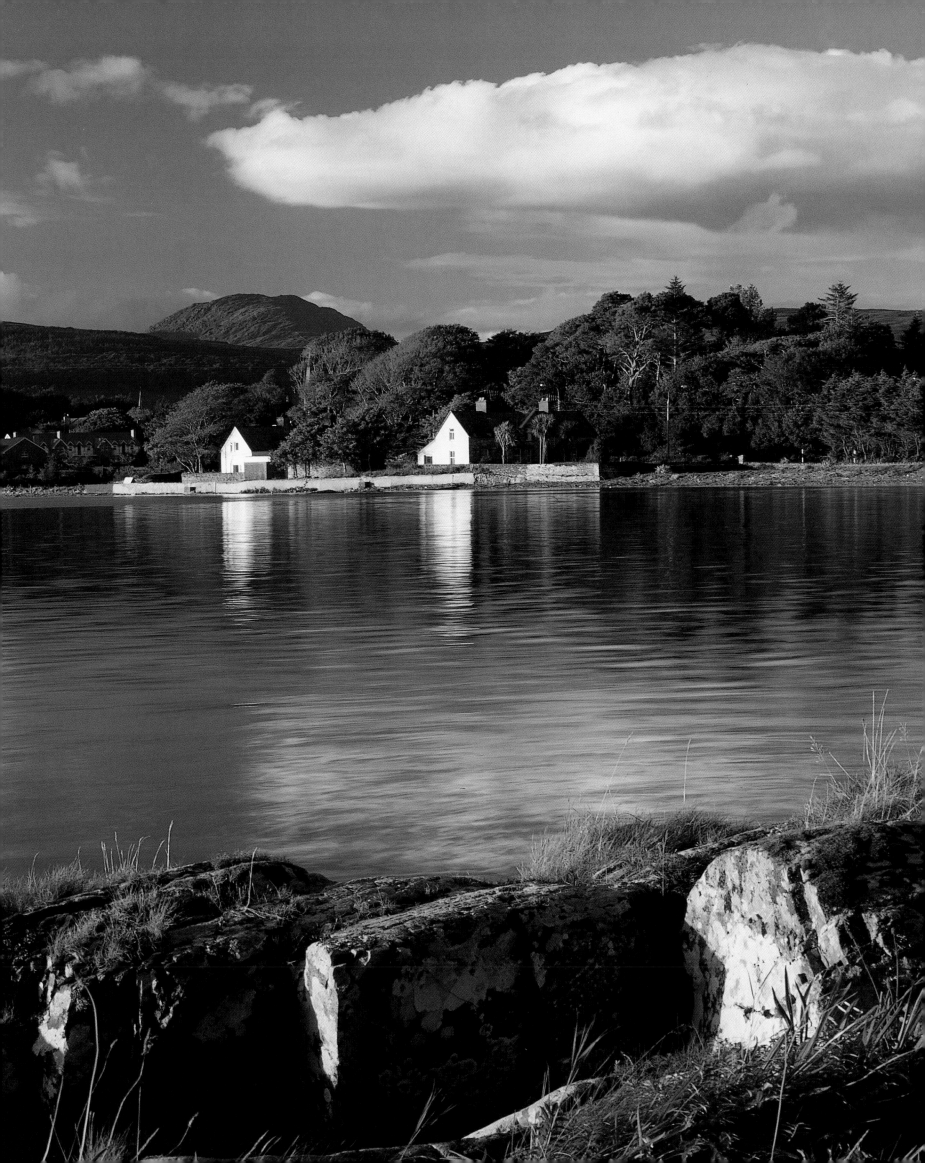

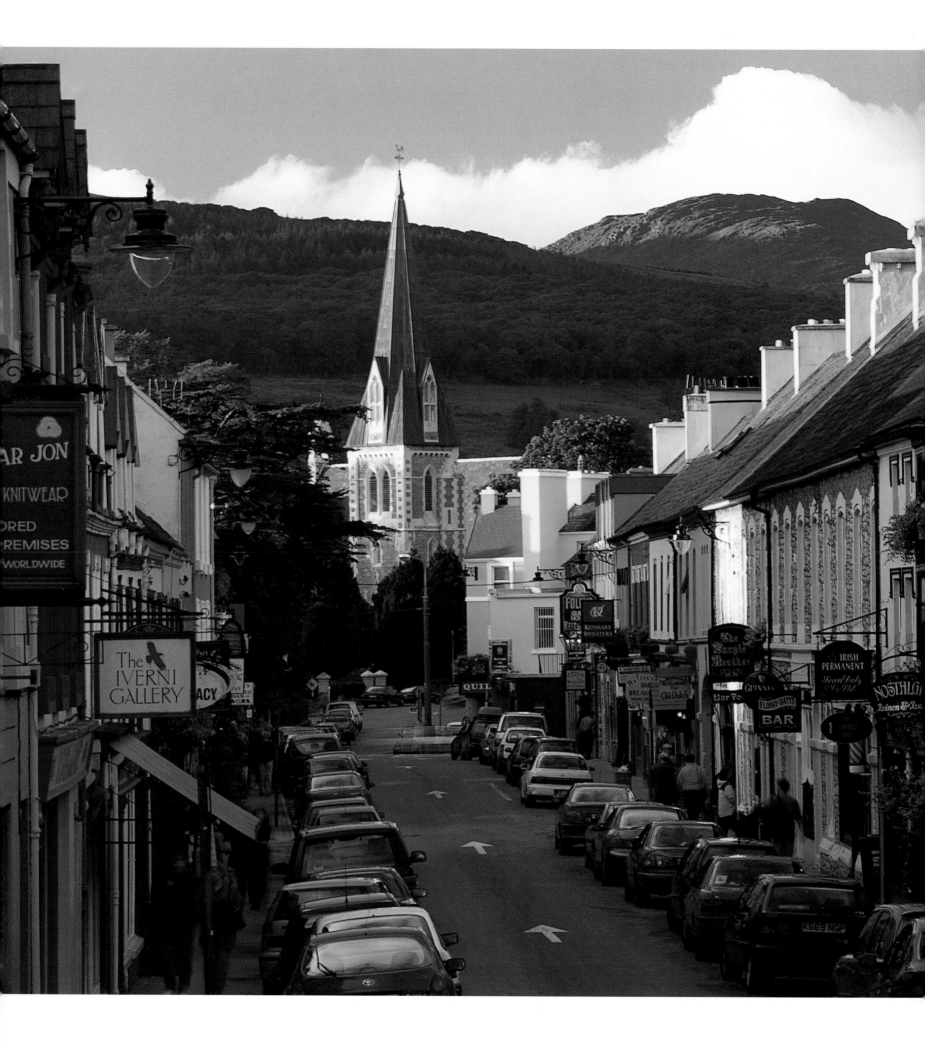

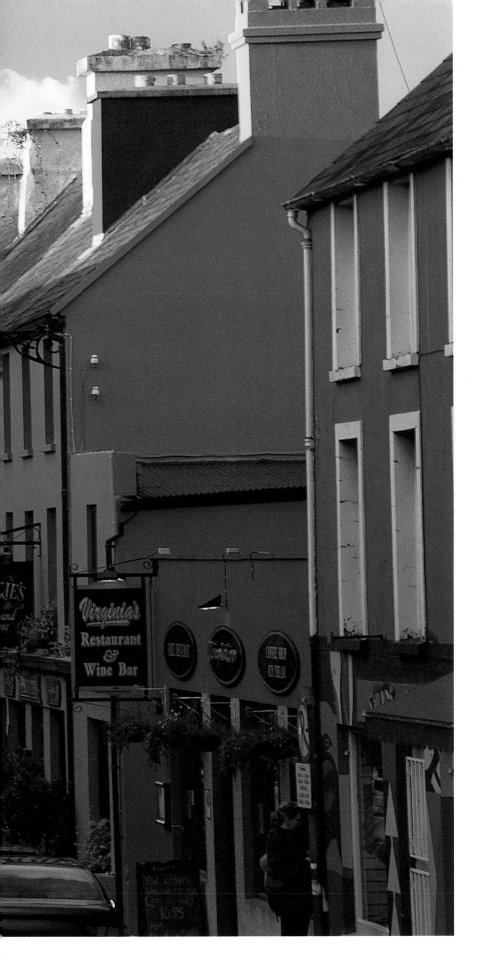

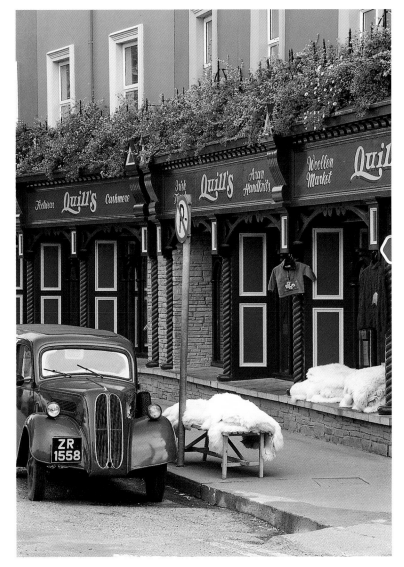

*H*enry Street, Kenmare (left): *this prospect is terminated by the Church of the Holy Cross, built in 1864 for Father John O'Sullivan by the architect Charles Hanson, a pupil of the younger Pugin. Kenmare has more restaurants of the first rank than any other place of its size in the whole of Ireland: but needs other than those of sustenance are also abundantly catered for* (above). *The estate houses* (overleaf) *built by the Marquis of Lansdowne in the late 19th century are particularly pretty.*

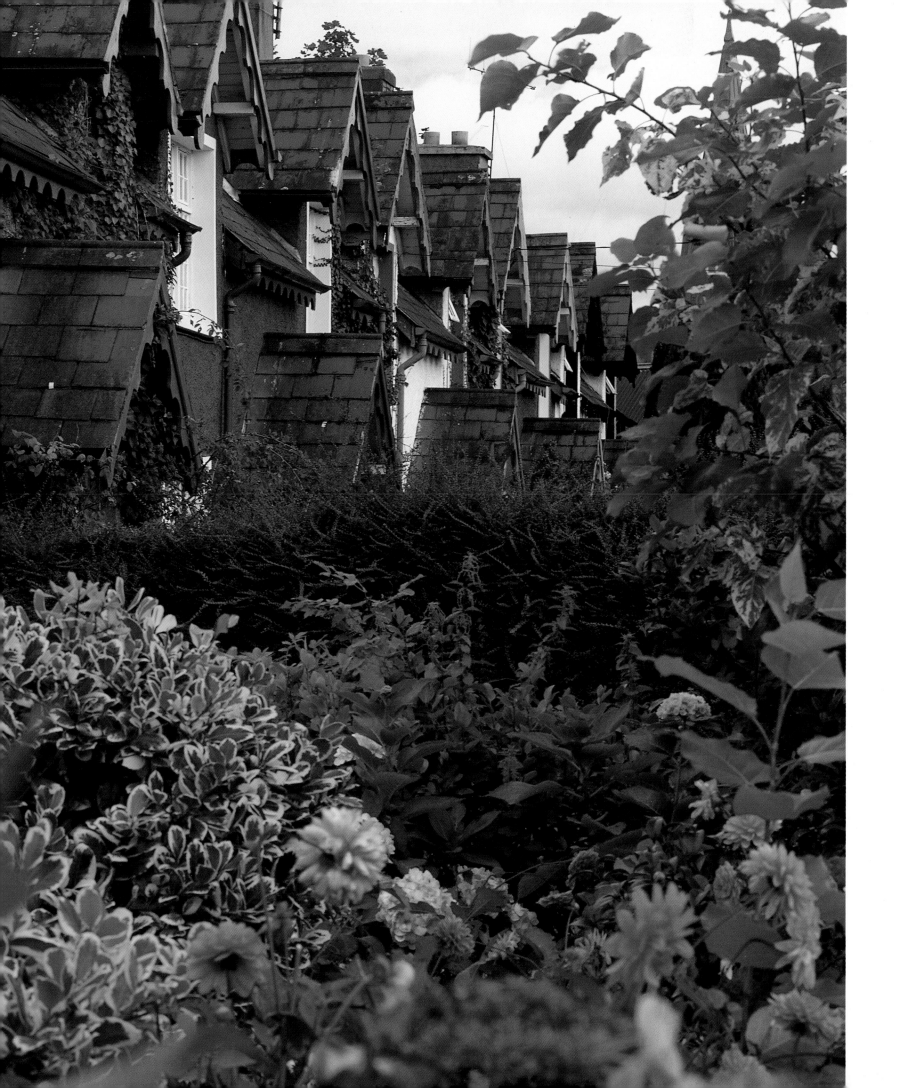

*F*olk-lore, history and mystification combine to make the fascination of these
two sites at Kenmare: the dreaded 'cursing stones' at Feaghna (opposite);
'Cromwell's Bridge' over the Annihy river, near the centre of the village.

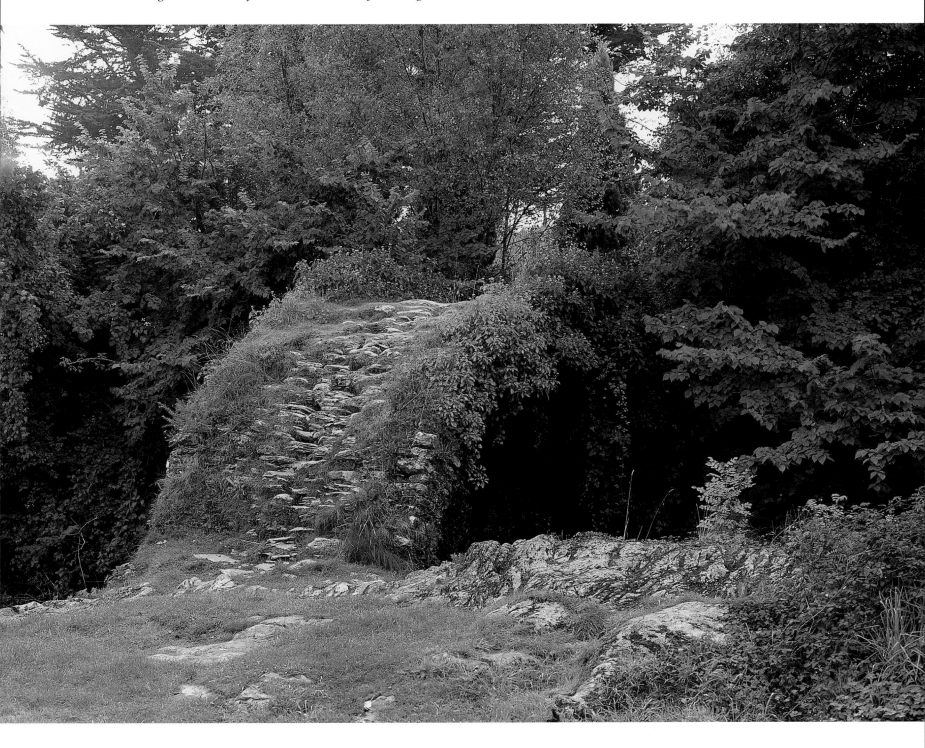

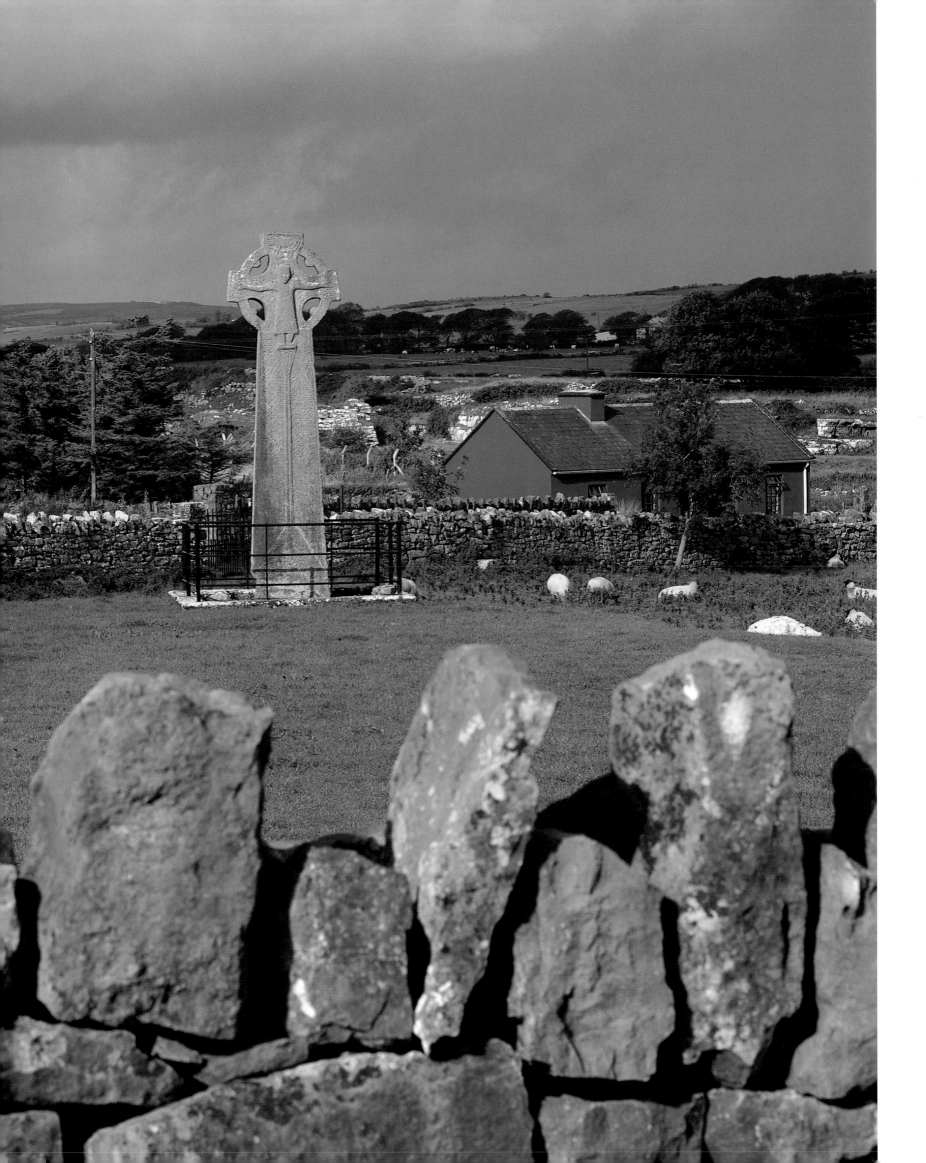

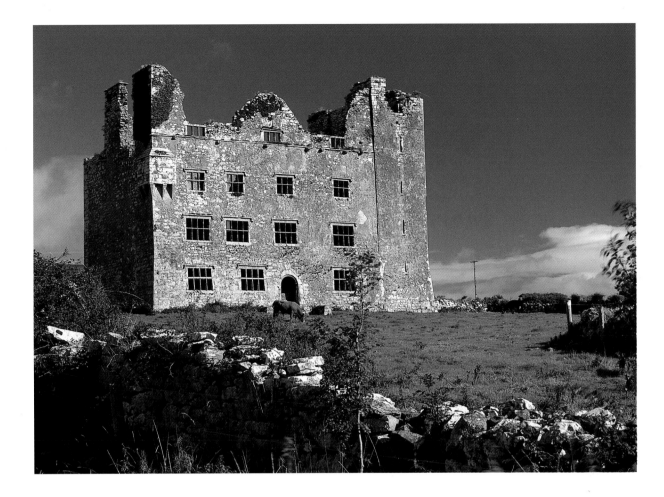

The limestone outcrops of the Burren form the backdrop to one of Kilfenora's remarkable High Crosses (opposite). *On the road leading out of Kilfenora to Corofin and Ennis lies Lemaneh Castle* (right). *The original tower house of c.1480 is on the right of the present ruin, with the remains of one of the few fortified Jacobean manor houses in Ireland attached.*

KILFENORA is a tiny village in the north of County Clare with a population of not many more than two hundred. It is remarkable for two things: the cluster of fascinating stone monuments surviving from medieval times and indeed earlier, and its situation on the edge of the Burren, that gaunt limestone land in whose fissures flowers more commonly associated with Arctic and Mediterranean climes flourish in profusion.

The Roman Catholic diocese of Kilfenora is now incorporated in the Archdiocese of Tuam; the Church of Ireland diocese has been united with a number of other western dioceses since the early 17th century, when it was seen as the poorest in Ireland, and described as being 'not worth above four score pounds to the last man'. The cathedral, of which only the chancel remains in use for public worship, is dedicated to St. Fachtna; St. Fionnur, whose name is given to the village, was a person of such ephemeral attainments that scholars doubt if he ever existed.

The design of stone carvings in and around the cathedral gives substance to the theory that a particular school of sculpture flourished here in the 12th and 13th centuries. There are four magnificent high crosses, quite unlike those in the rest of Ireland. The O Dughartaigh, or Doorty Cross, is the most elaborate, with figure carving and Urnes-style decoration. It lay amongst weeds until a Russian refugee, Lubya Tankanikov, brought it to public attention and it was re-erected by the Office of Public Works in 1945. An unusually plain cross without the 'Celtic' ring stands in the north-western corner of the graveyard. Outside the church door is the shaft of a narrow cross with interlaced carving. In a field isolated from the buildings is a thirteen-foot-high cross on which the Crucifixion is depicted; the curious triangular motif on its base suggests that it may have marked an important tomb.

The Burren Display Centre, situated at the widest part of Kilfenora's main street, won a Carnegie Award for Excellence shortly after its opening in 1975. Two kilometres outside the village is the Iron Age Ballykinvarga Ring Fort, with its formidable *chevaux-de-frise*. A dozen or more stone monuments lie scattered over the landscape within the compass of a morning's walk.

Kilfenora

(*Cill Fhionnurach* = St Fionnur's Church)

CLARE

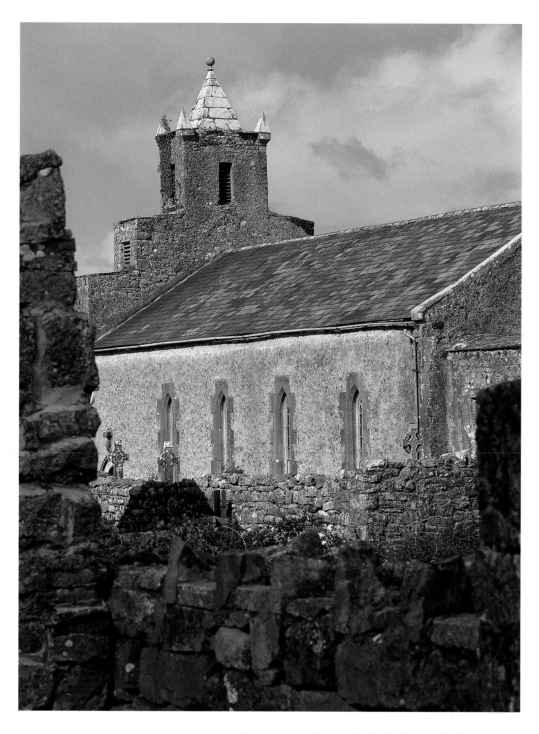

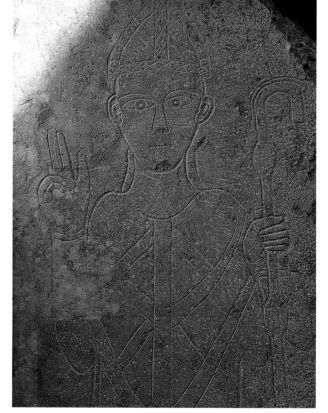

*F*ormerly a Roman Catholic diocese, Kilfenora is rich
in ecclesiastical monuments: Kilfenora Cathedral,
where only the chancel is still roofed (above);
St. Fachtna's Roman Catholic church of 1917 (above
right); an incised episcopal figure in the cathedral
(right). Of more secular interest is the Ballykinvarga ring
fort, 50 metres in diameter, with existing walls which
measure five metres at their highest (opposite).

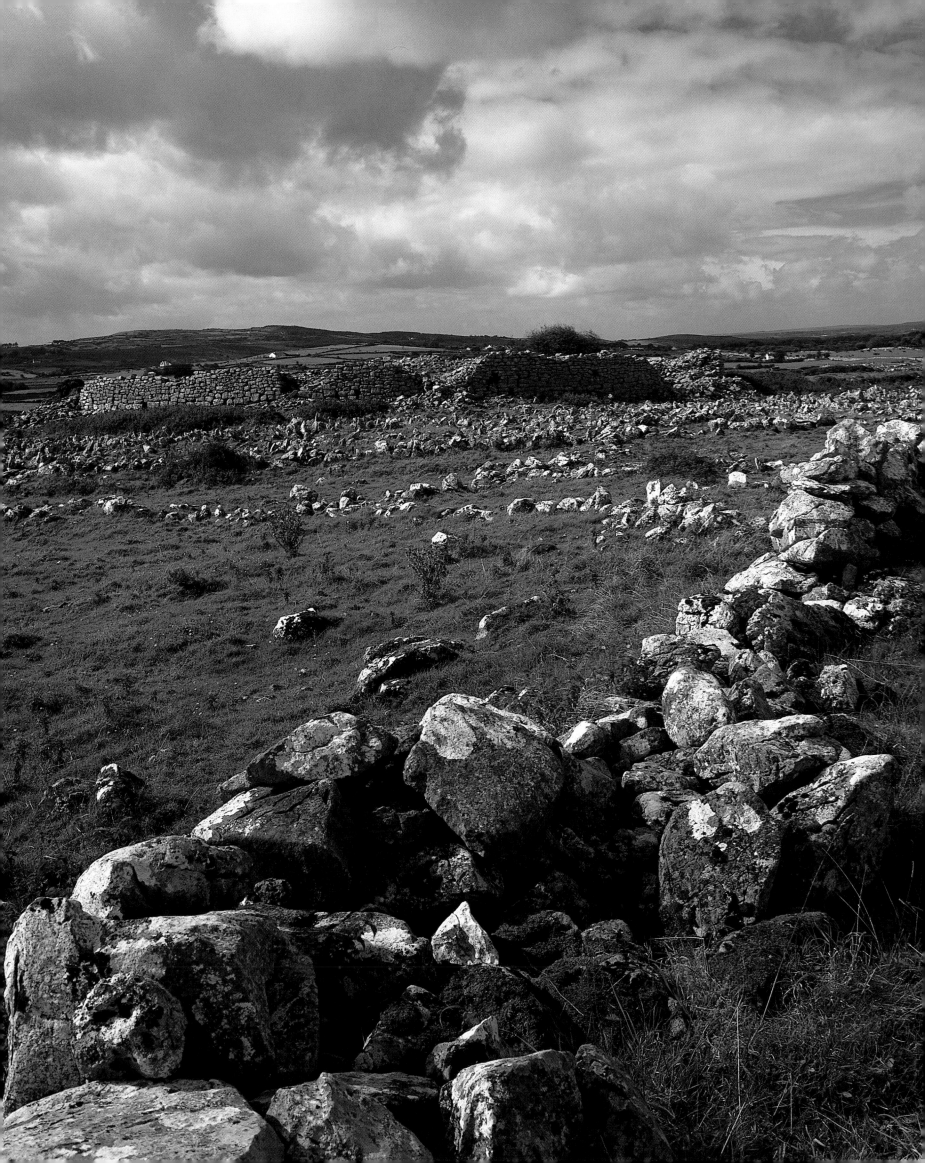

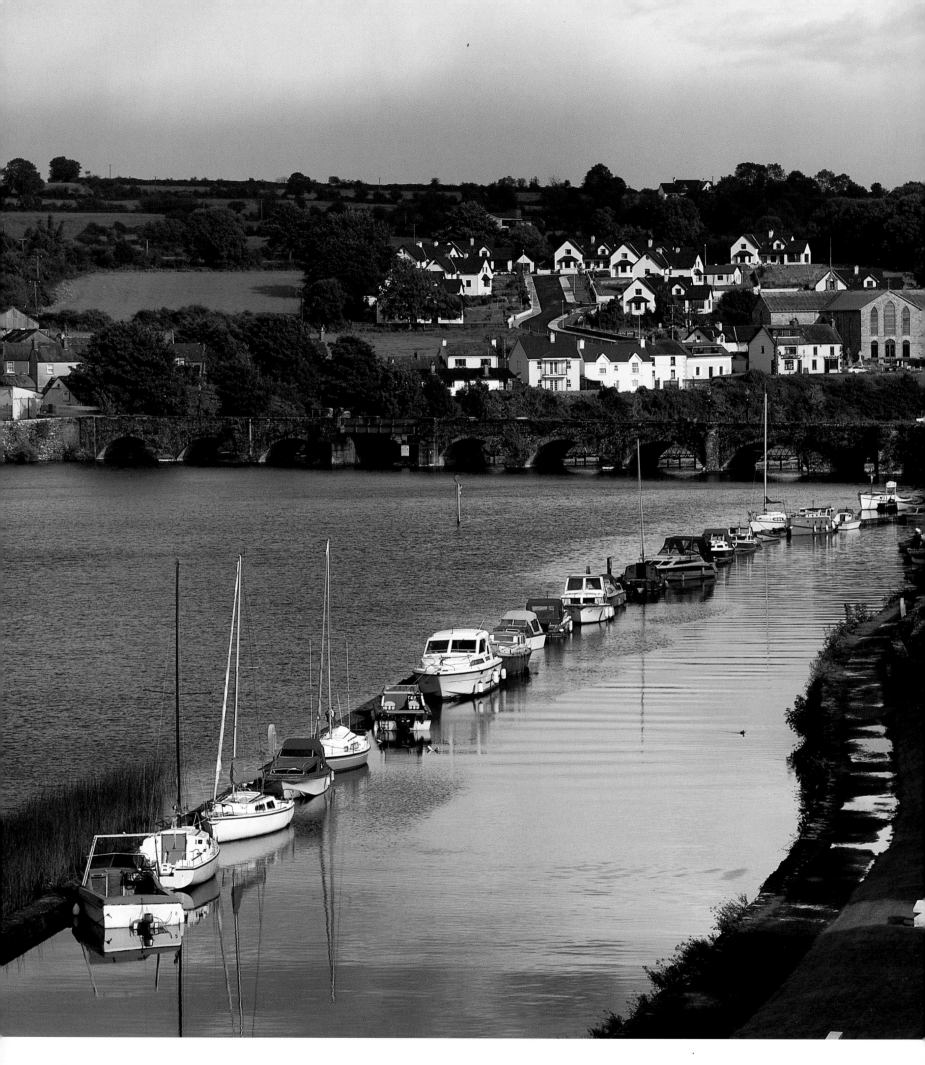

Killaloe

(*Cill Molua* = Church of Molua)

CLARE

Oh where, Kincora, is Brian the Great?
And where is the beauty that once was thine?
- Gone, O Kincora!

lamented the Gaelic poet Mac Liag (translated here by James Clarence Mangan) in reference to the palace of Kincora – which stood in the most elevated part of what is now Killaloe – and to its most famous resident, King Brian Ború. The present-day Diocese of Killaloe corresponds roughly with what was the Kingdom of Thomond in the 11th century – the kingdom of the O'Briens. It was Brian the Great who finally drove the Vikings from Ireland, as a result of his great victory at the Battle of Clontarf in 1014. (O'Brien is still the most common name in the local telephone-directory, a fact which might or might not have impressed the royalty of the past.)

It seems that the passing beauty bemoaned by the poet had to do less with the deceased ruler's person than with the place in which he resided. We do not know much about the appearance of King Brian, but Killaloe is a place of great beauty – its glorious situation on the west bank of the river Shannon, its noble thirteen-arched stone bridge, its dignified cathedral dedicated to St. Flannan (another O'Brien prince), its pretty cluster of houses rising up from the waterside to the location of the former palace.

The cathedral stands on the site of an earlier monastery. The first cathedral was built by Dónal Mór O'Brien and destroyed in 1185 during a war against the neighbouring king of Connacht, Cathal Carrach, ten years before Dónal Mór's death. The building we see today is a thirteenth-century structure which incorporates some of the fabric of the older building, including the Romanesque south-west doorway. The most conspicuous alteration is relatively modern – the stepped battlements on the tower, added in 1890. A twelfth-century high cross from Kilfenora was inserted in

the west wall in 1821 by Bishop Mant of Killaloe, whether as an act of preservation or pillage it is difficult to discern.

A small twelfth-century oratory, also dedicated to St. Flannan, stands in the cathedral grounds, and a ninth-century oratory, dedicated to St. Lua, was rebuilt in the grounds of the Roman Catholic church in a genuine act of preservation for it would otherwise have been submerged when the level of water in Lough Derg was raised at the time of the construction of the Shannon Hydroelectric Scheme in 1929. This diminutive early Christian building was carried, stone by stone, from the sanctuary on St. Lua's Island.

The steep main street of Killaloe (above) *climbs from the river Shannon to the site of the former palace of the Kings of Thomond. Below the village flows the majestic Shannon, with the Shannon Navigation and the celebrated thirteen-arched bridge which spans both* (opposite).

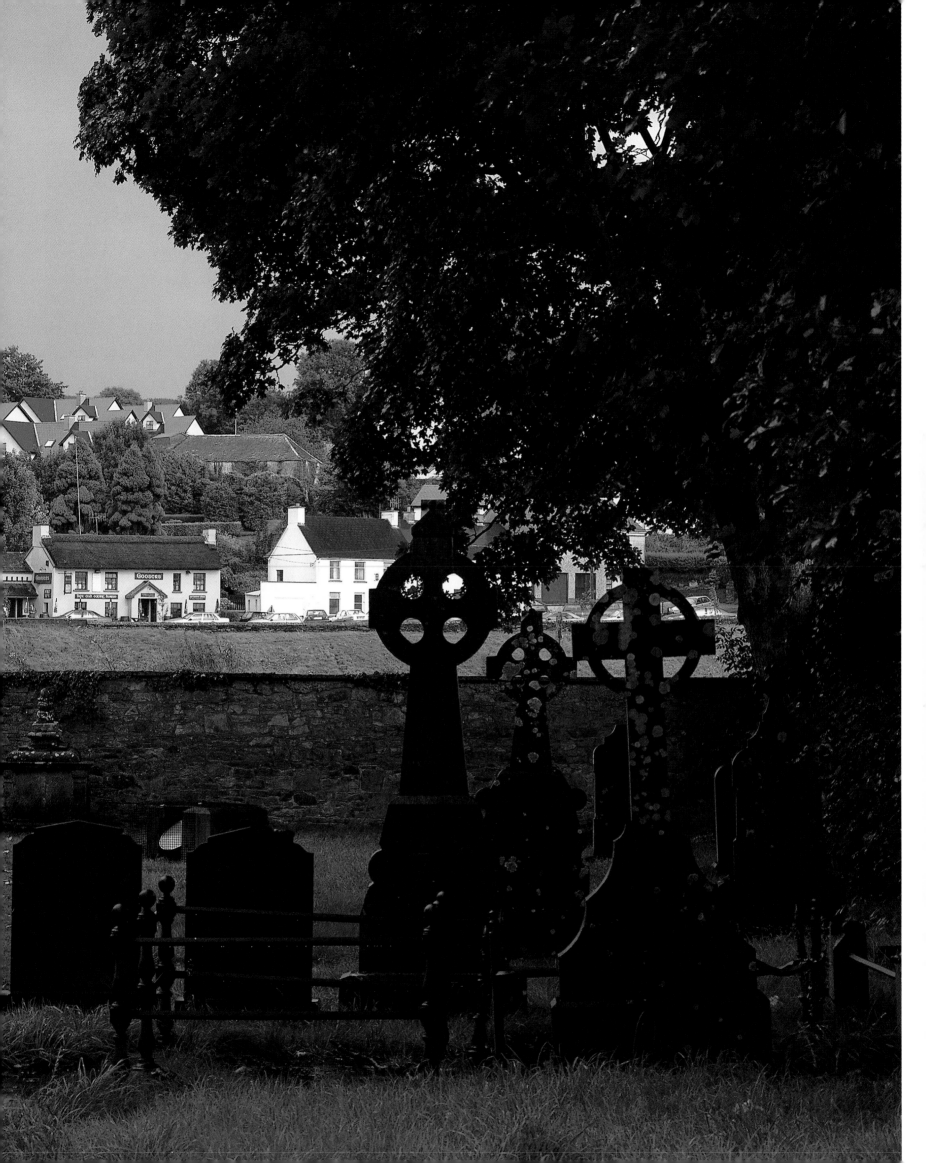

*T*ime and religious belief have left many imprints on Killaloe: St. Flannan's Cathedral *(right); a stone circle at Grange (below); and one of Killaloe's immemorial burial grounds (opposite).*

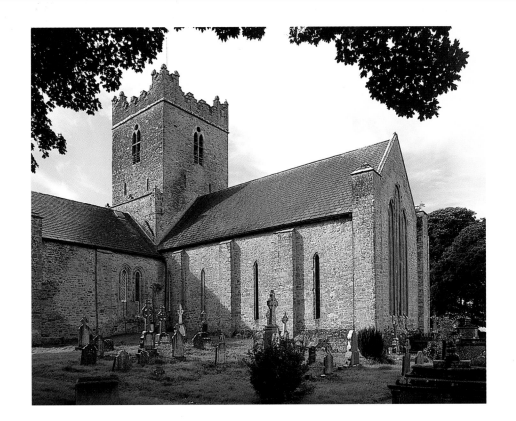

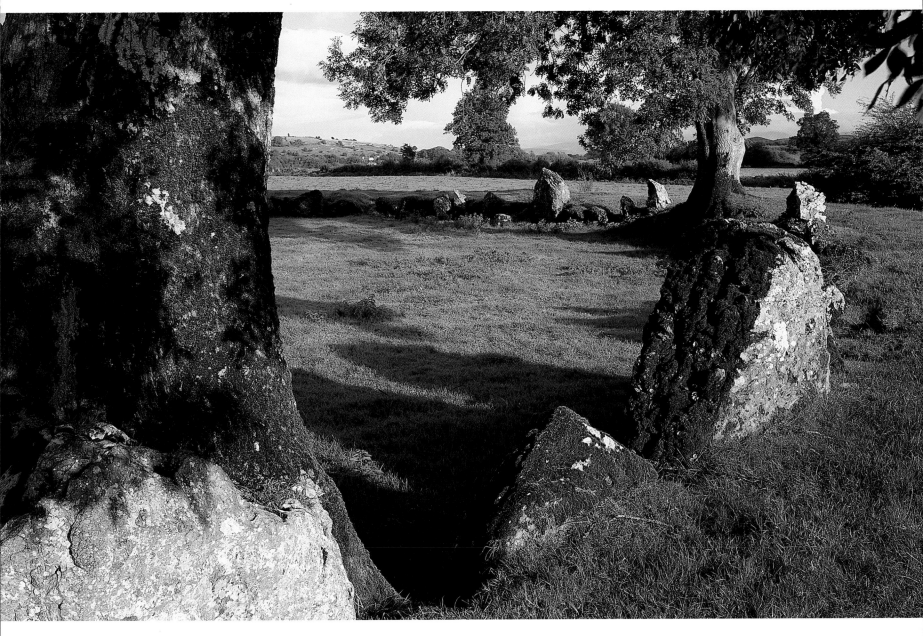

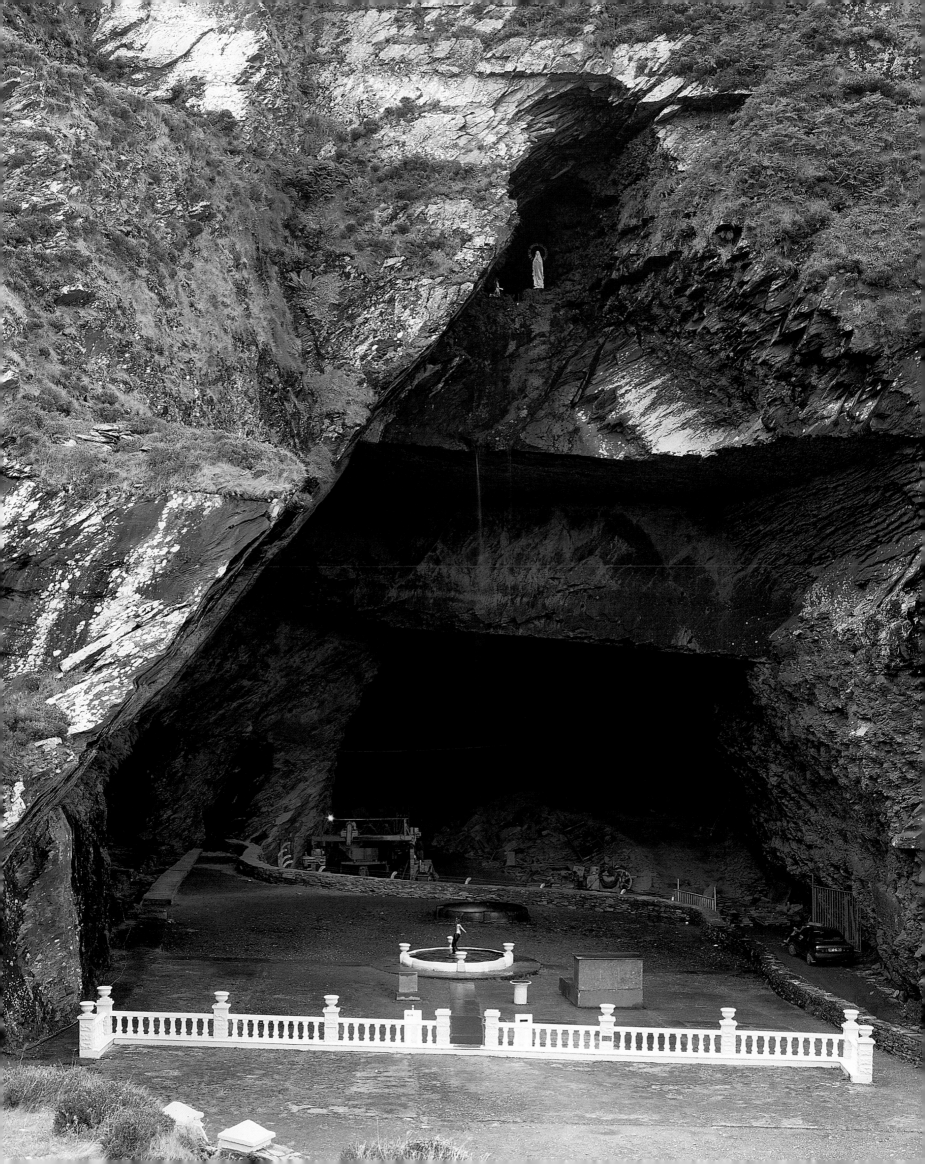

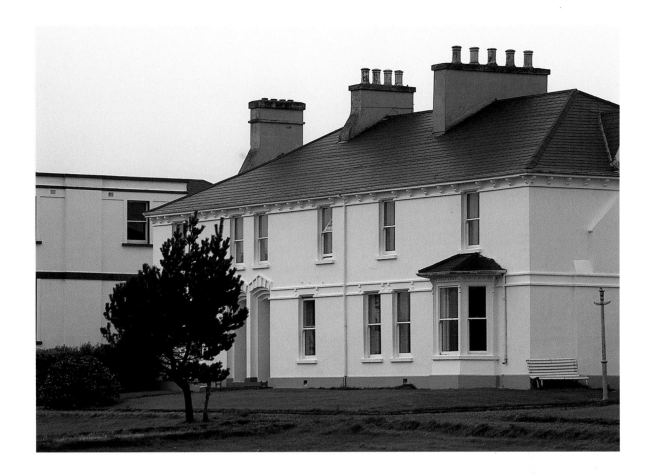

The devotional and industrial coincide at the holy grotto situated at the entrance to a slate quarry at Knightstown (opposite). Almost all the housing in Knightstown was created for employees of the succession of maritime and technological installations which were established in the village from the middle of the 19th century (right).

Knightstown

(*Baile an Ridire* = Town of the Knight)

KERRY

THE KNIGHT referred to is the Knight of Kerry, whose ancestral seat was at Glanleam on Valentia Island. The Knight no longer lives there, but his title is preserved in the name of this remarkable island village, which is quite unlike any other in County Kerry, or indeed any other on the western seaboard.

Valentia is about seven miles long and three miles across at its broadest. Its fertility, in comparison with a marshy and mountainous mainland, earned for it the title 'Granary of the South West'. The slate quarries were even more important to the island's economy, and for this reason a processing yard and harbour for the export of finished slates was established in the early 19th century. The 19th Knight was of entrepreneurial disposition, and was responsible for developing the quarries and for petitioning for the establishment of the Transatlantic Cable Station – one of the technological marvels which led to an influx of trained personnel who contributed more than any other factor to the prosperity of Knight's Town.

The perilous task of cable-laying began in 1857 from two specially adapted ships. Seven years later Europe and America were connected via Knightstown and Heart's Content, Newfoundland. Sir Robert Peel was present when the first official messages were passed from Queen Victoria to President Andrew Johnson. So important did the service become that four operators were employed solely to deal with stock exchange reports. At its height, the service dealt with an average of three thousand messages a day.

The Cable Station building was designed by Thomas N. Deane of Cork in 1868, and fine terraces of houses were built for the employees – on the foundation of the Irish Free State in 1922 there was a staff of 242 persons. An observatory flourished for a time, and Guglielmo Marconi established a Wireless Station in 1912. A lighthouse and a coast-guard station – both with attendant dwellings – as well as a lifeboat station, add to the official marine appearance of the village. Since the decline of wireless telegraphy many of the officers' houses have been bought as holiday homes and are exceptionally well-maintained by their new owners.

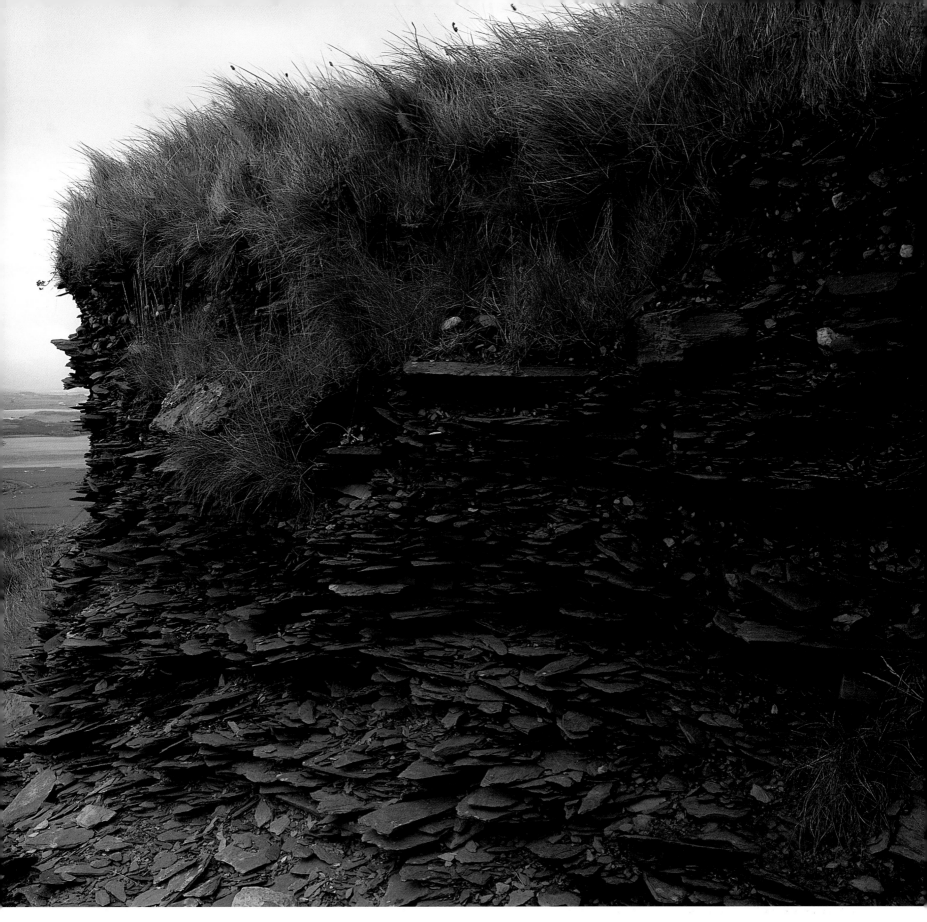

The car-ferry plies several times an hour to the mainland at Reenard, on the opposite shore, seen beyond the clock-tower on the quay at Knightstown (opposite above). *A village of neat houses* (opposite below), *Knightstown is especially famous for its slate. Perhaps the most prestigious buildings to be roofed with it are the Houses of Parliament in London.*

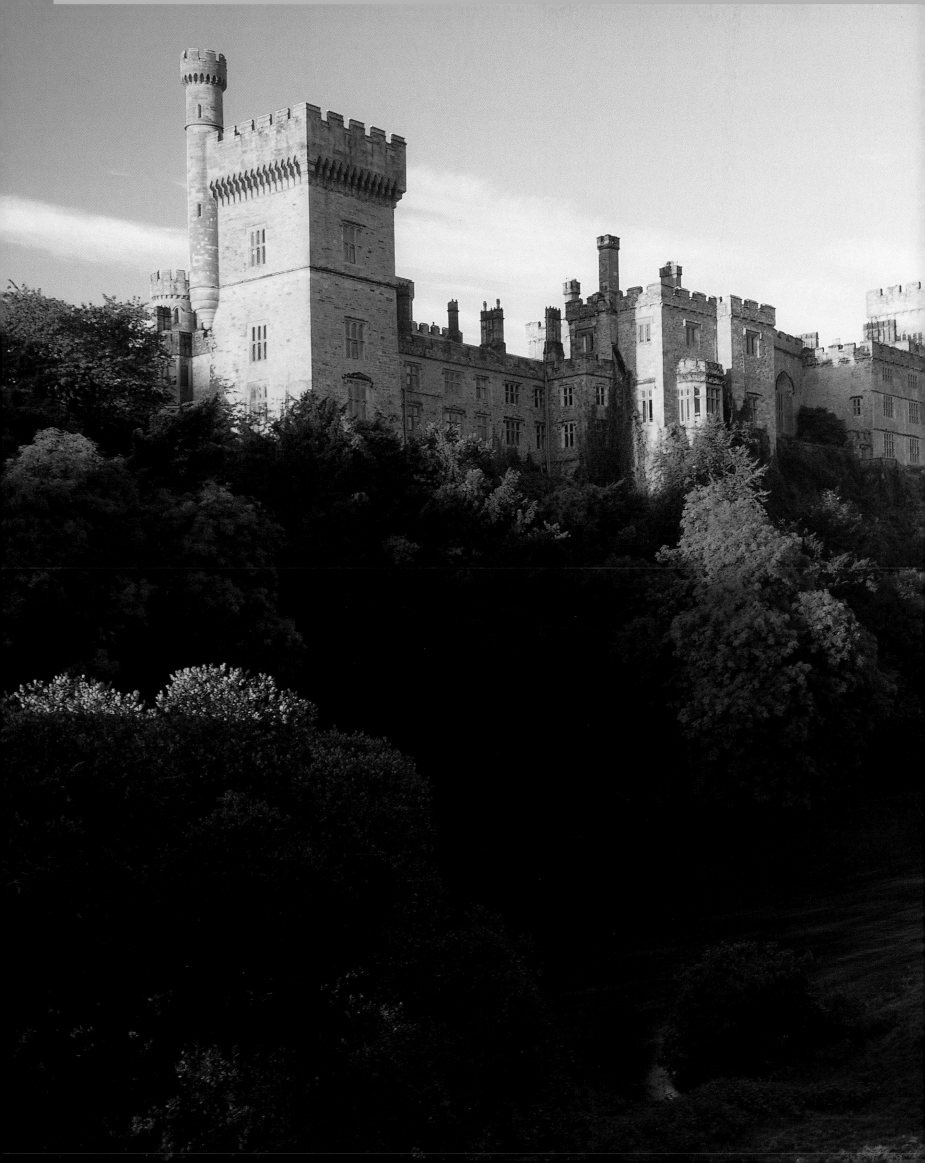

Lismore

(*Lios Mór Mochuda* = Mochuda's Great Enclosure)

WATERFORD

IN TERMS OF ITS HISTORY, traditions, fine buildings, and the achievements of its people and those associated with them, Lismore is a 'city'. Fortunately its population is now very small, and it can therefore be included in this book without insult to those who might, with justification, wonder at the 'village' designation. To nowhere, if not Lismore, can the phrase 'small is beautiful' be more appropriately applied; its intimacy, and its walkability, have recently made it a prime destination for the discerning tourist – abetted by the successful efforts of the citizens to maintain its patrimonial allure.

The immensity of the Castle, in its commanding situation high above the wooded Blackwater, is what immediately enthrals the visitor. It was begun in 1185, and the present fabric embraces secular and monastic remains from that time. Bishop Myler McGrath granted it to Sir Walter Raleigh in the late 16th century. Raleigh subsequently sold it to Richard Boyle, the 'Great Earl' of Cork. In 1753 it became the property of the present owners, the Dukes of Devonshire; between 1840 and 1858 the 6th Duke masterminded the remodelling, for which he employed the architect Joseph Paxton.

The Great Earl's third son, Roger Boyle, was a distinguished dramatist whose play *Altimera* (Dublin, 1662) was the earliest in the 'Restoration' mode; his seventh son, the scientist Robert Boyle, formulated 'Boyle's Law' on the pressure and volume of gas. In 1814 the wonderful Lismore Crozier and the *Book of Lismore* were discovered in the castle walls, where they had probably been hidden from Viking raiders – eight sackings of the medieval city are recorded, and there may have been more. The *Book of Lismore* contains the Lives of the Munster Saints, a copy of the Book of Rights, Ossianic poetry, and biographies of Charlemagne and Marco Polo!

St. Carthage is the patron of Lismore – he was affectionately addressed as *Mo Chuda* ('My comrade') and this epithet is incorporated in the Irish name for the town. The university which he founded in A.D. 633 attracted students from Christianized Europe, among them the future king of England, Alfred 'The Great'. The present St. Carthage's Cathedral was built in the 1630s; subsequent alterations and extensions have, curiously, increased its visual appeal. Medieval tombs dating from an earlier church, a marvellous tower and ribbed spire by the Pain Brothers of Cork (1827), a memorial window to a local benefactor, Francis Curry, designed by Burne-Jones and made by the William Morris workshop (1896), and other artefacts, co-exist harmoniously. The Roman Catholic Church of St. Carthage is an attractive essay in Lombardic Romanesque of 1884 by W.G.Doolin.

Lismore Castle, home of the Dukes of Devonshire, has welcomed many distinguished guests: Edward VII and Queen Alexandra who arrived in Lismore by train, William Makepeace Thackeray who travelled by carriage, and Fred Astaire who came by limousine and whose sister Adèle married the 9th Duke.

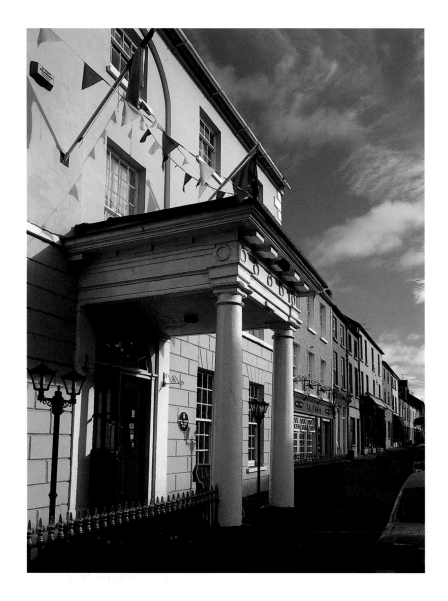

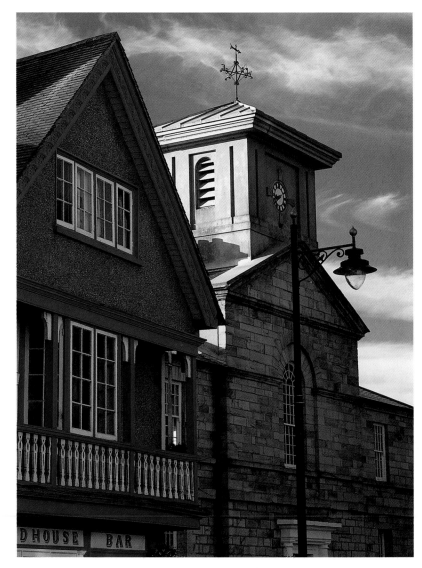

*T*he village of Lismore combines elegance and tradition: *the portico of the Lismore Hotel* (above) *is a dominant feature of the main street; the Square is remarkable for its neoclassical Court House (now the Heritage Centre)* (above right); *the entrance to St. Carthage's Cathedral in the North Mall has a remarkably imposing gateway* (right).

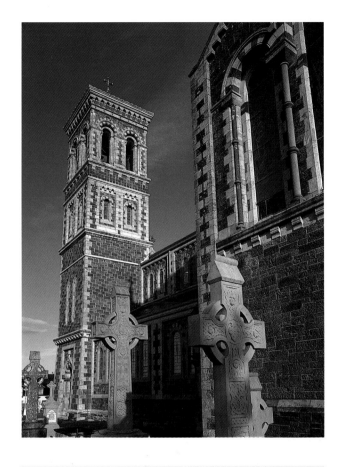

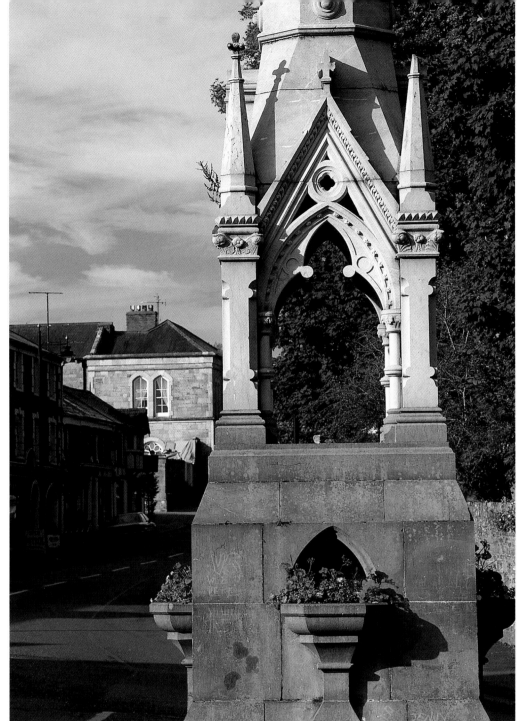

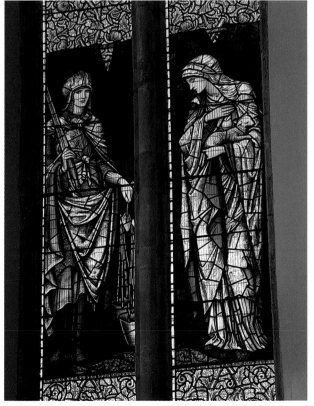

*L*ismore is singularly well endowed with ecclesiastical
monuments (clockwise, from right): *the memorial
of 1872 to Archdeacon Andrew Power; windows depicting
Justice and Humility by Burne-Jones in St. Carthage's
Cathedral; and St. Carthage's Roman Catholic church.*

Rosscarbery

(*Ros ó gCáirbre* = Carbery's Wooded Promontory)

CLARE

IT IS VERY EASY to miss Rosscarbery, for there are many distractions on the main road from Cork City to the peninsulas and islands of West Cork, not the least being the lagoon of Rosscarbery itself, over which the road passes by means of a causeway which affords such delightful prospects that one is quite likely not to notice the sign for the village.

There is much of an interestingly intimate nature to divert the motorist or cyclist away from Rosscarbery. Coming from the east, there are notices which entice one down quiet green lanes – to the grassy ring-forts of Teampaillín Fachtna and St. Fachtna's holy well, to the megalithic tomb and the standing stone near Burgatia cross-roads, and to the little strands of Creggane and Ownahincha. Coming from the west, side roads offer the extraordinary Drombeg stone circle, and a glimpse of the shell of Coppinger's Court – a grandly conceived Jacobean mansion which was to have been the centrepiece for a new English town, but its life was cut short when it was put to the torch during the 1641 rebellion. Another side road leads to the remains of Carrigagappul Castle and Downeen Point, overlooking Rosscarbery Bay. The offshore rock known as Carraig Chlíodhna is haunted by the goddess of that name: the Wave of Clíodhna is one of the three great ocean waves of mythology.

The main part of the village is situated on what can reasonably be described as an eminence; unusually for eminences, it is invisible from the highway below. There is a very charming square with several fine traditional shop fronts, and some newer developments, built mostly for summer visitors, which fit in surprisingly well. (The massive circular tower of the new hotel on the main road is totally out of keeping and out of scale with everything in the man-made and in the natural environment, and one wonders how it was allowed.) There is a dignified cluster of conventual buildings near the handsome post-Emancipation Roman Catholic church. The Protestant church, with its doorway in a pastiche Hiberno-Romanesque style, is the cathedral for the Diocese of Ross. It contains a number of exceptionally interesting relics of the colonial period.

There are still a number of slate-hung houses. These are found mainly in the south-western counties, and are occasioned by the moist climate and the availability of the raw material. The slates are bedded in lime mortar and fixed on to the walls in overlapping courses. The quarry on Benduff Hill behind Rosscarbery produces a greenish-grey slate with an attractively rough texture which makes the buildings thus roofed or clothed look as if they have grown out of the landscape.

Rosscarbery, ancient capital of The Carberies and former seat of the Bishops of Ross, makes a particularly alluring sight viewed across its lagoon.

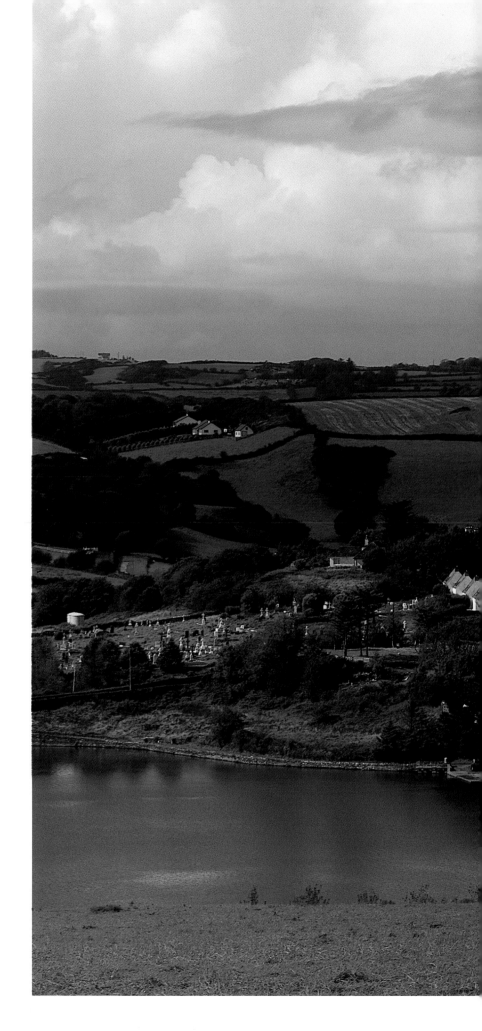

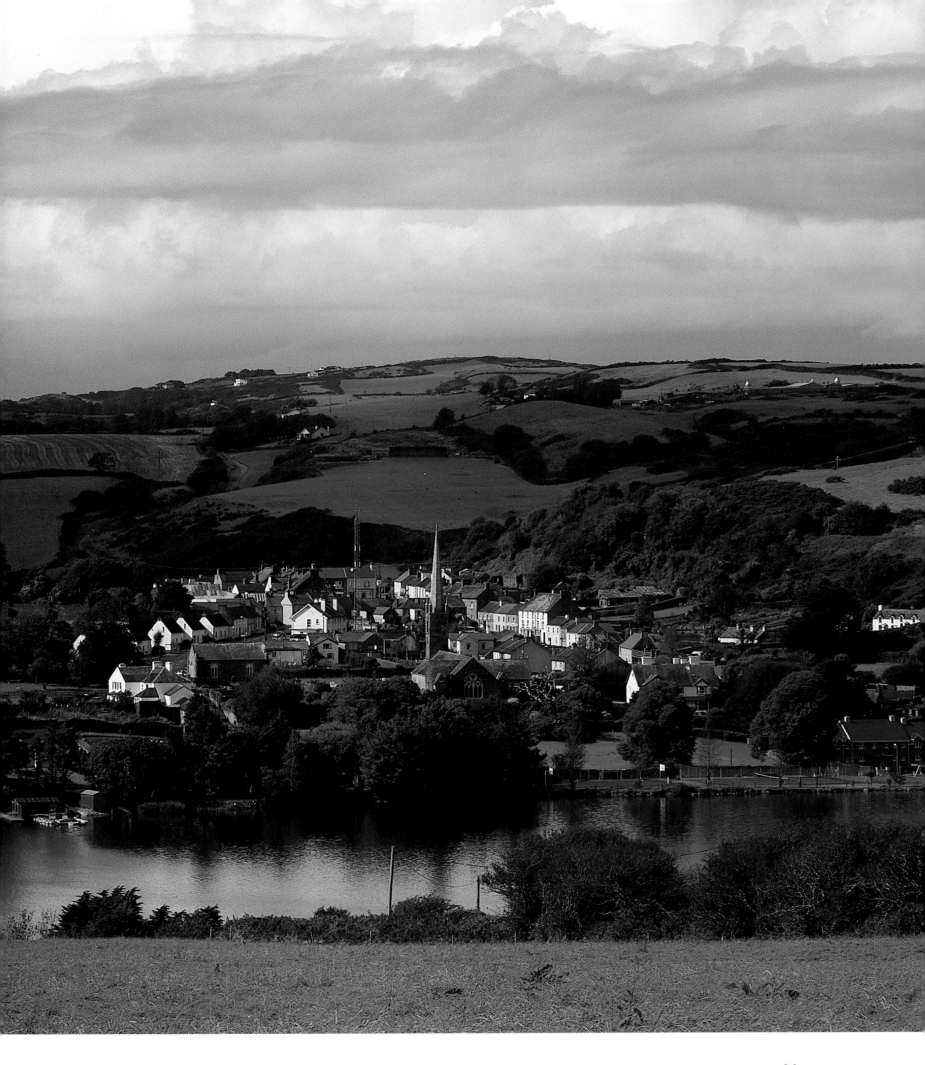

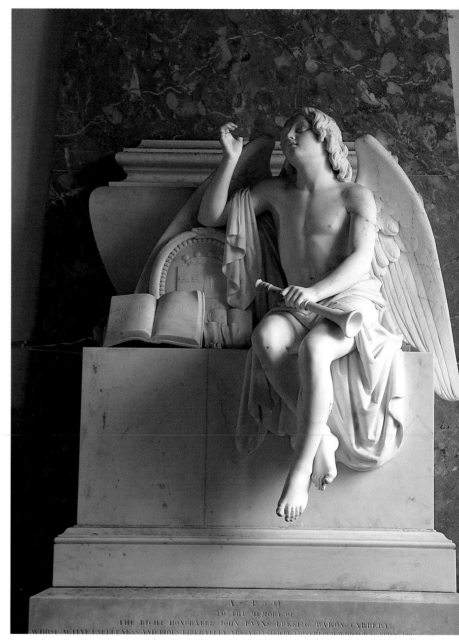

*S*t. *Fachtna's Cathedral* (opposite) *was built in the 16th century near a now vanished early-Christian site. A dyspeptic 1960s guidebook describes it as 'miserable'. Far from being such, it is packed with interesting monuments and memorials* (above left). *A sculpture by the Belgian artist Guillaume Geefs* (above right) *commemorates the 6th Lord Carbery and was brought to its present location when Rathbarry church, three miles away, was demolished.*

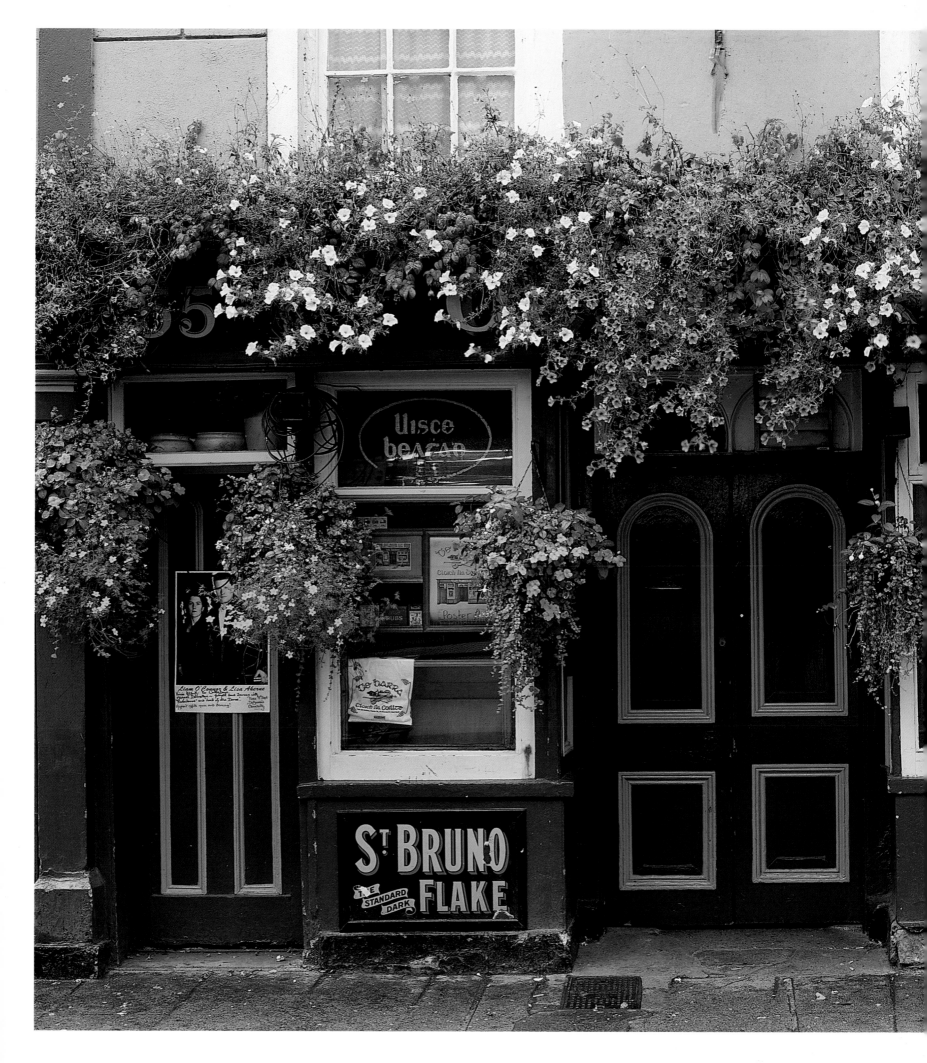

A Traveller's Guide

WHILE every effort has been made to ensure that the information given in the following entries is correct, the author and the publisher cannot be held responsible for any inadvertent omissions, inaccuracies or alterations made after publication. Opening dates and times of local attractions change seasonally and sometimes alter from year to year; it is always advisable to check with the venue or the nearest Tourist Information Office in advance. The annual *Tourist Information Network* brochure covers the whole of Ireland and is the essential guide to the locations and opening hours of all official information bureaux. When in Ireland, the best guide to current events in sport, theatre, music and other entertainments is invariably the local newspaper, wherever you happen to be.

The star ratings for hotels are those given by the Irish Tourist Board and the Northern Ireland Tourist Board. (Some premises, often the best in the neighbourhood, choose not to have a star rating.) Guide-books published in Ireland are more comprehensive and reliable than those produced elsewhere; essential are *Be Our Guest* published by the Irish Hotels Federation, the *Ireland Accommodation Guide* published by Creative Input, and *Where to Stay in Northern Ireland* published by the Northern Ireland Tourist Board. There are also several specialist guides such as *The Friendly Homes of Ireland*, *Logis of Ireland*, and *Ireland's Blue Book* which lists a range of country mansions from the plainly bucolic to the sybaritic. As well as hotels, hostels, country houses and guest houses there are hundreds of bed-and-breakfast establishments – far too numerous to name here. Visitors are strongly advised to consult the latest editions of *Town & Country Homes*, and the excellent *Guide to Bed & Breakfast in Northern Ireland*. All these guide-books should be available from the Tourist Offices listed below.

De Barra's in Clonakilty, near Rosscarbery, County Cork; this wonderful pub simply had to be included although Clonakilty itself is by no means a village: in fact, it is one of the most visited towns in Ireland, having won the Tidy Towns Competition in the final year of the 20th century!

A Traveller's
Guide

Plumbridge, County Tyrone

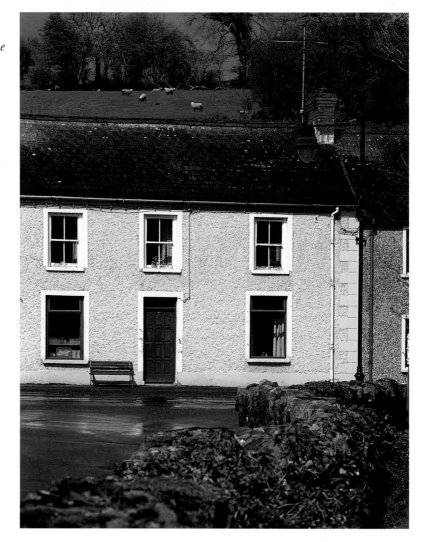

Tourist Boards

Irish Tourist Board

DUBLIN
Dublin Tourism Centre, Suffolk
Street, Dublin 2; tel. 01-6057700
LONDON
150 New Bond Street, London
W1Y 0AQ tel. 0171-4932301
NEW YORK
345 Park Avenue, New York
NY10154; tel. 212-4180800
SYDNEY
5th Level, 30 Carrington Street,
Sydney NSW 2000; tel. 02-9299-
61677

Northern Ireland Tourist Board

BELFAST
59 North Street, Belfast BT1 1NB;
tel. 01232-246609
LONDON
24 Haymarket, London SW1Y 4DG;
tel. 0541-555250
NEW YORK
551 Fifth Avenue, Suite 701, New
York NY 10176; tel. 212-9220101
SYDNEY
All-Ireland Tourism, Level 5, 36
Carrington Street, Sydney NSW
2000; tel. 02-92996177

ULSTER
Northern Ireland

Belleek, County Fermanagh
Sights
Castle Caldwell Forest;
tel. 013656-31253
Explore Erne Exhibition, Gateway
Centre; tel. 013656-58866
Where to Stay
**Hotel Carlton; tel. 013656-58282
*Fiddlestone Guest House;
tel. 013656-58008
Riverside Guest House;
tel. 013656-58649
Where to Eat
Cleary's; tel. 013656-58403
Fiddlestone Cafe; tel. 013656-58008
McDonnell's; tel. 013656-58392
McMorrow's; tel. 013656-58423
Pottery Tea Rooms;
tel. 013656-58501
Rooney's; tel. 013656-58279
Thatch Coffee Shop;
tel. 013656-58181
Information Enniskillen; tel. 01365-
323110

Cushendall, County Antrim
Sight Ossian's Grave
Event
John Hewitt Summer School
(June) (Carnlough – 8 miles); tel.
01266-44247
Where to Stay
**Caireal Manor Guest House;
tel. 012667-56465
Moneyvart House Hostel;
tel. 012667-71344
*Thornlea Hotel; tel. 012667-71223
Where to Eat
Gillan's Restaurant; tel. 012667-
71404
Half Door; tel. 012667-71300
Harry's; tel. 012667-72022
Lurig Inn; tel. 012667-71527
Information Ballycastle;
tel. 012657-62024

Glaslough, County Monaghan
Event
Harvest Time Blues Festival
(September) (Monaghan – 6
miles); tel. 047-82982
Where to Stay
Castle Leslie; tel. 047-88109
Pillar House Hotel; tel. 047-88269

Information Monaghan;
tel. 047-81122

Loughgall, County Armagh
Sights
Ardress House & Farmyard
(National Trust) (3 miles); tel.
01762-851236
The Argory House and Grounds
(National Trust) (6 miles);
tel. 01868-784753
Dan Winter Ancestral Home
(Orange Order Heritage Centre);
tel. 01762-851344
Events
Apple Blossom Festival (May);
tel. 01861-529606
Ulster Pipe Band Championships
(August) (Armagh – 5 miles);
tel. 01232-833811
Where to Eat
Famous Grouse; tel. 01762-891778
Information Armagh; tel. 01861-
521800

Moneymore,
County Londonderry
Sight
Springhill House, Costume
Museum and Gardens

(National Trust); tel. 016487-
48210
Where to Eat
Bier Keller; tel. 016487-48282
Springhill House Coffee Shop;
tel. 016487-48210
Information Cookstown;
tel. 016487-66727

Plumbridge, County Tyrone
Sights
Gortin Glen Forest Park (8 miles);
tel. 016626-48217
Ulster History Park (near Gortin –
10 miles); tel. 016626-48188
Sperrin Heritage Centre (Crannagh
– 10 miles);
tel. 016626-48142
Woodrow Wilson Ancestral Home
(Strabane – 10 miles); tel. 01504-
883735
Where to Eat
Pinkerton's Cafe; tel. 016626-48327
Information Strabane; tel. 01504-
883735

Portaferry, County Down
Sight
Exploris Heritage Centre and
Aquarium; tel. 012477-28062

Event
Portaferry Galway Hookers Regatta
 (June); tel. 012478-26846
Where to Stay
Barholm Hostel; tel. 012477-29598
***The Narrows Guest House;
 tel. 012477-28148
***Portaferry Hotel; tel. 012477-
 28231
Where to Eat
Christine's Cafe; tel. 012477-38971
Cornstore; tel. 012477-29779
Exploris; tel. 012477-28062
Ferry Grill; tel. 012477-28448
Scotsman; tel. 012477-28024
Information tel. 012477-29882

Rathmelton, County Donegal
Event
Lenon Community Festival (July)
Where to Stay
Ardeen; tel. 074-51243
Clooney House; tel. 074-511255
Crammond; tel. 074-51055
Meadowell; tel. 074-51290
Where to Eat
House on the Brae Restaurant;
 tel. 074-51240
Information Letterkenny; tel. 074-
 21160

Strangford, County Down
Sight
Castleward House, Gardens and
 Cornmill (National Trust) (2
 miles); tel. 01396-881204
Event
Castleward Opera (May);
 tel. 01232-661090
Where to Eat
Cuan; tel. 01396-881222
Lobster Pot; tel. 01396-881288
Information tel. 01477-29882

Virginia, County Cavan
Event
Virginia Street Fair & Vintage
 Displays (June)
Where to Stay
Lisduff House;
 tel. 049-45054
***Park Hotel; tel. 049-47235
**Sharkey's Hotel; tel. 049-47561
St Kryan's; tel. 049-47087
The White House; tel. 049-47515
Information Cavan; tel. 049-31942

LEINSTER

Ardagh, County Longford
Sights
Ardagh Heritage Centre;
 tel. 043-75277
Ardagh House and Yard;
 tel. 043-75003
Where to Eat
Midhir & Etain; tel. 043-75277
Information Longford;
 tel. 043-46566

Carlingford, County Louth
Sights
Carlingford Heritage Centre;
 tel. 042-9373454
Contemporary Crafts Gallery; tel.
 042-9373005
Activity
Carlingford Adventure Centre;
 tel. 042-9373100
Events
Annual Sheepbreeders' Show (end
 August); tel. 042-9373118
Carlingford Regatta (mid August);
 tel. 042-9373731
Carlingford Fun Weekend (end
 August); tel. 042-9373118
Where to Stay
Beaufort Guest House;
 tel. 042-9373878
Carlingford Adventure Centre
 Hostel; tel. 042-9373100
Gahan House;
 tel. 042-9373682
**McKevitt's Village Hotel; tel.
 042-9373144
***View Point Hotel; tel. 042-
 9373149
Where to Eat
Carlingford Arms;
 tel. 042-9373418
Carlingford Marina;
 tel. 042-9373073
Georgina's Bakehouse;
 tel. 042-9373731
Jordan's Town House & Bistro;
 tel. 042-9373223
Magee's Bistro; tel. 042-9373751
Murphy's Cottage;
 tel. 042-9373735
Oyster Catcher Lodge;
 tel. 042-9373922
Terrace Restaurant; tel. 042-
 9373731
Information tel. 042-9373888

Near Dalkey, County Dublin

Dalkey, County Dublin
Sight
Dalkey Castle Heritage Centre;
 tel. 01-2858366
Where to Stay
***Court Hotel 2m; tel. 01-2851622
****Fitzpatrick's Castle Hotel (1
 mile); tel. 01-2850207
****Tudor House; tel. 01-2851622
Where to Eat
Guinea Pig; tel. 01-2859055
Laurel Tree; tel. 01-2848126
P.D.'s Wood House;
 tel. 01-2849399
Queen's; tel. 01-2854569
Ragazzi; tel. 01-2847280
Il Ristorante; tel. 01-2840880
Torlua's; tel. 01-2840756
Information Dublin;
 tel. 1850-230330

Enniskerry, County Wicklow
Sight
Powerscourt House & Gardens; tel.
 01-204600
Event
County Wicklow Gardens Festival
 (May–July); tel. 0404-66058
Where to Stay
**Enniscree Lodge Hotel; tel. 01-
 2866037

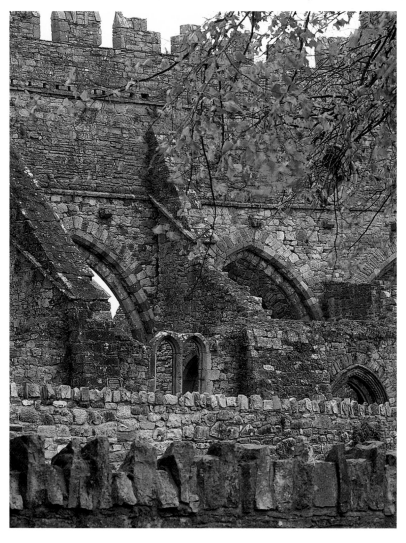

Activity
Brandon Hill Walk – signposted
Where to Stay
***Waterside Guest House; tel. 0503-24246
Where to Eat
Waterside Restaurant; tel. 0503-24246
Information Kilkenny; tel. 065-51500

Kilmore Quay, County Wexford
Sight
Yola Farmstead Folk Park (8 miles); tel. 053-31177
Where to Stay
**Hotel Saltees; tel. 053-29602
***Quay House; tel. 053-29388
Information Rosslare; tel. 053-33232

Slane, County Meath
Sights
Brú na Boinne Archaeological Park & Visitor Centre; tel. 041-9880305
Ledwidge Cottage Museum; tel. 041-9824544
Where to Stay
Boyne View; tel. 041-9824121
Castle View House; tel. 041-9824510
**Conyngham Arms; tel. 041-9824155
Hillview House; tel. 041-9824327
Mattock House; tel. 041-9824592
Roselawn; tel. 041-9824711
Where to Eat
Boyle's Tea Rooms; tel. 041-9824195
Game Keeper's Lodge; tel. 041-9824155
O'Neill's Restaurant; tel. 041-9824090
The Poet's Rest; tel. 041-9823252
Roadrunner Restaurant; tel. 041-9824666
The Village Inn; tel. 041-9824230
Information Brú na Boine; tel. 041-9880305

Tyrrellspass, County Westmeath
Sights
Belvedere House, Gardens & Jealous Wall; tel. 044-49060
Tyrrellspass Castle; tel. 044-23105
Where to Stay
**Village Hotel; tel. 044-23105

Where to Eat
Castle Restaurant; tel. 044-48650
Information Mullingar; tel. 044-48650

CONNACHT

Boyle, County Roscommon
Sights
Animal Farm Visitors Centre; tel. 079-68031
Boyle Abbey; tel. 079-62604
Frybrook House; tel. 079-62170
King House; tel. 079-63242
Lough Key Forest Park; tel. 079-62212
Event
Boyle Arts Festival (July–August); tel. 079-63085
Where to Stay
**Forest Park; tel. 079-62229
**Royal Hotel; tel. 079-62016
Where to Eat
King House Coffee Shop; tel. 079-63242
Information tel. 079-62145

Inishmaan, County Galway
Sights
Dun Chonchur Fort
Synge's Cottage and 'Chair'
Where to Stay
Tigh Chonghaile; tel. 099-73085
Where to Eat
Ard Alainn; tel. 099-73027
An Dúin Restaurant (no telephone)
Information tel. 099-73010

Newport, County Mayo
Sights
Ancestral Home of the late H.R.H. Princess Grace of Monaco (3 miles)
Burrishoole Dominican Abbey (ruins) (2 miles)
Salmon Research Visitor Centre, Furnace Lake (3 miles)
St Patrick's Church
Events
International Handball Competition (August); tel. 098-25711
Newport Sea Angling Festival (August); tel. 098-41265
Where to Stay
An Oige Hostel; tel. 098-41358
*Black Oak Inn; tel. 098-41984

**Summerhill House Hotel; tel. 01-2867929
*Powerscourt Arms Hotel; tel. 01-2863507
Lackan House Hostel; tel. 01-2864036
Where to Eat
Curtlestown House Restaurant; tel. 01-2825083
Information Bray; tel. 01-2867128

Gowran, County Kilkenny
Sights
Shankill Castle & Gardens (3 miles); tel. 0503-226145
St Mary's Collegiate Church – key at 4 Dover Row
Kilfane Glen, Waterfall & Cottage Orné (5 miles); tel. 056-24558
Event
Gowran Park Races, monthly except July, November & December
Information Kilkenny; tel. 056-51500

Graiguenamanagh, County Kilkenny
Sight
Duiske Abbey; tel. 0503-24238

Bridge Inn; tel. 098-41524
Newport House Hotel; tel. 098-41222
Traenlur Lodge Hostel; tel. 098-41358
Where to Eat
Bay View Restaurant; tel. 098-41524
Kelly's Kitchen; tel. 098-41149
Information Westport; tel. 098-25711

Rosses Point, County Sligo
Sights
Drumcliffe Church & Visitor Centre (3 miles); tel. 071-44956
Lisadell House (7 miles); tel. 071-63150
Events
Drumcliffe Summer Classical Music (selected dates) (3 miles); tel. 071-44956
Sligo Arts Festival (May–June) (5 miles); tel. 071-69802
Yeats International Summer School (August) (Sligo – 5 miles); tel. 071-42693
Where to Stay
***Ballincar House Hotel; tel. 071-45361
Bayview; tel. 071-62148
Coral Reef; tel. 071-77245
Kilvarnet House; tel. 071-77202
Liscorrach; tel. 071-77250
Oyster View; tel. 071-77201
Philmar House; tel. 071-45014
Sanuid; tel. 071-42773
Sea Park House; tel. 071-45556
Silver Seas; tel. 071-45014
***Yeats Country Hotel; tel. 071-77211
Where to Eat
The Moorings Restaurant; tel. 017-82069
Information Sligo; tel. 071-61201

Roundstone, County Galway
Events
Connemara Four Seasons Walking Festivals; tel. 095-21379
Connemara Pony Show (August) (Clifden – 10 miles); tel. 095-21663
Where to Stay
Eldon's Hotel; tel. 095-35933
**Roundstone House; tel. 095-35864
*Seal's Rock; tel. 095-35860

Where to Eat
Beola Restaurant; tel. 095-35010
O'Dowd's Seafood Bar; tel. 095-35809
Shamrock Restaurant; tel. 095-35010
Information Clifden; tel. 095-21163

MUNSTER

Adare, County Limerick
Sights
Adare Heritage Centre; tel. 061-396255
Augustinian and Trinitarian Priories, and several historic remains
Croom Mills Heritage Centre (4 miles); tel. 061-397130
Event
Adare May Fair (May); tel. 061-396894
Where to Stay
*****Adare Manor; tel. 061-396566
***Carrabawn Guest House; tel. 061-396067
****Dunraven Arms; tel. 061-396633
***Fitzgerald's Woodland's House Hotel; tel. 061-396118
Where to Eat
The Arches; tel. 061-396246
The Blue Door; tel. 061-396481
The Golden Dragon; tel. 061-396383
The Inn Between; tel. 061-396633
The Wild Geese; tel. 061-396451
Information 061-396255

Allihies, County Cork
Sight
Former Copper Mines
Event
Beara Arts & Allihies Theatre Festival (July–August); tel. 027-70765
Where to Stay
Sea View Guest House; tel. 027-73004
Village Hostel; tel. 027-74107
Information Kenmare; tel. 064-41233

Castletownsend, County Cork
Sight
St Barrahane's Church

Event
Festival of Classical Music (July–August); tel. 028-36193
Where to Stay
Castle Guest House; tel. 028-36100
Information Skibbereen; tel. 028-21766

Dunmore East, County Waterford
Where to Stay
**Candlelight Inn; tel. 051-383215
**Corballymore Guest House; tel. 051-383143
Dunmore Harbour House Hostel; tel. 051-383218
**Haven Hotel; tel. 051-383150
**Ocean Hotel; tel. 051-383136
Where to Eat
Strand Seafood Restaurant; tel. 051-383174
Information Waterford; tel. 051-358397

Glengariff, County Cork
Sights
Glengariff Forest Park
Ilnacullin (Garinish) Island & Italian Gardens; tel. 027-63040
Where to Stay
**Casey's Hotel; tel. 027-63010

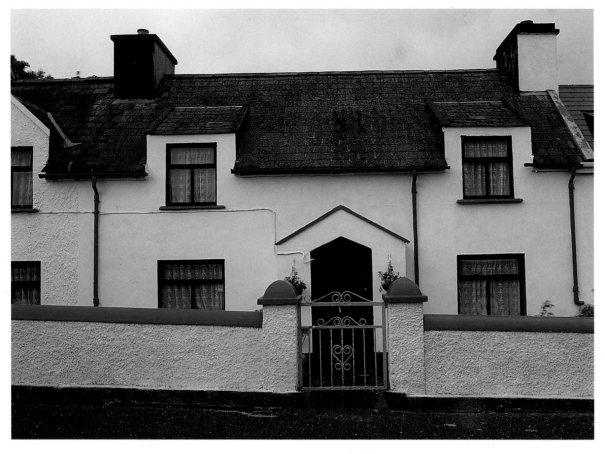

Where to Stay

***Kincora Hall Hotel; tel. 061-376000

***Lakeside Hotel; tel. 061-376122

***Lantern House; tel. 061-923034

****Tianarana Guest House; tel. 061-376966

***Waterman's Lodge; tel. 061-376333

Where to Eat

Dalcassin; tel. 061-376762

Galloping Hogan; tel. 061-376162

Gooser's; tel. 061-376791

Irish Molly's; tel. 061-376632

Simply Delicious; tel. 061-375335

Information 061-376866

Knightstown, County Kerry

Sights

Skellig Experience Heritage Centre (3 miles); tel. 066-9476306

Valentia Island Heritage Centre; tel. 066-9476411

Where to Stay

An Oige; tel. 066-9476141

Where to Eat

Boston's; tel. 066-9476140

Information Cahirciveen; tel. 066-9472589

Lismore, County Waterford

Sights

St Carthage's Cathedral; tel. 058-54137

Lismore Castle Gardens; tel. 058-54444

Lismore Heritage Centre; tel. 058-53009

Where to Stay

*Ballyrafter House; tel. 058-54002

Lismore Hotel; tel. 058-54555

Information 058-54975

Rosscarbery, County Cork

Sights

Cathedral of St Fachtna; tel. 023-48166

Event

Carbery Agricultural Show (mid July) (Skibbereen – 12 miles); tel. 028-38270

Where to Stay

***Celtic Ross Hotel; tel. 023-48104

*Owenahincha Hotel; tel. 023-48722

Information Clonakilty; tel. 023-33226

**Eccles Hotel; tel. 027-63003

Glengariff Independent Hostel; tel. 027-63211

Golf Links Hotel; tel. 027-63500

Murphy's Village Hostel; tel. 027-63010

Information Bantry; tel. 027-50229

Holy Cross, County Tipperary

Sights

Farney Castle Visitor Centre; tel. 0504-43281

Holy Cross Abbey; tel. 0504-43241

Information Nenagh; tel. 067-31610

Kenmare, County Kerry

Sights

Kenmare Heritage Centre; tel. 064-41233

Kenmare Heritage Trail; tel. 064-41034

Event

Walking Festivals (various dates); tel. 064-41034

Where to Stay

***Dromquinna Manor Hotel; tel. 064-41657

***Dunkerron Guest House; tel. 064-41102

Failte Hostel; tel. 064-42333

***Foley's Shamrock Guest House; tel. 064-41379

***Kenmare Bay Hotel; tel. 064-41300

*Lake House Guest House; tel. 064-84205

***Lansdowne Arms Hotel; tel. 064-41368

*****Park Hotel; tel. 064-41200

***Riversdale House Hotel; tel. 064-41299

***Rose Garden Guest House; tel. 064-42288

*****Sheen Falls Lodge Hotel; tel. 064-41600

***Shelburne Lodge Guest House; tel. 064-41013

*Wander Inn; tel. 064-41038

Where to Eat

Cafe Indigo; tel. 064-42357

Lime Tree; tel. 064-41225

Old Bank House; tel. 064-41589

Packies; tel. 064-41508

Purple Heather; tel. 064-41016

Information 064-41233

Kilfenora, County Clare

Sights

The Burren Display Centre; tel. 065-7088030

Numerous field monuments

Information Ennis; tel. 056-6828366

Killaloe, County Clare

Sight

St Flannan's Cathedral

Events

Killaloe Chamber Music Festival (July); tel. 061-202620

European Pike Angling Challenge (September); tel. 061-453808

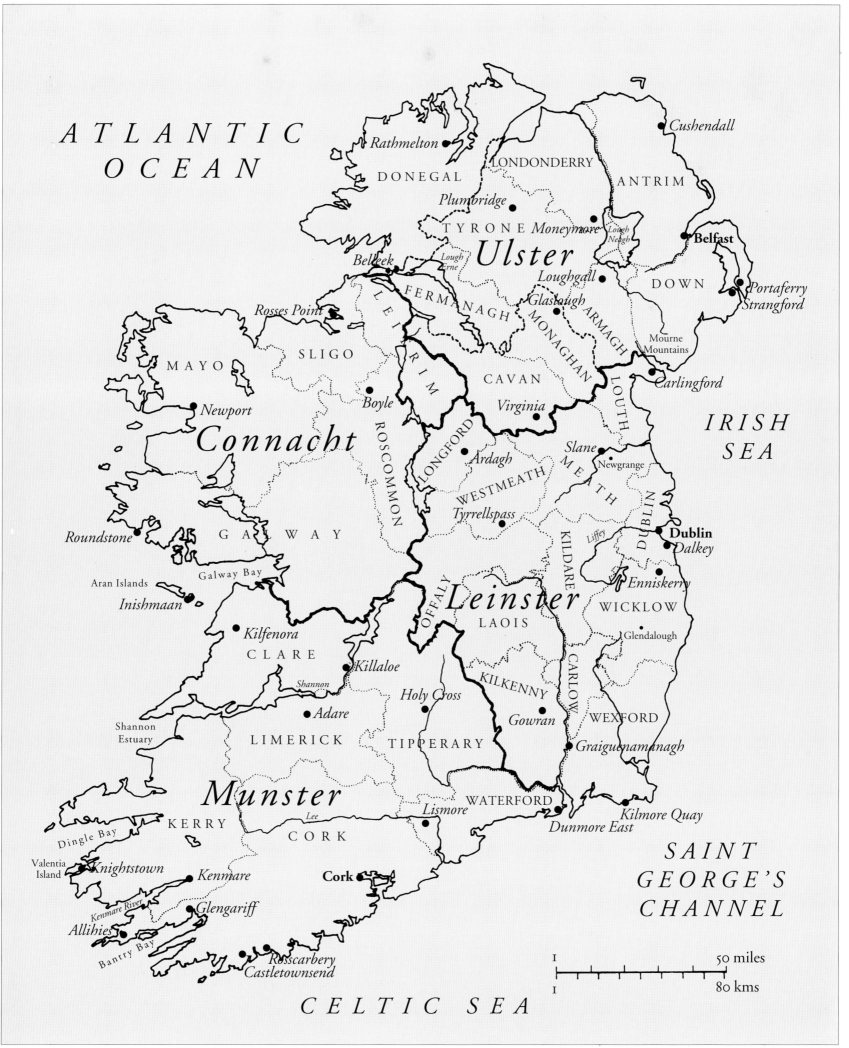

ATLANTIC
OCEAN

Rathmelton

DONEGAL

LONDONDERRY

ANTRIM

Cushendall

TYRONE

Plumbridge

Ulster

Moneymore

Lough
Neagh

Belfast

Belleek

Lough
Erne

FERMANAGH

Loughgall

DOWN

Rosses Point

LEITRIM

Glaslough

MONAGHAN

ARMAGH

Portaferry
Strangford

SLIGO

Mourne
Mountains

MAYO

CAVAN

LOUTH

Carlingford

Newport

Boyle

Connacht

ROSCOMMON

Virginia

IRISH
SEA

LONGFORD

Ardagh

Slane

MEATH

Newgrange

WESTMEATH

Roundstone

GALWAY

Tyrellspass

Liffey

DUBLIN

Dublin
Dalkey

Galway Bay

OFFALY

Leinster

KILDARE

Enniskerry

Aran Islands

LAOIS

WICKLOW

Inishmaan

Glendalough

Kilfenora

CLARE

Killaloe

KILKENNY

CARLOW

Shannon

Holy Cross

WEXFORD

Shannon
Estuary

Adare

Gowran

Graiguenamanagh

LIMERICK

TIPPERARY

Munster

WATERFORD

Kilmore Quay

KERRY

Lee

Lismore

Dunmore East

Dingle Bay

CORK

SAINT
GEORGE'S
CHANNEL

Valentia
Island

Knightstown

Kenmare

Cork

Glengariff

Kenmare River

Allihies

Bantry Bay

Rosscarbery
Castletownsend

CELTIC SEA

50 miles

80 kms

Select Bibliography

BRETT, C.E.B, *Portaferry and Strangford,* Belfast, 1979

CARVILLE, Geraldine, *The Heritage of Holy Cross,* Belfast, 1973

DELANEY, V.T.H. and D.R., *The Canals of the South of Ireland,* London, 1966

CRAIG, Maurice, *The Architecture of Ireland,* London, 1982

CURL, J.S., *Draperstown and Moneymore,* Belfast, 1979

DALLAT, Cathal, *The Road to the Glens,* Belfast, 1989

EGAN, Oliver, *Tyrrellspass, Past and Present,* Tyrrellspass, 1986

EVANS, Rosemary, *The Visitor Guide to Northern Ireland,* Belfast, 1987

FITZ-SIMON, Christopher, *The Arts in Ireland,* Dublin, 1982

GALLAGHER, Lynn and ROGERS, Dick, *Castle, Coast and Cottage,* Belfast, 1986

GUINNESS, Desmond, and RYAN, William, *Irish Houses & Castles,* London, 1971

HARBISON, Peter, *Guide to the National Monuments of Ireland,* Dublin, 1970

JOYCE, John, *Graiguenamanagh, a Town and its People,* Kilkenny, 1993

KEOGH, Imelda, *St Mary's Church, Gowran,* Kilkenny, 1995

LESLIE, Seymour, *Glaslough in Oriel,* Monaghan, 1913

LEWIS, Samuel *A Topographical Dictionary of Ireland,* Dublin, 1837

MITCHELL, Frank and RYAN, Michael, *Reading the Irish Landscape,* Dublin, 1997

O'BRIEN, Daniel, *Beara,* Castletownbere, 1991

O'CALLAGHAN, Kate, *Adare,* Limerick, 1976

PEARSON Peter, *Between the Mountains and the Sea,* Dublin, 1999

PFEIFFER, Walter and SHAFFREY, Maura, *Irish Cottages,* London, 1990

ROBINSON, Tim, *Stones of Aran,* Dublin, 1986

SHAFFREY, Patrick, *The Irish Town,* Dublin, 1975

SIMMS, Annagret, and ANDREWS, J.H., *Irish Country Towns,* Cork, 1995

SOMERVILLE-LARGE, Peter, *The Coast of West Cork,* Belfast, 1972

SPELLISSY, Sean, *Clare, County of Contrasts,* Ennis, 1987

TRENCH, C.E.F., *Slane,* Meath, 1976

WILLIAMS, R.A., *The Berehaven Copper Mines,* Northern Mine Research